HISTORY OF
ITALIAN PAINTING

1250—1800

F. M. GODFREY
PH.D.

SECOND EDITION, REVISED AND ENLARGED

TAPLINGER PUBLISHING CO., INC. New York

FIRST AMERICAN EDITION PUBLISHED BY
TAPLINGER PUBLISHING CO., INC., 1965
119 West 57th Street, New York 19, N.Y.

LIBRARY OF CONGRESS CATALOGUE
CARD NUMBER : 65-16699

MADE AND PRINTED IN THE UNITED KINGDOM

INTRODUCTION

This student's guide is intended for those who wish to learn how to appreciate the language of form in the visual arts. It is not for the expert; it endeavours to present the knowledge of the specialists in a form acceptable to students of any age, but more particularly to the young in search of landmarks in the evolution of Italian art.

In our time the visual arts have found their place in a curriculum of humanist studies, not only as an auxiliary to the knowledge of civilizations, but in their own right as a life-enriching pursuit. The eye is no longer neglected among the senses as a means of absorbing values of form as essential as those transmitted by word or sound. In fact the formative influence of visual images upon the human mind may well be superior to that of the purely intellectual approach. Thus in the curriculum of Schools, Colleges and Universities the visual arts and their history are no longer the Cinderella among humanist studies; they now play their part in the education of the individual to the full stature of all his faculties. The recognition generally accepted today, that pictorial art is a manifestation of the human life-force of the highest order, has prompted the present course of studies.

In this volume a survey of Italian Painting from the thirteenth to the eighteenth century is offered. In 38 chapters the incomparable efflorescence of artistic creation in Italy is reflected and the nature of the leading masters described in selected works of major significance. A history of painting must centre upon the great masters and the continuity of their Schools. But the appreciation of the personal style of a master must always be joined to the question: what is his unique contribution to the art of his time and country and where does he stand in relation to his predecessors and followers?

Such an inquiry will help to establish certain aesthetic principles like the development of a sculptural, a linear and a painterly style, or the conquest of space, volume, light, and movement in pictorial science. We may recognize an identity of purpose in masters widely separated by time such as Giotto, Masaccio, and Piero della Francesca whose structural form and expressive power prepared the way for Michelangelo. Or we may watch the effects of mixing oils with colour which made

possible the painterly style of Venice; or trace the Florentine researches into perspective recession; or the Paduan fascination with the remains of Roman antiquity.

The book also treats of Movements and Schools, such as the Mannerist Movement of the sixteenth century which was an escape from Classicism; or the School of Bologna, which was its modernised form as well as being the root of the Baroque. Chapters on the Roman Baroque and the Venetian Rococo with side glances at Genoa and Naples round off the picture of five centuries of Italian painting. I am greatly indebted to the Seicento scholar, Mr. Denis Mahon, for generous advice and constructive criticism on the chapters dealing with his period.

It is hoped that this new one-volume edition, which has been enlarged and brought up to date, may find its use as a systematic course on the History of Italian Painting in places of Higher Education.

ACKNOWLEDGEMENTS

We would like to express our appreciation to the following for courtesies in connection with photographs:

By gracious permission of H.M. the Queen vii, 241, 243, 308

Ashmolean Museum, Oxford 59; Bayerische Staatgemaldesammlungen 162, 226; Fototeca Berenson, Firenze 52, 53; Duveen Bros. Inc., New York 6, 41, 136; The Frick Collection, New York 6, 142; Isabella Stewart Gardner Museum, Boston 127; Istituto Centrale del Restauro, Rome 68; Istituto Editoriale Italiano, Milano 69, 70, 71; H.S.H. Prince Liechtenstein 20; Metropolitan Museum of Art, New York 137; Trustees of the National Gallery, London 4, 8, 9, 24-28, 33, 34, 37, 38, 43, ii, 50, 54, 57, 65, 67, iv, 79, 80, 84, 85, 93, 94, 101, 110, 112, 119, 123, 125, 128, 129, 132, 138, vi, 140, 141, 145, 149, 155, 156, 158, 159, 182, 190, 202, 216, 223, viii, 233, 234, 236, 238-240, 246, 250, 252, ix, 253, 254, 263-265, 272, 273, 277, 298, 304, 306, 309, 310, 313; National Gallery of Art, Washington (Samuel H. Kress, Mellon, and Widener Collections) 5, 29, 41, 42, 73, 78, 82, 95, 97, 105, 136, 207, 299; National Gallery of Canada, Ottowa 102, 103, 111; National Gallery of Ireland, Dublin 51, 286; Museo Civico, Padova 35; Soprintendenza alle Gallerie, Firenze 2, 16, 19, 36, 44, 45, 47, 48, 56, 62, 74-76, 83, 98, 99, 104, 106, 108, 147, 148, 150, 180, 184, 195, 197, 199, 201, 203, 219, 276, Mantova 115-117, Napoli 292, Urbino 60; Palazzo Schifanoia, Ferrara 121, 122; Palazzo Pubblico, Siena 18; Sir John Stirling-Maxwell 116.

Thyssen Collection, Castagnola 126, 133; Barber Institute, University of Birmingham 294; City of Glasgow Art Gallery 100; Walker Art Gallery, Liverpool 22, 124; Dr. Giovanni Paccagnini 117; Kunsthistorisches Museum, Wien 114, 209; Dr. Licisco Magagnato 39; Professor Pietro Zampetti, Venezia; Denys Sutton, Esq., Editor of APOLLO for pl. iii; Gabinetto Fotografico Nazionale, Roma 1, 3, 10-12, 23, 30-32, 87, 164, 165, 168, 170, 175-178, 186, 187, 193, 260-262, 278-281, 283, 285; A.F.I., Venezia 134, 135; Azienda Editoriale Arnaud, Firenze i, v; Osvaldo Böhm, Venezia 130, 131, 217; J. E. Bulloz, Paris 49, 58; A. C. Cooper Ltd., 21, 61, 63, 64, 66, 81, 107; Mansell Collection 7, 13-15, 17, 40, 46, 77, 86, 90, 91, 101, 118, 139, 143, 146, 163, 166, 174, 179, 181, 183, 191, 192, 224, 229, 237, 242, 255, 269, 282, 284, 288, 289; Royal Academy, London 153, 302; Wallace Collection, London 311, xii; Victoria & Albert Museum, London 167, vii, x, xi; Director of Art, Arts Council of Gt. Britain 194, 231, 232, 297; Lord Ellesmere 220; Fitzwilliam Museum, Cambridge 245; Trustees of the Chatsworth Settlement, Devonshire Collection 157.

CONTENTS

x

CONTENTS

I. ROMANESQUE AND BYZANTINE FORERUNNERS OF GIOTTO

Cavallini — Cimabue — Duccio — Ugolino da Siena

Towards the end of the thirteenth century PIETRO CAVALLINI exchanged the Byzantine method of working in mosaics for the spontaneity and vigour of painting 'al fresco'. He was the first to impart mass and volume to his figures and a Roman humanity. CIMABUE the Florentine combined in his monumental Madonnas a Byzantine solemnity with a rude primitive force. DUCCIO of Siena was an elegant Gothicist of Byzantine education. He is a narrator of sacred story whose nimble figures act by simple symbolic gestures.

Early Italian painting grew out of mosaic decorations on walls and vaults of Christian churches. To decorate the interior of a church with vast mural compositions, such as can still be seen in the ancient mosaics of Italy and of Greece, was a painstaking and a costly process. Thousands, even millions, of small cubes of coloured glass, no more than half-an-inch in size, or sometimes grounded with tiny plates of gold or silver, were sunk into soft mortar according to the artist's design. However splendid such mosaics might look—and those in Ravenna and Monreale, in Venice and Rome, are among the most gorgeous church decorations in the world—their scope is limited by nature of the regal and hieratic bearing of their figures, the essential flatness and linearism of their design, their frontality and the absence of the third dimension. Christ and His Saints express magic and majesty, but they command only a limited range of symbolical gestures.

Yet in one respect the Byzantine mosaicists, working in Italy during the fifth to the fourteenth centuries, were able to cast their spell over the future of Italian painting : they developed the iconographical scheme of the Gospel stories which influenced the compositions of Duccio and even of Giotto ; though Giotto transformed the old iconographical pattern by the expressive realism of his narrative and by his discovery of spatial depth and solid form. But mosaics proved too slow and too expensive to answer the growing demand for church decoration that came in the wake of the monastic revival, and were too static, and too ornamental to express sufficient variety of action and emotion.

Artists who were born around the middle of the thirteenth century developed new means of expression and a new method of painting. This new method of covering large wall-spaces with scenes from Holy

Script or from the lives of the saints was called *al fresco*. That meant painting upon wet plaster with a full brush dipped in water-colours. The artist had to be quick to apply his colour to the wall before the plaster was dry. This ensured a new spontaneity and freshness of painting, which was no longer flat and two-dimensional, and rigid in

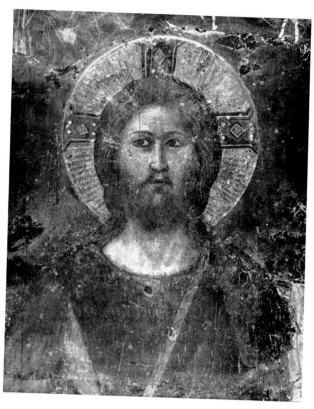

1. PIETRO CAVALLINI. *Head of Christ*. Trastevere, S. Cecilia (photo : Gabinetto Fotografico Nazionale).

action, but could depict movement and depth and feeling more freely and vividly than the solemn mosaics.

It stands to reason that the first masters of fresco-painting were still somewhat bound by tradition, and many of them worked in both mediums, now in mosaic and now *al fresco*. Perhaps the greatest of them was PIETRO CAVALLINI, born around 1240 or 1250, who lived mainly at Rome and at Naples. He decisively influenced Giotto, the founder of all Italian painting of the Renaissance. We know from

Roman documents that in 1293 Cavallini decorated the Church of Santa Cecilia in Trastevere with a representation of the *Last Judgment* and therein we find the figures of Christ and the apostles.

The first thing that strikes us in the *apostolic* figures, seated upon marble thrones and clad in Roman togas, which fall weightily in solid folds from their shoulders upon their knees, is their antique dignity and strength of body and mind. These men, notwithstanding their haloes, are more like Roman judges or senators sitting in a Court of Law, meting out justice. It is their physical presence, their powerful rocklike form which convey grandeur and gravity. These apostles remind us more of Roman statuary than of Byzantine mosaics, and Cavallini was the first to transfer sculptural form and roundness of shoulder and limb upon the flat surface of wall-painting. How he has achieved this becomes more evident if we watch the transitions of light and shade upon the heads and garments of the apostles, the contrast between the brightly lit and darker parts of the face, which also enables him to express tenderness and serenity.

The most impressive figure of all is that of Christ the Judge, with His awe-inspiring fixed gaze which, like the Godhead in Græco-Roman mosaics, conveys the divine and mysterious power of the Creator. But no mosaicist could use such vigorous means of conveying physical and moral strength as Cavallini, who moulded this head with his rich and vibrant brush : the sinuous strands of hair which enhance the roundness of the head within the great circle of the halo, the strongly-arched brows and well-defined lids with the great black pupils, which look through us and beyond. This is no meek and suffering Christ, but a heroic shape ; no longer the beardless youth of the mosaics, but a Pantocrator of Roman strength and supernatural power.

Besides the Roman Cavallini there were two other contemporary artists, forerunners of Giotto, who helped Italian painting to become a native art and free itself from the Byzantine manner which still enslaved mediocre craftsmen : Cimabue of Florence, and Duccio of Siena.

CIMABUE forms a link with Cavallini whom he met in Rome, and with Giotto who became his follower and his assistant on the great mural decorations in the Church of S. Francis at Assisi. Like Cavallini, Cimabue strove to instil his native force into the inherited pattern of Byzantine art. In his early *Madonna Enthroned* (Uffizi) who holds the blessing Jesulus upon her lap, while angels with bright wings are towering up by the side of the lofty and marble-encrusted throne, he creates a solemn image or icon of the faith. It is a picture of majesty, where the Madonna with the inscrutable gaze of her dark almond-shaped eyes is

borne aloft, on her architectural throne with its concave arches and pillars, by the angel-host inclining their heads toward her in a melodious rhythm. The Virgin's blue mantle falls around her great shape in countless twisting folds. But while the ornate throne, the profusion of gold leaf, the strict frontal position and symmetry are in the Byzantine tradition, the massive form of the Madonna, her overpowering grandeur, and the fierce fiery prophets in the lower arches sound a new individual note in the art of the primitive master. Toward the end of his life he painted another Madonna which is in the Louvre : and here the throne is less prominent, the folds less angular, and the Virgin, the round-headed curly-haired Child, and the attending angels have become simpler, more appealing, less remote from human affairs. The Louvre Virgin is truly gigantic. As she sits in immutable majesty, her great body is moulded by organic folds. She holds the imperious Child, whose hand blesses but also commands. Upright in a long grey tunic, serious above His years, He is a Pantocrator in the lap of the Magna Mater.

Cimabue was a profoundly dramatic artist ; and at Assisi, where he worked from 1277 to 1280, there is by his hand a Crucifixion whose tragic violence can still be felt even in the dim outline of a damaged fresco.

Here too he painted a *Madonna and Angels with S. Francis*, one of the truest images of the great founder of the Franciscan Order or Begging Friars, who was also the leader of the religious revival at the beginning of the thirteenth century. Cimabue has not embellished the saint. A small sturdy figure faces us in his poor monk's habit, bearded and with a thick crown of hair around his tonsure, his hands and feet pierced with the stigmata of Christ's wounds. It is not a portrait from life, for S. Francis had died in 1226, but it is true to the spirit of the saint which later legend has falsified and weakened. It conveys an unbending will, strength and endurance as well as suffering, pity, sympathy and, in the dark far-away glance, a power of mystical exaltation. It is the real S. Francis : he who from his ardent faith drew the strength to support on narrow shoulders the edifice of the church, toppling over with pride and worldliness. Later artists have clothed the saint in beautiful raiment, but Cimabue was near enough to the real S. Francis to create this crude, tragic, and memorable image.

The third of the great primitive masters of Italian antiquity, who with Cimabue and Cavallini infused the neo-Hellenistic art of Byzantium with an Italian aroma, was DUCCIO DI BUONINSEGNA. He was born at Siena, only about forty miles from Florence, where he and his followers developed the great rival school of painting. Just as Giotto's work

2. CIMABUE. *Madonna Enthroned*. Firenze, Uffizi (photo : Soprintendenza alle Gallerie, Firenze).

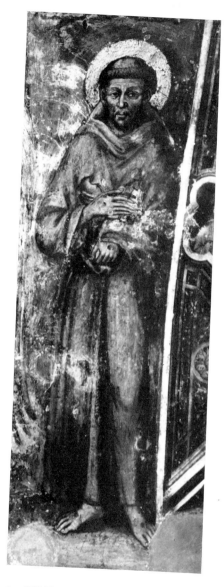

3. CIMABUE. *Madonna and Angels with S. Francis:* detail. Assisi, S. Francesco (photo: Cabinetto Fotografico Nazionale).

became a landmark and an inspiration for many generations of Floren-
tines, so Duccio was the life-giving force of the sister school in neigh-
bouring Siena. But since he was born a generation before Giotto and
for a time had Cimabue for his master, he must be considered as ' the
last of the great artists of Antiquity, in contrast to Giotto who was the
first of the moderns ' (Berenson).

So close was he to Cimabue and his classical manner of painting
life-size Madonnas on elaborate thrones, with large saddened eyes and
faces of sculptured immobility, that one of them has been attributed to
both masters in turn. As a young man Duccio had been to Florence
in 1285, and there under the shadow of Cimabue he painted the
Madonna Rucellai, yet with a new uncommon grace and gentleness in
the kneeling angels who support the throne.

Duccio was back in Siena in the following year, and there he began
to work out his own style, which was to be quite different from the
powerful Roman manner of Cimabue and Cavallini. He may have
visited Constantinople or at least learnt his craft from a Byzantine
master, for in the works of his maturity he followed Byzantine models
in his arrangements of sacred story. He became above all a vivacious
narrator and illustrator, a ' pictorial dramatist ' who used his figures like
actors in a Passion-play : more like symbols than real people of flesh
and blood, yet single-minded and emphatic in their sacred role. In
Duccio's Gospel illustrations a mediaeval spirit blends with Gothic
lineament and a Byzantine language of grouping and symbolic gestures.

His masterpiece was a great altar, painted for the Cathedral of Siena
between 1308 and 1311, the *Maestà*, representing the Virgin and Child
surrounded by angels and saints. This panel was painted on both sides,
with apostle figures in the Gothic cusps of the frame and with stories
from the youth of Christ and the life of the Virgin in the predella below.
On the reverse was painted the Crucifixion and the Lord's Passion.
This resplendent altarpiece, which is now partly dispersed, was borne
in festive procession from Duccio's workshop to the Cathedral, and a
public holiday was declared in the city of Siena. This is how a con-
temporary describes the event :

' The shops were closed and the bishop ordered a great and devout
company of priests and friars to form a solemn procession, accompanied
by the nine lords of the city and all the magistrates and all the people.
And one by one all the most worthy citizens were to walk closest to the
said altarpiece, bearing flaming candles ; and behind them came the
women and children with much devotion. These accompanied the said
panel as far as the Cathedral, to the chime of bells, leading the procession
around the Close, as is the custom, to the greater glory and tribute of such

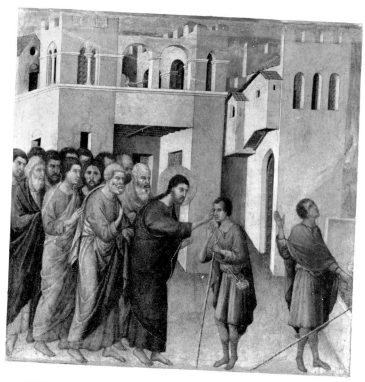

4. DUCCIO. *Jesus Opens the Eyes of a Man Born Blind*. London, National Gallery (photo : National Gallery).

a noble painting as this. . . . And all day long they remained in prayer with much almsgiving to the benefit of the poor, imploring God and His Mother who is our protectress, that by her infinite mercy She may defend us against every adversity and every evil, and guard us against the traitors and enemies of Siena '.

The main panel of the *Maestà*, still in the Cathedral Museum at Siena, is an archaic altarpiece of motionless figures, closely aligned in three tiers without space to move, yet noble and courtly though apostles and angels are still composed to a Byzantine formula. The smaller scenes of the predella are more freely grouped and more vivacious in action. In one of them, where *Jesus Opens the Eyes of a Man Born Blind*, the scene is laid in a rising street of a mediaeval town, with pink and grey house fronts, broadly shaded and lit, quaintly receding into depth of space. Here the apostles are watching the miracle in a solid group of well-rounded figures, while Christ in His shining blue mantle and scarlet robe touches the blind man's eye. To the right the same beggar

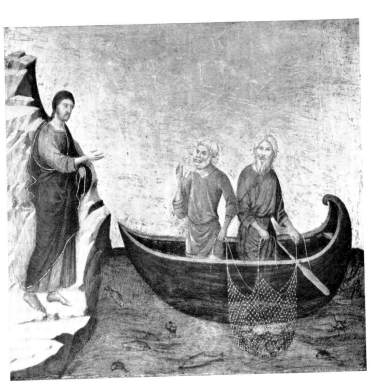

5. DUCCIO. *Calling of S. Peter and S. Andrew*. Washington, National Gallery of Art, Samuel H. Kress Collection (photo: National Gallery of Art).

is seen again as he recovers his sight after washing his eyes in the waters of Siloam. This scene must have impressed even the most simple minded, though the apostles hardly stand on their feet and the beggar's hand and gesture are more symbolic than natural.

In the *Calling of S. Peter and S. Andrew* Duccio has employed an extreme economy of means. The two fishermen are drawing-in the catch in their quaint little boat, when they hear the call of the Lord. The head of Christ with the fixed gaze is still markedly Byzantine as He stands on the cliff which enhances His slender frame. S. Andrew hears but does not comprehend, but S. Peter, stout-hearted and sturdy, raises his hand as if to swear allegiance and gazes at the Lord in eagerness of dedication. Duccio closely follows the pictorial scheme of the Byzantine mosaics, like those in Sant Apollinare Nuovo, Ravenna, dating from the sixth century. Here the Calling of S. Peter and S. Andrew is nearly the same, except that the youthful Christ of the mosaic is beardless and foiled by a great sun-like nimbus, as He faces the

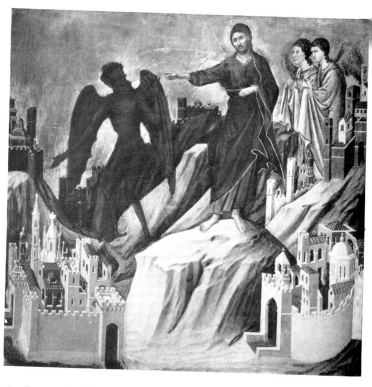

6. DUCCIO. *Temptation of Christ*. New York, Frick Collection (photo : Courtesy Duveen Bros. Inc.).

beholder with magic gaze. Duccio's mediaeval vision and primitive sense of space are made apparent in the *Temptation of Christ*. Here the Lord from a rocky eminence reproves the Devil for tempting Him with the kingdoms of this world. The toy city of Siena with spires and embattled walls encircles the dark looming figures ; the commanding Christ and the stark silhouette of the winged demon. Upon a foil of formal rocks the contest between the forces of Good and Evil takes place with dramatic vehemence.

Craggy rock facets rise behind the white-robed angel sitting on the empty tomb in *The Three Marys at the Sepulchre*. It is perhaps one of Duccio's boldest formal inventions with the great rock-pyramid towering up behind the angel who in shining garb sits astride the tomb in the ghostly light. The three women recoil from the apparition—they who had come with their vases of ointment only to find that the Lord had risen from the tomb. Just so is the presence of Christ enhanced by the summit of the rock in the *Transfiguration*, where He stands between

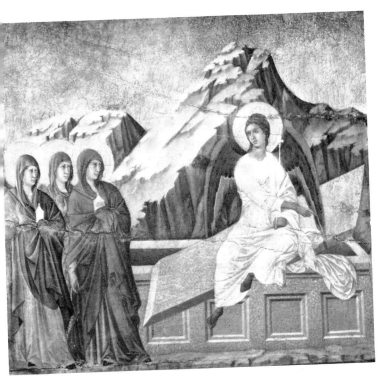

7. DUCCIO. *The Three Marys at the Sepulchre.* Siena, Opera del Duomo
(photo : Alinari).

Moses and Elijah, while the apostles Peter, John, and James lie dazed
and adoring at the foot of the hill in a Byzantine fashion.

Here, as always, Duccio excels in luminous colour : the gold thread
of Christ's robe in Gothic radiation of line, the glowing blue over
crimson of S. James, the rose-coloured hill, the chiselled arabesque of
the golden haloes, the coppery hair and weathered tints of Christ's
countenance. Beauty and solemnity of the grave old prophets who pay
homage to the Christ could not be expressed more graphically, though
the fluted folds and bent knees of Elijah hardly suggest a body beneath
the robes.

Duccio's contemporary and follower, UGOLINO DA SIENA, repeated
many subjects from the *Maestà* altarpiece : one of them is the *Betrayal*
of Christ. Ugolino adopted only the central group, where a compact
throng of soldiers and pharisees, contains three simultaneous actions.
Christ, motionless in the centre endures the sinuous embrace of Judas,
while the slim Roman legionaries seize Him by the shoulder, and

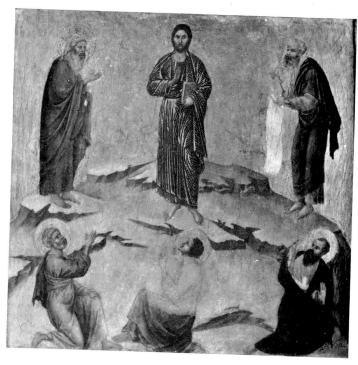

8. DUCCIO. *Transfiguration*. London, National Gallery (photo: National Gallery).

impetuous Peter rushes to cut the ear of Malchus. In Duccio's version the central tree tops the figure of Christ, while to the right a group of fleeing apostles acts as a balance to the main body of men. By concentrating upon the cruel drama of the betrayal and by confining it to the pit of a rocky valley, Ugolino has simplified Duccio's dramatic composition. In Duccio's stories from the Life of Christ, the traditional schemes of the Byzantine mosaics are recreated by means of an impeccable formal elegance, a new emotional content in facial expression and gesture and a more realistic attempt at rendering the surrounding space and architecture. No other School outside Siena is so close to the neo-Hellenistic shapes and patterns of Ravenna and Monreale, yet intensified by a sense for pictorial drama and stylistic refinement.

Duccio was above all a Christian humanist, and his *Maestà* is the pictorial expression of the mediaeval faith in the decorative style of a monastic miniaturist. He was a narrative artist who, imbued with the poignancy of his sacred subject, seizes its significant moments, transforming the hieratic art of the mosaics by his own personal lyricism.

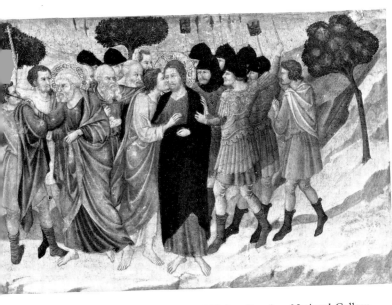

9. UGOLINO DA SIENA. *Betrayal of Christ*. London, National Gallery
(photo: National Gallery).

Giotto, who also uses Byzantine models for his representation of Christ's
Passion, is more powerfully dramatic and more realistic. Duccio's
figures are less safely poised, less firmly constructed, but they are
always convincing in their spiritual language of form, their balanced
grouping, their stylish precision.

II. GIOTTO'S BREAK WITH THE MEDIAEVAL TRADITION

GIOTTO: the first modern painter, was formed by Roman and Florentine influences He comes as a liberator from the mediaeval limitations of Byzantine art. His strength lies in his feeling for form and in his genius for simplification. He always presents the vital moment of a story. He is intelligible to all. His figures have mass, solidity, and physical presence. Without scientific knowledge of anatomy or perspective Giotto suggests movement and depth. Emotion is controlled, locked in ample form and essential gesture.

GIOTTO, like Dante, was an end and a beginning. His iconology, the time-honoured language of Christian imagery is mostly traditional, but in his Legends of S. Francis, he greatly enlarges its scope. His power of expression breaks free from mediaeval bonds. Giotto introduced into painting a new feeling for nature and for the human form. His pictorial language is at once broad and austere. It appears that Giotto reacted strongly against the apocalyptic grandeur of his master Cimabue and was attracted by more classical forms. In his narrative scenes from the Life of S. Francis and from Holy Script he rendered the human actors and their sparing gestures with dignity and restraint, creating a basic language to which Masaccio could turn a hundred years hence—though he had no immediate followers of note. It has been said by an early chronicler that Giotto ' translated the art of painting from Greek into Latin and made it modern '. Like Dante he introduced a *lingua volgare* which simple people could understand. He reacted with a certain violence against the Byzantine limitations of form and movement and against the archaising symbolism of mediaeval art. He had come to liberate the art of painting from the Byzantine formula and ornateness and to recover its nakedness and truth. At the dawn of the Renaissance Giotto, like Dante, is the creator of the heroic individual in art, however dependent they both were on the transcendental vision of the Christian Universe. Historically speaking, Giotto advanced from Cimabue's passionate mediaevalism towards a new concept of man and of nature, by two formative influences : the impact of Roman painting and of contemporary Gothic sculpture.

It is believed that Giotto started in Cimabue's workshop at Florence between 1280-85 and that he spent the next decade in Rome among the fresco painters and mosaicists of the Cavallini School. Dante expressed in prophetic rhyme the historical situation which is as valid today as it was in 1300. ' Cimabue believed he held the field in painting ; and

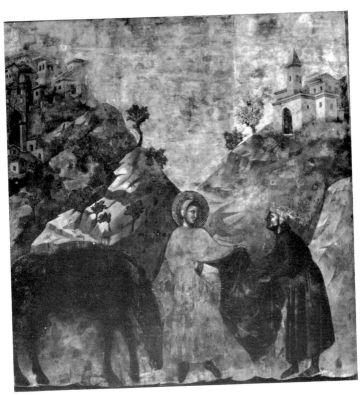

10. GIOTTO. *S. Francis gives his Cloak to a poor Knight.* Assisi, S. Francesco (photo : Gabinetto Fotografico Nazionale).

now the cry is with Giotto, so that the former's fame is overshadowed.' In 1296 Giotto was called to Assisi by the General of the Franciscan Order to ideate and largely execute 28 scenes from the Life of S. Francis on the walls of the nave in the Upper Church of San Francesco at Assisi. In 1299 he was summoned by Pope Boniface VIII for work at the Lateran Church, leaving the completion of the S. Francis cycle to his assistants. Apart from the Roman *gravitas* of Pietro Cavallini, Giotto had absorbed other influences. His contact with northern Gothic must have been through the sculptures of Arnolfo da Cambio (façade of Florence Cathedral) and Giovanni Pisano whose pulpits in Pisa and Pistoia combined French Gothic with classical elements. In his Assisi frescoes Giotto conveys the religious emotion by which the Franciscan preachers and writers had kindled the popular imagination. Thus he becomes the first painter of the Franciscan movement, illustrating the life of the saint according to the *Vita* of Thomas da Celano and of Bonaventura. Already in Giotto's first fresco, *S. Francis gives his*

Cloak to a poor Knight, his firmness and breadth of form can be felt and also his economy of expression. The scene is set in a solitary landscape of intersecting hills and ornamental trees, topped on the left by a group of monastic buildings and on the right by the town of Assisi. The action could not be simpler. S. Francis has dismounted from his horse which nibbles at the grass, while the saint passes his cloak to the poor knight. The latter eagerly bends forward to receive the gift gazing intently upon S. Francis. The impulse of the youthful saint and the knight's gratitude and amazement are made apparent in those two solid figures, joined by the richly realized cloak, whose deep hollows and triangular folds have weight and relief. The grazing horse is not only an example of Giotto's eye for animal form, it also balances the group ; while above and beyond, the contrast of lighted rock and shaded hill defines the landscape of Assisi. In the centre, the inverted triangle of blue sky leads the eye to the haloed figure of S. Francis.

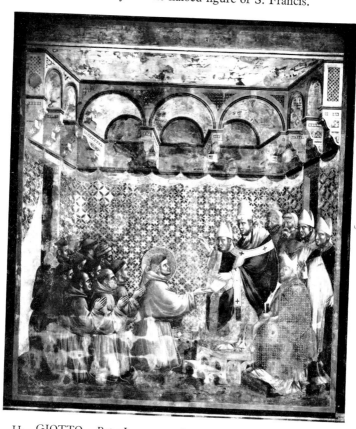

11. GIOTTO. *Pope Innocent confirms the Franciscan Rule.* Assisi, S. Francesco (photo: Gabinetto Fotografico Nazionale)

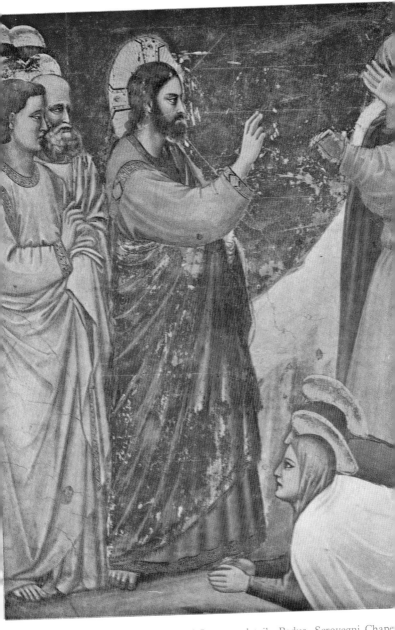

PLATE I. GIOTTO. *Raising of Lazarus,* detail. Padua, Scrovegni Chape
(Photo: Courtesy Messrs Arnaud, Florence)

All the first episodes of the cycle are by Giotto's own hand, such as *Francis renouncing his Inheritance*, the *Dream of Pope Innocent III*, the *Expulsion of the Demons* from Arezzo, the *Manger at Greccio* and the more lyrical *S. Francis preaching to the Birds*. One of the most powerful scenes is that where *Pope Innocent confirms the Franciscan Rule*. In a **11** brightly lit hall, before a backdrop of tapestry and stage-columns the poor friars are seated below the Pope and his Court of prelates. They are gazing anxiously from haggard faces at the imperious Pontiff, whose hard marmoreal features indicate the secular pride and power of the Curia. Never before has Giotto moulded a human form more sculpturally than the perfect oval of the Pope's head and tiara ; never engraved more deeply the psychological meaning of face and gesture. The worldly Pope and his cardinals look contemptuously upon the frightened flock of friars and their leader, who has come to plead their cause, be it the confirmation of the Order or the permission to go out into the world to preach. The dramatic moment lies in this contrast between the omnipotent Church and the spiritual friars, a contrast which S. Francis is pleading to reconcile and to overcome.

The Miracle of the Spring with its Gothic rock, rising steeply and **12** blocked out by alternating planes of light and shadow, is perhaps not entirely by Giotto's hand ; though the figure of the saint, praying that water may gush forth from the stone and his two companions with their mute language of glance breathe Giotto's spirit. But the figure of the peasant, flung across the rock to quench his thirst is too bold and original to be the work of assistants. The last scenes from the *Death of S. Francis* onwards are painted in a lighter, more decorative style and must be assigned to Giotto's workshop after he left for Rome in 1299.

In 1303 a chapel was founded by Enrico Scrovegni inside the antique amphitheatre at Padua. When two years later the chapel was consecrated, Giotto began to cover the whole length of the nave and the entrance wall with frescoes of stories from the youthful life of the Virgin, the life and Passion of Christ and a Last Judgment. These frescoes were probably completed in 1313. They are the first monumental illustrations of the Gospel story and form a continuous narrative in 34 sections along the whole length and breadth of the walls, without architectural divisions. The Padua frescoes are Giotto's epic masterpiece, comparable to Dante's *Commedia*, just as the Assisi cycle was essentially lyrical like Dante's *canzoniere*. They are contemporaneous with Cavallini's *Last Judgment* in S. Cecilia, Rome, and Giotto shares its Roman breadth and solemnity. But these are modified and enriched by the incisive modelling of figures and drapery which reflect the

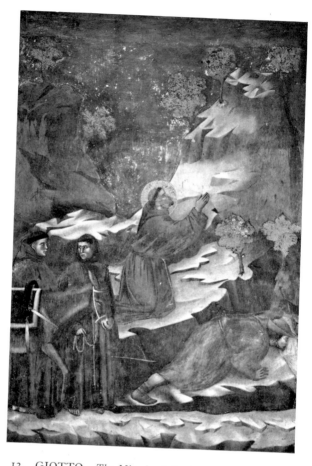

12. GIOTTO. *The Miracle of the Spring.* Assisi, S. Francesco (photo : Gabinetto Fotografico Nazionale).

Gothic sculpture of Giovanni Pisano. In this second and principal phase Giotto moves from the Romanesque towards a Gothic classicism. Some of his Paduan frescoes, like the *Bridal Procession of the Virgin*, have the stately dignity of French Cathedral sculpture. At the same time Giotto's figures assume greater volume and amplitude and a generous articulation of folds and robes. Space is defined by Gothic rocks and buildings. Nature is not rendered realistically, but in geometrical abstraction. Giotto's main concern was the human significance of the story and its implied drama, which is suggested in clear and simple terms.

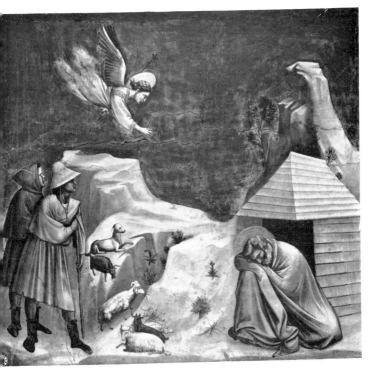

13. GIOTTO. *Dream of Joachim*. Padua, Cappella Scrovegni (photo : Anderson).

The epic unfolds with the Joachim episodes, his Expulsion from the Temple and his Life among the Shepherds. In the *Dream of Joachim* **13** the future father of the Virgin Mary sits huddled up in a cloak, sunk in sleep before a wooden hut, while an angel speeds from the sky to tell out his message that a child will be born to Anne, the aged wife of Joachim. Never before has the absorption in sleep or the balm and relief of dream been so forcefully rendered. Joachim's roseate mantle in the diffused light lends relief to his body in great sweeping curves, not by line or contour, but as living sculptural form. Rocks and building are of an almost geometrical order. Two diagonals divide the picture plane : one is formed by the downward swoop of the angel, skirting Joachim's back ; the other runs from the top of the pyramidal rock down to the crevice with the grazing sheep. While one diagonal isolates the sleeping man, the other connects him with the angel and briskly approaching shepherds.

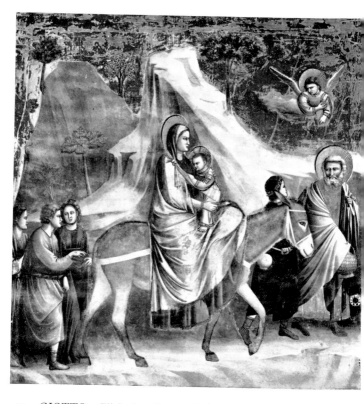

14. GIOTTO. *Flight into Egypt*. Padua, Cappella Scrovegni (photo : Anderson).

The figures in these preliminary scenes like the *Meeting at t* *Golden Gate* or the *Flowering of the Rods* seem blocked out in so cubic mass in contrast to the more fragile architecture. Rocks are frequent foil to Giotto's figures, as in the *Flight into Egypt*, where th Virgin, sitting upright and motionless on her mount, gazing steadfast into the distance, is framed by a great pyramidal rock. Here it is th contrast of stillness and movement which conveys a sense of dange and mystery. It really is a 'flight', with Joseph striding ahead an looking across his shoulder to the stable lad, as if to urge him on h way, with the attendants walking behind. But the Virgin is a immaculate and majestic shape which determines the noble simplici of the group.

Not all the frescoes in the Scrovegni Chapel are as serene an contained. Some are fierce and violent like the *Mocking of Christ c*

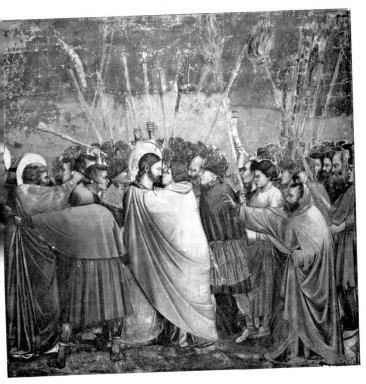

15. GIOTTO. *The Betrayal.* Padua, Cappella Scrovegni (photo : Alinari).

Christis before Caiphas. In *The Betrayal*, amidst the medley of arms and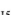
of men, of raised lances and torches, the Kiss of Judas stands out in
unforgettable grandeur. His vicious embrace—he is marked by his
aquiline nose, his vampire eye, his yellow cloak—is countered by the
noble countenance, the proud rejection, the intangible glance oɪ Christ.
For Giotto's Saviour is an image of Hellenic beauty, dark haired, with
fixed gaze, a leader of men. No longer does Judas entwine the Lord
as in Ugolino's *Betrayal.* It is with impetuous force that his bulky
form almost obliterates the slender, unassailable Christ. On the extreme
left a formidable S. Peter cuts the ear of Malchus, while a dark-hooded
pigmy of a soldier seizes his cloak. Like Flemish Bosch or Brueghel,
Giotto has made this soldier bell-shaped and almost grotesque, an
astounding simplification of form. Yet his hunched-up back and his
out-stretched arm are as eloquent as the broad sweep of Judas' mantle
or the gesticulating priest in his purple robe on the other side. Giotto's
figures are now as solid as rock ; they have breadth and mass ; their

21

c

hands grip and pull; their feet stand with real weight and he prese
structural form expressive of stark emotions.

During these years of his maturity Giotto also created the *Ognissa*
Madonna, the Rimini *Crucifix* and the *Navicella* mosaic. The gigan
Madonna, surrounded by angels, is of great majesty, a *Magna Mater*
more than human power, yet seated on an insubstantial Gothic thron
The angels, kneeling in front and standing around the throne in pe
spective recession are of a more gentle, classical mould, with straig
Roman brows and noses. If the *Ognissanti Madonna* is still a herc
abstraction, the Rimini *Crucifix* is altogether a more natural form. T
shapely curves of loins and knees, the transparent veil emphasizir
bodily shape and the hollow beneath the chest are a departure fron
Byzantine stylisation. Equally, Christ's noble head with the ey
closed in death, the half-open mouth, the natural rhythm of the boc
are worlds apart from the rigid abstractions of mediaeval crucifixes.

In his last fresco-cycle at the Bardi Chapel in Sta. Croce (*c.* 1322-25
Giotto returned to the theme of his youth in four monumental scene
from the *Life of S. Francis*. These are perhaps his most forward-lookin
achievements. In these frescoes Giotto obtained a new integration
figures in the space and a realisation of true architectural form, as
the grand cubic palace, no longer the box-like architecture of Assis
but a real Renaissance building, obliquely placed, in front of whic
S. Francis renounces his Inheritance. In another scene of the legend:
16 *S. Francis before the Sultan* with its inlaid marble architecture, the mute
play of monumental figures, the soft colour and light and the restraine
emotions, Giotto seems to foreshadow Piero della Francesca. Th
S. Francis of the *Stigmatisation* is now a heroic shape of giganti
corporality, although at a far remove from Sassetta's exalted luminary
Finally, the *Burial of S. Francis*, an oblong composition of classica
equilibrium in the arrangement of mourning friars around the bier o
their founder, has a new vividness and individuality of mien and gestur
and a psychological scale, portraying a variety of human conditions
from humility and affection to mystical ecstasy; a clear anticipation o
Masaccio's Renaissance manhood in the frescoes of the Carmine Chapel

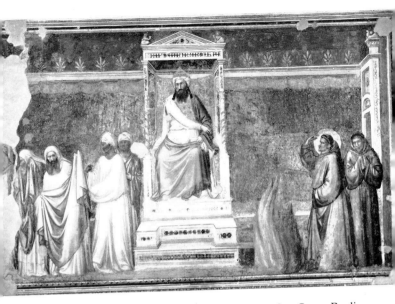

16. GIOTTO. *S. Francis before the Sultan.* Florence, Sta. Croce, Bardi Chapel (photo: Soprintendenza alle Gallerie, Firenze).

III. THE SIENESE INTERLUDE

Simone Martini — Piero and Ambrogio Lorenzetti — Sassetta ·
Giovanni di Paolo — Francesco di Giorgio — Neroccio dei Lan

The art of Siena has been called a modified Gothic. If Giotto's art is huma
earthly, and sculpturesque: that of SIMONE MARTINI and his followers
ornate and entirely linear. It is an art of beautiful surfaces. The three-dimension
space does not exist. The resistance of matter is overcome. Figures move and writ.
as their spirits dictate. A courtly grace and elegance is heightened by delica
colour and a profusion of gold. Sienese masters develop a poetic purity of line an
of movement which is at the opposite pole to the Florentine realism.

The art of Siena transcends the limitations of physical reality and soli
form in search for an ideal of rhythmical beauty and linear eleganc.
SIMONE MARTINI, who was born in 1285, at first followed in the pat
of Duccio. He was thirty years old when he painted his *Maestà*, th
Madonna and Child under a canopy, with saints and angels, of rar
loveliness. It is a work more spacious and airy than Duccio's *Maest*
and endowed with a flowing, ecstatic rhythm in the kneeling angels wh
offer lilies and roses to the Madonna.

Simone's art is refined, courtly, aristocratic. Giotto conveye.
sculptural form, Simone used a Gothic rhythm of line, a sublimatio
of the visual world. When he painted scenes from the *Legends c*
17 *S. Martin* at Assisi, he is all aglow with the courtly graces, traditions
and gay costumes of the age of chivalry. Here in a scene of noble genr.
the Emperor dubs the youthful S. Martin a knight, while attendant:
hold his armour and court musicians play a festive tune. In his grea
18 wall painting of *Guidoriccio da Fogliano* representing the victorious
general riding through a landscape, there is a strange modernit
about the barren hills and turreted castles, free from any detail but for
the spiky palings and lances which enclose the valley through which the
war lord is passing. His is a stalwart figure, safely ensconced on his
steed, a massive silhouette upon the azure sky, relieved only by the gaily
caparisoned horse, the diamond pattern upon his robes.

But the most significant work of Simone, by which he is chiefly
19 remembered, is the Uffizi *Annunciation* of 1333. Painting has perhaps
never attained a more spiritual mood, where the human figure has been
transformed into rhythmical arabesque, swaying in the breeze. As
Mary withdraws from the angel under the impact of the message, her
slender and sinuous form is of the purest Gothic, as is the white-robed

24

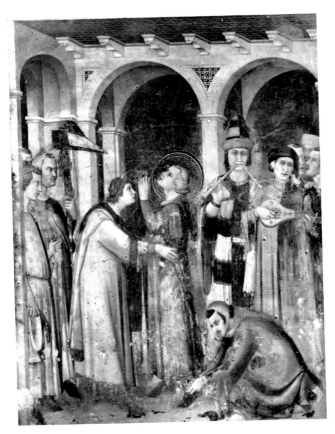

17. SIMONE MARTINI. *The Investiture of S. Martin.* Assisi,
S. Francesco (photo : Anderson).

angel with his fluttering cloak and fiery wings composed within the
pointed arch of the frame.

The same slender form and lovely mien, as of a great lady in the court
of heaven, distinguishes the single figure of *S. Catherine.* Here we can 20
study the exquisite shading which firmly models the oval face with
brown and blushing tints, the undulating strands of auburn
hair, the Byzantine fixity of the eye, the pattern of hand which holds the
palm, the grace and melancholy beauty of the saint.

Toward the end of his life Simone painted small panels of the Lord's
Passion, like *The Road to Calvary* in the Louvre, with a new compactness
and dramatic vehemence of massed figures, topped by a Gothic castle. 21
Here the executioner's cruelty and the loud lament of the women are
relieved by the stupendous ornateness of embroidered costumes and
gorgeous colour.

25

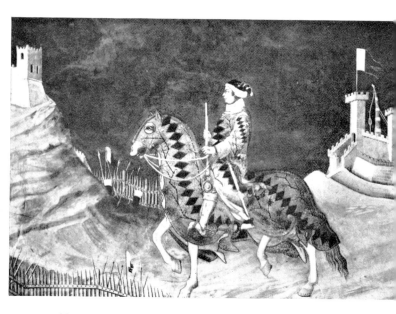

18. SIMONE MARTINI. *Guidoriccio da Fogliano:* detail. Siena, Palaz
Pubblico.

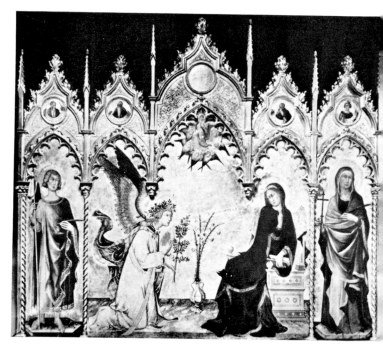

19. SIMONE MARTINI. *Annunciation.* Firenze, Uffizi (photo:
Soprintendenza alle Gallerie, Firenze).

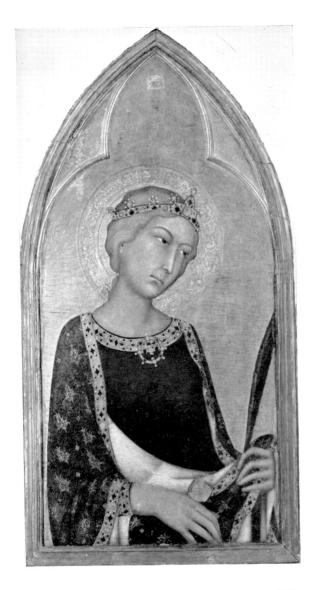

20. SIMONE MARTINI. *S. Catherine*. Formerly Collection of Prince Liechtenstein, now National Gallery of Canada (photo : Courtesy of H.S.H. Prince Liechtenstein).

Another late work of Simone, who died at Avignon in 1344, is the *Return of the Child Jesus to his Parents* after his dispute with the doctors 22 in the Temple. A Gothic expressionism of gesture in the reproaching hand of Joseph and the pleading of Mary enliven the work, in which the

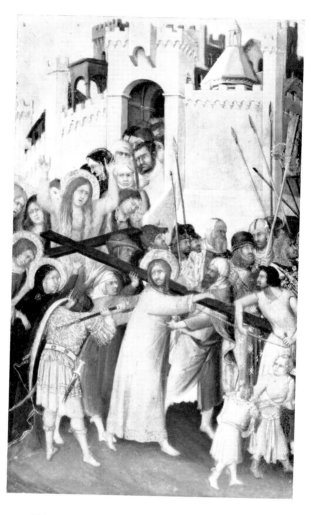

21. SIMONE MARTINI. *The Road to Calvary.* Paris, Louvre (photo : A. C. Cooper Ltd.).

force of the spirit does not shrink from distorting bodily form, and where the jewelled hem of robes and the chiselled gold of haloes show that Simone's art owed much to that of the French miniaturists. His style in its subjection of matter to spirit, its suavity and suppleness of all forms, its intricate convolutions of line, its sheer beauty and knightly grace, is that of a painter of the Gothic.

Contemporaneous with Simone Martini were PIETRO and AMBROGIO LORENZETTI, active between 1306 and 1348. Of the two brothers,

22. SIMONE MARTINI. *Return of the Child Jesus to his Parents.* Liverpool, Walker Art Gallery (photo: Walker Art Gallery).

Pietro is more akin to Simone and to the Gothic. His finest work is a *Madonna between S. Francis and S. John the Apostle* at Assisi, a wall **23** painting but with all the delicacy of line which circumscribes form and with the profusion of gold as if it were painted on panel. The impeccable beauty of S. John recalls that of Simone's S. Martin, but a new intensity of feeling and a fine spatial relationship enlivens the group, where all eyes are fixed upon the Child and where the figures are firmly constructed by contours rather than modelling. That is the Gothic inheritance, composing in linear relief, in perfect stillness and outward beauty, images beyond earthly reach and reality. Also at Assisi, Pietro

23. PIETRO LORENZETTI. *Madonna between S. Francis and S. John the Apostle.* Assisi, S. Francesco (photo: Gabinetto Fotografico Nazionale)

decorated the Lower Church with scenes from Christ's Passion, and here in the great pyramidal group of the *Deposition* he combines dramatic intensity with a melodious linear rhythm.

His brother Ambrogio was a less emotional artist, a scholar and thinker with a Renaissance curiosity about the visible world. His chief work is a great allegorical fresco (1337-1339) in the town hall at Siena where for the ruling party of the 'Nine' he represented *Good and Bad Government*, an elaborate political concept, disguised as an epic cycle of many symbolical figures. Here twenty-four councillors, in red and black robes, move toward their ruler who sits enthroned with the Virtues inspiring Good Government such as Justice, Peace, Wisdom, and others. These idealised female figures are painted in the Sienese idiom which suggests volume by a synthesis of contour and colour. But the chief attraction of Ambrogio's cosmological painting is the picture of town and country life which he added to his stern political Morality. Here the chalk hills of Siena with turreted cities, her vineyards and olive groves, her burghers and country folk at their daily pursuits, make their first appearance in monumental painting; a poetical transformation of a mediaeval reality.

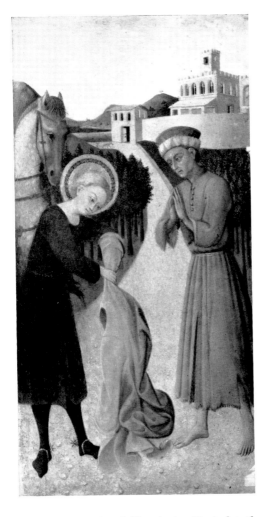

24. SASSETTA. *S. Francis gives his cloak to the poor Knight:* detail. London, National Gallery (photo : National Gallery).

The brothers Lorenzetti died of the plague which ravaged Siena in 1348 and brought to an end the heroic age of Sienese art. This was left in the hands of lesser masters such as Barna da Siena and Bartolo dt Fredi, who decorated the walls of San Gimignano Cathedral wiih expressive and vivid scenes from the Old and New Testaments, and of Andrea Vanni a friend of S. Catherine of Siena. Vanni painted a tender and spiritual portrait of the saint. For Siena was the city of saints, the birthplace of S. Catherine and of S. Bernadine's Franciscan revival.

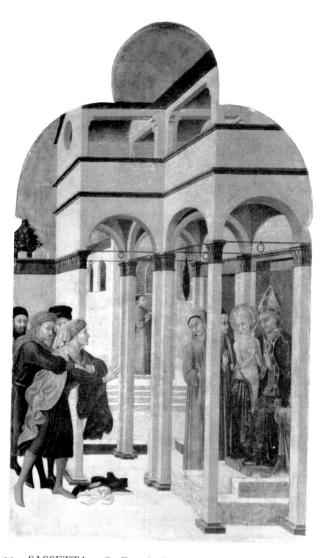

25. SASSETTA. *S. Francis Renounces his Earthly Father.*
London, National Gallery (photo : National Gallery).

Small wonder then that one of her most lovable masters, Stefano di
Giovanni, called SASSETTA (1392-1450) was to paint again the Legends
of S. Francis, but now in the courtly and more spiritual style which
differs so profoundly from Giotto's solid and earth-bound presentation
and the realism of Florence.

Seven of the eight panels of Franciscan legend which Sassetta
completed in 1444 for the Church of S. Francis at Borgo San Sepolcro,

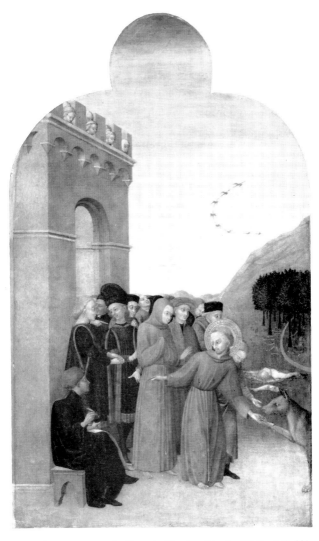

26. SASSETTA. *S. Francis Pleads with the Wolf of Gubbio.*
London, National Gallery (photo : National Gallery).

as parts of a great altarpiece, are now in the National Gallery, London. In the first *S. Francis gives his cloak to the poor Knight*, while on the **24** right an angel with fiery wings appears to the sleeping saint, rousing him to the religious life. In the limpid sky we behold a celestial castle with banners of the Cross. S. Francis, now a youthful knight, fair and comely, has dismounted from his grey horse with its red trappings, to give his light-blue mantle to the poor nobleman who worships him. A

winding path, lined with formal trees, leads to a radiant building with th
Umbrian hills stretching behind. On the right, S. Francis in crimso
raiment sleeps on a golden couch under a starry-blue canopy. Th
open bedchamber and balcony are steeped in sunlight and the who
scene is like a fairy tale of the chivalrous Middle Ages.

25 In the next panel *S. Francis Renounces his Earthly Father* and in h
nakedness is sheltered from the wrath of his father by the bishop. Th
violence of the movement, where the man's fury can hardly be restraine
by his friends—his face awry, his red robe fluttering in the wind—i
skilfully opposed by the stillness of the group around the bishop, th
pity and grief on their faces and by the noble and slender pillars an
arches of roseate stone. The beauteous form of S. Francis convey
the spiritual life in contrast to the worldly passion of the father. The dram
could not be described more eloquently, though Giotto had painted i
with a greater weight of solid buildings and of physical form.

One of the most enchanting of Sassetta's legends is the scene wher
26 *S. Francis Pleads with the Wolf of Gubbio*, to make his peace with th
citizens of the town. In sight of the bloody limbs of a mangled chil
S. Francis is seen dictating to the scribe the contract which he is making
with the wolf. Anxious women look down from the embattled gateway
while townsmen are massed behind the saint. A winding path lead
to a copse on a barren hill and a flight of birds repeats the curve upor
the azure sky. Poetry and enchantment of the Franciscan legend are
perfectly matched by the innocence and novelty of Sassetta's invention

The same S. Francis with large brow and slender body kneels in his
mountain retreat to receive the Stigmata or wounds of Christ. As he
looks heavenward, his eye veiled in exaltation, a winged figure
of Christ in a red and golden mandorla is seen in the deep-blue
sky. The radiance of the apparition forces S. Francis upon his knee,
his eye entranced, his brow contracted, while a brother Franciscan
witnesses the miracle. A reddish glow invests the mountain-tops and
the light-tipped laurel tree, enhancing the solitude of the supernatural
scene.

Close to Sassetta in time and spirit is GIOVANNI DI PAOLO, another
of the Sienese Primitives who lived in the fifteenth century and con-
tinued to paint with the vision of the fourteenth. But he is even more
quaint than Sassetta, whose beauty of form and fine spacing were beyond
his power. In his masterpiece, a series of scenes from the life of S. John
the Baptist, the most original invention is the fantastic panorama of
spiky rocks and mapped-out fields, representing the Wilderness through
27 which the youthful Baptist strides briskly, unmindful of the dark gorges
and aggressive crags. This small predella shows how closely linked

34

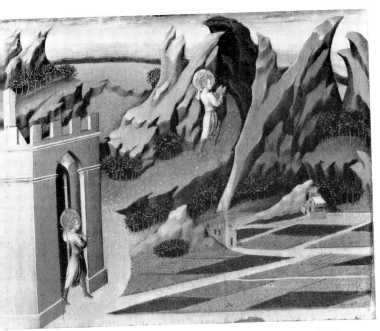

are the ancient and modern ways of seeing. Giovanni disregards the laws of perspective by which size diminishes in distance. S. John, whom we see twice at different stages of his journey, has always the same stature, and the nearby trees are even smaller than those farther away. The rocks are mere abstractions from nature, but they have a life of their own, and in their grotesqueness and steepness are suggestive of danger.

More archaic even, in her profusion of gold and courtly grace, is a panel of *S. Dorothy and the Infant Christ* by FRANCESCO DI GIORGIO. **28** The slender Gothicism of the saint, with the vertical folds of her robe falling in melodious lines over her arm, the graceful stance and appealing face of the martyr to whom the Child Christ appeared with a basket of roses, have the regal loveliness of a mediaeval sculpture.

The coherence and oneness of Sienese painting over a period of almost two centuries is such, that in the work of NEROCCIO DEI LANDI (1447-1500) we seem to meet again the supple sinuous line, the elegance and distinction of Simone Martini. The *Virgin and Child with S. Sigismund and S. Anthony Abbott* can serve as an epitome of all that was **29** best in Sienese art : the grace, the purity, the ornateness, the escape

28. FRANCESCO DI GIORGIO. *S. Dorothy and the Infant Christ*. London, National Gallery (photo : National Gallery).

if you will, into a world of legend and idealisation, with all the accoutrements of gold leaf and restrained luxury of flowing hair and princely mien. In that context the lofty S. Sigismund, with his finely arched brow and ingenuous glance, lightly holding the orb and the sceptre in noble hands, is the scion of this chivalrous Gothic world, which artists like Neroccio and Matteo di Giovanni led to the brink of the Renaissance.

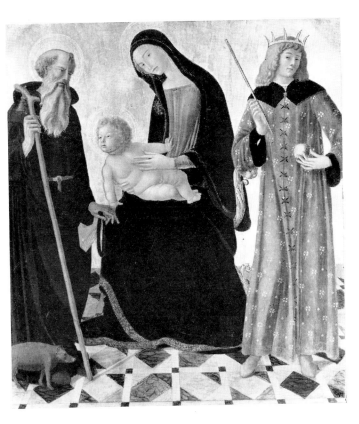

29. NEROCCIO DEI LANDI. *Virgin and Child with S. Sigismund and S. Anthony Abbot*. Washington, National Gallery of Art (photo: National Gallery of Art, Washington).

‚

IV. THE INTERNATIONAL STYLE

*Francesco Traini — Lorenzo Monaco — Altichiero — Gentile
Fabriano — Pisanello — Masolino da Panicale*

*The International Style or International Gothic is the last mediaeval style befc
the Renaissance. It is the style of the European courts equally at home in Fran
Burgundy, Italy, and Flanders. It combines a new realism of observation: whe
animals, plants, flowers, trees are carefully studied with an aristrocratic taste f
fair knights and ladies in precious costumes. A naturalist reflection of the beautif
world goes hand in hand with a sense of melodious line, of patterned brocades, a
noble architecture. It is the swansong of chivalry.*

The Gothic, which became an international style, had its origin i
France, not only in the art of the cathedrals, but also in the painting
illustrated Manuscripts, Psalters, and Books of Hours. From Franc
it spread all over Europe and northern Italy, and to Naples through th
Anjou dynasty which ruled that kingdom. One of the masters fro
Siena, Simone Martini, had spent the latter part of his life at Avigno
where the Popes were in exile, and it is partly through him that th
courtly art of the Gothic was brought to Italy.

 But there is another aspect of Gothic art which was outside Simone'
temperament, and delight in beautiful and delicate forms : tha
was the world of tragedy, of suffering, and of death. For in th
Middle Ages man was haunted by thoughts of retribution for his sin:
and of the moral purpose of life. Morality plays were performed where
in man is confronted by Death and has to give an account of his deed:
Such a morality play was painted about 1360 by an artist fron
Pisa, probably FRANCESCO TRAINI, upon the walls of the cloister in th
Campo Santo of that town. This vast narrative cycle, the *Triumph c
Death*, has been called by one writer ' as mere illustration by far th
greatest Italian achievement of the Middle Ages '. In it Traini confront
the pleasurable world of the courtly and the genteel with the wretched
ness of the poor and the saintliness of the Christian anchorites.

 The Gothic fantasy of this artist has conceived four sharply contrast
ing scenes against a vast prospect of rocks, under a sky where angels and
demons fight for the possession of the souls. In the centre a group o
cripples and lepers, their faces awry with atrocious suffering, their back
bent, their arms raised in fruitless invocation, cry out that Death ma
come to end their misery. Yet their lament remains unheeded. For
Death swoops down upon a lovely bower with Cupids swinging fron
the trees, where a gay company of ladies and courtiers, in rich and

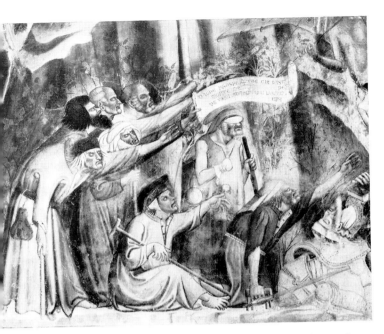

30. FRANCESCO TRAINI. *Triumph of Death:* detail. Pisa, Campo Santo
(photo : Gabinetto Fotografico Nazionale).

varied costumes, are seen conversing and making music. Some are
making love, others caress falcons or dogs, some are intent upon the
music, while the anxious lutanist is waiting for the zither-player to take
up the tune. It is a life of abandon and merry-making, such as the noble
Florentines lead in Boccaccio's *Decameron*, while the pest was raging
in the city.

A similar contrast, engendered by the ferocious fantasy of the artist
is enacted on the other side of the wall. Here a noble hunting party,
emerging from a rocky gorge, comes unawares upon three open coffins 32
where the corpses of kings and prelates are rotting. In his mediaeval
realism the artist has not spared us the sight of verminous, inflated
bodies and skeletons. He even suggests the malodorous air, for the
huntsmen are seen holding their noses, bending forward and backward
and looking meaningly at one another. Even the dogs sniff and horses
shy, as they approach the three biers, and their movement adds to the
confusion. Thus these gaily attired people with their strange hats
and hunting gear, their varied expressions and gestures, their volumin-
ous clothes and well-groomed horses—the Gothic painter's delight in
multifarious detail—are reminded of the proximity of death. This is

39

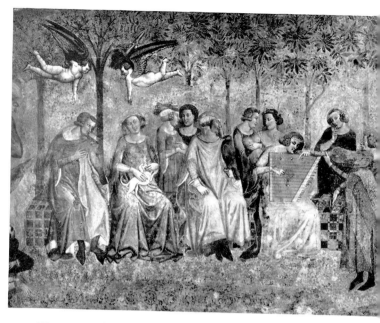

31. FRANCESCO TRAINI. *Triumph of Death:* detail. Pisa, Campo Santo (photo: Gabinetto Fotografico Nazionale).

obviously the lesson which a hermit reads to them from his scroll, while farther up the roughly-hewn steps, where the flat-patterned picture gains real depth, other hermits are seen leading a saintly life among the tame animals of the wood.

Where did this artist hail from, who unfolded his savage tale with such artistic cunning, who could organize huge wall-spaces and sustain dramatic tension, paint with graphic contours in crude colours and glaring light, master movement and individual gait and subsume his epic narrative to a stark moral purpose? His ornamental, frieze-like composition, his knowledge of the ways and fashions of courtiers suggest a master who followed neither in the wake of Giotto nor of the Sienese, but of the International Gothic. His power of observation, his portrayal of the aristocratic world—though not his macabre and poetical vision of Death—influenced many followers from Pisanello to Benozzo Gozzoli.

The *Triumph of Death* by the master from Pisa, who also painted the *Last Judgment* in the Campo Santo, is a monument of stirring and savage grandeur.

During the second half of the fourteenth century, painting in Italy divided into two main streams: the followers of Giotto who like Maso,

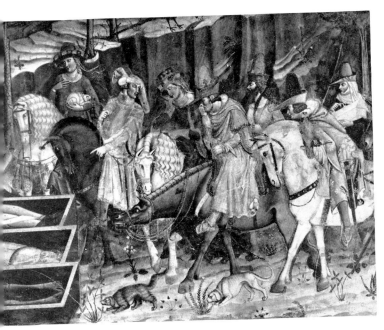

32. FRANCESCO TRAINI. *Triumph of Death:* detail. Pisa, Campo Santo
(photo : Gabinetto Fotografico Nazionale).

Daddi, Orcagna strove after powerful form ; and the Sienese Gothicists
whose strength lay in line rather than modelling, a refined ornateness
and spirituality. One master, however, LORENZO MONACO, combined
the qualities of both schools. He was born at Siena, but worked at
Florence, and in his art a melodious fluency of line and decorative
splendour blend with a Giottesque amplitude of form.

Born around 1370, he took his vows at the Camaldolese monastery
of S. Maria degli Angeli at Florence in 1391. His art, like that of Fra
Angelico after him, is religious, contemplative, monastic in spirit. He
also painted illuminated manuscripts. His finest works, of which there
are two versions, the *Coronation of the Virgin with Attending Saints* are 33
in the Uffizi and National Gallery. Before a Gothic tabernacle with
an embroidered curtain of crimson and gold in the Sienese style, a lofty
Christ in a sky-blue mantle crowns the Virgin. The convolutions of
Christ's mantle and the slender angularity of the Virgin are of the
Gothic. But the weighty figures and sculptural heads of the apostles
are of Giotto's lineage. The fine ecclesiastical faces, especially of the
younger saints, the solemn apostles with their carefully groomed
beards, the breadth and flow of their robes, the background of gold, the

41

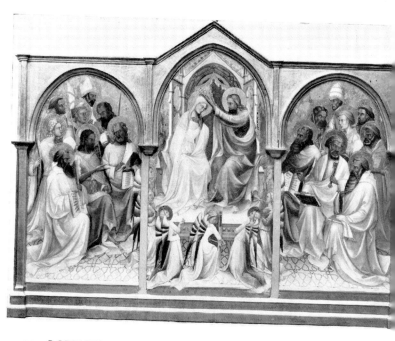

33. LORENZO MONACO. *Coronation of the Virgin with Attending Saints.* London, National Gallery (photo : National Gallery).

strange perspective of the tiled floor, but above all the dazzling brightness of colours, of crimson and blue, make this a characteristic work of the period, where solid form blends with Gothic lineament and Sienese preciousness.

Lorenzo Monaco was a true artist because he did not accept the data of reality without transforming them to suit his vision. In the small predella, representing *Legends from the Life of S. Benedict,* he cleansed his visions from all earthly residue, and in the mediaeval fashion painted three scenes in one. S. Benedict exhorts S. Maurus to rescue brother Placidus from drowning, which he does in the centre by walking on the water, as if it were dry land ; and S. Benedict spends a night in the convent of Sister Scolastica during a storm, for which she had been praying. Lorenzo invested his saintly figures with such beauty and dignity in their white and golden raiment ; he steeped his quaint houses in such pure colour—pale pinks and green—and in such an unearthly light, avoiding all superfluous detail and ornament that he lays bare the very soul of the legends. Yet the flowing lineaments of the robes reveal form, and the monastic spirit of the master speaks in a language of clear symbols.

34. LORENZO MONACO. *Legends from the Life of S. Benedict.* London, National Gallery (photo : National Gallery).

More formidable is another distant follower of Giotto, this time from north Italy, from Verona. He is ALTICHIERO who from 1372 to 1384 worked in the town where Giotto had painted his greatest work, the frescoes of the Arena at Padua. Here Altichiero decorated the Oratory of S. George with stories from the life of this saint. In the *Execution of S. George* the burly executioner holds his sword suspended, while a **35** pagan priest exhorts the saint, who does not heed his words. The powerfully constructed forms of the three principal figures in their ample robes and melodramatic action show Giotto's impact upon the far more complex master from Verona. His closely-packed figure-composition, where the foreground action is framed by the solid wall of lances in front of the sheer rock and towering city, is rich in observation of individual character and costume, with a new sense of genre and incident, as in the father dragging away his boy from the scene of execution. For clear narrative, firm, living figures, and compact design Altichiero is without peer in his time and country.

The court art of the International Gothic culminates in a work of sumptuous splendour which Palla Strozzi, the rival of Cosimo Medici in Florence, commissioned in 1423 from GENTILE DA FABRIANO. Gentile was an important figure also as the master of Pisanello and Jacopo Bellini. He was born in the province of Umbria around 1370 and had been summoned by the Lords of Venice to help in the decoration of the Doge's Palace. His works there are lost, and it is by the

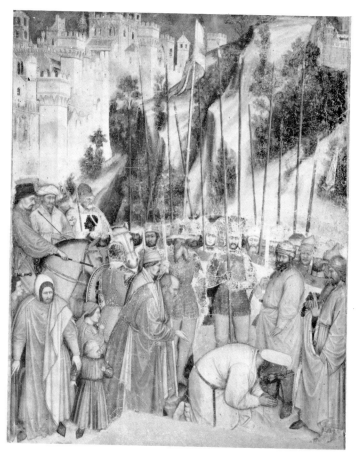

35. ALTICHIERO & AVANZO. *Execution of S. George.* Padua, Oratorio di San Giorgio (photo : Museo Civico, Padova).

36 *Adoration of the Magi* that Gentile is chiefly known as the artist who, at the waning of the Middle Ages, commemorated its courtly life in a work of glowing beauty and colour.

But this beauty is of an external nature. It is concerned with appearances : with patterned brocades of crimson and gold, blissful youth and dignified manhood, proud steeds and noble greyhounds, birds and flowers and golden tints of light. Gentile's *Adoration* is a royal pageant, where three-quarters of the picture space are filled with the throng of men and of horses, winding their way from afar through undulating hills to the simple manger. Just so will another Florentine, Benozzo Gozzoli, in the next generation array his princes and their

44

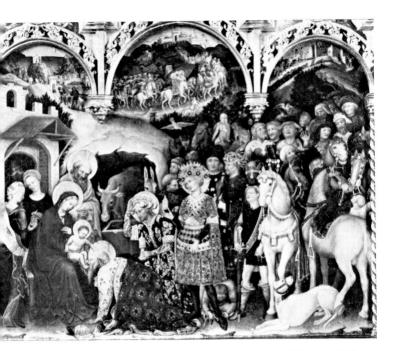

6. GENTILE DA FABRIANO. *Adoration of the Magi*. Florence, Uffizi
(photo : Soprintendenza alle Gallerie, Florence).

ttendants, as they emerge from a rocky valley with all their train and
trappings, in another picture of the Adoration, painted for Piero dei
Medici. Gentile da Fabriano has so adorned his kings from the east
that their gorgeous attire, their graceful bearing, their knightly weapons,
and golden diadems are like a song of Chivalry. His *Epiphany* is the
highlight of decorative art, propelled by an almost pagan enjoyment in
surface-values and in the coloured reflections of life : the masterpiece
of the International Style.

Knights errant, princes, chivalrous saints were also the favourite
subject of the other great master of the Gothic, Antonio Pisano, called
PISANELLO (1395-1450). Besides being a painter, he was the foremost
medallist of the age, which accounts for the incisiveness of his drawing :
the fine relief, the modelling, and the precision with which his brush
renders natural form. He lived at the most art-loving courts of Italy
and served the Este princes at Ferrara, the Gonzaga at Mantua, and the
Malatesta at Rimini. Like Gentile da Fabriano he was at work in the
Ducal Palace at Venice as the foremost master of his time, and like
him he never tired of glorifying the old feudal order of perfect knight-
hood.

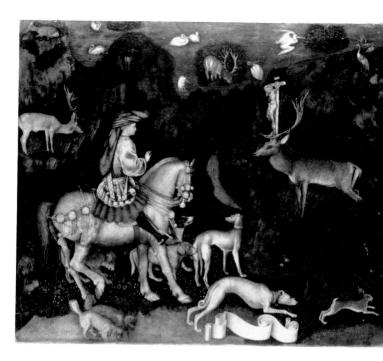

37. PISANELLO. *Vision of S. Eustace.* London, National Gallery (photo National Gallery).

One of his strangest works he painted early in life : the *Vision of S. Eustace*, the story of the knight as hunstman, to whom the Crucified Christ appeared between the antlers of a stag, so that the warrior Eustace was converted to Christianity and became a saint. Pisanello did not try to paint the spiritual experience of conversion ; his hunts man sits unmoved astride the mangificent charger, in his golden double and fur, beneath his gigantic blue turban. He raises his hand only lightly, in a courtly gesture of surprise, and the horse appears more startled by the vision than does the knight. Pisanello's main purpose was to erect this monument to knighthood, and to fill every nook of the picture with animal-form, closely observed after life and chiefly in profile : hare and hounds, swans and herons, stag and doe, and even a bear climbing up a rock. Nor has he organized his birds and beasts after any system, but scattered them everywhere over the picture-space without regard to the lie of the land. His picture looks more like an oriental carpet or miniature than like a fifteenth century painting but what a glorious pattern it makes with its sovereign disregard for space !

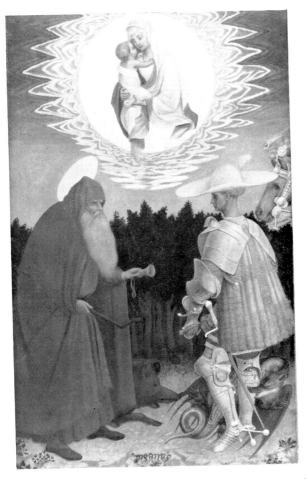

38. PISANELLO. *The Virgin appears to SS. George and Anthony Abbot*. London, National Gallery (photo : National Gallery).

Pisanello must have been a very original man, with a strange longing for the chivalrous past and an uncanny gift of minute observation and precise rendering of what his eye had seen. In another picture at the National Gallery, where *The Virgin appears to SS. George and Anthony Abbot*, who seem to be quite unaware of the golden vision in the sky, Pisanello invented the most romantic costume imaginable. Every link in the silvery shirt of mail is inscribed with metallic precision and the shining armour matched with the broad-brimmed straw hat and a feather. This fastidiously dressed knight holds converse with the grim, looming shape of S. Anthony, before a dark curtain of fir trees, from

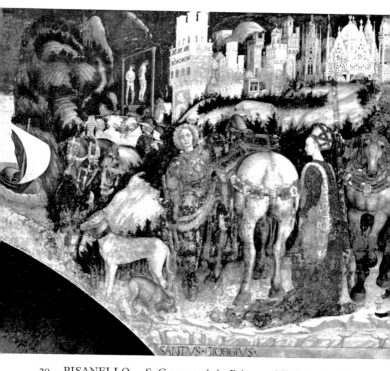

SANTVS·GIORGIVS·

39. PISANELLO. *S. George and the Princess of Trebizond.* Verona,
S. Anastasia (photo : Courtesy Dr. Licisco Magagnato)

which the radiant knight below and the haloed Virgin above stand out
in stark contrast. The artist has arranged his saints in symmetry and
in depth, and here he painted constructed figures more broadly than
are usual in the International style.

39 Pisanello's famous fresco of *S. George and the Princess of Trebizond*
(1432) surrounds a Gothic arch in the church of S. Anastasia, Verona.
It is like no other rendering of the subject ; a luxuriant still life of
courtly appurtenances and natural forms, without any action. S.
George stands wistfully by his charger, as motionless as the princess
opposite ; in her long trailing robe, her domed head with the great coif,
her impassive profile, she is a fashionable and monumental shape, gazing
across to her liberator. Large bulky horses seen from front or back
protrude into space, and all manner of dogs are portrayed. A wealth
of naturalist observation is in strange contrast to the fragile city of
Gothic turrets and embattled palaces in the middle-distance. Pisanello's
mural is an outstanding example of the International Style where
objects are not logically organized in space, but displayed like a pageant
of the artist's skill, invoking the twilight of the chivalrous Middle Ages.

48

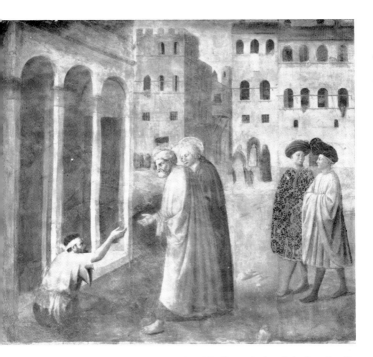

40. MASOLINO DA PANICALE. *Healing of the Cripple:* detail.
Florence, Cappella Brancacci (photo : Anderson).

The History of Art does not run in straight channels which the
student can follow and the scholar classify and label. Movements
overlap and different forces are at work simultaneously. Thus when
Masaccio is born, with whom the Renaissance proper begins, the
international Gothic is at its height. Gentile da Fabriano and MASOLINO
DA PANICALE indulge their florid sense of ornateness against which
Masaccio had come to rebel. The work by which Masaccio established
his fame was first commissioned to Masolino. A Florentine silk
merchant, Felice Brancacci, wanted his family chapel decorated by
scenes from the life of S. Peter. Masolino started the work in 1425 but
left its completion to Masaccio. The two Florentine dandies who walk
across the city square in the *Healing of the Cripple* are typical of **40**
Masolino's refined Gothicism. They tread the earth lightly and are
dressed in the latest costumes of the day : the one in a green mantle
with a black pattern of flowers, the other in a richly-pleated golden
tunic. Their heads are decked in the ample turban-like cloth biretta,
their faces, though finely modelled, have the same regular and refined
features.

41. MASOLINO DA PANICALE. *Annunciation*. Washington, National
Gallery of Art (photo : Courtesy Duveen Bros. Inc.).

But in the newly acquired panels of the National Gallery, representing *John the Baptist and S. Jerome*, Masolino, though still composing figures of Gothic slenderness and refinement, has enclosed something of Masaccio's depth and dignity in the spirituality of these old apostolic heads and in the illusion of space and bodily form. As for colour, it is a ravishing harmony of luminous crimson and violet, with subtle modification of tone where the light plays upon the cloth. For Masolino was a magician of colour, his main vehicle for reflecting the exterior beauty of the world.

And what could be more beautiful than Masolino's ripest work, the large *Annunciation* at Washington, where the grandeur of Masaccio **41** has yielded again to the courtly graces of the International Gothic. Like Gentile da Fabriano, Masolino cared more for the pageant of gorgeous colour, the melody of flowing lines, the preciousness of patterned brocades, and the noble restraint of courtiers, than for the structural form of human bodies. With the angel in his garment of golden roses kneeling before the Virgin—as before a great Lady who receives his salutation with becoming meekness and dignity in the ornateness of her Gothic chamber—the International Style of the chivalrous age comes to a triumphant close.

V. THE CONQUEST OF SPACE AND OF VOLUME

Masaccio

MASACCIO takes up the story of Italian painting where Giotto had left it, b
with enormously enlarged vision. The flatness of mediaeval painting was overcor
by Masaccio's three-dimensional space: where figures, trees, hills in their volumetric
fullness were carefully graded in depth. Masaccio constructs the human figure
sculptural largeness. In his frescoes the new man of the Renaissance in physic
and moral prowess rules supreme over the universe. He has poise and individu
character. Alternating planes of colour build up and define the human form.

MASACCIO is Giotto's heir. He came after a century to take up paintin
where Giotto had left it, and moved it onto a novel plane. In his wo
human figures acquire a weight, a volume, and a bodily mass like th
eternal rocks. They are firmly grounded in space ; they move, the
breathe, they act with dignity and with power : a race of men after th
heart of the Renaissance. For the Renaissance was not primarily
discovery of classical art, but a rebirth of man : an awakening of bod
and mind to a sense of its own power, dormant for so long and fettere
by the mediaeval Church. For such an efflorescence of the spiritu
and physical prowess of man there was only one analogy in history : th
Greek and Roman Antiquity. That is why the artists of the Renaissanc
preferred Classical forms of sculpture and architecture to Gothic an
Byzantine abstractions.

In Florence there had already been one great explorer of space an
perspective, the architect Brunelleschi, and one eminent sculptor of th
human body, Donatello. From them Masaccio must have learned ho
to create sculptural form in painting, and how to create the illusion c
bodily existence in the three-dimensional space. In his early *Portra*
42 *of a Youth* he has not advanced very far on the way in which Masolin
painted his Florentine gentlemen. The boy is seen in strict profil
and the ivory contours of his face, the small ear and eye, the parall
folds of his purple cap and doublet are still of Gothic fineness. Bu
there is strength and breadth in the face and a set purpose in th
character of the boy.

Masaccio had to accomplish his work, which laid the real foundation
of Renaissance painting, in a very short life-time. He was born in th
Valdarno outside Florence in 1401. Bred in the country, he was familia
with the rude and stalwart peasant-types which we meet in his frescoes
By 1422 he was living in Florence and in 1428/9 he died at Rome. Hi

42. MASACCIO. *Portrait of a Youth*. Washington, National Gallery of Art, Mellon Collection (photo: Courtesy National Gallery of Art).

rincipal works, an altarpiece for Pisa and the murals in the Carmelite Church at Florence, were painted between 1426 and 1428. The monumental *Madonna and Child* in the National Gallery was the centre **43** of the Pisa polytpych. From a background of gold leaf the great Renaissance throne stands out in solid grandeur, with its lofty step, its Roman rosettes and pillars. As the light falls in from the left, it creates the great depth of the throne, a perceptible vacuum filled by the large form of the Mother of God. She sits wrapped in a great mantle of glowing ultramarine, whose simple folds, moulded by the light and the broad grooves of shadow, reveal her powerful limbs. The Virgin's face and the Child's body are no longer circumscribed by line, but softly modelled with the brush in orange flesh-tones. While the Madonna

43. MASACCIO. *Madonna and Child*. London, National
Gallery (photo : National Gallery).

holds out a bunch of grapes to the Child, He clutches them with His
left hand and with the right pushes them into His mouth. Masaccio
had observed the ways of young children and painted the small Jesus
from life. Two rustic angels in purple-pink robes sit at the foot of the
throne, with one listening to the other plucking the strings of his lute.
This great mother, as she bends over the Child her weary head,
saddened at His fate, seems to brood over His future ; He looks into

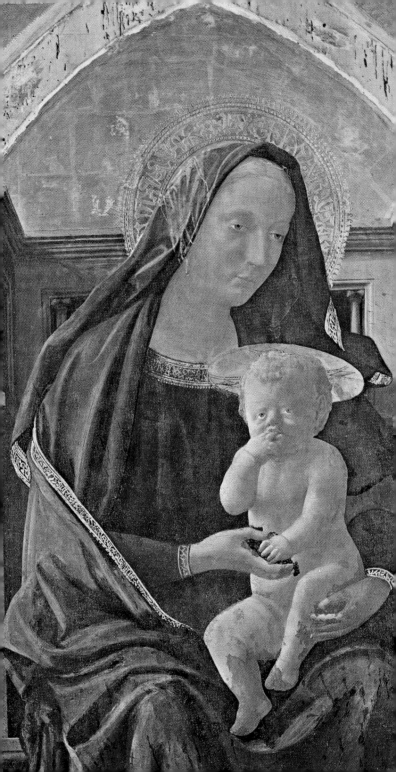

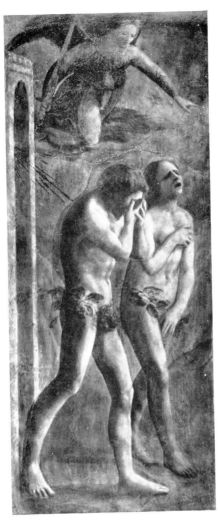

44. MASACCIO. *Expulsion from Paradise*.
Firenze, Cappella Brancacci (photo : Sopr-
intendenza alle Gallerie, Firenze).

the world with a frown, under a shining halo seen in elliptic fore-
shortening.

Masaccio's Madonna enthroned derives from those of Giotto,
Cimabue, and Duccio ; but she alone is a colossus, planted, as it were,
in the real space upon the solid throne of grey stone which contains
her majestic form. Though the background is gold, sculptural round-
ness and real depth are obtained by a sequence of forms contrasted by

colour and defined by light : the pink angels stand out from the ste
the Child's body from the Virgin's robe, the lighted columns from t
shaded wall. By such means Masaccio endows his Madonna with
' almost monolithic solidity '.

By 1425 Masaccio was already assisting Masolino da Panicale
painting the frescoes of the Cappella Brancacci. But soon Masoli
became his pupil's pupil and his suave and ornate style gained in for
and substance by his contact with Masaccio. In 1425 Masolino l
Florence for Hungary, and Masaccio remained in sole charge of t
Chapel decorations. He painted the *Expulsion from Paradise, T
Tribute Money, S. Peter Baptising the Neophytes, S. Peter Healing t
Sick or Giving Alms to the Poor.* By his heroic concept of man and l
the new freedom of figure-composition these frescoes became the Scho
of the World, where later artists like Raphael and Michelangelo did n
disdain to learn.

44 Masaccio painted the *Expulsion from Paradise* at the entrance-wa
of the Chapel. He depicted the Archangel in the clouds, holding t
sword over the first parents of man who flee from Paradise. It is a narrow
rectangular space which the two distressed nude figures fill almc
completely. Masaccio has not spared their shame. He painted the
in the full frontal light and modelled their powerful bodies with plan
of stark shadow. This interplay of light and shade, which throv
forms into plastic relief, is called chiaroscuro. Adam walks with h
head bent and hides his face for shame. But Eve cries out aloud ar
her face is awry as with physical suffering. They seem propelled by a
invisible force, for the angel only hovers over them and his swor
does not touch them. Their own despair and an irretrievable fa
drives them through the barren and lonely space.

45 In *The Tribute Money* Masaccio attempted a more ambitious con
position of many figures. It is the moment when Christ command
Peter to pay the required coin to the Roman soldier at Capernaur
With imperious gesture He tells Peter to go to the lake of Gennesar
and extract the coin from the mouth of the fish, while the rockli
apostle, looking straight at the Master with sustained passion, repea
His gesture. There are two subsidiary scenes besides the central grou
On the left Peter is crouching down by the lake-side opening t
fish's jaw, his wintry head bent over the task ; while over on the rig
he disdainfully pays his coin to the jeering soldier.

But the centre of the deepest tension is the great circle of men aroun
Christ, each of them in a wide mantle, which gives them the appearanc
of Roman citizens rather than of Christian apostles. They are all c
them stark individual characters, determined men of action, real peop

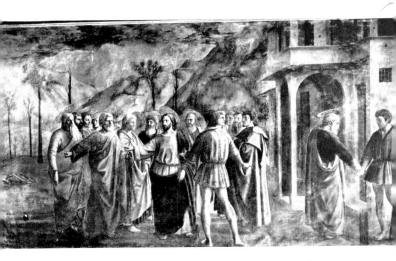

45. MASACCIO. *The Tribute Money*. Firenze, Capella Brancacci (photo: Soprintendenza alle Gallerie, Firenze).

of the Tuscan countryside : some rustics, some noble, some blind followers or fanatics, some with a will of their own, bearded ancients, or splendid youths, like S. John, who gazes at the Lord with such strength of dedication.

Men such as these seem to create the space in which they move : the reddish earth on which they stand with such proud possession, with the hills descending to the lake, and the snowcapped mountains behind. This space is well defined by alternating colours on the apostles' robes—plain reds and blues and greens and yellow—by the changing lights and the receding tree-forms. But the overweening impression is that of classical calm and balance and of physical presence, enhanced by the spiritual bond and moral purpose which unites the apostles around their Master.

In the scene where *S. Peter Heals the Sick with his Shadow* Masaccio 46 concentrates all his power of compact figure composition. In the narrowest space, a diagonal section of a Florentine street with projecting houses and Gothic windows, Peter stands motionless like a column. Wrapt in his great mantle he gazes in front of him, an exalted figure, accompanied by the youthful S. John in whose presence he works his miracle. A great shadow falls upon the cobbled wall of the house where the unshapely sick crouch in ardent adoration. Beams of light pour down almost vertically upon the grey and roseate housefronts and upon the powerful group beneath, moulding bodies and staunch heads of the men whose right half is cast in shadow.

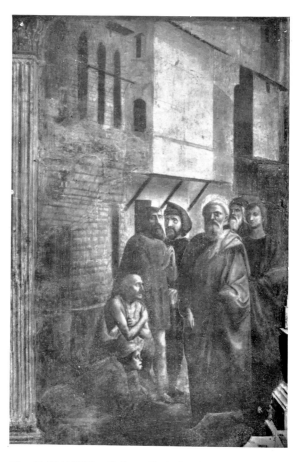

46. MASACCIO. *S. Peter Heals the Sick with his Shadow.*
Firenze, Capella Brancacci (photo : Anderson).

While in *The Tribute Money* Masaccio created large open spaces around
the apostles, in the *Healing of the Sick* he enhanced the physical
presence of men by placing them large and upright into the foreground
close to the steeply rising housefronts, but carefully spaced by the
vertical divisions of lighted planes. Masaccio united sculptural form
and spatial sense to create an ideal of Renaissance man where the
Christian spirit animates a heroic body.

Before leaving Florence for Rome, Masaccio made another advance
into the scientific exploration of architectural space in a great mural
painting of the *Trinity* in Santa Maria Novella. Here the gigantic
Crucifix, flanked by the Virgin and S. John, is seen above eye level

47

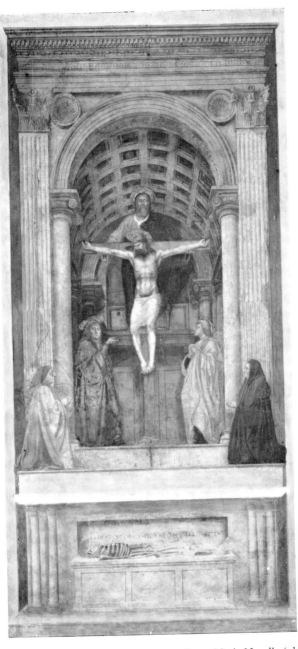

47. MASACCIO. *Trinity*. Florence, Santa Maria Novella (photo: Soprintendenza alle Gallerie, Firenze).

under a coffered vault of deep recession. With this fresco of the *Trinity* architectural illusionism enters the scene of Renaissance painting, which will lead to Melozzo's *Inauguration of the Vatican Library* and hence to Raphael's Vatican *Stanze*. It is as if a Roman triumphal arch, borne aloft upon fully rounded pillars, is opening in the wall of the nave and this illusion is strengthened by the figures of two donors, kneeling in front of flat pilasters on either side of the arch. This painted architecture of Roman solidity and grandeur contains the heroic shape of the Crucified, placed as in the foreground of an apse. Connecting link between the Trinity and the worshippers is the Virgin Mary whose figure turns outward and whose hand points to her Son on the Cross. It is a rigidly balanced composition whose classical architecture bears the mark of Brunelleschi.

VI. THE AGE OF INNOCENCE

Fra Angelico da Fiesole — Fra Filippo Lippi

FRA ANGELICO DA FIESOLE is a master of the transition. His fervent religious art developed in monastic surroundings. The blissful purity of his sacred images is about equidistant from the decorative Gothic as from the pride and vigour of the Renaissance. The intensity of his feeling, the translucency of his colour, and the facial beauty of his angelic figures are all his own. Yet his classical simplicity, his sense of volume, his instinct for placing figures in the space are inspired by the work of Masaccio. FILIPPO LIPPI'S art is equally confined to religious subjects and no less sincere than Fra Angelico's: though in his wayward life he broke away from monastic bonds. In his youth he came under the spell of Masaccio's work at the Carmine, where he painted some frescoes in the cloister. But later he moved towards a Gothic calligraphy of line and rarefied colour. His wistful Madonnas and angelic children have a poetry of their own, and the latter a quite secular gaiety. In his late frescoes at Prato Cathedral, Lippi foreshadows the narrative murals of Ghirlandaio.

When Masaccio died in his prime in 1428/9, FRA ANGELICO was painting his first surviving work, the altar for San Domenico in Fiesole. He was the older man, born in 1387, who continued his active life until 1455. He grew up in conventual surroundings, possibly in the same monastery of Santa Maria degli Angeli as Lorenzo Monaco, whose style and spirit were akin to his own. In 1407 he entered the Dominican Convent of Fiesole, where he took his vows. Later, in 1438, when Cosimo dei Medici rebuilt the Convent of San Marco in Florence, Fra Angelico painted upon the walls of the cells and cloisters and Chapter House his frescoes illustrating the life and Passion of Christ, for the meditation of the monks.

Angelico has been called a reactionary in whom a mediaeval piety and a monastic quietude engendered sacred pictures of transcending beauty. But Masaccio had not lived in vain, and though Angelico was averse from scientific researches into problems of space and perspective, his genius assimilated much of that ' classical simplicity ' by which Florentine artists overcame the ornateness and floridness of the Gothic style. Angelico was that unearthly colourist whose ethereal tones were singularly suited to depict a paradisian world ; and he was capable of creating human form of expressive power within idealised landscapes or architectural surroundings.

In his exquisitely stylish *Annunciation* of 1430 at Cortona, Angelico 48 painted the Virgin and Angel within the noble precincts of an arcaded loggia. Here he was already displaying a firm sense of form and of volume combined with a sustained urgency of glance and gesture.

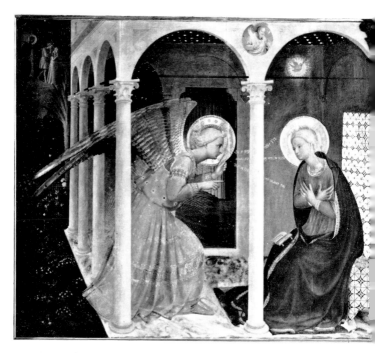

48. FRA ANGELICO DA FIESOLE. *Annunciation.* Cortona, Museo
Gesù (photo: Soprintendenza alle Gallerie, Firenze).

Eight years later he was to vie with Lorenzo Monaco in a sumptuou
49 representation of the *Crowning of the Virgin*, now in the Louvre, wher
Angelico's advance over the archaic master is made manifest. Fc
Angelico painted a great circle of saints and angels around the step
of the throne, where the Virgin kneels in profile before the Lord
Saints and martyrs are no longer the bearded symbolical patriarchs o
Heaven, but an assembly of beautiful figures, blissful worshippers i
their luminous raiment of crimson and gold, of pale green and heavenl
blue. As they stand or kneel on the tiled pavement and on the step
of the throne, they move in the living space, and by the turn of thei
bodies and the ecstatic ardour of their faces they draw the spectato
toward the mystery of the Coronation.

The predominant impression of the Coronation is the brightness o
singing colours, of rose and ultramarine, and of the golden tubas of th
angelic host raised across the sky. Angelico's monkish simplicity wa
such that to the modern eye he appears singularly naïve in his gesture
as well as in his colours. Hands are raised in demonstrative eloquence
to express wonder or horror, the martyrs' blood flows of the pures

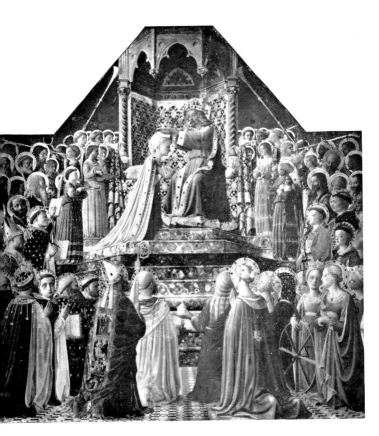

49. FRA ANGELICO DA FIESOLE. *Crowning of the Virgin.* Paris, Louvre (photo : Bulloz, Paris).

red, dalmatics are embroidered with starry gold, houses are white or pink or green, a transfigured world of unique simplicity and beauty.

But Angelico was not only the mediaeval monk who painted choirs of angels in shining raiment. He was also a story-teller who had looked at the earth and its inhabitants and he gives a good account of them in the narrative scenes affixed as predellas beneath the great altarpieces. In one of them he tells the story of the *Crucifixion of Saints Cosmas and* [50] *Damian*, describing how the stones and arrows, hurled at them, return to their tormentors. Such a composition might easily result in confusion ; but Angelico has arranged his figures in two parallel planes, the martyrs and their three brothers facing us in the middle-distance, while in the foreground the movement and dismay of the archers and stone-throwers are drastically rendered. This martyrdom takes place on a

63

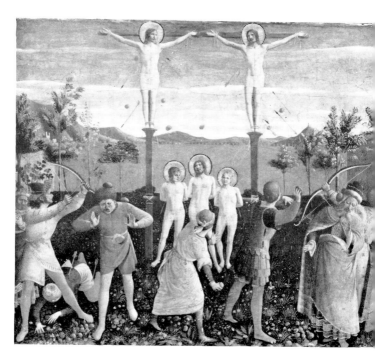

50. FRA ANGELICO DA FIESOLE. *Crucifixion of SS. Cosmas and Damian*. Munich, Pinakothek (photo : National Gallery).

flower-starred meadow, bounded by a line of olive trees, with the Tuscan hills in the distance.

51 In the *Attempted Martyrdom of Saints Cosmas and Damian by Fire* Fra Angelico chose for a background a bright rectangular expanse of wall, like a curtain or stage-setting, and in front of it the martyrs are bound to the stake, but the flames turn to consume the executioners instead. The skill of the composition, though childlike in the extravagant gestures of those who kindle the fire, succumb, or seek shelter is remarkable. But the most beautiful of all the predellas is the *Decapitation of Saints Cosmas and Damian*, not only because of the robes of bright crimson and blue which make such a pretty pattern upon the greensward, but because of the enchanting landscape which encloses the scene of the execution : the sunsteeped castle and the graceful curtain of cypresses, screening the triple range of hills, in their graded tones of russet and terracotta.

 The narrative scenes from the life of SS. Cosmas and Damian probably formed part of the High Altar in S. Marco, Florence, whose centre

iece was the Virgin enthroned with saints and angels (*c.* 1440). Four anels with single figures of saints may have acted as pilasters to the altarpiece. One of them is the full length of *S. Benedict,* here reproduced in colour. It illustrates the unruffled piety and otherworldliness of Angelico's saints, the monastic peace of the contemplative life which filled Angelico's mind and that of his figures. But although S. Benedict is an hieratic form, he has a portrait-like individuality, with his domed head, strong nose and neck, and stands firmly on his dais. The blithe figure with its long perpendicular folds seems poised half way between the Gothic and Renaissance styles, and structural form is joined to thereal weightlessness.

How great a landscape painter Fra Angelico was can be gathered from a small detail of the *Deposition* in the Museo di San Marco. Here we look upon the Apennine hills, topped with their walled farmsteads and castles. With his fine sense of pictorial recession, the artist has built up his distances : the graphic trees, the geometrical houses, and the hills and valleys graded in colour and light. The ' painter-monk of

52

52. FRA ANGELICO DA FIESOLE. *Deposition:* detail.
Firenze, San Marco (photo : Fototeca Berenson, Firenze).

Fiesole ' was no pious amateur who received his visions in a dream
but a sensitive artist who tempered the poetry of his feelings with a new
Renaissance concept of space and of classical form.

This classical strain, purified and devoid of all flourish, is most
strongly felt in the murals of the monastic cells of San Marco. Again
Fra Angelico painted his favourite themes from the Life of Christ and
the Virgin, the Annunciation, the Coronation, the Resurrection, and
others. There is now no graceful loggia where Mary meets the angel
but a barren cell with still and statuesque figures ; no choir of saints
sing hymns to the crowned Virgin, but a semicircle of monastic founders
kneeling and gazing heavenward, where a meek Virgin receives the crown
from a majestic Christ. The sacramental character of the act, the

sorption of the mind by the mysteries of religion, informs all figures with a restrained exaltation and a sense of humility.

In the *Transfiguration*, too, the awe-inspiring figure of Christ wrapped the great folds of his winding-sheet, upright in a great orb of light He spreads his arms to embrace the world, is a Godhead of such grandeur and majesty, that Duccio's *Transfiguration* of the previous century appears a merely decorative Byzantine icon. The same gift for modelling powerful human form and for endowing it with a visionary spirit also informs the heads of Moses and Elias in the *Transfiguration*. is the essence of Angelico's genius.

In 1447 Angelico was summoned to Rome to decorate the apartments of the Pope with scenes from the life of S. Stephen and S. Lawrence. He adapted his style to the grander surroundings of the Vatican and painted fully rounded figures in elaborate architectural settings. In 1449 he was made Prior of the Dominican Convent of Fiesole for three years. He died at Rome in March 1455.

The fifteenth century was an age of discovery in Italian art. Space and volume, perspective and light, anatomy and movement, were the problems with which the scientific genius of Florence grappled. But not all Florentine painters were engrossed in the mathematics of art. Some, and perhaps the most appealing, took the formal achievements of the age in their stride and enlarged the painter's vision in other directions : such as beauty of line and colour, the charm of maidens and healthful children, the elegance of costume. If FILIPPO LIPPI experimented at all, it was with new effects of tone and of colour, which he made more richer and more precious.

His biography by Vasari is like a tale from the Arabian Nights ; it must be read with discretion. From it we learn that Filippo spent his youth in that very convent of Carmelite monks where Masaccio was at work in the Brancacci Chapel, and so his early work has something of the grandeur and corporality of that master ; especially the *Confirmation of the Carmelite Order* in the cloister of S. M. del Carmine and in the early *Madonna of Humility* at Milan. But besides Masaccio there was Masolino, and not far away Fra Angelico da Fiesole, and by them Fra Filippo was attracted to more Gothic and mediaeval styles of painting. Yet he was a more worldly artist than they : cheerful and with an eye for external beauty, genre, and illustration. The cloister was not to claim him for long. In 1431 he left the convent and after a few years at Padua he settled in Florence where he worked for Cosimo Medici, patron of Fra Angelico. From 1431 he lived in the Medici Palace.

Vasari held that ' Masaccio's spirit had entered the body of Fra Filippo ' : but as he developed away from his youthful source of

53. FILLIPPO LIPPI. *Nativity:* detail. Berlin, K.F. Museum (photo: Fototeca Berenson).

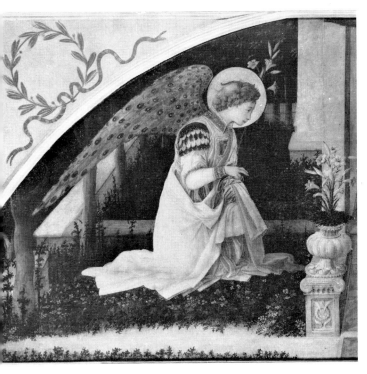

spiration, the larger forms become attenuated, broad modelling is
ansformed into a fine tracery of line, simple colours are broken up,
d the monumental is exchanged for the elegant and the graceful. In
e *Nativity* of the Berlin Museum the poetry of Filippo is all-pervading. **53**
he Holy Child is laid amidst the flowers and the fragrance of a forest
ade, in the shadow of high cypresses ; here the Virgin, youthful and
ail, in her mantle of heavenly blue, kneels in adoration. Light, that tips
e foliage, makes her face transparent, picks out her slender neck under
e delicate veil, and throws the folds of her mantle into firm relief.

Elsewhere, as in the London *Annunciation*, the lines of the drapery **54**
ecome more involved, modelling less apparent, the figures more
orldly. The curly-haired angel with his peacock wings, his pleated
own, and roseate mantle, is charmingly human and quite without the
everity of an archangel. The Virgin is all grace and meekness and
iety. As she bows before the salutation of the angel, both figures
ollow the sweep of the lunette which was to crown a doorway in the
Iedici Palace. The *Hortus conclusus* and marble inlay upon the floor

55. FILIPPO LIPPI. *Virgin and Child.* Munich, Alte
Pinakothek.

show Filippo's mastery over perspective, and his decorative sk
fashions brocades and heraldic patterns with delicate relief. Sometim
Fra Filippo will break into a riot of colour and festive genre as in t
round picture of the *Adoration.* Here a joyful, enraptured crow
follows in the train of the Magi, and all manner of decorative detail a
inscribed, like the naked children dancing upon the ruins or the enorm
ous peacock stalking on the roof of the manger. Fra Filippo had
lively sense of humour and in one of his loveliest Madonnas he painte
two chubby boy angels, lifting up the Child on their shoulders an
looking artfully out of the picture.

Or he will place the *Virgin and Child* in the forefront of a wid
landscape, between fantastic rocks, with the river Arno winding i

55

ourse toward the city of Florence. And though the Madonna seems in a pensive mood, the Child with His large head and short neck is as playful as His mother is serene. But much of Filippo's draughtsmanship is now employed in drawing the elegant curve and embroidered hem of the Virgin's cloak and in the delicate tracery of pleats and veil. As one writer put it : ' Fra Filippo, having attempted the Masacciesque with desperate uncertainty, had recognized that he was gifted for line rather than mass, grace rather than grandeur '.

But Fra Filippo was not only a painter of saintly Madonnas in pious contemplation, surrounded by curiously worldly and sometimes mischievous boy angels drawn from Florentine life, but, like Fra Angelico before and Ghirlandaio after him, he also undertook great fresco cycles like those in Prato Cathedral and in Spoleto. Among these the *Feast of Herod* and the *Funeral of S. Stephen* are perhaps the most forward-looking of his murals. In the Dance of Salome the lithe movement and swirling drapery anticipate similar figures in Botticelli and Ghirlandaio, while the recession of a tiled floor leading into the oblong room where Herod is feasting, and the architectural perspective of well lit columns and pilasters in deep recession towards the apse of a church in the *Funeral of S. Stephen* are in the spirit of Brunelleschi. Compare pl. 109. Verticals and horizontals are strictly balanced in these severely classical compositions. Moreover, the mourners around the bier of S. Stephen are the contemporary Florentines, just as Ghirlandaio in the next generation will portray members of the Medici circle in his Legends of S. Francis or in scenes from Holy Script. Thus Filippo Lippi, blending the worldly and the sensual with the religious is an artist of the transition, moving from Angelico's mysticism to the more secular and realistic art of the Laurentian age.

VII. THE SCIENCE OF PERSPECTIVE

Paolo Uccello

PAOLO UCCELLO'S mastery over perspective substantially advanced Florentir science. With Fra Angelico and Masaccio, perspective—the apparent decrea. of objects in size as they recede into the distance—had been a matter of vision rathe than calculation. Uccello explored its mathematical laws, the laws of foreshortenir solid bodies and of lines diminishing inwardly. He strikes a balance between h decorative fancy, the naturalistic portrayal of objects in the receding space, an their adaptation to geometrical form.

Fra Angelico had lived a sheltered life behind the cloistered walls o his Dominican convent while in Florence the contest of the arts wa in full swing : the battle between the Gothic exuberance of Gentil da Fabriano, Lorenzo Monaco, and Masolino—the animal-naturalisr and costume-pageant of Pisanello—the Renaissance conquest of spac and heroic form of Masaccio. Sculpture and architecture had set the pace with Donatello's *S. George* and with Brunelleschi's great cupol. of the Florentine Cathedral.

In such surroundings an ingenious youth grew up, PAOLO UCCELL((1397-1475), who as a boy of ten entered the workshop of the sculpto Ghiberti then at work at the great bronze doors of the Baptistery Among the older apprentices at Ghiberti's studio was Masolino. Afte: seven years of apprenticeship Paolo became a member of the Painter's Guild of S. Luke. By 1425 he received his first commissior to go to Venice, where Gentile and Pisanello had been before him, tc work on the mosaics in San Marco's Church. On his return the Florentines asked him to paint upon the inner wall of the Duom(an equestrian statue of their victorious general *Sir John Hawkwood* Uccello took as his model one of the Byzantine horses from the roof of S. Marco firmly placed the Condottiere upon his saddle and raised horse and rider upon a rectangular marble socket with sharply projecting cornices, drawn in perspective recession, so that the whole monument looked more like a sculpture than a painting. He made the back of the horse almost spherical, its neck like an arch, so that by simplifying nature he increased the compactness and power of the animal.

All his life Uccello was fascinated by horses, studying their natural form and adapting them to a geometrical pattern. Some years later when he followed Donatello to Padua, perhaps in 1447, he may have

56. UCCELLO. *Recession of the Flood*, detail. Florence, Santa Maria Novella (photo: Soprintendenza alle Gallerie, Firenze).

watched the great sculptor at work on his *Gattamelata*, the grandest equestrian statue since that of the Emperor Marcus Aurelius on the Roman Capitol.

It must have been after this contact with Donatello's sculptures and bronze reliefs that Uccello painted his perhaps greatest work, the fresco

UCCELLO. *Recession of the Flood* (Rosini). *Storia della Pittura Italiana,* Pisa 1839.

56 of the *Flood* and *Noah's Ark* in the Chiostro Verde at Santa Mari
Novella, Florence. Only fragments of these murals remain, but w
have Vasari's detailed and admiring description of Uccello's wor
' representing the dead, the tempest, the fury, the winds, the flashes o
lightning, the rooting up of trees and the terror of men. . . . In per
spective he has represented a dead body whose eyes are being pecke
out by a crow and a drowned child whose body, being full of water, i
arched up. He further represented various human emotions, such a
the disregard of the water by two men fighting on horseback, th
extreme terror of death of a woman and a man who are riding
buffalo.' Vasari also describes ' the ark being open in perspectiv
with ranges of perches in the upper parts, divided into regular row
where the birds are stationed, which fly out in flocks foreshortened i
several directions '.

The noble ruin of the *Flood* and of its *Recession* reveal a new breadt
and fullness of the human form, and Uccello's inventiveness an
structural skill of composing so vast and varied a scheme. The inwar
leading lines of the ark to whose walls draped and nude figures cling
while others float or fight, reveal a unified concept pertaining to no othe
of Uccello's paintings. But most memorable is the solitary figure of
56 patriarch in the right foreground of the ark in the *Recession of the Floo*
He is wrapt in the wide folds of his cloak and gazing out over the waters
his hand raised in wonder. This is a visionary and Dantesque shap
of such majesty and spiritual depth as to form a link with Masaccio'
heroic and humanist concept of man.

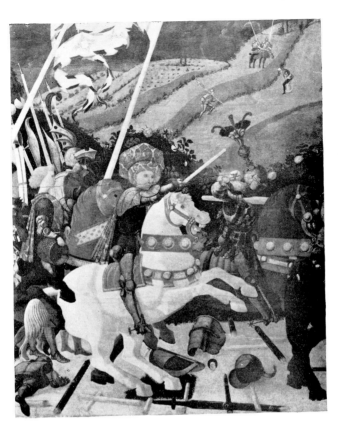

57. PAOLO UCCELLO. *The Rout of San Romano:* detail. London, National Gallery (photo : National Gallery).

In 1456 Uccello received another commission after his heart. He was to paint for the ground floor of the Medici Palace a great historical pageant in three sections, representing *The Rout of San Romano*, the **57** victory of the Florentine general Niccolo da Tolentinò over his Sienese rivals. One of the three panels of this great mediaeval joust is in the National Gallery, one remains in Florence, and one is in the Louvre.

Scholars have argued whether Uccello's paramount interest in perspective recession and foreshortening, in vanishing points and intersecting diagonals, has done harm to his paintings. Vasari, his first biographer, thought that he had wasted his time and become melancholy over it. But nowadays we appreciate his formal experiment and know that in him geometrical form modified Florentine naturalism and gave unity to his composition. And though his battle-pieces show many instances of skilfully contrived foreshortening—as in the fallen

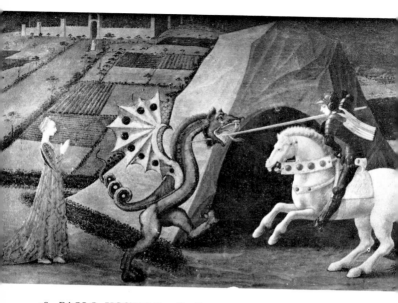

58. PAOLO UCCELLO. *S. George and the Dragon*. Paris, Musée Jacquemart-André (photo : Bulloz, Paris).

warrior on the ground, the transversals of splintered lances, cuirasses, and helmets, and the planimetrical bodies of hills and horses—these in no way diminish our delight in the vast decorative pageant.

The battle is enacted on a long and narrow strip of foreground, curtained off from the rising hills behind by a thick orange-grove. There is no middle distance, no melting of the foreground plane into the blocked out and schematic hills, no real integration of space. Here Niccolò da Tolentino on his prancing white horse with red and golden trappings, conducts the fray, his baton raised, his eye cool and determined. His small elderly head is covered by a huge ceremonial coif of red damask. Next to him rides his fair equerry, one of the proudest figures in Renaissance painting. Then follow the men-at-arms in their fantastic armour with visors drawn, on dark horses with blue saddles, raising their red and black and yellow lances in a striking pattern of parallel and intersecting lines. Indeed, some of Uccello's horses are severely formalised. Light plays in flat planes upon the front legs and flanks of the grey and white chargers, while the movements are halting, as if arrested in action.

The laws of movement and of anatomy had still to be discovered. But what sustained energy is here transmitted and what glorious pageant in alternating colours of horses and their trappings: in bronze

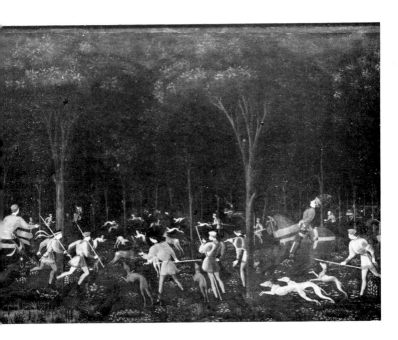

9. PAOLO UCCELLO. *A Hunt at Night:* detail. Oxford, Ashmolean (photo: Ashmolean Museum).

rmour and waving pennons, silhouetted against the pink earth and he green shrubs. An Italian writer has thus formulated Uccello's advance : ' Uccello transformed the linear-colouristic vision of the Gothic into a volume-cum-colour vision ; and this by means of perspective '.

The *Rout of San Romano* was Uccello's finest achievement, apart from the tragic ruin of the Chiostro Verde frescoes. Later he seems to have fallen back into Gothic painting, as when he presents *S. George* **58** *and the Dragon* in a severely heraldic style where all figures are in strict profile, with neatly mapped-out fields leading up to a castle, almost like Giovanni di Paolo's earlier abstraction of fields and rocks. The princess with her courtly gait and elongated form has sprung right from Pisanello's painting of the same subject. Notwithstanding its fierce energy, the greenish dragon with bat's wings and curling tail is a fantastically Gothic invention. Only the young knight on his bulky horse, piercing the dragon's jaw with his long lance, is a link with the battle-picture.

More exciting still is Uccello's painting of 1468, *A Hunt at Night* **59** in the Ashmolean Museum, Oxford. The oblong picture breathes an

60. PAOLO UCCELLO. *Profanation of the Host:* detail. Urbino, Palazz
Ducale (photo : Soprintendenza, Urbino).

extraordinary gaiety and verve, enhanced by the vivid scarlet of th
huntsmen's doublet, hose, and saddle, cast upon the inky green of woo
and meadow. Three trees in the foregound divide the picture-space
and the huntsmen and hounds, driving in from the sides toward th
centre where the stags are pursued in the middle-distance, indicat
the climax of the hunt—the moment of the kill. It is not only th
converging movement of the chase, the receding depth of the woo
interior which we admire, but the loving care with which plants an
minute flowers are scattered about the grass, the gay dots of colour
and the jerks and gestures of the huntsmen whose shouts and straine
profiles convey the excitement of the chase.

60 His last work (1469) is the *Profanation of the Host,* where Uccell
relates in seven scenes the story of a woman who sold a consecrate
Host to a Jewish merchant in order to redeem her cloak. The Hos
which the merchant tries to burn begins to bleed, the crime is discovered
and the offenders are punished. The small size of the work with it
neat expressive figures is almost puritanical in its simplifications an
the obvious geometry of space construction. The science of per
spective has never been more purely applied to art than in th
diminishing lines of beams and tiles and in the geometrical planes o
the walls. No decorative detail comes between the artist and his idea
of formal abstraction.

III. THE CONQUEST OF LIGHT AND THE TRIUMPH OF PORTRAITURE

Domenico Veneziano — Alessio Baldovinetti

fter movement, anatomy, and perspective came the conquest of light and of 'mosphere. Light in painting has the magical gift of creating space, and OMENICO VENEZIANO invented the white morning light which defines and :epens the architectural space. His supple line and his refined sense of individual :aracter make his profile portraits of noble ladies the most exquisite of the .enaissance. The work of his pupil BALDOVINETTI is as delicate in design as it luminous. His vast and detailed landscape behind the Madonna is the first realistic view of the Florentine countryside.

'he only link between Andrea del Castagno and DOMENICO VENEZIANO : Vasari's story that Castagno murdered him, out of professional :alousy. But as Domenico lived until 1461, four years longer than :astagno, this unlikely tradition can be discounted. Domenico came ɔ Florence from Perugia in 1439, and his character as a proud and elf-confident young artist is manifest from a letter which he wrote to ?iero dei Medici, asking him for his good offices to obtain employment.

' I have heard just now that Cosimo is determined to have executed, hat is painted, an altarpiece, and requires magnificent work. This ews pleases me much, and would please me still more if it were possible ɔr you to ensure, through your magnanimity, that I painted it. If his comes about, I hope in God to show you marvellous things, even :onsidering that there are good masters like Filippo Lippi and Fra ⁊iovanni (Angelico), who have much work to do.'

How did Domenico advance the story of Florentine painting and vhat was his contribution among the Gothicists, the sculptural painters, he naturalists then working in Florence ? His emphasis does not seem ɔ lie on technical experiment and innovation, although he had assimil- ᵻted the knowledge that was abroad. In his small predella paintings ᵻt Cambridge, the *Annunciation* and the *Miracle of S. Zenobius* he lesigned an atrium and cloistered walk with graceful Renaissance pillars ᵻnd a street lined with picturesque houses, where he shows that he had nastered perspective to a degree. In his figures, the Angel of the Annunciation and the mother lamenting over a dead child, movement ᵻnd expression are suggested forcibly, and in the great altarpiece of :he *Madonna with Four Saints* in the Uffizi, the figures have a solidity ᵻnd individual character worthy of Masaccio. **62**

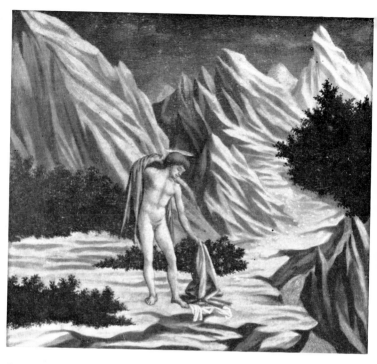

61. DOMENICO VENEZIANO. *S. John in the Desert*. Washington, National Gallery of Art (photo : A. C. Cooper Ltd.).

Domenico Veneziano advanced Florentine painting by introducing the brilliant white daylight that invests his street and his courtyard and his crystalline hills (*S. John in the Desert*), and which gives to his *Madonna with Four Saints* their radiance and suppleness of mien. In the Uffizi altarpiece it is not only the faces which shine with reflected light, but light constitutes the very space between the white pillars and the niche where the Madonna is enthroned : for here the rays of the morning sun light up the apse of the church and cast an oblique shadow along its walls. Moreover, the tiled floor leading to the steps of the throne show Domenico's mastery of perspective recession. Just so will Piero della Francesca, the greatest Italian master of daylight painting, define architectural space by gradations of colour and light and by geometric perspective. For in 1439 Piero worked with Domenico at the now lost frescoes from the Life of the Virgin in S. Egidio at Florence.

In the *Martyrdom of St. Lucy* the narrative and scenarium are of the simplest; but the radiance of southern light upon the walls, the

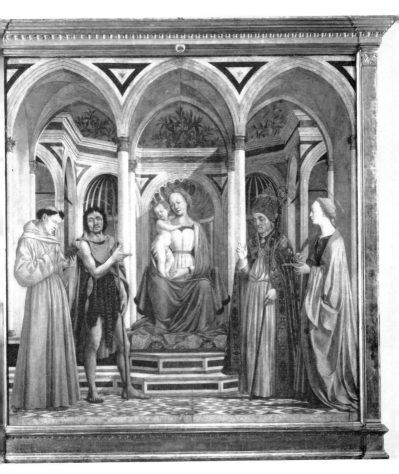

62. DOMENICO VENEZIANA. *Madonna with Four Saints*. Florence, Uffizi (photo: Soprintendenza alle Gallerie, Firenze).

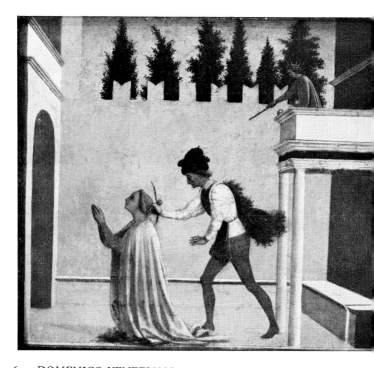

63. DOMENICO VENEZIANO. *Martyrdom of S. Lucy.* Berlin Museu
(photo : A. C. Cooper Ltd.).

loggia, the folds of S. Lucy's cloak, the swift nervous movement of th
executioner within the plain geometrical setting, make a selectiv
design of great distinction.

Domenico's colours, his ivory whites and reds and light-blues ar
saturated with light, and the modelling of his flesh-tints in his rar
portraits is of the slightest. These profile portraits of ladies in close
lying brocades of Gothic design, with lofty brow and firm mouth an
the flowing line of the neck, reveal character as only the side-view of
64 face can do. The impeccable *Profile of a Girl*, serious and inscrutabl
like an Egyptian princess, is a noble form, cool as marble, with he
roseate flesh-tints set against the blue of the sky, her wavy strands o
hair and the golden arabesque upon her red bodice, contrasting wit
the monumental stillness of her face.

65 The National Gallery *Portrait of a Lady*, though ascribed to
Baldovinetti has all the qualities which Domenico brought to perfectior
It is painted in pale gold upon blue, and the same character animate

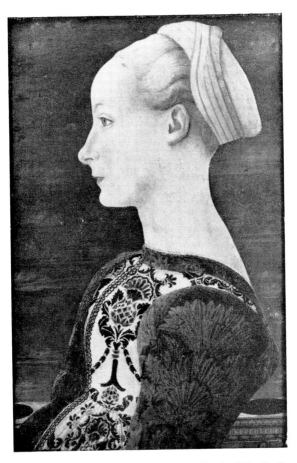

64. DOMENICO VENEZIANO. *Profile of a Girl*. Berlin
Museum (photo : A. C. Cooper Ltd.).

face and ornament. The lady's bright eye and smiling mouth, the
sensitive nose, the serpentine coils of hair and the writhing, prickly
palm-ornament upon her sleeve convey the same unity of style. This
young lady will continue to puzzle us because of the utter restraint which
the silent portrait imposes upon the eloquent sitter.

Some masters are chiefly remembered by one great picture, and so
it is with ALESSIO BALDOVINETTI who, with Piero della Francesca, was
Veneziano's pupil. Yet during his life he was of very great consequence,
because he never tired of improving the old tempera paint with new
varnishes, and because he shared Uccello's spatial discoveries, worked
with Castagno, and became the master of Verrocchio and Pollaiuolo.

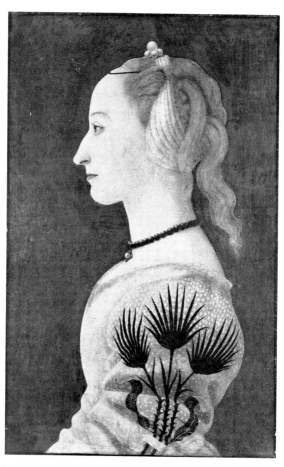

65. ALESSIO BALDOVINETTI. *Portrait of a Lady*.
London, National Gallery (photo : National Gallery).

66 His *Madonna* in the Louvre is not only of exceptional refinement and
delicacy of feature, as she tenderly adores the Child ; the novelty resides
in the landscape that stretches far and wide beneath her, and in the
relationship between the figures and the space. Baldovinetti painted
this picture in 1460, long before Pollaiuolo's panorama of the Arno
Valley which, measured by the lyrical beauty of these shimmering hills
and still waters, is more like a surveyor's map than an artist's vision (see
pl. 79). Moreover, Baldovinetti related his figures to the surrounding
space, and the Madonna's towering shape is in line with the descending
hills. Nor do the countless details of the landscape, the creeks and trees
and bridge and winding river, diminish the unity of the whole, so subtle is

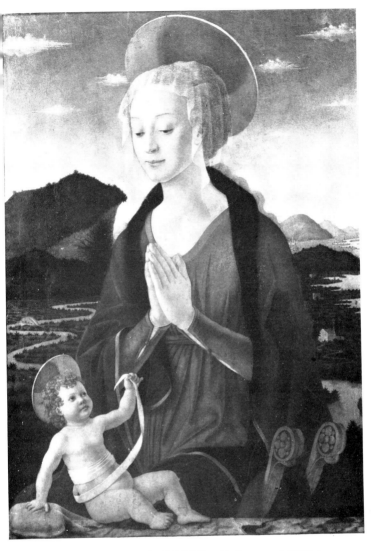

66. ALESSIO BALDOVINETTI. *Madonna and Child in a
Landscape.* Paris, Louvre (photo: A. C. Cooper Ltd.).

the scale and the proportion between the solemn Madonna and the
bird's-eye view of the Tuscan plain. Only Piero della Francesca, by
means of his magical light, will give to his landscape behind the
Montefeltro portraits an even greater poetical truth.

IX. THE MONUMENTAL IN ART

Piero della Francesca

PIERO DELLA FRANCESCA is like no other painter of the Renaissance for tu
reasons: he is emotionally impenetrable—his figures have a monumental aloofne
comparable to Greek statuary of the archaic age—and he invented an entire
original use of colour and form. Though Piero inherited Uccello's perspectiv
Domenico's light, and Masaccio's ' bulk ', he used planes of cool colour steeped
light to build up his painted architecture. A helpful formula for Piero's innovatic
has been given by Roberto Longhi, who called it a perspective synthesis of for
and colour.

With PIERO DELLA FRANCESCA (1416 ?-92) we reach the highest pea
of fifteenth century painting. Of course he was no isolated summi
He had learnt from Masaccio the emphasis on human grandeur an
heroic surroundings, from Uccello how to simplify forms by geometric
means, and from Domenico Veneziano the poetic quality of light. Bu
Piero's work assumes an individual gait, a classical simplicity an
largeness expressed in cool colour and marmoreal form.

He was born in Borgo San Sepolcro, a small town at the Apennin
foothills, not far from Arezzo, where his first impression was of Sienes
rather than Florentine art. But in 1439 he began a long stay at Florenc
followed by appointments which he held at the courts of Urbino an
75 Ferrara. Federigo da Montefeltro, whose portrait he painted in
famous diptych, became his life-long protector. At Ferrara, wher
Lionello d'Este attracted poets and artists to a humanist court, he woul
have met a great Flemish artist, Rogier van der Weyden, who perhap
taught him the use of oil varnishes and the Flemish way o
seeing landscape. But in 1452 he had the chance of his life : t
decorate the choir of S. Francesco at Arezzo with legends of the Tru
Cross. This work was to occupy him intermittently for seven years
By 1459 he was in Rome, working in the Vatican, but the remainin
years he spent either in Tuscany or in his native Borgo (where he wa
an honoured citizen and a magistrate), or in neighbouring Urbino. Hi
interest in mathematics grew so great that he wrote a treatise D
Prospectiva Pingendi dedicated to the Duke of Urbino and later, wit
eyesight failing, gave up painting altogether. A contemporary rememb
ered later that 'when he was small he had led the excellent maste
Pietro della Francesca by the hand, because he had grown totall
blind '.

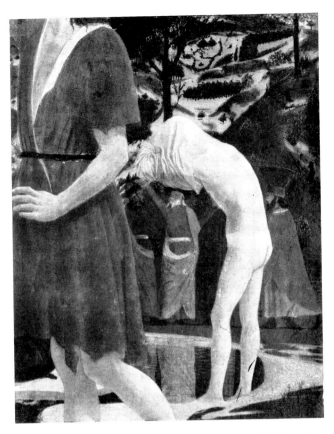

67. PIERO DELLA FRANCESCA. *Baptism of Christ:* detail.
London, National Gallery (photo : National Gallery).

One of his earliest surviving works is the *Baptism of Christ* in the **67**
National Gallery. No other painting is quite like this one for at least
three reasons : its shimmering brightness of colour and light, its static,
columnar quality of figures, and its sense of atmosphere and recession,
which leads the eye beyond the figures into the valley and up the hills
of Piero's native country. Moreover, Piero has invented ideal shapes
of great strength and splendour, especially in the angels whose flaxen-
haired, flower-wreathed heads and columnar necks are truly monu-
mental. The motionless, bearded Christ, who stands so firmly in the
shallow water where the sky and the hills are reflected, is a powerful,
almost rustic shape, while the Baptist, seen in profile as he steps from
the bank toward the Saviour, has the measured grace of a figure on a
Greek vase-painting.

Nothing could be more true to nature than the pure and slend
shape of the neophyte stripping off his shirt. Here light creates for
and the modelling of his body in bluish-white flesh-tones is masterl
the bend of his body following that of the river, leads the eye inwa
toward the brown hills and sandy patches which Piero has sketched
with an almost Impressionist touch. The trees and plants indica
recession and define the space, from the leafy arabesque of plants
the near foreground to the trees fanning out right and left: the
punctuate the great airy space which lies between the scene of tl
Baptism and the undulating chain of hills.

Piero laid in his colours in geometrical blocks of paint, and this
one of the reasons why one speaks of his pictorial architecture. The
blocks or planes of colour are visible in the middle-distance: where tl
guardians of the Old Testament law, in long tunics and towering ha
walk on the opposite bank of the river. Their robes are reflected
the water in such geometrical blocks of colour: red, blue, and ochr
Piero has observed a careful balance of uprights and horizontals ar
opposed his human statuary by the line of hills, the dove, the river-ben
His divisions of space are marked by a diminishing scale of trees ar
figures.

68 The Urbino *Flagellation of Christ* (*c.* 1459) is perhaps the greate
example of a classical division of architectural space. Nowhere ha
Piero's love of Renaissance architecture and noble proportions borr
greater fruit. Everything in this picture, barring the human figures,
of geometrical precision: the calculated sequence of regular bodie
their diminishing lines, the law of the Golden Section* by which th
picture-space is divided, and the alternating planes of colour and ligl
which define tiled floor and coffered ceiling and marble entablature.

Never has art blended so nobly with a mathematical purity of spac
construction as in the open hall where Christ is bound to the colum
and where His tormentors do their work with a detached and inexorab

*The Euclidean proportion of the Golden Section, which underlies the classic
harmony of Piero's architectural divisions, is illustrated by the followin
diagram. The angle at A=90°, and AC=½AB. An arc is drawn from (
through A, and another from B through the point of intersection of CB and th
first arc. The intersection-point D then divides AB into the Golden Sectio

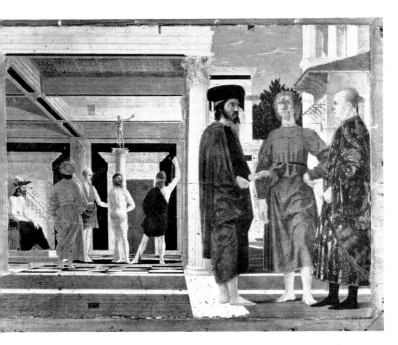

3. PIERO DELLA FRANCESCA. *Flagellation of Christ*. Urbino, Palazzo
Ducale (photo : Istituto Centrale del Restauro, Rome).

rythm. But in the rarefied atmosphere of silvery light there are strong
accents of colour: in Pilate's blue mantle and pink robe, the grey velvet
cloak of the onlooking man, and the deep green of the executioner on the
right. But who are the three grandiose figures in the foreground,
discussing the event with high seriousness and unperturbed solemnity ?
The bearded oriental with his Greek turban is perhaps the eastern
emperor Palaeologus, whom Piero might have seen in Florence at the
time of the Church Council which the Pope convened after the fall of
Constantinople. He faces a princely person in a sumptuous blue mantle,
emblazoned with a golden pattern of heraldic flowers. The young man
in the centre is a figure not unlike one of the angels in the London
Baptism. As he stand firmly with bare feet upon the floor, his ample
cloak girded by a belt, looking in front of him from clear grey eyes,
he seems to listen to the argument between the two older men. Are
they discussing the fate of the Church, symbolized in the suffering
Christ as Sir Kenneth Clark suggests, or are they, as the older tradition
has it, councillors of the murdered duke of Urbino, whom Piero
portrayed here without human relationship to the scene of the back-
ground ?

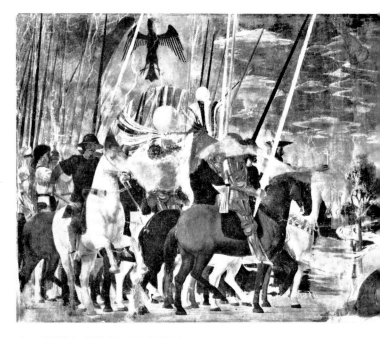

69. PIERO DELLA FRANCESCA. *A Battle-scene: Constantine's Victor*
over Maxentius: detail. Arezzo, S. Francesco (photo : Istituto Editoria
Italiano, Milan).

Their imposing shape, impenetrable as if cut out of porphyr
enhances the depth of the hall, as the eye wanders away from the
sculptured girth along the white marble band of the floor to the princip
scene. *Convenerunt in unum* was the old inscription at the base of th
panel, a verse from the second psalm : ' The kings of the earth s
themselves up, And the rulers take counsel together, Against the Lo
and against his anointed '.

Piero's frescoes in the choir of San Francesco at Arezzo, painte
between 1452 and 1466 with Giotto's in Padua and Masaccio's
Florence, are among the greatest mural paintings in the world. Th
are placed horizontally one above the other and illustrate scenes fro
the Golden Legend by Jacopo da Voragine. Here Piero painted th
Death of Adam, the *Finding of the True Cross*, the *Visit of the Queen*
Sheba to King Solomon, the *Dream of Constantine*, and two great battl
scenes, representing Christian victories over the Infidels. *Constantine*
69 *victory over Maxentius* is preceded by the *Dream*, where the Empero
lying asleep in his golden tent in the mysterious moonlight and watche
over by his guards, receives the angelic message : ' In this sign sha

90

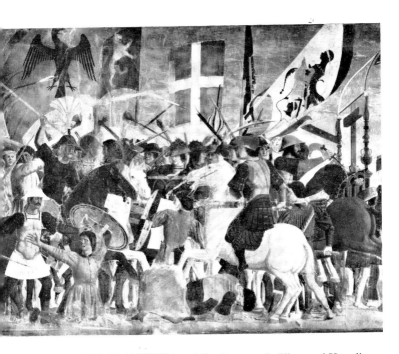

70. PIERO DELLA FRANCESCA. *A Battle-scene: the Victory of Heraclius over Chrosroes:* detail. Arezzo, S. Francesco (photo: Istituto Editoriale Italiano, Milan).

thou conquer'. It is the sign of the Cross, with which Constantine is bearing down upon the fleeing host of Maxentius in the first battle-scene. Nonetheless, the religious significance of the Arezzo frescoes is slight. They relate a 'secular saga' in terms of clear-cut, stately figures and solemn occasions, conceived on a grand scale and in an unemotional, almost objective style. Other than Masaccio who modelled his Apostles in the Carmine by powerful chiaroscuro, Piero created even the human figure in large geometrical zones of colour transformed by light.

Uccello's *Rout of San Romano* was painted in Florence during the same years and most likely Piero made the short journey from Arezzo to see it. But compared with Uccello's tournament—though the pattern of lances and heraldic pennons is similar—Piero's battle has a graver momentum, fierceness, and stance, a processional solemnity with which Constantine, holding the slender cross in front of him, leads the advance. The splendid chargers with their rounded cruppers —in alternating colours of bay, blue-black, and white—follow one another in close array, with their towering riders and battle-emblems, 57

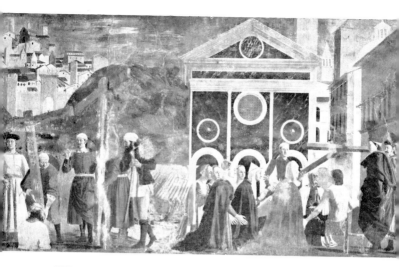

71. PIERO DELLA FRANCESCA. *Discovery and Proof of the Cross.* Arezzo, S. Francesco (photo : Istituto Editoriale Italiano, Milan).

their legs interwoven in the quick advance. The space is divided by the serpentine stream and the single tree, and there the enemy rear-guard is seen dragging his horse out of the marshy bed.

70 On the opposite wall *The Victory of Heraclius over Chosroes* is consummated. This ' almost inconceivable shambles of wounded, fallen, and dead ' is made graphic by the brightness of contrasting colours : the blue saddles of white horses, purple or crimson doublets, green or russet helmets, red banners upon the blue sky, criss-crossed by flying lances. Left, right, and centre the eye is arrested by groups of warriors in single combat : here an athletic youth with dark hair and eye wards off the naked sword of his adversary; another throws up his arm and shouts while an unperturbed warrior grips his hair before dealing the fatal blow. Over on the right the fate of the battle is decided where, steadfast and rigid, the bearded soldier drives his dagger into the throat of Chosroes' son.

71 On another wall the *Discovery and Proof of the Cross* are consummated. In Voragine's legend the spot where the three crosses were buried is revealed by a Jew and in the fresco he is seen with a group of Umbrian farmhands dragging the True Cross out of the ground. One cross has already been raised and the labourers stand around with their tools, watching and discussing the event. On the left the Empress Helena with her courtier seems to give orders, and the sunburnt workman opposite, leaning on his spade, is all ' eagerness to hear what

. Helena is saying '. In the Raising of the Crosses the labourers present a scene of rustic life. They are firmly rooted to the soil in the hilly country beneath the walled city of Arezzo, which has to serve as an imaginary Jerusalem.

The right half of the fresco relates the story how the true Cross was discovered by holding it over the dead body of a youth. At the third trial ' the body that was dead came to life '. The scene is still in the open, and we pass from the hill country outside Arezzo to the city square, where in front of a classical temple of coloured marble with circles and arches in the style of Alberti, the miracle is performed. The Empress in a cone-shaped hat, and her attendants in long slate-blue tunics, kneel in wonder and worship, while the youth is resuscitated. The perfect little temple frames and contains the group of figures and the Cross forms a uniting link between them. The actors are types rather than individuals, in the stately calm of their being, witnessing a solemn ritual.

The proportions of classical architecture and the poise and balance of ' Olympic ' figures are the expression of Piero's ' innate classicism '. His visual language was composed of basic geometrical shapes such as the square, cone and cylinder and by his mastery of perspective design. But his human actors are like beings from a different planet. Some scenes in the Arezzo frescoes, like the Death of Adam, bring to mind Uccello's patriarchal figures in the Chiostro Verde. But Piero's 56 compositions are governed by clearer divisions of space, where movement is frozen in the act and where the architecture of forms strictly follows mathematical laws. From the start Piero's shapes seem to be the purest emanations of his mind, greater than life and unsullied by reality. His archetypal forms impress and fascinate, the more they are uncommunicative and impassive. The early *Madonna of Mercy* painted in 1445 for his native Borgo is in all essentials identical with the *Madonna del Parto* of nearly twenty years later, or the *Virgin Annunciate* at Arezzo. Piero's figures are ideated rather than realistic, although they do not lack human, even sensual appeal. The head of the *Madonna of Mercy* is perfectly rounded with the light rebounding from the waxen skin. Her expression is childlike or sphinxlike and she appears infinitely remote like an oriental icon, with her eyes half-closed under heavy lids, the shapely curve of the small mouth, slightly drawn in at the corners.

The Virgin of the Arezzo *Annunciation* betrays no emotion at the 72 angel's message, though her hand is raised in response to his gesture. Her lofty shape and immobile stance are emphasized by the great rounded pillar which separates the architectural section on the right

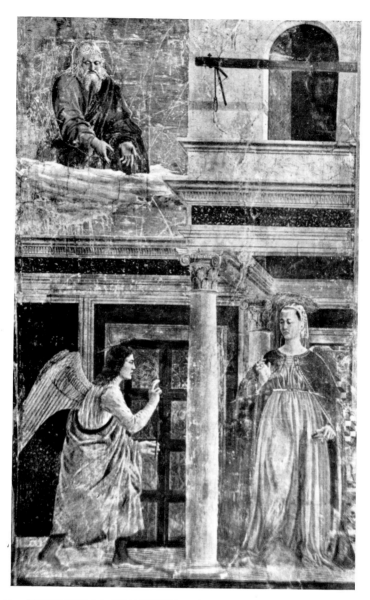

72. PIERO DELLA FRANCESCA. *Annunciation*. Arezzo, S. Francesco
(photo : Il Milione, Milan)

with its marble intarsia from the larger one on the left where the angel
approaches. Her expression—if expression there be—is one of remote-
ness, withdrawnness and pride. Piero's obsession with architectural
form is taken to such extremes that the monumental Virgin, robed in
blue and in pink with tubular folds of her dress, forms an integral part

94

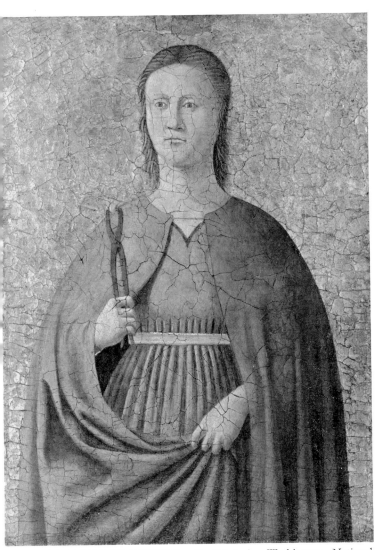

73. PIERO DELLA FRANCESCA. *S. Appolonia*. Washington, National Gallery of Art, Kress Foundation (photo : National Gallery of Art, Washington)

with her courtly ambience : the Corinthian pillars, the oblong slabs of red and white marble, the inlaid door and the proportions of architectural members in their perspective foreshortening. The Virgin's domed head and cylindrical neck, the bell-shaped cloak falling over her shoulders are like the human equivalent of the nearby pillar, within the subtle modulations of colour and light. Individual saints like the *S. Apollonia* (attributed by Sir Kenneth Clark to an assistant) are similar archetypal shapes.

73

74 The Borgo *Resurrection* (1462-63) is by common consent Piero's masterpiece. It unites all the formal elements of his art with a deeply spiritual content. Christ's banner divides the space into the now familiar square and oblong parts. The grey tree verticals are balanced by the transversal of the sarcophagus. The landscape of undulating hills is sketched in with dark brown patches under the grey light of dawn. A lower tangent of hills marks out the middle-distance. There are two levels of vision : the earthly one where the Roman soldiers lie in dazed sleep—their robes and armour a harmony of slate blue, golden brown and red—and the upper sphere where the awesome Christ in a rose-coloured shroud rises from the tomb with hypnotic frontal gaze. An unearthly radiance illumines His heroic shape and the edge of the marble tomb upon which falls the shadow of the reclining warrior. He is a more articulate and more broadly constructed variation of one of Giotto's guards in the *Resurrection* at Padua.

Above this lower realm of pagan humanity there rises with powerful tread—as firm as the angels' stance in the London Baptism—the figure of Christ, not propelled by invisible force, but starkly, humanly ; His left foot planted upon the edge of the tomb, His knee fully rounded in tangible space, the folds radiating downwards. His left hand firmly grips the shroud and His body is modelled with complete anatomical truth. Piero's God of the Resurrection is the Christ in Majesty of Byzantine painting, but rendered with all the refinement that pictorial science and his own synthesis of direct light and muted colour and space could muster, a Godhead of stirring, transcendental power, yet clothed in human raiment. He is not only Grecian in body and limb, but forms the spiritual and physical centre of the composition ; an unfathomable God whose gaze penetrates beyond the reach of humanity.

Christ's torso echoes the contours of the hills, His head towers above the line of the horizon, like the cone-shaped summit on the left. The characteristic trees mark the country's recession in depth. There is an unending variety of related shapes and directions within the balanced finality of the composition. The Resurrection is like the sum total of Piero's achievement. Roberto Longhi wrote these words about it : ' Christ, awe-inspiring in His remoteness, His features like those of a pale Umbrian peasant who has risen before daybreak, one foot resting on the edge of the sarcophagus as though on the edge of His field, surveys with deep sorrow His Kingdom of this World '.

In 1465 Piero had come to Urbino to paint the famous diptych of *Duke Federigo* and *Battista Sforza* his wife, with the triumphal chariots (on the reverse of the panel) seen against the silvery background of the
75 Umbrian countryside. Federigo's bust—as it looms large before the

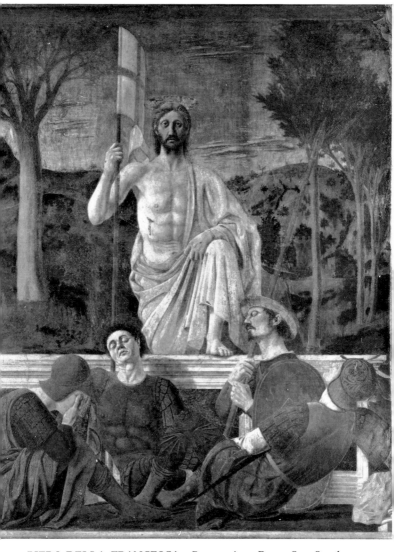

74. PIERO DELLA FRANCESCA. *Resurrection*. Borgo San Sepolcro
(photo : Soprintendenza alle Gallerie, Firenze).

adiant lake and misty hills, in his weathered skin, black cap, and red
air—is a monumental as well as a detailed form. Piero has not
bandoned the tradition of painting portraits in profile, but he has
ndowed this one with all the bulk and vigour of a sculptured head.
The very scale of the bust in its large facial planes and rounded mass

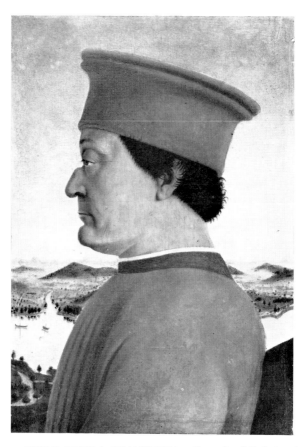

75. PIERO DELLA FRANCESCA. *Portrait of Federigo da Montefeltro.* Florence, Uffizi (photo: Soprintendenza alle Gallerie, Florence).

before the protracted aerial distance, increases the impression of rock like solidity of the duke, who was a model prince, a great soldier, and a paternal and enlightened ruler.

All the elements of the duke's face—the protruding chin, the nose broken in tournament, the surveying eye under the heavy lid, even the naturalist portrayal of warts and wrinkles and curling hair—have been welded into one sculptural whole. This powerful portrait, rising above the delicate panorama of sun-warmed lake and hills and pallid sky, perpetuates a memorable human presence by the contrast of three dimensional form with the limitless aerial space.

Such a contrast between human figures and a detailed panorama of landscape had been perfected with the loving care of the miniaturist

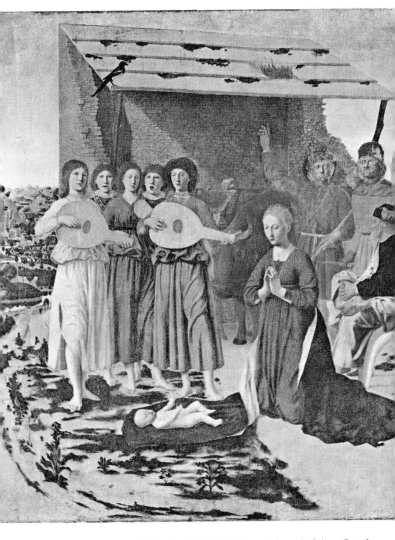

PLATE IV. PIERO DELLA FRANCESCA. *The Nativity*, London, National Gallery (Courtesy: Trustees, National Gallery)

y Flemish painters earlier in the fifteenth century. Piero toward ᴛe end of his life reconciled this Flemish naturalism with his own ideas ʙout light, space, and geometrical design. In the London *Nativity* all ᴛese elements come together. Here the shed provides the uprights ᴨd horizontals of the design, with the shadow crossing it in the ᴅagonal, while the bend of the greensward continues in the serpentine ᴅad that winds its way between the rocks and hills of the middle-ᴅistance. Yet trees and meadows are no longer the ' excited blots and ꜱcribbles ' of the Baptism, but the rounded, formalized shapes of ꜰlemish painting, while the tiny Child on its blue velvet carpet recalls ᴛhat of Hugo van der Goes, whose *Adoration of the Shepherds* caused a ᴦeat stir when it was sent to Florence from Bruges in 1475.

But in spite of these semblances the *Nativity* is an unmistakable work ᴏf Piero by the generous sweep and pearly light of the landscape, the ᴦchitectural form of the angels' robes—their folds like fluted columns, ᴛheir colouring cool lavender and blue and marble white—and the ᴛender grace of the kneeling Madonna. The solid wall of the shed ᴇnhances the depth and life of the landscape, and the Nativity with its ꜰlemish articulation of form and its shepherds left unfinished, is a ꜱignificant work of Piero's old age.

X. MOVEMENT, ANATOMY, AND LANDSCAPE

Andrea del Castagno — Antonio and Piero Pollaiuolo — Andrea Verrocchi

Perspective, anatomy, movement, and light were the main concern of the ne[w] generation of Florentines. CASTAGNO placed his sculptured muscular figures [in] the architectural space drawn with geometrical precision. He was the first [to] convey movement convincingly. ANTONIO POLLAIUOLO was fascinat[ed] by anatomy. He explored the dynamics of physical stress and in his athletic nud[es] rendered force in action. He surpassed Castagno in the science of movement a[nd] painted landscape 'of astonishing sweep and truth'. VERROCCHIO shar[ed] the metallic precision and gaunt anatomy of figures placed in the forefront of roc[ky] landscapes. He too was a master of movement.

Uccello subjected appearances to his structural experiments and h[is] aim was not life-likeness but rather that his design should be satisfactor[y]. An artist, who was so engrossed in geometrical pattern making, cann[ot] be counted among the Florentine realists. But ANDREA DEL CASTAGN[O] was different. In him perspective, relief, movement, and anatomy we[re] a means to an end : that the human figure should gain in plastic strengt[h] in sharpness of outline, and power of limb, to express the Renaissanc[e] ideal of heroic manhood.

There is a certain ruthlessness and brutality about his figures : wit[h] their sharp metallic contours and the vigour of their steely limbs an[d] swarthy faces. His favourite subjects were monumental figures [of] mercenary captains like *Pippo Spano*, mail-clad and holding a nake[d] sword in his hand, challenging and aggressive ; or *Farinata deg[li]* 76 *Uberti*, the Florentine leader of the Ghibelline party, whom Dant[e] placed into hell as his political adversary. Among Castagno's portrai[ts] of famous men Farinata expresses the Florentine ideal of heroic an[d] even tragic leadership. Farinata's portrait is of such grave dignit[y] that Castagno must have remembered Dante's verse in the tent[h] Canto of the *Inferno*, where Farinata rises from his flaming tomb wit[h] such pride ' as if he held the Inferno in great disdain ', *Come aves[se] l'Inferno in gran dispitto.*

But Castagno's importance in the development of Florentine ar[t] partly rests upon the use he made of perspective to obtain a perfec[t] 77 spatial illusion. In *The Last Supper* he anticipated Leonardo d[a] Vinci by constructing an oblong room in deep recession, open towar[ds] the spectator, with its slanting walls and diminishing ceiling drawn wit[h] great precision. The marble slabs at the back of the room with thei[r] verticals and horizontals form a tranquil foil to the rugged humanit[y]

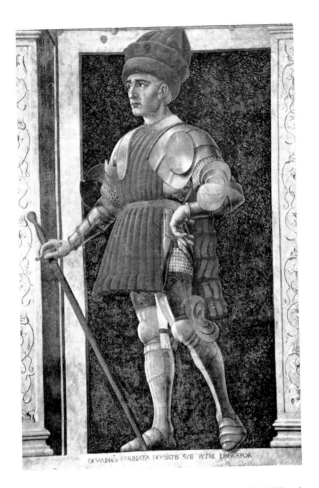

DOMINVS FARINATA DE VBERTIS SVE PATRIE LIBERATOR

76. ANDREA DEL CASTAGNO. *Farinata degli Uberti*.
Firenze, Museo di S. Apollonia (photo: Soprintendenza
alle Gallerie, Firenze).

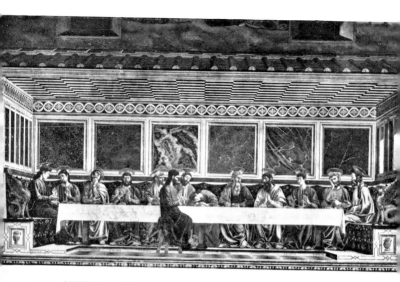

77. ANDREA DEL CASTAGNO. *The Last Supper*. Firenze, Museo
S. Apollonia (photo : Alinari).

of the Apostles. They are seen in brooding isolation not yet, as with
Leonardo, combined into lively groups. Only S. John and S. Peter
are more closely drawn into the aura of the Lord. These grave and
sombre apostles with their intricate drapery are modelled in strong
light and their heads are cutting across the lower edge of the marble
intarsia.

If movement is restricted in *The Last Supper*, it is the principal
agent in a work of Castagno's maturity, the *David with the Head of
Goliath* at Washington. No other representation of the youthful hero
flushed with his unbelievable triumph over the giant adversary, conveys
the same nervous agitation as this supple and serious boy who comes
running to announce his victory, with sling still dangling from his
hand, his hair and short tunic fluttering in the wind. As he looks into
the distance and waves his hand, he rises, a lofty and tenuous shape
above the blue horizon with its streaks of scattered cloudlets. In
Castagno's Pantheon of heroic youth and manhood the David, by his
vitality and adolescent grace is a strange and haunting image.

To sum up : Castagno, coming one generation after Masaccio, was
equally remote from the latter's Renaissance humanism as from Piero
della Francesca's Olympic tranquillity. He shared with Piero and
Domenico Veneziano their interest in light and perspective. But his chief
aim was to express physical prowess and sheer force. He was a virtuoso

78

102

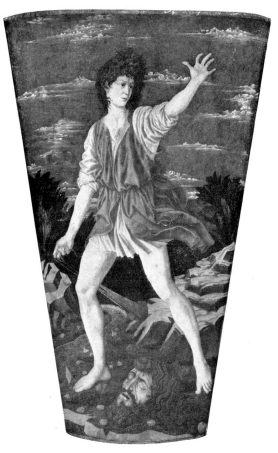

78. ANDREA DEL CASTAGNO. *David with the Head of
Goliath*. Washington, National Gallery of Art, Widener
Collection (photo : National Gallery of Art).

in the Florentine science of painting interior architecture and heavily
draped figures. Only rarely, as in the figure of David, does he betray
tenderness and sensibility.

Movement, anatomy, and landscape painting come into their own
with the brothers ANTONIO and PIERO POLLAIUOLO, who were followers
of Castagno and worked as sculptors as well as painters. Antonio, the
elder of the two, was first apprenticed to a goldsmith. He appears to
have been the greater master. The picture which must have astonished
the Florentines by its boldness and novelty was the *Martyrdom of S.* 79
Sebastian showing the strides Renaissance painting had made since

103

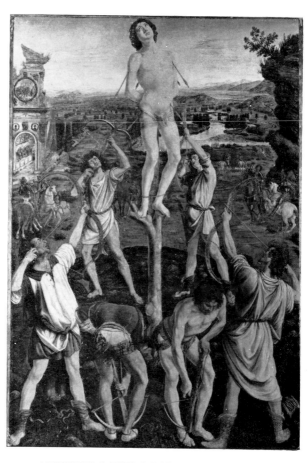

79. ANTONIO & PIERO POLLAIUOLO. *Martyrdom of S. Sebastian.* London, National Gallery (photo : National Gallery).

Giotto and Masaccio had got it under way. This landmark of the Florentine School is now in the National Gallery, London ; its date 1475, when it was painted for the private Chapel of the Pucci family in the Church of the Annunziata at Florence. The youthful saint is believed to be a portrait of Gino di Lodovico Capponi.

One glance at the monumental picture, which has been restored to its original brilliance of colour, informs us that the Pollaiuoli were aiming at a perfect realization of the human figure in the surrounding space. In order to obtain that transparency and graphic clarity of vision, that wide panoramic view over the Tuscan countryside, they chose a

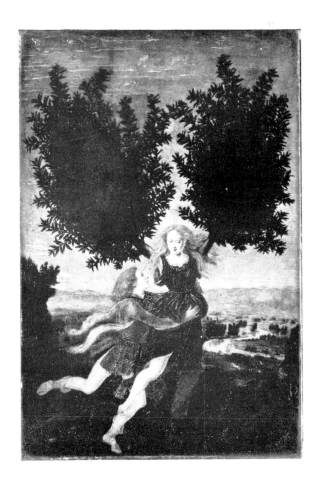

80. ANTONIO & PIERO POLLAIUOLO. *Apollo and
Daphne*. London, National Gallery (photo : National Gallery).

vantage-point not on a level with but above the scene of the martyrdom.
We look down upon the archers and the saint tied to his tree, and far
beyond them, upon a vast prospect of river valley which is their native
Val d'Arno. To evoke the illusion of graded recession, the Pollaiuoli
placed horsemen and a triumphal arch in the middle-distance, and then
the shimmering river, the diminishing trees, until in the far-away
distance the greenish-blue hills melt into one with the azure sky. Thus
the vitality of the archers, their dynamic limbs and folds, are resolved
into the manifold life of the earth beyond.

For Pollaiuolo's chief concern was with anatomical study of man in
violent states of body and mind. The six archers surround the martyr

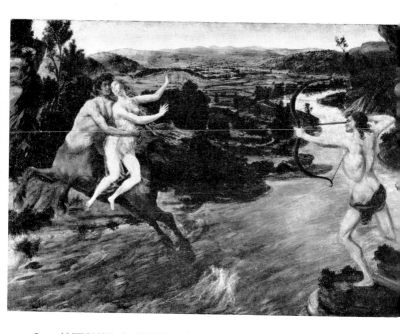

81. ANTONIO & PIERO POLLAIUOLO. *Hercules and Nessus*. New Haven, Jarves Collection (photo: A. C. Cooper Ltd.).

in a full circle, and it is their taut sinews and muscular strains, their athletic weight and exertion which occupied all the painters' attention. The foreshortened figure of the bending archer on the left in his double of crimson velvet, the sculptured reality of his stunted shape, is expressive of great physical power. The nude man by his side is shown in the reverse position, while the two framing archers in luminous blue and pale green, strain every nerve of arm and face as they aim at their victim. S. Sebastian, though lacerated by arrows, is not represented in agony, but yearning heavenward, whence help is to come to the protagonist of the faith.

We can well believe Vasari when he wrote that Antonio ' dissected many bodies to examine their anatomy, being the first to show how the muscles must be looked for to take their proper place in figures '. Yet for his naturalistic veracity he paid a price in the grimacing faces and ungainly bodies of the executioners, sacrificing beauty of form on the altar of science. This he avoided in the enchanting little panel of 80 *Apollo and Daphne*, where the nymph is changed into a laurel bush as result of her prayer for protection against the pursuing god. The golden-haired loveliness of the smiling nymph and the tossing movement and dance-like rhythm of Apollo's pursuit are rendered

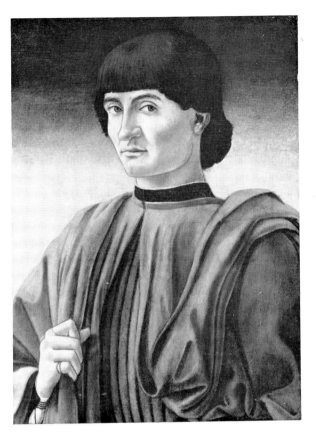

82. ANTONIO & PIERO POLLAIUOLO. *Portrait of a Man.*
Washington, National Gallery of Art, Mellon Collection (photo :
National Gallery of Art, Washington).

with airy litheness, without impairing the substance of bodily form.
Here, as in his *Hercules and Nessus*, the human figures are in the fore- 81
ground plane, to allow for the realistic portrayal of the vast expanse of
river landscape with its rippling water, flowing among the hills and
creeks to shimmering distances. The athletic form of Hercules,
aiming his bow at the centaur Nessus who carries off his wife Dejaneira
is of such strength and anatomical truth, that his swelling chest, the
shaded hollow of his back, his taut sinews and strained muscles convey,
as much as his bow, the tension of his physical effort. Giotto, Masaccio
and Piero della Francesca only suggest potential movement, Pollaiuolo
rendered it by the vibrancy of line and the exertion of tensed bodies.
He conveyed energy by an excessive and detailed naturalism. Cast-

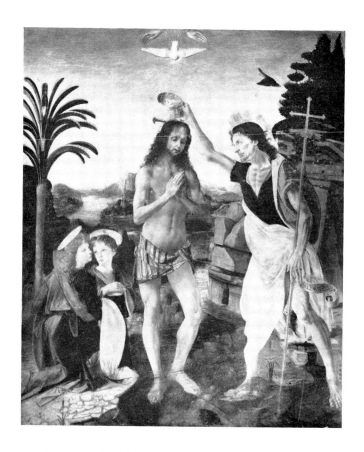

83. ANDREA VERROCCHIO. *Baptism of Christ*. Florence, Uffizi (photo : Soprintendenza alle Gallerie, Florence).

agno's beginnings in this field were driven to their outer limit. Botticelli and Leonardo will use the vehicle of line with even greater fluency, but also more poetically than Pollaiuolo. In landscape he followed Baldovinetti's exploration of natural truth in his topographical delinea-
66 tion of river valleys seen from above and extending to infinity. But these are glorified relief maps of the Tuscan countryside. As the Pollaiuoli reacted against the immobility of figures of an earlier generation by rendering ubiquitous movement, there will be a return to poise and tranquillity before the end of the century.

82 In the *Portrait of a Man*, who clasps his red tunic with supple fingers can be felt that vigour, intelligence, and relentless pursuit of purpose, which distinguished the Florentine superman of the Renaissance.

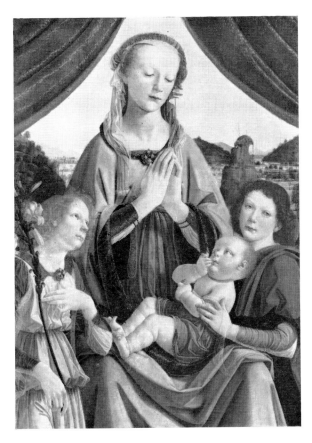

84. ANDREA VERROCCHIO. *Madonna and Child with Angel and S. John the Baptist.* London, National Gallery (photo : National Gallery).

Like Pollaiuolo, with whom he shares the mastery of figures in movement, ANDREA VERROCCHIO (1435-88) was a goldsmith and a sculptor as well as a painter. In fact he was pre-eminently a sculptor, and his slender David with the Leonardo smile, his stupendous Colleoni, are of greater renown than his scanty paintings. Verrocchio maintained a famous workshop in Florence where, besides Leonardo, other promising pupils like Lorenzo di Credi and perhaps Perugino learned their craft. Andrea must have been a splendid tutor to have kept Leonardo for four years (1472-76), whose skill in drawing flowing hair and knots owed much to Verrocchio. But Leonardo had a genius for painting, far superior to that of Verrocchio. On seeing the

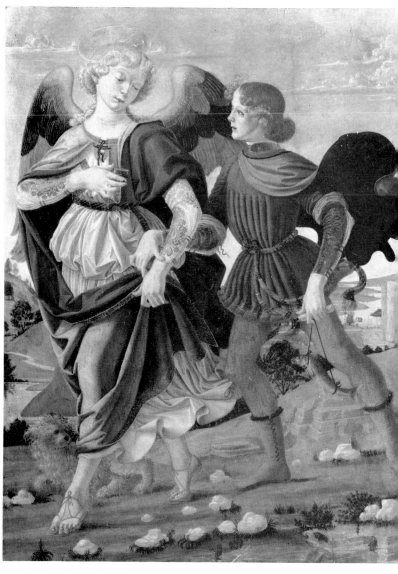

85. ANDREA VERROCCHIO. *Tobias with the Angel*. London, National
Gallery (photo : National Gallery).

graceful angel which Leonardo painted in his master's picture of the *Baptism of Christ*, Verrocchio is said to have laid aside his brush and **83** devoted himself entirely to sculpture. The story is aporcryphal ; but he could well have left painting in the hands of so gifted a pupil. Indeed the difference between the ingenuous boy angel who gazes so intently upon his companion with the rapturous face and rippling gold thread of hair, is very marked ; and so is that between the left half of the landscape with its luminous infinity and the harsh foreground of rocks opposite where the Baptist, a gaunt and unlovely figure, hastens to pour his vessel over the Christ who stands timidly in the water, not like a leader of men, but like ' a poor teacher '.

Two paintings in the National Gallery will illustrate how Verrocchio translated his sculptural style into painting. In the *Madonna and Child* **84** *with Angel and S. John the Baptist* the Virgin towers up firmly in the forefront of the fine Tuscan landscape. A southern brightness of light and colour informs the picture, especially in the pale-blue robe of the Virgin, laid over her knees in great triangular folds. The plasticity of the angel's ruffled skirt might be carved out of marble, but his hair is of finer texture, his feeling more pronounced than was Verrocchio's wont, whose children, like the young Baptist opposite, are more sober and less emphatic. Verrocchio's sculptural manner is also felt in the bony structure of the Madonna's face and neck and in the brown shadows modelling the flesh.

Darker in tone, but more elegant of gait and costume is the *Tobias* **85** *with the Angel* from Verrocchio's workshop. Perhaps the Tobias with his lovely face and precious attire, who so daintily clasps the angel's hand, is a reflection of Leonardo's presence in the workshop. As he strides along—clad in a blue doublet and red hose, his belt and tunic fluttering in the wind, the fish dangling from his hand, by the side of the lovely angel who hardly treads the ground in the urgency of the journey—he is a picture of fastidious elegance and charm. With stylish, almost affected gesture, the angel Raphael holds the vase of ointment which will cure the blindness of Tobias' father. Perhaps the intricacy and metallic sharpness of robes, the grace of movement, the sweetness and earnestness of expression are altogether beyond Verrocchio's known style of painting and belong to the Florentine aura in which ripened the calligraphic style of Lippi and Botticelli.

XI. THE HEROIC NUDE IN MOVEMENT—
VOLUME AND ARCHITECTURAL SPACE

Luca Signorelli — Melozzo da Forli

*LUCA SIGNORELLI approximates very closely to the titanic element i

Michelangelo. His principal subject was the male nude in movement, where h

could best express physical energy, the strain and stress of limbs, muscles, sinews r

violent action. MELOZZO DA FORLI, like Signorelli, worked in the ambienc

of Piero della Francesca. He developed architectural illusionism and the fore

shortening of figures, seen from below. His grand Renaissance individuals anticipat

the manner of the sixteenth century.*

SIGNORELLI, though he was probably a pupil of Piero della Francesca,
whose largeness of manner and even light he adopted, belongs essenti-
ally to the Pollaiuolo type of Tuscan artist to whom dynamic action
of the human nude was of primary interest. This dual influence
upon him, the pictorial architecture and reflected light of Piero and the
physical vigour of Pollaiuolo is characteristic of his early work. Later
he evolved his own pre-Michelangelesque ' *gigantismo* ' of somewhat
harsh classical nudes and monumental Madonnas, worlds apart from
Piero's equipoise.

For him *man* was the centre of the Universe. His chief concern was
the human body in movement; and he never tired of painting virile
nudes in the act of physical exertion, with bulging muscles and marked
sinews, their giant bodies modelled in strong light—a primeval race of
athletic men. His preferred types are heroic, mercenary captains and
86 soldiers of fortune whom he painted as archers and executioners, in his
scenes of martyrdom and in *The Scourging of Christ*. In an antique
setting of frieze and column a heroic Christ is scourged; He the fairest
and strongest of men is leaning against the column in Classical *contrap-
posto*. The taut anatomies of His tormentors are strongly defined by
lighted planes and incisive shadows. Like Pollaiuolo before him,
Signorelli has shown a variety of physical action : four athletic bodies
differently poised revealing the swelling sinews of limbs strained in
physical exertion. The executioners' brutality and movement are
contrasted by Christ's poise and melancholy.

Though Signorelli painted many devotional pictures and altar-
pieces with large and expressive figures, firmly held and cast in a heroic
mould, his chief work is found upon the walls of a church : *The Last
87 Judgment* with the *Deeds of Anti-Christ* and the *Resurrection of the Dead*,

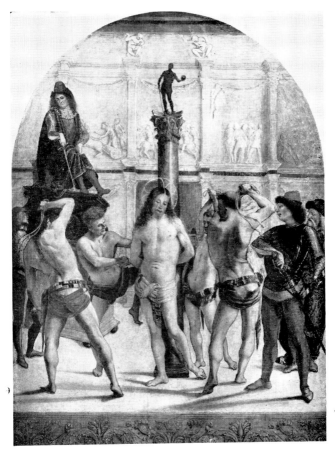

86. LUCA SIGNORELLI. *The Scourging of Christ*. Milan, Brera
(photo : Anderson).

the Chapel of S. Brizio at Orvieto Cathedral. Here Signorelli could
indulge his passion, surpassed only by Michelangelo, of showing the
human nude in all conditions and postures, expressing vital energy
and drama. In the *Deeds of Anti-Christ* Signorelli has painted his vision
of Inferno : a cataclysm of tortured humanity in the throes of damnation,
the demoniac ferocity of satanic forces unleashed upon a welter of
mangled nudes. But in the *Resurrection* a more lyrical note prevails.
Here, to the clangs of the tuba sounded by winged archangels of
gigantic stature, the hard crust of the earth breaks open and from it
rises a new race of men with gestures of deep longing and rapture.
Some are painfully wrestling, with dazed eyes, to free themselves from

87. LUCA SIGNORELLI. *The Last Judgment: Resurrection of the Dead*
Orvieto, Cathedral (photo: Gabinetto Fotografico Nazionale).

the dark prison of the tomb; others are trying the power of their limb
Here a boy kneels to help another to rise from the earth; there a ma
bends low to assist a youth, still half-buried in the ground. Other
stand about in groups or yearningly gaze upward to the angelic host c
join their hands in prayer, clothed in their new raiment of flesh whic
Signorelli modelled broadly in swelling planes and sinuous curves.

This rude native force and sense of vital energy in movement whic
created the Dantesque frescoes of Orvieto Cathedral, is also latent i
88 his portraiture. Our *Portrait of an Old Gentleman*, in his scarlet ca
and tunic relieved by the black shoulder-strap, his silvery hair an
shrewd face—is representative of the Renaissance. This head with th
subtle realization of the eye, the bushy brow, the sagging lid
strong nose, and olive skin—is set against the pale-blue sky, gre
water, and green pasture. Two amazons approach from the left an
two youths stand or recline before a triumphal arch: scenes fror
classical lore which Signorelli used to enliven his middle-distance.

Signorelli's style developed from the largeness and calm of his yout
to the nervous animation of his maturity, when he painted his stirrin

88. LUCA SIGNORELLI. *Portrait of an Old Gentleman.*
Berlin, Kaiser Friedrich Museum.

pictures of Christ's Passion. Such is the violence of his *Pietà*, even in ⁸⁹ the small confines of a predella—so tempestuous the grief of the women supporting the fainting Virgin, so like a Maenad is the wildness of Magdalena who with flowing hair and raised hand runs toward the scene—that one thinks of Greek tragedy rather than of the Christian epic. The agitation of the women around Mary, by the side of this beautiful figure of Christ, is balanced by two turbaned men and two noble women in billowing robes, discussing the event with compassionate gestures. The suffering of Christ has rarely found a more vibrant echo than in this group of mourners around the Crucified.

89. LUCA SIGNORELLI. *Pietà:* detail. Glasgow, Sir John Stirling-Maxwell Collection (photo : T. & R. Annan & Sons Ltd.).

It is usual to connect MELOZZO DA FORLI with Piero della Francesca, whom he met in Urbino working for Duke Federigo. But Melozzo (1438-94) learnt as much from Mantegna at Padua, especially the bold foreshortening of figures seen from below, like the enraptured musician-angels in the Vatican with their voluminous drapery and glowing faces. Melozzo anticipates much of the sixteenth century and suggests grandeur, and individual character of imposing figures in sumptuous architectural setting. His masterpiece is a picture of *Pope Sixtus IV*
90 *inaugurating the Vatican Library*. Here a recession of pillars and arches creates an architectural space, where the Pope, surrounded by his nephews, Cardinal Riario and della Rovere, entrusts the library to the humanist Platina, kneeling before him. It is a ceremonial occasion and Melozzo has given it its pomp and circumstance by painting vigorous portraits of powerful individuals, just as Raphael will do after him in his picture of Leo X attended by two cardinals. It is a humanist scene, as the Pope receives in audience a great scholar who looks at him with that frankness and pride which distinguished the men of the Renaissance. And though the figures are posed and carefully spaced in depth on each side of the central column, we are not aware of it : so naturally do they move, so weighty and solid is their presence, so self-assured are they of man's power and dignity as ruling members of a

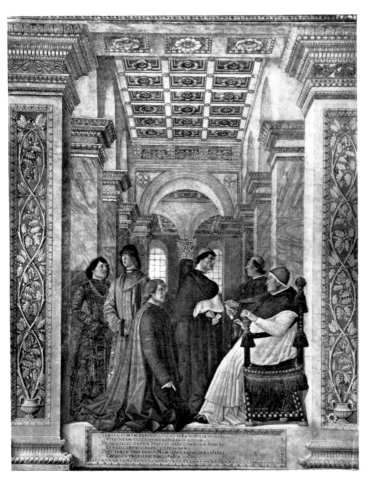

90. MELOZZO DA FORLI. *Pope Sixtus IV inaugurating the
Vatican Library.* Vatican (photo : Anderson).

spiritual and secular hierarchy. But this group of prelates and human-
ists is closely linked to the sumptuous architecture seen from below by
means of a raised platform and composed of decorative pilasters and
columns, leading to the central arch along the skilfully foreshortened
ceiling. This feat of scientific perspective and architectural illusionism
continues Masaccio's experiments in the Trinity fresco at Santa Maria
Novella and the geometrical order and purity of Piero della Francesca. **47, 6**

XII. GLOWING COLOUR AND LUMINOUS ATMOSPHERE

Pietro Perugino — Bernardino Pinturicchio

PERUGINO'S work forms the greatest possible contrast to that of his Umbrian contemporary Signorelli. He was averse to movement. His figures stand like pillars beneath the arches to which they are related. Their emotion is restrained, their beauty repetitive. But they have strength as well as sweetness. Perugino's novelty is the intensity of his colour and his feeling for space. His splendid oil technique made possible the luminous atmosphere, the breath-taking spaciousness of his Umbrian landscapes. His pupil PINTURICCHIO shared some of these qualities, but animated his gorgeous decorations with movement of graceful though insubstantial figures.

With PIETRO PERUGINO we enter upon the mid-summer beauty of Italian painting. Together with Signorelli he had been a pupil of Piero della Francesca at Arezzo. There he had learned the classical calm and order of composition, the laws of perspective recession, and how to conceive his figures ' as architectonic members in the effect of space '. Born in Perugia, the war-like capital of gentle Umbria, he spent much of his life at Florence, where from Verrocchio he learnt the science of intricate design, and from the young Leonardo the art of modelling softly with chiaroscuro. Equipped with the best that the age had to offer in pictorial science, he also had his own contribution to make. This was a new richness and translucency of glowing colour and a dreamlike beauty of landscape backgrounds—the shimmering vales and rivulets of his native Umbria. The undulating hills and fragrant meadows, punctuated by the slender stems of fine-leafed trees, the wide-open skies of exhilarating blueness, portray the very essence of an Italian summer. These effects he obtained by sensitive gradations of tone—his greens varying from mossy to olive and bluish tints—and by the smoothness of the new oil technique, which had come to Florence from Flanders and was used by Baldovinetti before him.

Perugino was among the Florentine masters whom Pope Sixtus IV had called to Rome to decorate his private chapel in the Vatican with frescoes from the lives of Moses and of Christ. There in 1481 he painted his first masterpiece, *Christ giving the Keys to S. Peter*, in which, besides his personal gift for portraiture in bold inventions of virile characters, he showed his mettle in a grand concept of space. For behind the balanced group of apostles on each side of Christ in the near foreground, is a noble piazza, a vast expanse of rising ground which

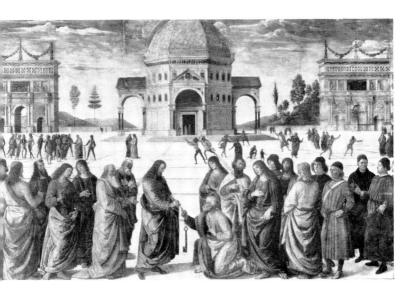

1. PIETRO PERUGINO. *Christ giving the Keys to S. Peter*. Sistine Chapel
(photo : Anderson).

eads to an octagonal temple, crowned with a cupola. This classical
building is the central pivot of the picture, with limpid air and distant
ills suggesting an infinity of space. Smaller figures in the middle-
distance and the diminishing lines of the big paving-stones convey the
llusion of depth and the intervals of space.

From Melozzo da Forlì, who was then also working in the Vatican,
Perugino adopted the architectural form of perspective arcades ; and
in his great Florentine altarpiece of 1489, the *Virgin Appearing to S.
Bernard*, he composed his figures into just such a loggia with arches
and pillars, letting in the air and the open country beyond. These
arches lead the eye to an enchanted distance of Umbrian hills and
valleys, under a limpid sky. The Virgin, who appears in a vision to
S. Bernard (like Beatrice to Dante), and her attendant angels are of that
physical beauty and grace and feminine languor which the boy Raphael
learnt in Perugino's workshop. His heads and figures, simply and
firmly modelled, with their sunburnt fleshtones and the melodious flow
of their garments, express a deep calm, an unruffled serenity.

Our National Gallery triptych of the *Virgin Adoring the Child with
the Archangels Michael and Raphael, and Tobias* is a no less characteristic
work of Perugino's maturity. It was painted in 1498 for the Certosa of
Pavia, commissioned by Lodovico Sforza, Duke of Milan. Leonardo

119

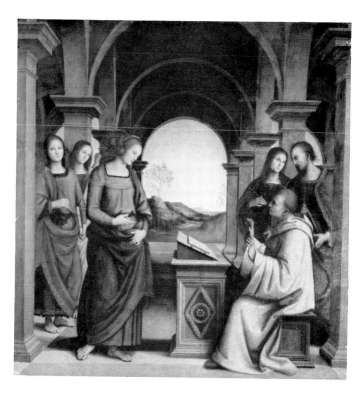

92. PIETRO PERUGINO. *Virgin Appearing to S. Bernard*. Munich, Alte Pinakothek.

was court painter to the Duke, and Perugino had to compete with this supreme master, then at work at his *Last Supper* in Santa Maria delle Grazie. Small wonder that he tried to instil into his altarpiece all the beauty that was in him to give, together with a superlative finish, especially in the gradations of tone, in the grace and elegance of his figures, and in the breathtaking landscape. The immensity of a summer sky and a wide expanse of lakes and hills and meadows are seen behind the Madonna in successive distances of graded greens and golden

93 browns. The Archangel Michael, standing squarely upon the greensward, holds his great shield, embossed with classical ornament, in the manner of Donatello's *S. George*. His round childlike face conveys youth rather than strength. His bronze-coloured wings are of the same metallic substance as his shining armour with its highlights and composite tints of greenish-blue and of brown. The shimmer of the flesh is matched by that of the armour, painted with such smoothness and

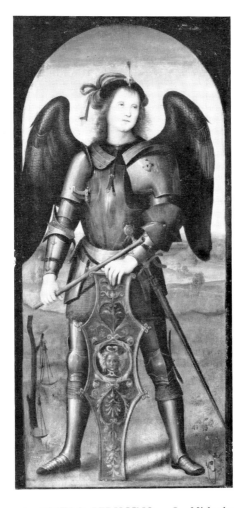

93. PIETRO PERUGINO. *S. Michael*:
detail from an altarpiece. London, National
Gallery (photo : National Gallery).

delicate finish that design and form are wholly merged in the painterly
style of Perugino's brush.

Perugino lived until 1523, but from 1500 he was content with re-
arrangements of his stock figures, so that he drew upon himself the
contempt of Michelangelo. His importance lies in the painting of
atmospheric space, to which he imparted a cosmic breadth, and in
which he was excelled only by his pupil Raphael.

121

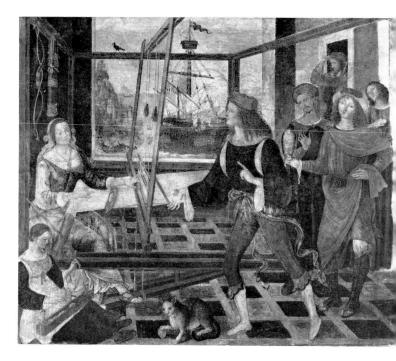

94. BERNARDINO PINTURICCHIO. *Return of Ulysses*. London
National Gallery (photo : National Gallery).

Perugino's other pupil who closely followed his master in the style
of his figures and in the poetic idealization of landscape was BERNARDINO
PINTURICCHIO (1454-1513). He had assisted Perugino in the frescoes
of the Sistine Chapel and later decorated the Borgia appartments in the
Vatican for Alexander VI with gorgeous murals like the *Disputation of
S. Catherine*, where he painted the portraits of the Borgia children, of
fair-haired Lucrezia and brooding Cesare. His gift for painting brilliant
pageants and gay costumes, for movement and vivid narrative, can also
be studied in the Cathedral Library at Siena, where he related the life
of the future Pope Pius II.

No proper idea can be formed in England of Pinturicchio's talent
for decorative cycles. But a fresco in the National Gallery, the *Return
of Ulysses*, reflects his skill for festive and light-hearted composition.
Here the great window of Penelope's chamber looks upon the harbour
where Ulysses' ship lies at anchor and the perspective of tiled floor and
loom lead the eye toward it. The door has been flung open, and elegant
young men gaily attired in green and blue and scarlet, bring the news
of the arrival. Their flowing hair and ribbons and dancing gait convey

94

a sense of excitement: their hands speak as much as their lips, and the young falconer as he stands graceful and self-conscious, holding his cloak and his bird, is a favourite shape of Pinturicchio. Pinturicchio was essentially a decorator of luxurious refinement and sophistication, in whose narrative and fantastic art the insubstantial figures are apparelled in gay costumes of sparkling colour.

XIII. THE CONSUMMATION OF LINEAR DESIGN AND RHYTHMICAL MOVEMENT

Sandro Botticelli — Filippino Lippi

The name of BOTTICELLI conjures up an impeccable delicacy of design and e grace and rhythmical quality of line. Also the memory of elongated rather angula bodies, of melancholy faces framed by writing tresses, and of eyes dimmed by tears be the subject Venus or Virgin. Line is Botticelli's main vehicle of expression, and colour is secondary. For him line conveys the dream fantasies of his youth and the penitential religion of his old age, a flowery meadow and a fluttering robe, but above all movement: the blowing of the wind and the swiftness of the Annunciation Angel' gait. By his abstractions and elongations of form Botticelli reveals Gothic as wel, as Mannerist affinities. FILIPPINO LIPPI, Botticelli's pupil continues the graceful linear style of Florence and moves towards Mannerism in his attenuated Madonnas and their billowing draperies. He is restless and sentimental as well as sophisticated and fond of decorative arabesques.

The name of SANDRO BOTTICELLI is for ever linked with the Golden Age of Florence, in which Lorenzo Medici the Magnifico was the ruling spirit. Botticelli was Fra Filippo's pupil and adopted his particular form of wistful Madonna, wreathed by angels. But Filippo was not his only master. In the worshops of Verrocchio and Pollaiuolo he learnt how to give rounded form and incisive contour to his figures in the sculptural style then prevailing. Yet Botticelli's singular gift was for rhythmical line suggestive of movement, the vehicle which he developed to give expression to his impassioned and nostalgic spirit.

His early works, the monumental *Fortitude* ensconced on her marble throne and the genre-like Madonnas reveal the source of his training, Verrocchio's incisive plasticity and Fra Filippo's ingenuous Madonnas and chubby children. But from the start Botticelli favours a serious expression of sadness and foreboding in his Madonnas ; and in his *Judith and her servant carrying the head of Holofernes* he evolves the quality of movement by the swiftness of gait, the undulating folds and flying robes of figures striding in the forefront of a panoramic landscape. It was Botticelli's good fortune that in the early 1470s he was drawn into the cultured circle of the Medici, princely patrons and humanists, whose neo-Platonic philosophy, reconciling Antiquity and Christianity influenced his whole outlook. For twenty years, until the death of Lorenzo, Botticelli worked in the service of the Medici, whom he glorified (as Gozzoli had done before him) as kings and their court in the *Adoration of the Magi*. These splendid worshippers, arrayed in a wide circle bowing and paying homage to the Virgin and Child are

95

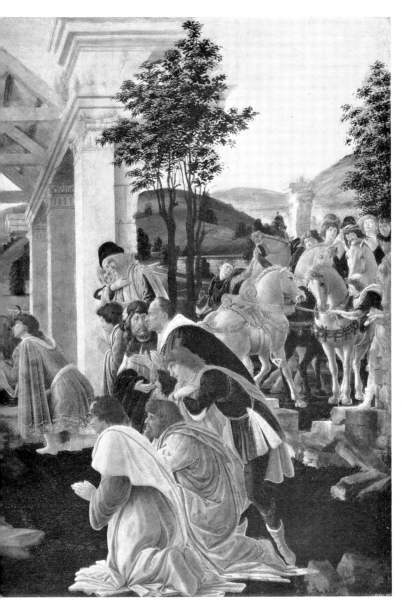

95. SANDRO BOTTICELLI. *Adoration of the Magi:* detail. Washington National Gallery of Art, Mellon Collection (photo: National Gallery of Art, Washington).

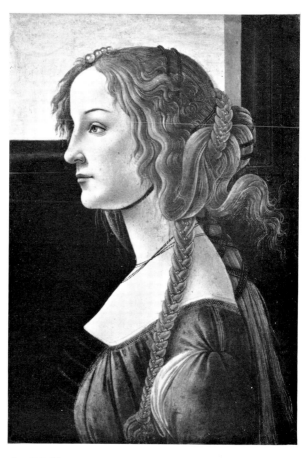

96. SANDRO BOTTICELLI. *Portrait*. Berlin, Kaiser Friedrich Museum.

realistic portraits of the Medici, their friends and scholars in period costume. The brightness and spaciousness of the scene, the antique ruins behind which the Tuscan hillside unfolds, the emphatic gestures of the courtiers in their rich, voluminous robes reveal the master of movement whose forceful and sweeping line faithfully records appearances.

But Florentine science and realism were only a point of departure for Botticelli. He employed his poetic temperament in creating images as personal and as stylish as any in Italian art. His famous presentation of Simonetta Vespucci as *Venus* or in many a portrait testifies to his creation of an imaginary ideal of beauty. For Simonetta, the celebrated Lady of the Medicean circle, died young of consumption, and Botticelli's

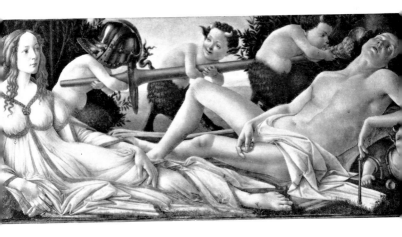

97. SANDRO BOTTICELLI. *Venus and Mars*. London, National Gallery
(photo : National Gallery).

paintings of her were not taken from life. Simonetta, like Dante's
Beatrice was transmuted into an ideal image of melancholy beauty : a **96**
golden-haired, ivory-browed sphinx, with the intricate linear tangle of
tresses and the impeccable delicacy of contour.

Giuliano dei Medici, Lorenzo's brother, was also commemorated by
Botticelli, the same Giuliano who fell a victim to the Pazzi conspiracy
against the Medici rule under the very dome of Florence Cathedral.
Giuliano's proud form appears in the *Adoration*, he stands as Mercury by
the side of the Graces in Botticelli's *Primavera* and he lies entranced at
the feet of the Goddess of Love in our picture of *Venus and Mars*. Yet **97**
Botticelli had no direct knowledge of Greece or Rome and was prompted
by Lorenzo's scholar Angelo Poliziano, to paint mythological subjects.
In three compositions Botticelli was to describe the realm of Venus :
her birth from the sea, her dominion over the forces of spring, and her
sway over the warrior-god Mars.

Giuliano dei Medici, the favourite of Florentine youth and the victor
in the last mediaeval tournament held in Florence in 1475, impersonates
Mars, while the celebrated Simonetta is represented as the solemn,
inscrutable goddess who watches over the sleep of her heroic lover.
Giuliano, his athletic frame fatigued from battle, has laid down his arms
and fallen into heavy sleep. Venus inspires the sleeping god with visions
of victory and of its prize : the dream-creation of her own grave beauty.

But besides transmitting to posterity his most personal form of
antiquity, Botticelli endowed his Venus with the infinite delicacy of
linear design in the pleated transparency of her robe, and with the

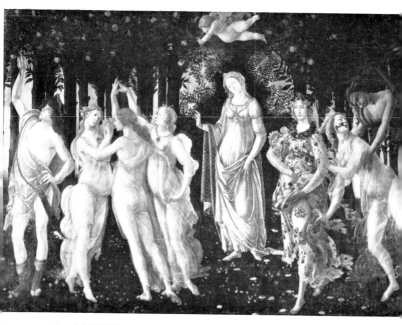

98. SANDRO BOTTICELLI. *Primavera*. Florence, Uffizi (photo:
Soprintendenza alle Gallerie, Firenze)

unruffled calm of her face. Only the baby fauns' pranks and gambols
as they play with the armour of Mars, relieve the solemnity of the
picture.

Poliziano's stanzas, named *Giostra* after the tournament of 1475 were
the inspiration of Botticelli's cycle and of its monumental masterpiece
98 the *Primavera* or Realm of Venus. Lorenzo's court poet was steeped
in classical learning, and more especially in Ovid's Metamorphoses and
Virgil's pastoral poetry. Botticelli followed his literary conceits, and
by translating them freely into his ethereal and wholly original vision
of antique gods and nymphs, he created the strangest poetry in
Quattrocento painting. Here a delicately draped Venus, like a goddess
of fruitfulness is the centre of the composition, standing on a luxuriant
meadow beneath a flying Cupid. On her right the three graces move
in slow and rhythmical dance and Mercury dispels threatening clouds
with his wand. To the left of Venus, Flora the goddess of Spring,
in a robe wholly wreathed with flowers, scatters roses, while Boreas
strains to elope with the nymph Orithia. This poetic mythology, this
Garden of Love, is bounded by an orange grove, a screen of trees and
leafy pattern and golden fruit, in front of which the impeccable figures

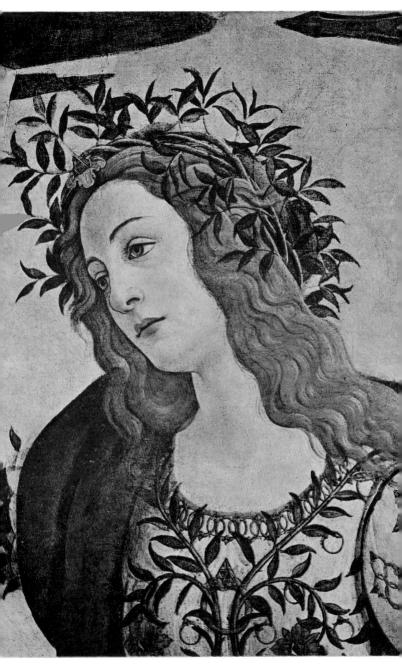

PLATE V. SANDRO BOTTICELLI. *Pallas and the Centaur*, detail.
Florence, Uffizi (photo: Courtesy: Messrs Arnaud, Florence)

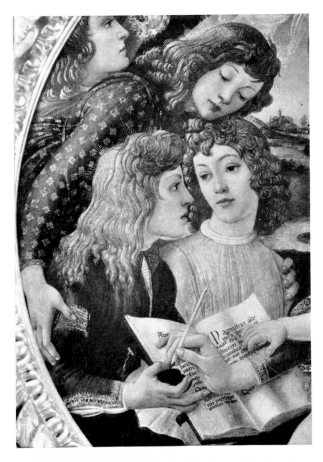

99. SANDRO BOTTICELLI. *The Madonna of the Magnificat:*
detail. Florence, Uffizi (photo : Soprintendenza alle Gallerie,
Florence).

stand or move, singly or in groups, in their coy and yet sensual undula-
tions of body and limb. Botticelli's Antiquity is tinged with melancholy,
but also exquisitely ornate and supple and Pre-Raphaelite in the literal
sense of the word ; because his lengthened and sinuous figures, decked
in their gauze-like and billowing robes, have more of the Gothic than
of Raphael's substance and bloom.

In 1481 Botticelli was called to Rome by Pope Sixtus IV to join
Perugino, Ghirlandaio and others in decorating the Sistine Chapel.
After two years of fresco painting he returns to Florence ; and now he
designs his great altarpieces and circular panels of the Virgin and Child,
wherein he develops his wistful type of Madonna, in the gaunt angularity

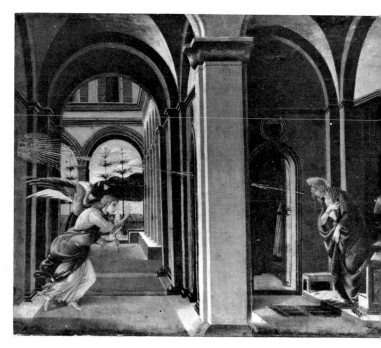

100. SANDRO BOTTICELLI. *Annunciation*. Glasgow, City Art Gallery (photo : City Art Gallery, Glasgow).

of her face and tearful expression, yet made attractive by her compassion with the Child who looks away from her into the distance. Once he painted the Child upon her lap guiding her hand, as she writes into a book the words of the Magnificat, while two angels hold the crown suspended over her head and others gaze at one another in affectionate wonder. It is in this *Madonna of the Magnificat* that Botticelli has so composed his figures into the circular space of the tondo, that the incline of heads and bodies, the flow of locks and ribbons and embroidered hem make a unified arabesque of compact and elegant beauty.

With Lorenzo Magnifico's death in 1492 and the virtual rulership of Florence by a puritanical monk, Girolamo Savonarola, Prior of San Marco, the Medicean age had come to an end. Savonarola, roused by the worldly government of the Papacy and by the paganism of the Florentine neo-Platonists, wanted to purify life and art from all sensuous luxuries. Painting was to be strictly religious ; portraits, nudes, fineries were banished from it and public burnings of works of art, which did not conform to the friar's rule, were instigated. Botticelli was deeply affected by Savonarola's preaching, and the art of his last twenty years reflects the fundamental change of his spirit.

Henceforth he was to paint only religious subjects in austere surround- **100**
ings such as the Glasgow *Annunciation*, where all the inner life is in the
figures, while the unadorned cloister of grey pillars and arches seems to
dwarf the human form. The abstract quality of Botticelli's figures, re-
markable even in Venus and Flora, could now be likened to the flame of
incorporeal spirits. As the angel of the *Annunciation* storms into the
atrium of the Church, his soles hardly touching the ground, the Virgin
bows low in contrition and in awe. She is no longer clad in precious
robes, but wrapped in a loose mantle which hides her whole form. Line
has assumed such precision and vibrancy in the angel as to express pure
values of movement, especially in his body contours and mighty wings.

By 1498 Savonarola had lost the battle with the Borgia Pope, and
with two companions had died the martyr's death by fire on the great
Piazza at Florence. In an allegorical picture at the National Gallery
Botticelli commemorated the event and his own mystic transformation.
It is a kind of vertical triptych with the *Nativity* in the centre, the **101**
redemption of man in the foreground, and the angels of the empyrean
above. A Greek inscription states that the picture was painted in 1500
during the troubles of Italy, when Satan was let loose upon earth,
who now lies enchained and trodden underfoot '. In the mystical
vision of Botticelli the birth of Christ leads to the redemption and to a
life of paradisian bliss. The three mortals whom the angels receive in
tempestuous embrace, while demons lurk in all corners, represent the
souls of three Florentine martyrs, Savonarola and his two companions.

The *Nativity* is Botticelli's testament of beauty, with its abstract
purity of line, curving and defining bodies and robes, as in the great
hollow formed by Mary's mantle or the ovoid shape of Joseph's cloak.
Line assumes the litheness of flame in the olive-bearing angels' rhythmical
dance upon the azure and gold of the empyrean. On each side of the
golden-thatched manger, supported by the formalized rocks, angels
lead kings and shepherds to worship the Child. This *Mystic Nativity*
is composed without depth, but with an infinite variety of movement,
and a symbolism of gesture, which leads the eye upward from the
earthly paradise to the celestial sphere and the circular dance of the
angelic choir.

During the last years of his life Botticelli probably gave up painting
altogether. New men, of different fibre like Michelangelo and Leonardo
were measuring their strength in Florence.

To sum up Botticelli's achievement : he had mastered all the science
of his age but subjected it to conveying profound spiritual experience
and poetic vision by means of line so pure and so mobile as to become
abstract and even surrealist. His early works still show the sculptural

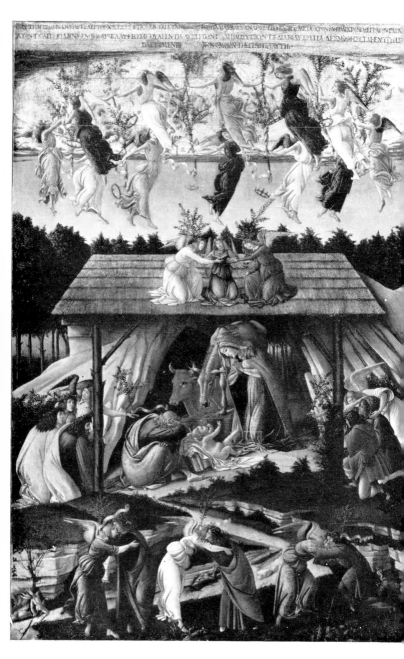

101. SANDRO BOTTICELLI. *The Mystic Nativity*. London, National Gallery (photo : National Gallery).

tyle and incisiveness of his masters, his Madonnas the often repetitive simplicity of Fra Fillipo. But soon he endows them with premonition and refines their apparel with utmost delicacy. His figures, be they Venus or Virgin, betray an ' ineffable melancholy ' and a veiled voluptuousness. Brought up in the naturalistic tradition of Florence, he was a poetic visionary who transformed reality according to an idealized concept of life, past and present. But beside the painter of wan and wistful Madonnas and the Gothic calligraphy of *Primavera* there is the forceful and virile painter of the monumental *S. Augustine*-fresco at Ognissanti and of the great altarpieces of the 1480s. At the end of that period his line assumes a functional swiftness and ubiquity which is nothing short of tempestuous. He still paints classical allegories like the *Calumny of Apelles* or Christian subjects like the *Annunciation*, where figures are bent at will and distorted in irresistible flight, though they may be stabilized by lofty Renaissance architecture. Finally, this subjection of body to spirit is made to serve a fanatic religious austerity which sacrifices comeliness to the expression of anguish, humility and penitence.

In a sense Botticelli was an abstract artist. Walter Pater has called his line and colour ' the medium of abstract painting '. He used appearances to become ' the exponent of ideas, moods, visions ' of his own. In that respect Botticelli is a very modern artist, however remote his Christian and pagan iconology may appear. This iconology owes nothing to antiquity, but much to the poets of his age and also to Dante and Boccaccio. It is an Antiquity with a personal and contemporary look. His tapestry-like *Realm of Venus* is set in a Tuscan garden landscape, but his graces and deities are the pure emanations of his own fantasy. Botticelli was the supreme artist of linear decoration, whose work is divided between the glorification of graceful living and humanism of Medicean Florence and his most personal rendering of the Christian mysteries. Like the Pre-Raphaelites he was an artist of the *Fin-de-Siècle*. His dreams had the sweetness, the yearning and the frailty of a waning civilisation. By his functional line that could render ' the movements of the tossing hair, the fluttering draperies and the dancing waves ' he had enriched the pictorial language of the fifteenth century. For in Botticelli's paintings this liberated line created form, as other painters did through modelling in the round, rich colour and chiaroscuro.

In 1952 Bernard Berenson noted in his diary ' that artists evolved their types out of their call to give the human shape tactile value and movement and in the case of Botticelli to refine on his inheritance from Filippo Lippi as he left his legacy to Filippino '. Indeed FILIPPINO

133

K

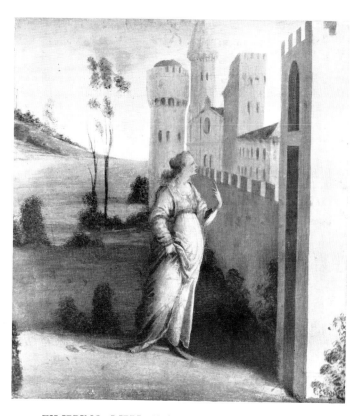

102. FILIPPINO LIPPI. *Esther appears before the Palace Gate.*
Ottawa, National Gallery of Canada (photo: National Gallery of
Canada).

LIPPI was his father's and Botticelli's pupil. He perfected the linear
style to a degree which may be described as tinted calligraphy. In his
compositions, form and substance were subordinated to decorative
grace and sentiment. His father's ideal of human beauty became
mannered and sophisticated in Filippino. He was chosen to complete
Masaccio's scenes from the *Life of S. Peter* in the Carmelite Church,
where he introduced many Florentine portraits.

How delightful an artist Filippino was before he became mannerist
and sentimental appears from two small panels, painted when he was a
102 young assistant in Botticelli's workshop. In the first *Esther appears
before the Palace Gate* to seek audience with the King Ahasuerus, and
103 in the second we see *Mordecai on Horseback led by Haman.* Haman
had persecuted the Jews and wronged Mordecai and will have to die

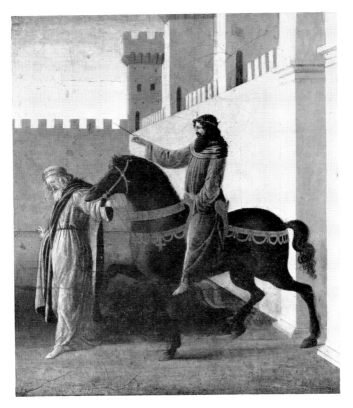

103. FILIPPINO LIPPI. *Mordecai on Horseback led by Haman.*
Ottawa, National Gallery of Canada (photo : National Gallery of
Canada).

for it ; but first he must honour his enemy by leading him through the
city, decked in the royal regalia.

Filippino has related this story with a few telling gestures, placing
his actors against a backdrop of castle wall and garden. There
are no flourishes and no trappings. In the golden light, by the
shore of the great castle, Esther appears in sollioquy, like a heroine in
Racine's play. And what could be simpler and more regal than the
dark silhouette of Mordecai on horseback, seen against that bright
castle wall, with the fallen favourite of the king leading his horse's bridle.
Haman's distraught face and silvery beard, his tragic gait are contrasted
with the triumphant Mordecai, proudly erect on his horse, raising the
royal sceptre. Filippino was a susceptible artist who will follow many
masters, from Lippi to Leonardo, but here he speaks nobly in the
language of Botticelli.

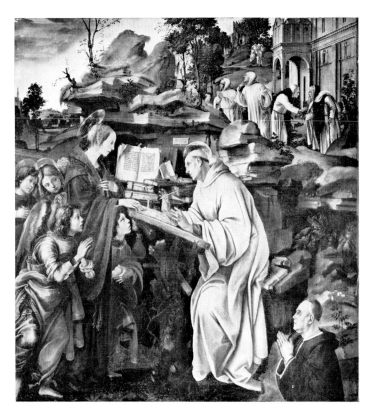

104. FILIPPINO LIPPI. *Vision of S. Bernard.* Florence, Badia (photo : Soprintendenza alle Gallerie, Florence).

104 His most popular work is the *Vision of S. Bernard*, where in a detailed landscape of rocks and hills the Virgin with a host of cherubs appears to the saint who is writing down his vision in a book. The immaculate frailty and limpid transparency of the Madonna and the childish eagerness of the adoring boy angels have a tender sentimental appeal. But compared with Perugino's classical symmetry and deep calm in the treatment of the same subject (see Fig. 92), Filippino's design appears restless and over-elaborate. He was indeed a Mannerist *avant la lettre*, with his elongated and over-refined shapes, his incongruity of space and his multifarious diversions from the principal theme.

85
105 It is a far cry from Verrocchio's vital design of *Tobias with the Angel* to Filippino's languid youth in his profusion of drapery, as he obeys the persuasion of the angel, who tenderly leads him by the hand

136

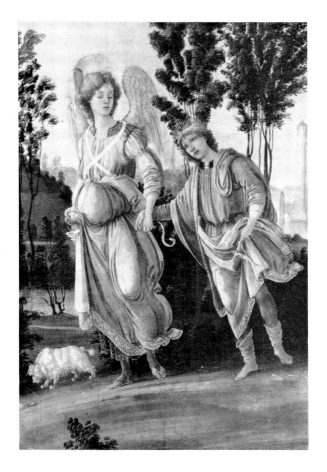

105. FILIPPINO LIPPI. *Tobias and the Angel*. Washington,
National Gallery of Art, Samuel H. Kress Collection (photo :
National Gallery of Art, Washington).

through an enchanting landscape. Movement and youthful energy
are no longer the propelling force for Filippino, so intent on designing
the swelling robes of the angel and his indolent grace.

XIV. NARRATIVE PAINTING AND THE PAGEANT OF FLORENTINE LIFE

Benozzo Gozzoli — Domenico Ghirlandaio — Piero di Cosimo

Neither GOZZOLI nor GHIRLANDAIO were artists of the front rank. They were chiefly decorators and historical painters who inherited the science and reflected the life of the times. Gozzoli was the more primitive artist, a keen observer of natural form who in harsh contours and gay colour and in the crowded Gothicizing manner of tapestry depicted the Medicean pageant. Ghirlandaio was an unsophisticated artist who could organize huge wall spaces with balanced grouping and contemporary portraits. He lacked Botticelli's spirituality and sense of movement and was mainly concerned with the stylish imitation of appearances. He painted the aristocratic splendour of Florentine society without much recourse to religion or fantasy. Neither of them was an innovator in the technical sense; nor was Piero di Cosimo, an eccentric and original painter of mythological subjects with an almost northern contempt of classical beauty.

Apart from great autonomous artists and pioneers, the Florentine School was rich in decorative painters who portrayed the glittering surface of social life. These gifted artists did not advance pictorial science : they were eclectics, realists, painters of genre recording the pageant of the Medicean Era. The oldest of them, BENOZZO GOZZOLI (1420-98), had been Fra Angelico's assistant and in his legends of S. Francis combined memories of Giotto with a greater measure of realism. Then in 1459 Piero dei Medici commissioned him to paint the frescoes of the Palazzo Riccardi and suggested as a subject the *Journey of the Kings from the East* with all the train of attendants, which in the hands of Gozzoli became an apotheosis of the Medici, their friends, and relatives in gold embroidered costumes, riding on white chargers through a Gothic landscape of formalized rocks and castles.

Gozzoli's colourful fancy was guided by Gentile da Fabriano's splendid array of the journeying kings, painted a generation earlier, but he had learnt how to give individual character to his figures and how to combine a measure of courtly grace in the young, with the harsher veracity of his virile portraits. On the extreme left the rocks open, disgorging more than fifty travellers in contemporary costume, led by an imperious group of princes. Right in front are the older Medici : gout-stricken Piero riding on a white steed, wearing crimson and gold, his powerful head under a square cap ; behind him his brother Giovanni, a white kerchief tied around his shock of black hair ; and next to him their father, Cosimo the elder, soberly clad, upright and pensive, with his ageing head, his aquiline nose—the founder of Medicean riches and power.

138

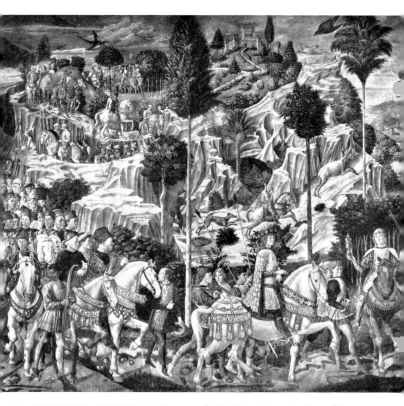

106. BENOZZO GOZZOLI. *Journey of the Kings from the East*. Firenze, Palazzo Riccardi (photo : Soprintendenza alle Gallerie, Firenze).

In front of this cavalcade of ancestors and their kin, including the painter himself who inscribed his name upon his cap, rides the pride of the house, Cosimo's grandson Lorenzo Magnifico, representing the youngest of the kings. In his golden doublet and tunic, his red hose, his jewelled cap and crown, this eleven-year-old boy is feasted as the paragon of princely youth : not a likeness, but a symbol of illustrious rulership among the pages and equerries escorting him. Gozzoli's fancy abounds in motives from contemporary life and he conceived the *Journey of the Kings from the East* as a festive train of Florentine nobles over the Tuscan hills, with lively portraits, well-drawn dogs and deer, meandering through meadows and gardens without much recession of space, in the manner of woven carpets or tapestry.

Gozzoli was a master of the transition from the Gothic to the Renaissance, with a naturalistic gift of minute observation and a luxurious sense of decorative detail. Yet—though he portrays the

feathery crown of cypresses, the birds in flight, and the movement of the chase—his gorgeous pageant, his dazzling local colours, his towering rocks are still of the International Style. He is a herald of the Renaissance mainly in his portraits of three generations of Medici princes and of the Emperor Palaeologus and the Patriarch Josephus and in the gaiety with which he depicts the Tuscan world in a delightful frieze around the walls of the Medici Chapel.

With DOMENICO GHIRLANDAIO (1449-94) fifteenth century painting reaches the threshold of the sixteenth, not only in date, but in the monumental character of figure composition, the firmness of grouping and the mastery over space. In all this Ghirlandaio sums up the innovations of his century. In other respects he was an eclectic, a virtuoso of narrative painting based on Holy Script, but purporting to reflect the festive pageant of life in Florence. Sacred subjects provided but a pretext for his indefatigable portrayal of the great Florentine houses, their self-assured men and stately women, their palatial architecture and fastidious costumes. Domenico's gift for portraiture was such that our pictorial knowledge of the Medici is based upon two series of frescoes in Santa Trinità and Santa Maria Novella. There the onlookers—in scenes from the lives of S. Francis, of S. John the Baptist and the Virgin Mary—are the Florentine bankers and merchant princes Sassetti and Tornabuoni; in one of them Lorenzo Medici himself looks across to his children and their tutor in the foregound of a church where the solemn confirmation of the Franciscan Rule by Pope Honorius is enacted.

Ghirlandaio's delight in organizing large spaces with scenes of decorative genre and historical narrative was so great, that Vasari relates his regret that he could not cover the outer walls of Florence with his frescoes. So prolific an artist lacked the depth and refinement of Botticelli, Lorenzo's favourite, who glorified the classical aspirations of the Medici. Ghirlandaio was mainly employed by the wealthy associates of the Medici Bank who, in homage to the ruling house, included their portraits in the religious frescoes of their funerary chapels. There they can still be seen life-like, proud and self-possessed, in the forefront of sacred pictures where they have no function or role to play. No wonder that Savonarola thundered against the secularization of art and against the vain-glorious men whose portraits looked down upon the worshippers from the walls of the sanctuary. But Ghirlandaio was unrepentant and continued to portray his Florentine patrons in massive groups, now in the *Calling of the First Disciples*, now in the *Birth of the Baptist*. Here the bedchamber of S. Elizabeth bursts open, and while the nurse stretches out her arm to receive the newborn child, a Floren-

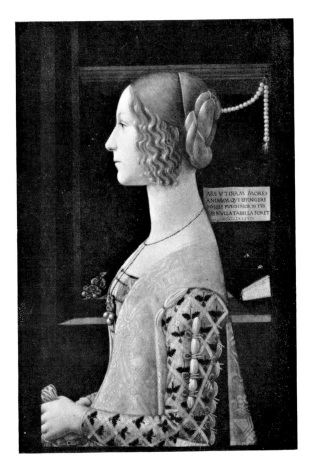

107. DOMENICO GHIRLANDAIO. *Portrait of Giovanna Tornabuoni.* Castagnola, Thyssen Collection (photo : A. C. Cooper Ltd.).

tine lady enters with her attendants, proudly erect in her stiff brocades. Behind her a beautiful servant girl, bearing a basket of fruit upon her head, steps into the room, with billowing robes, a figure derived from Filippo Lippi's *Birth of the Virgin* in the Pitti Museum. The visitor who brings presents to the mother of the Baptist is no other than *Giovanna Tornabuoni*, the youthful wife of Lorenzo, whose single **107** portrait is one of the most immaculate profile busts of the Renaissance.

The pristine beauty of the noble young woman is sharply delineated upon the dark neutral background. The artist has given his sitter that jewel-like perfection and plastic relief, where female beauty and elegance combine to form an arabesque of linear delicacy and translucent colour.

141

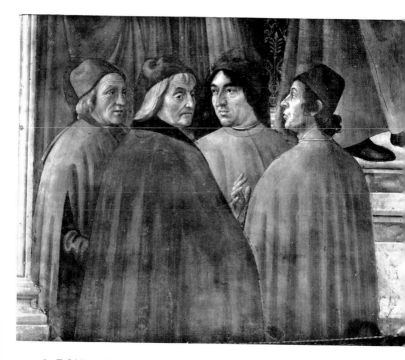

108. DOMENICO GHIRLANDAIO. *The Angel Appears to Zacharias: the Humanists*. Florence, S.M. Novella (photo: Soprintendenza alle Gallerie, Florence).

Her slender neck, crowned by the small head with the impeccable profile, the golden ringlets subtly delineated, form as intricate a pattern as the slashed sleeve of crimson brocade and the brooch of pearls and a ruby. The severe simplicity of the background is broken only by the string of corals, a book, a rosary, and the cartolino which says that this would be the most perfect image if the lady's mind and virtue could also be represented.

But it is not only the princes and noble ladies whose pictorial records Ghirlandaio has kept for us on the walls of Florentine churches; also their retinue, their artists, and scholars have their realistic presence in a corner of some sacred picture. At the edge of the great temple where *The Angel Appears to Zacharias*, Ghirlandaio painted the group **108** of poets and humanists who were the glory of the Laurentian age. In the right foreground stands Marsilio Ficino, who tried to harmonize Plato's philosophy with Christian doctrine. Here is Angelo Poliziano, poet and Latinist, to whom Lorenzo entrusted the education of his children; next to him is Cristoforo Landino, who wrote the famous

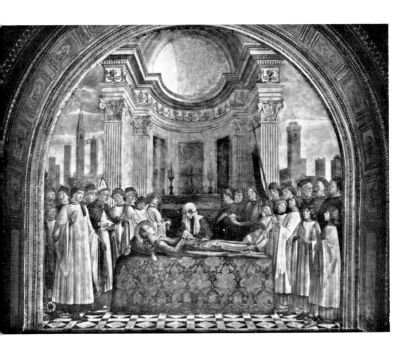

109. DOMENICO GHIRLANDAIO. *Funeral of Santa Fina*. Pieve, S. Gimignano (photo : Anderson).

Dante commentary. Ghirlandaio has caught this group of scholars with the Bishop del Becchi, Lorenzo's own aged teacher, in lively converse, such as they might hold at street corner or market place. It is a picture of everyday life at Florence, closely observed and deftly painted with firm, generous strokes of the brush : a group of men with the marks of intellectual tension and vitality. It is true that these portraits are irrelevant to, and have no place in, the sacred drama, but as individual portraits of the men of the Renaissance they are of great historical interest.

His mastery lay above all in his grouping and space construction. In one of his earlier works, the *Funeral of Santa Fina*, the saint is laid **109** on her bier in front of the rounded apse of the church. This is clearly a memory of Filippo Lippi's *Burial of S. Stephen* in the Choir of Prato Cathedral. The illusion of depth is enhanced by the perspective recession of tiles, the semi-circular grouping of figures and the great swinging curve of the open-air apse. Priests and acolytes are so arrayed as to lead the eye inward, and the youthful faces of the choirboys alternate with those of the aged attendants around the bishop. But it is

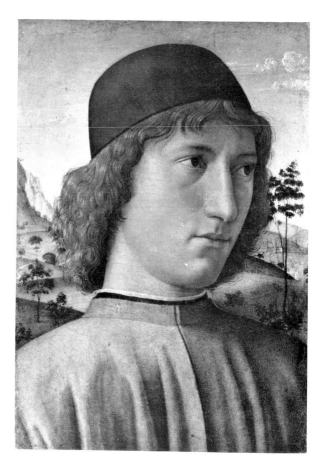

110. A follower of DOMENICO GHIRLANDAIO. *Portrait of a Young Man in Red*. London, National Gallery (photo : National Gallery).

not only their fine expressive heads and movements which animate the scene, it is also the changes of light and of tone, the brilliant whites of the surplices and the planes of shadow in the altar-niche. This enclosed architectural space is enlarged on either side by the open sky with the mediaeval turrets of San Gimignano.

Ghirlandaio had started his professional life as a goldsmith ; hence his fine draughtsmanship and sculptural prowess. The *Portrait of a* 110 *Young Man in Red*, ascribed to a follower, is yet an epitome of the virtues to be acquired in Ghirlandaio's workshop, where even the boy Michelangelo was apprenticed for a time. The bust of the young man is broadly placed into the picture space and drawn with firm contours

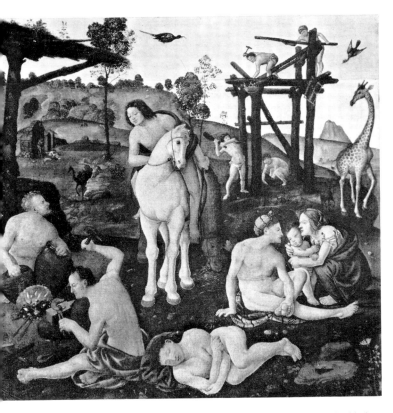

and a conspicuous largeness of facial planes. This simplification of form, with the boldly foreshortened shaded half of the face, is contrasted by the calligraphy of the rich golden hair and by the irregular landscape. The character of the young man is as clearly defined as his outward form. Ghirlandaio's freedom of handling, solidity and largeness, and a sense of untroubled beauty are clearly conveyed by this vital portrait.

The variety of Florentine talent at the turn of the fifteenth century was enriched by the oddly original genius of PIERO DI COSIMO (1462-1521), who took his name from his master Cosimo Rosselli. He had been to Rome as Rosselli's assistant in 1482 to work in the Sistine Chapel and won distinction there in competition with the greatest Florentines. One of them especially left his mark upon Piero's early work : Luca Signorelli. Like him he was fascinated by the human nude, a primeval humanity of gods, satyrs, and heroes, whom he painted in

legendary or fantastic narratives. In our picture from the National

Gallery of Canada *Vulcan and Aeolus as Teachers of Mankind*, a pagan idyll seems enacted, a kind of prehistoric Garden of Eden, where man and God and beast live peaceably together in useful pursuits or somnolent leisure. Piero has laid his scene in an open landscape of rising folds and meadows crowned with trees, from which his rather ungainly nudes are powerfully detached. In the middle-distance a primitive house is being built of palings, to the amazement of the inquisitive giraffe. This realistically observed animal has furnished the date of the picture, for a giraffe was sent to Florence as a gift from the Sultan in 1487.

On the left Vulcan is seen forging a horseshoe, while Aeolus blows the bellows and seems to be talking to the waiting rider. By contrast to the labouring blacksmith, a youth with the ears of a faun lies crumpled up in the near foreground, and behind him a happy family group illustrate the simple life of primitive people. Piero di Cosimo's art is a strange inlet of the fantastic and the romantic into the classical world of Florence. His figures betray a northern, perhaps a Flemish influence, but his sympathy with plant and tree and dumb animal and with the half-humanized world of primeval man lend to his mythological pictures a touching animation.

Some of Piero's more grotesque paintings with strangely expressionist hybrid and animal forms were done for the *Studiolo* of a rich Florentine wool merchant. They represent the early history of man with hunting and battle scenes of fabulous creatures and a *Forest Fire* (Ashmolean, Oxford). In their savage and distorted shapes of man and beast they seem like a protest against the over-refined art of Florence, a romantic return to nature, like Rousseau's in the eighteenth century. Stone and Iron Age are symbolized, the discovery of fire and the use of metal. Piero also painted religious subjects and character portraits and the famous half-nude bust of Simonetta (in Chantilly), a profile like Botticelli's with a snake-like necklace and plaited hair. But Piero's art moves away from linearism towards a soft modulation by chiaroscuro. His life was as eccentric as his work. One of his finest mythological paintings is the *Death of Procris* in the National Gallery. Here a strange pathos prevails in the beauty of the dead nymph and the hazy lagoon melting far away into the sky. The sadness of Cephalus over the death of his young wife flows over into the landscape and is also expressed by the great lonely dog and the flight of cranes. For Piero was obsessed with animal form and a master in their portrayal, like Pisanello, Jacopo Bellini and Leonardo.

XV. PADUAN SCIENCE AND ANTIQUITY— MANTEGNA'S WORLD OF GRANITE

With MANTEGNA the focus of scientific experiment shifts from Florence to Padua. The Florentine discoveries of anatomy, perspective, space, and the naturalist rendering of objects were applied in the north by a host of visiting artists. All this Mantegna transforms by the strength, the fury even, of his expressive force and by the nostalgic enthusiasm of his classical erudition. The result is a primeval world of cyclopic rocks and antique monuments, inhabited by a heroic race of men in Roman gait and garb. This world is not softened by his bright local colours and metallic linearism. It is a sculptural world of space-creating buildings, rocks, figures standing out in utter transparency and precision of contour.

Florentine science and artistry had spread to the north of Italy by the early fifteenth century : Gentile da Fabriano and Pisanello were working in the Ducal Palace at Venice, Castagno in San Zaccaria, while Lippi and Uccello were active in neighbouring Padua. This ancient university town was to become the humanist centre of the north, and the meeting ground of artists from Florence and Venice. The strongest influence upon the Paduan School did not come from a painter, but from the Florentine sculptor Donatello, who from 1443 to 1453 worked at the statues and low reliefs of the High Altar in Sant'Antonio. It is from Donatello that ANDREA MANTEGNA, the greatest master of the Paduan School, adopted his incisive, relief-like drawing, which became his main vehicle of expression.

In Donatello's work Mantegna experienced the antique spirit in a modern body, an art which did not copy classical motives slavishly, but combined with Roman form and proportion a Christian intensity of feeling and a strength of will and of character which was of the Renaissance. From Donatello's biblical heroes and Christian saints, S. George and the boy David, his poignant scenes from Christ's Passion, or his equestrian statue of *Gattamelata*, Mantegna learnt how to instil the world of Imperial Rome with the force and the spirit of his own age and person.

He had come as a boy of eleven to the Paduan workshop of a popular drawing master and antique collector, Francesco Squarcione, and had been adopted by him as his son. Squarcione was originally a tailor, then a painter and head of a studio who, himself childless, adopted his more promising pupils, as was the custom of the time, in order to employ them on his commissions. Besides Mantegna there were Marco

Zoppo and Gregorio Schiavone, protagonists of the Paduan style who drew their marble arches and cornices with perspective precision and used a decorative profusion of fruit garlands and cupids.

After six years in the house of Squarcione Mantegna separated from his master, and in 1448 as a lad of seventeen received his first major commission : to share with two established Venetian masters, Antonio Vivarini and Giovanni d'Alemagna, the painting of frescoes in the Eremitani Church at Padua. In these frescoes from the lives of S. James and S. Christopher, completed in 1456 and destroyed in the last war, Mantegna showed the whole range of his classical learning and the strength of his sculptural and architectural form. The Eremitani frescoes signified for the north what Masaccio's and Piero's did for central Italy : a summit of contemporary art and science attained by individual genius. Yet with a difference ; for Mantegna was nurtured on Antiquity and his scenes from the lives of Christian martyrs were set in archaeologically derived surroundings. His dignified and majestic S. James is shown beneath a triumphal arch or in a forecourt of a Roman building with arches and architraves and a marble pavement drawn with metallic precision. But the actors in the sacred drama seem no more important than the whole grandiloquent stage set of an imaginary but literary transcribed Rome. Stout hearted legionaries and fair officers in full armour, their features engraved as hard and lustrous as bronze or marble, are disposed in calculated order around the main protagonist in the architectural space. Nature has no role to play in Mantegna's Universe, except for the hanging garlands of fruit— a classical motive—and the unyielding rocks. His overweening sense of monumental form even penetrates into Christian subjects, as in the 112 London *Agony in the Garden*, where a gigantic Christ kneels upon layers of cyclopic rocks, praying before a group of nude angels, who carry the instruments of His martyrdom. The figure of Christ is greater than life and taken up by the pyramidal rocks, towering over an imaginary Jerusalem, where a Roman amphitheatre is the most prominent feature. The winding road and stream in the foreground lead the eye inward toward a group of legionaries who, with Judas, issue from the city. Only the apostles, lying in the forefront of the picture in deadly torpor, introduce a human element into Mantegna's ' world of flint ' : one of them askew in strong foreshortening and bold modulation of bodily form, the other with knees and limbs relaxed under the shapely folds of his sky-blue tunic. Even the colours in this mountain world of granite and porphyry—the deep azure, rose, and moss green—serve to isolate rather than to fuse objects, and in the airless space cubic houses and rounded rock formations stand out in graphic clarity.

148

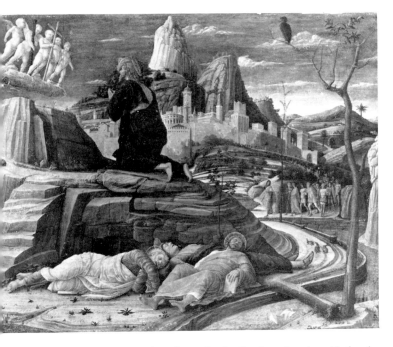

112. ANDREA MANTEGNA. *Agony in the Garden.* London, National
Gallery (photo : National Gallery).

In 1454 Mantegna had taken a step of great consequence for the
future of Venetian painting. He had married Nicolosia, the daughter
of Jacopo Bellini, abandoned the arid school of archaeological drawing,
quarrelled with his master Francesco Squarcione, and for a time
associated with the Bellini workshop. There were now two rival
studios in Venice : traditionalists like the brothers Vivarini, with whom
Squarcione joined hands, and the coming generation of young Vene-
tians, Giovanni and Gentile Bellini, supported by Mantegna. This
vital alliance was to fructify in two ways : Mantegna's lapidary style
was to be softened and mellowed, while Bellini's poetic idealism was
strengthened by contact with Mantegna's sculptural vigour. Yet
important commissions such as the High Altar for San Zeno in Verona,
a great triptych of the Madonna with monumental saints, kept Mantegna
in Padua until, in 1460, he moved to Mantua for life. These
saints are standing in solitary grandeur alongside massive square
pillars in perspective recession towards the centre, where the Madonna
and Child are enthroned beneath classical friezes and cornucopias upon
a sumptuous marble edifice, surrounded by singing angels. But the

149

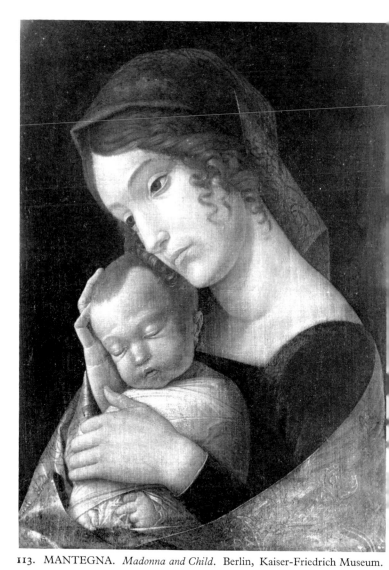

113. MANTEGNA. *Madonna and Child*. Berlin, Kaiser-Friedrich Museum.

essential novelty here is the feeling for space, a feigned Renaissance
hall open to the sky, where majestic saints stand meditating or reading
in front and behind painted columns with the cloud-streaked sky for
background. The S. Zeno altarpiece is a unified triptych, a *Sacra
Conversazione* conceived as one indivisible whole and a milestone in
Mantegna's discovery of architectural illusionism, as well as homage
paid to Donatello, the presiding genius of Paduan art.

There is, however, another more intimate and withdrawn side of Mantegna who so often displays his archaeological knowledge for its own sake with detailed realism. The Berlin *Madonna and Child* is 113 the most concentrated expression of religious experience in Mantegna's work which has a mystical quality and a simplicity of form, rarely attained in Western art. This Madonna moves us by a sustained intensity of human feeling, and a new inwardness and spirituality which could assume no other shape. These qualities beget an incomparable design, where the mother seems to absorb the new-born Child into her own being of which it forms an integral part. The two figures are contained within an oval contour. The mantle of burnished gold holds the group together, while the Virgin with one hand clasping the Child's body, with the other supporting His frail head, gently touches it with her cheek and shelters it with affection. The relief-like conception of form, not unlike Donatello's, is apparent in the elongated neck and head of the Madonna ; while the sorrowing glance of her almond-shaped eyes conveys mystic ardour. Her wanness and idealised beauty are contrasted by the pathetic realism of the Child.

This human tenderness and sentiment which now enters into Mantegna's work and fills his antique heroes with Christian yearning, is perceptible in the *S. Sebastian* of the Vienna Museum, endowed with 114 all the physical splendour and deep feeling of which he was capable. There is a rhythmical flow in the contours of this athletic body, as he stands cruelly transfixed and writhing before the tumbling classical edifice. But although his eyes are raised heavenward, his lips parted in physical pain, his brow distraught, he seems beyond human suffering. Mantegna has transmuted this heroic form in the bloom of youth with the visionary eye, into the Christian saint who nobly bears the palm of martydom. While the blazing light falls from above upon the large planes of his Roman body distended under the strain of his posture, the antique world around him lies in ruin. On the stony road that winds toward the distant city, on the circular mound in the white light under the azure sky, hurrying pygmies, his executioners, are seen to escape. The tiles of the foreground, with the shattered remains of antiquity, lead the eye upon serpentine paths toward shining distances under the low horizon. Mantegna inscribed with exquisite finish a wealth of architectural detail, the ornamental arch and noble column and glowing bricks : a perfect realization of architectural form. Thus over the antique world of broken splendour the Christian martyr is yet triumphant.

Or he portrayed *Judith*, the heroine from Judaea who had saved her people by going into the tent of Holofernes, the Assyrian general,

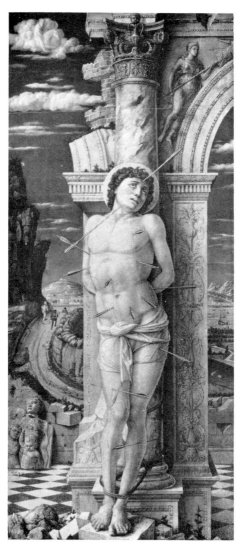

114. ANDREA MANTEGNA. *S. Sebastian.*
Vienna, Museum (photo : Kunsthistorisches
Museum zu Wien).

pretending that she would show him the way to conquer her nation.
But by night, when Holofernes lay heavy with wine after a feast, she
severed his head ; and Mantegna has seized upon the moment when
Judith, stepping from the tent with the naked sword, swings her arm

115. ANDREA MANTEGNA. *The Family of Lodovico Gonzaga*. Mantova, Palazzo Ducale (photo : Soprintendenza alle Gallerie, Mantova).

around to drop the head into the bag of her attendant. The triangular tent frames the two lonely figures, and Judith, as she looks over her shoulder with a fateful glance, is like an antique goddess, who dwarfs her impish attendant in oriental garb. The sculptural roundness of her powerful limbs is contrasted by the linear sharpness of pleats and the generous sweep of folds, a tragic figure in the dramatic poise of her action.

In 1460 Mantegna followed the call of Lodovico Gonzaga, Marquis of Mantua, to become court painter there, and except for two journeys to Florence and Rome, he did not leave the Marquisate for the rest of his life. For Mantua he painted his greatest work, the *Triumph of Caesar*, now a noble ruin at Hampton Court, and the frescoes of the Camera degli Sposi. It was as painter of the Gonzaga family that Mantegna became the great portraitist, for in a room of their castle he portrayed the Marquis Lodovico with his wife Barbara of Brandenburg and all their children in groups of captivating realism. In the Camera **115** degli Sposi he presented a picture of everyday existence, a family gathering of quite patriarchal character. It is a magnificent pageant,

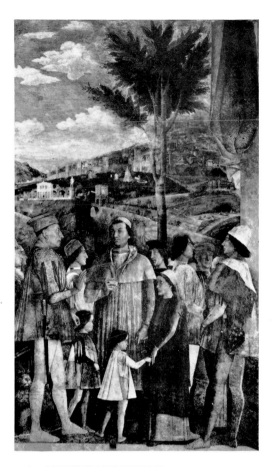

116. ANDREA MANTEGNA. *Meeting of Lodovico Gonzaga, Marquis of Mantua, with his son Cardinal Francesco.* Mantova, Palazzo Ducale (photo : Soprintendenza alle Gallerie, Mantova).

a still-life of an heroic race, conceived as an epic cycle, a saga of a great house, a ceremonial frieze. The Marquis Lodovico turns to his secretary, who has brought him a letter and now bends his head with the aquiline nose to receive his master's command. Lodovico's face is that of a man of action, grave, circumspect, yet not without a touch of princely condescension. In broad maternal amplitude the Marquesana is seated rocklike in the symmetrical centre of the composition. Like a peasant woman she seems content in the midst of her progeny, her giant face strongly lit, a sculptural presence of overwhelming strength.

On the second wall the *Meeting of Marquis Lodovico Gonzaga with his son Cardinal Francesco* is represented. Here a landscape with 116 Roman buildings towers up in converging stone ridges to a walled city, a landscape of yellow rock and red marble where the Cestius Pyramid and the Colosseum crown an otherwise imaginary Rome. Beneath it a splendidly-poised group of men stand and talk in an arrested movement. The cardinal is in the centre, full-face, with the protruding eye of his race, the sensuous lips, the chestnut hair, a prince of the Church. He holds by the hand his younger brother Lodovico, the future bishop of Mantua, who reverently gazes upward. The smallest boy who clasps his hand is Sigismondo, who in his turn will become a cardinal. These are among the first child portraits of the Renaissance, ingenuous creatures with protruding foreheads, pug noses, and pursed lips. The Marquis in his stiff short tunic, slashed sleeve, and sword has something static, almost halting in his gait ; only his hand make as gesture of ceremonious greeting. His Roman head with the double fold of his neck, his rounded chest, convey firmness and concentrated power.

All that Mantegna had attempted in the Ovetari Chapel and the S. Zeno altarpiece came to fruition in the Camera degli Sposi. Here, around the walls of quite a small room in the Ducal Palace, Mantegna painted not only the pageant of the Gonzaga House, three generations of powerful Renaissance personalities in the plenitude of life, complete with courtiers, dwarfs, grooms, dogs and horses—but he brought to perfection his life-long quest for the rendering of spatial and physical illusion. Here he frescoed arches and pilasters and drawn curtains to reveal a tableau vivant of the Gonzaga family, sitting or standing before inlaid marble walls, youths apparently placed in front or beside pilasters, some descending, others coming up the steps leading into the duke's presence. Nor was the artist daunted by the real doors and fireplaces cut out of the wall, arranging his monumental, life-size figures above or around them by changing the spectator's angle of vision. For we see the ducal family from below, but the Meeting of Ludovico with Cardinal Francesco more at eye-level. And here the wall opens to let in a wide sweep of foreshortened hills with a walled city under the cloud-flecked sky. Into this setting Mantegna placed his heroic race of men, and by his feigned architectural frame, he invented, almost incidentally ' quadratura painting ' which became all the vogue in seventeenth century Bologna and Rome.

But Mantegna is most ahead of his time in the optical illusion of his ceiling fresco in the *Camera picta*. For the flat ceiling is made to 117 look as if it were vaulted and open to the sky, letting in the azure and

117. MANTEGNA. Ceiling. Mantua, Camera degli Sposi (photo:
Soprintendenza alle Gallerie, Mantova).

light of heaven. Over a circular parapet, painted in the grey colour of stone, children and grown people are leaning, looking down as from a balcony or roof garden. Placed on the edge and seen from below —*di sotto in sù*—are a great laurel urn and a peacock. To complete the illusion, some of the putti are actually astride the balusters, holding wreaths or fruit. In this feat of architectural deception Mantegna anticipates Correggio's aerial fantasies and also the virtuosi of the Baroque.

XVI. THE IMPACT OF MANTEGNA UPON THE PAINTERS OF NORTHERN ITALY— THE PAINTERS OF FERRARA, LOMBARDY, EMILIA AND THE VENETO

Cosimo Tura — Francesco Cossa — Ercole Roberti — Lorenzo Costa
Francesco Francia — Vincenzo Foppa — Bramantino — Carlo Crivelli

The ripples of Paduan humanism reached as far as Lombardy, Ferrara, and the distant Marches. TURA, the greatest of Ferrarese painters, translated Mantegna's and Donatello's ' tortured reliefs ' into his own fanatical vision of Christian martyrs and penitent saints in a world of ominous rock and cave. Hallmarks of the Paduan School were a love of ruins, a metallic precision, lustrous colours, and a predilection for garlands of fruit and mouldings in low relief. Only in CARLO CRIVELLI is a Gothic exaltation of line and of spirit wedded to a refined luxuriance of ornamentation.

Mantegna's genius and the new monumental style exercised through the study of antiquity in the School of Squarcione at Padua a decisive influence upon the painters of Ferrara. Here a flourishing native school grew up under the patronage of the cultured princes of the Este dynasty. Lionello d'Este had called in Pisanello, the famous painter medallist, to perpetuate his profile in tempera and in bronze. A Flemish master, Roger van der Weyden, had stopped in Ferrara in 1450, leaving behind a famous triptych and much knowledge of the Flemish manner of oil painting. Piero della Francesca had introduced the classical manner and the science of perspective into the Este Palace ; and Mantegna came on a visit, a mere youth of eighteen, but already capable of competing with such masters. He befriended the young COSIMO TURA, who in his turn came to view his work in Padua and to ponder over the expressionist rigour of Donatello's sculpture.

Tura (1430-95) was a man of tempestuous energy and strenuous fancy, with a gift for depicting tormented physical form and an artistic temper that did not shrink from distortion. Upon the organ shutters of Ferrara Cathedral he painted an *Annunciation,* set under the coffered vault of a Triumphal Arch whose walls are embossed with nude figures of Classical art. The Roman architecture, the garlands of fruit, and the piled-up rock-formations in the middle distance are of Paduan extraction, while the tortuous folds of the angel's robes and their metallic precision are characteristic of Tura's unyielding force.

How deeply he had absorbed Mantegna's concept of the rock-bound earth appears also from the background of his *S. George and the Princess,*

158

118. COSIMO TURA. *S. George and the Princess.* Ferrara,
Opera del Duomo (photo : Anderson).

which is one of his strangest fantasies. The dramatic tension of the
fight, the agitation of the young hero, the fear bordering on madness,
are all expressed with ferocious intensity. Never before have muscular
strain and mental agony been represented with similar violence, not
only in the claw-like grip of S. George's hand and the frenzied cries
of his mouth, but also in the convulsive movement and savage temper
of his horse and in the anguish of the princess. The cascading folds
of her dress like great lapping waves seem to be frozen into metallic
form, like the spiky wings and bronzed coils of the heraldic dragon.
The white light upon hands and faces, the purple sheen of the robes,
and the inky green of the threatening mound, add a ghostly touch to the
heroic scene.

This passionate artist was court painter in Ferrara for successive
dukes and more particularly for lighthearted, pageant-loving Borso,

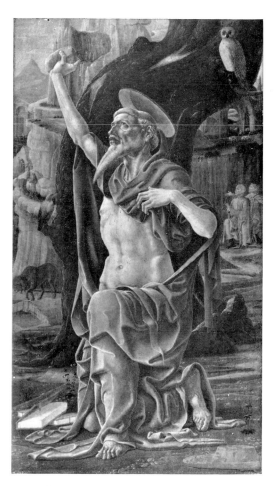

whose study and pleasure-houses he decorated. In 1474 he painted
a great triptych for Bishop Roverella, of which the centre panel is
in the National Gallery. Here a gaiety of colour, bright green and
blue and rose, combine with a decorative profusion of shells and grapes
and figurines upon the marble throne of the Madonna. A small tondo,
representing the *Flight into Egypt*, was once thought part of the triptych.
But its simplified and static form, the severity of rocks, the monumental
stillness of the figures, and the ass straining its neck for a blade of grass
which Tura's earth will not yield, make it of later date. The bold device
by which the donkey thrusts into one direction and the Virgin's knees
into the other shows Tura's mastery over spatial illusionism.

120. Ascribed to FRANCESCO COSSA. *Autumn.*
Berlin, Kaiser Friedrich Museum.

The inward fire and tension which consumed Tura are embodied
in the National Gallery *S. Jerome.* A figure of such compelling ecstasy, 119
gnarled like the tree which serves as a foil to his martyred body, is new
in the iconography of the saint. Rooted in the centre of the narrow
panel, beneath the unyielding rocks and stalactite caves, he has raised
his arm in terrible exaltation. The literary concept of the Christian
martyr, doing penance for the sins of man, has hardened into pictorial
form where the flesh is subdued by the spirit and where the writhing
folds of his cloak have a share in the rock-born energy that animates
the saint. There is no room for plant or flower in Tura's arid and
volcanic world.

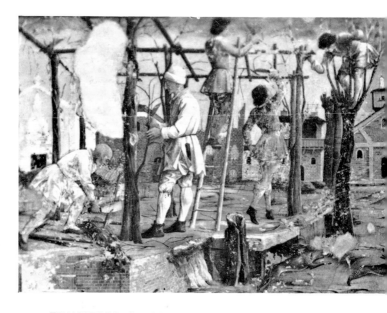

121. FRANCESCO COSSA. *Duke Borso, leaving the Temple of Justice, goes Hunting:* detail. Ferrara, Palazzo Schifanoia (photo : Museo Schifanoia).

Second to Tura at Ferrara's court was FRANCESCO COSSA, who had come under the spell of Piero della Francesca. To him is sometimes 120 ascribed the allegorical figure of *Autumn* which in her monumental stance is of Piero's lineage. Autumn towers up large in front of a hilly col. landscape, just as the angel choir of Piero's *Nativity* looms in front pl. iv of similar distances. Her dress of pale lilac, rippling down before hardening into those long vertical folds, enhances her statuesque character. There is an exhilarating spaciousness, a feeling for light and for air around the figure, whose marmoreal shape is relieved by the delicate arabesque of wine-leaves and grapes.

Piero's manner is less marked in the frescoes which Cossa painted for 21– the summer-house of Duke Borso, the Palazzo Schifanoia. Here is 122 more of Tura's harshness and of the Paduan requisites, the barren earth and the Roman ruins. The subject of these decorative murals, like those of the Gonzaga court at Mantua, is the private life of the reigning duke, skilfully woven into a representation of the Months. Borso is shown as a popular duke, a dispenser of justice, a huntsman, a gracious and jovial prince. Domestic justice was Borso's pride, and as he stands before the triumphal arch, giving a patient hearing to the burgher who with bared head argues his case, the flattery lies in the contrast of the illustrious presence with the humility of the people : the peasant

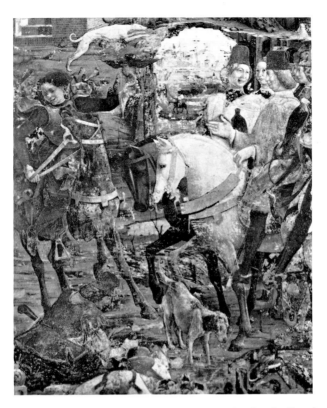

122. FRANCESCO COSSA. *Duke Borso, leaving the Temple of Justice, goes Hunting:* detail. Ferrara, Palazzo Schifanoia (photo : Museo Schifanoia).

striding in from the field, the poor widow and child waiting their turn by the column. Beneath the wreath of flowers and fruit, held suspended over the ducal crest by joyful putti, Borso appears as the ideal prince, approachable by all, amidst his courtiers erect in their stiff pleated doublets and hose.

The business of the morning done, the duke rides out with his friends **122** and falconers. His party firmly ensconced on their mounts, with set profiles, high cheek-bones, and aquiline noses, presents an array of courtly youth, a male society with a proud sense of their station. Their natural centre is the duke, himself fuller of mien, richer of gait, more jovial and more affable. The country through which they are riding is a rocky escarpment, with stone steps leading up to a trellis, where labourers in white smocks are at work. It is the month of March. **121** The trees are bare and the farm-hands trail vine branches for the arbour

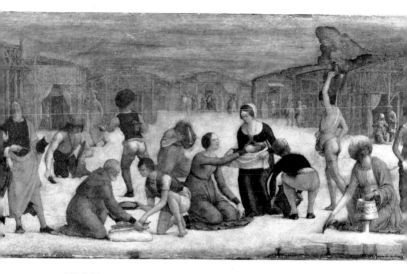

123. ERCOLE ROBERTI. *Israelites Gathering Manna:* detail. London. National Gallery (photo : National Gallery).

Beneath it a falconer pulls his rearing horse by the bridle and on his stretched-out hand holds his falcon delicately poised. With his heraldic horse and steely limbs he is not unlike Tura's *S. George.* Thus Cossa rendered ' the holiday life of his time ', bringing to his task a vivacious fantasy, a command of light and movement, and a joy in proud people and gay costumes.

Cossa's pupil was ERCOLE ROBERTI, with whom painting in Ferrara abandons the monumental aridity of Tura and under the Bellini influence from Venice becomes more human. His large altarpieces, grappling with classical figures in the architectural space, show the impact of Antonello da Messina who came to Venice in 1475. Ercole is a master of line and of movement, and in his *Israelites Gathering*
123 *Manna* the dynamics of lively figures in the foreground, before a receding camp of huts and dwellings, show Ercole's gift for combining fluency with strength. The patriarchal figures of Moses and Aaron on the left, the slender beauty of the urn-bearing youth, the rhythmic variations from standing to kneeling figures convey a sense of vitality and of grace.

But Ercole could also use his instrument of swift and nervous line
124 to express tragic emotion, as in the *Pietà* of the Liverpool Museum. Here it is not only the distraught face of the Virgin or the brittle line circumscribing the tortured body of Christ, which arouse pity and

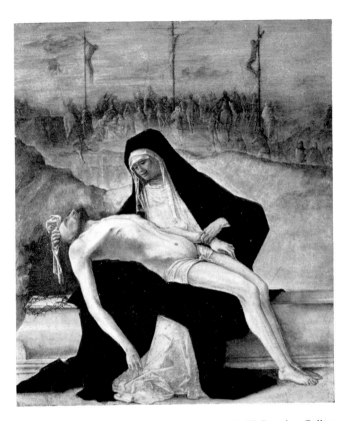

124. ERCOLE ROBERTI. *Pietà*. Liverpool, Walker Art Gallery
(photo : Walker Art Gallery).

compassion. These are enhanced by the great black silhouette of the
Virgin's mantle, its harsh angularity, detaching her form like a great
sheet of mourning from the ragged rocks and the livid drama of the
Crucifixion.

Ercole de' Roberti's masterpiece in the monumental Renaissance
style is the *Madonna enthroned with four Saints* (Brera), painted around
1480. An elaborate architectural throne of enormous height, with
pillars and carved base is placed in the open air to create an illusion of
free-standing figures and an airy space. The throne is constructed on
two levels with the vanishing point at the line of the horizon, beneath
the Madonna where the town of Ravenna nestles in the valley. On a
solid octagonal base, decorated with stone-coloured friezes, knobbly
columns support the upper plane, where the Madonna is seated under
a domed and lofty canopy. She is flanked by Saints Anne and Elizabeth,
kneeling i n prayer, and their aged faces contrast with that of the

165

youthful Madonna. Saints Augustine and Pietro degli Onesti, two stately figures, stand firmly by the outer pilasters below, which support the Renaissance arch of the throne. This severely classical composition breathes calm and solemnity, where figures and architecture gain in plasticity by the frontal light upon them and the airy landscape behind. This balanced altarpiece with its unifying light and soft tones and dreaming landscape forms a link between the Ferrarese harshness of line and metallic surfaces and the painterly style, the shimmering distances of Giovanni Bellini.

The painters of Ferrara—Cossa, Ercole, and LORENZO COSTA— shared their allegiance between the Este Court and that of the Bentivoglio in Bologna. Costa (1460-1535) who had followed Ercole to Bologna, showed his dependence on his master in a great altarpiece of the Madonna, seated upon a lofty Renaissance throne within the vaulted apse of a church, with Giovanni Bentivoglio and his wife as donors and their eleven children arrayed at the foot of the throne. These children are all variations of one and the same type, but Costa showed his strength as a portraitist in the stalwart picture of *Bentivoglio* in the Uffizi which is of 1490.

That year Costa joined hands with another Bolognese painter, Francesco Francia, and after Mantegna's death in 1506 he became court painter in Mantua, helping to decorate Isabella's studio with a mythological painting, the *Reign of the Muses* (Louvre), which is in the suave and monotonous style of his old age.

His associate FRANCESCO FRANCIA (1450-1517) is the real founder of the School of Bologna. He was an eclectic painter, because he aspired after a languid ideal of perfection, without a capacity for bold invention or decisive character. Raphael acknowledged him as a master of devotional art, while he incurred the contempt of Michelangelo. He had been trained as a goldsmith and his paintings retained the delicacy and precision of that discipline. Working for the Bentivoglio princes, he filled the churches of Bologna with altarpieces which, like the one in the National Gallery, are classical in composition, well balanced, and richly coloured. In his sweet devotionalism, his wide dreamy landscapes and deep azure skies, he is akin to Perugino.

The Paduan manner was brought to Lombardy by VINCENZO FOPPA (1427-1515), a master of the transition from the International Gothic to the Renaissance. Foppa belongs to the older generation of Lombard painters, though his concept of architectural form and of space derives from Bramante, and the Roman strength of his figures from Mantegna. In the London *Adoration* the gorgeous train of kings in their gold-embossed costumes of crimson and blue, the decorative pageant of

125

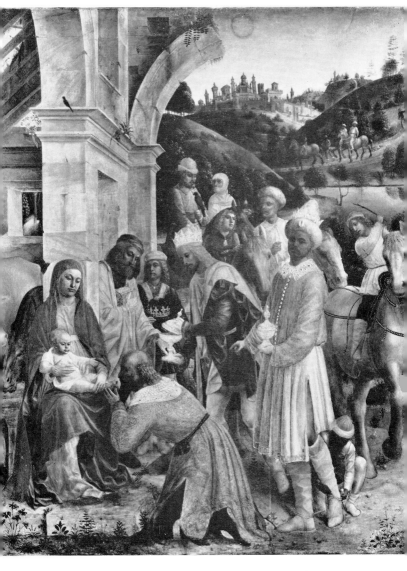

125. VINCENZO FOPPA. *Adoration.* London, National Gallery (photo : National Gallery).

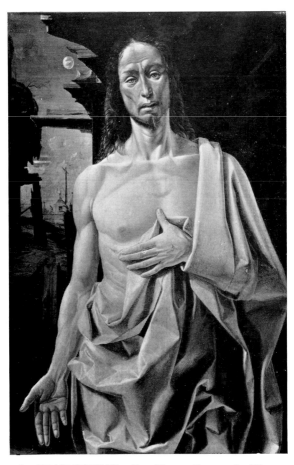

126. BRAMANTINO. *Ecce Homo*. Castagnolo, Thyssen Collection (photo : Thyssen Collection).

jewelled and turbaned princes, is still in the courtly style of Gentile da Fabriano. But the solemn Madonna is seated in front of Bramante's classical ruins, and the towering hills in the distance recall Mantegna. Foppa's heroic forms, the powerful substance of his figures in the cool marbled light, the simple grandeur of Roman arch and column are more clearly seen in his early *Martyrdom of S. Sebastian* at the Brera Museum. Here the figures are of Roman strength, but not without feeling, as in the troubled gaze of S. Sebastian whose brow is contracted with grief. One of the archers even looks with admiration and sympathy at the martyred saint who was once himself a Roman legionary.

Lombard painting, before the coming of Leonardo to the court of Lodovico Sforza at Milan, was swayed by visiting masters such as Bramante the architect who, in his rare paintings, showed a taste for heroic humanity comparable to Piero della Francesca's. To his pupil BRAMANTINO has long been ascribed an *Ecce Homo*, where a command **126** over bodily form and the architecture of folds combine to create a masterpiece of monumental art. The complexity of the drawing of Christ's winding-sheet, the subtlety of curling locks and beard, and the haunting face of the Saviour are in stark contrast with the larger planes of His body, in the white graded light which gives it plastic definition. This contrast is enhanced by the darkness of the shed and by the moonlit space that opens at the back. Foppa's ' interior form ' has become supple and sensitive, and the Redeemer looks upon the world with poignant sorrow.

In the middle of the fifteenth century Padua was the centre of artistic activity in the north and an inspiration for the great schools of painting in Venice, Lombardy, and Ferrara. Paduan science affected the work of the brothers Vivarini, who on the island of Murano tried to stem the tide of the new pictorial vision of the Bellini School and continued in the harsh sculptural manner of their master Squarcione. CARLO CRIVELLI (1435 ?-92) was a Venetian, grown out of the ' Paduan humus ', who had cut himself off from the main stream of Venetian painting by voluntary exile. But his genius for decorative line and his religious ecstasy held such a sway over his visual imagery that he created a world of abstract beauty, as intense as Tura's and as vibrant as Botticelli's. In Crivelli a Gothic purity and strength of line unites with a Byzantine richness of decoration and a new Renaissance grasp of architectural form. His frequent use of great garlands of fruit is a legacy from Mantegna.

His *S. George and the Dragon* is more stylish than Uccello's, more **127** precious than Tura's, but no less impassioned. Under the Gothic pinnacles, where the princess is praying, an immaculate young hero in gold-embossed armour swings his great sword over his head to strike down the dragon who is already transfixed by his lance. The taut and sinuous beast, the savage horse breathing fire with distended nostrils and flying mane, even the Gothic uprights of the narrow panel contribute to the heroic frenzy of the fight.

The S. George is of Crivelli's early period, a vision of personal beauty, but still close to the master of Ferrara and to the spirit of the Middle Ages. In his masterpiece of 1486, the National Gallery *Annunciation*, painted for the city of Ascoli in the Marches, Crivelli **128** is equal to the greatest Venetians in poetic tenderness with which he

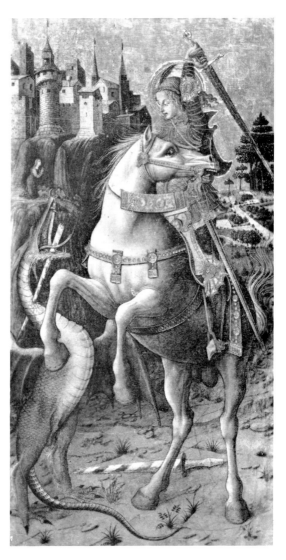

127 CARLO CRIVELLI. *S. George and the Dragon.*
Boston, Mass., Isabella Stewart Gardner Museum (photo :
Isabella Stewart Gardner Museum).

endows the human face, and in the boldness of space construction. In
the exuberance of decorative fancy and arabesque he is unrivalled. He
has laid the scene in a narrow Venetian street between lofty Renaissance
palaces, a busy thoroughfare with crossroads, steps, arches, balconies,

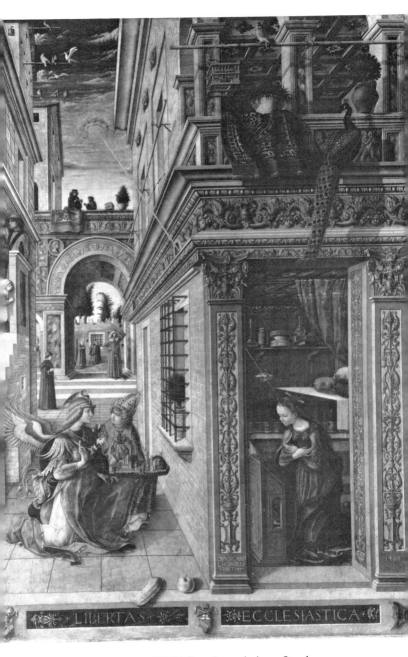

128. CARLO CRIVELLI. *Annunciation*. London,
National Gallery (photo : National Gallery).

and a distant view upon an enclosed garden. The angel of the Annunciation, accompanied by the young bishop Emidius with his symbolic offering of the city of Ascoli, approaches the sumptuous house where the childlike Virgin kneels in meek submission. Memories of the lagoon city linger on in the briskly foreshortened and shaded facade on the left, the Romanesque arch with the open loggia where people are seen conversing as in the background of Antonello's S. Sebastian in pl. 139. A Renaissance sense for marble palaces in perspective recession abounds, for sculptured frieze and coffered vaulting, for pilasters and cornices encrusted with classical pattern. A geometrical gift of linear definition is heightened by a perfect illusionism of decorative forms : such as the Turkish carpet, the splendid peacock, or the articles of domestic genre in the chamber where the courtly Virgin worships at her prayer stool.

No known tradition guided Crivelli's hand when he painted S. Gabriel in baroque luxuriance of robes and wings, his rich crown of hair adorned with a coronal and a feather as he sweeps across the narrow lane to salute the Virgin. His unusual companion is the boy-bishop Emidius, round-faced, ingenuous, in whose inquiring gaze mingle wonder and admiration for the celestial guide. Crivelli's *Annunciation* is Paduan in its structural firmness and precision, Byzantine in its luxuriant fancy, Venetian in the limpid air, the marbled streets and palaces, the richness and tender beauty of raiment. It is a work without peer in Venetian painting, grown apart from the compassionate spirit and the painterly vision of Giovanni Bellini.

XVII. VENETIAN PAGEANT AND PORTRAITURE

Gentile Bellini — Vittore Carpaccio

The Venetian School which was to add a painterly to the linear and sculptural styles, started quite soberly in the fifteenth century with topographical painting. GENTILE BELLINI and his pupil CARPACCIO portrayed in their great narrative paintings, with graphic precision the palaces, canals, bridges, gondolas, and city squares of Venice and her dark and slender people. Gentile was the more scientific artist who drew with calculated perspective, and painted rows of Venetians in strict profile. Carpaccio was more lyrical, sensual, and fanciful: a tireless story-teller and genre-painter in whose work a Venetian reality mingled with an imaginary Orient and with Christian legend.

Venetian Painting grew up quite detached from the rest of Italian art. The air and the light of the lagoon city, her oriental connections, the native love of gorgeous decoration and display conditioned the art of Venice. While only a few miles away in Padua her subject city, Giotto began the new classical art of the Renaissance, creating forms of real substance, simplicity, and dramatic power ; the Venetian Primitives of the fourteenth century were still painting hieratic Madonnas and gilded icons of Byzantine rigidity. Even Jacopo Bellini (1397-1470), who with his sons Gentile and Giovanni became the founder of the Venetian School, painted his own Madonnas in Byzantine frontality upon gold, in a style that was still mute and austere. Jacopo, like Squarcione, was an influential master and head of a great studio, without being a supreme artist. In his youth he had travelled to Florence and perhaps to Rome in the wake of Gentile da Fabriano, whose assistant he was, and worked at Ferrara by the side of Pisanello. Back in Venice he set up his workshop with his sons and daughter, opposing the academic humanism of the Paduan School with his Florentine knowledge and experience. It had been a great day for the Bellini cause, which was that of the future of Venetian painting, when Mantegna entered their circle by marrying Nicolosia, Jacopo's daughter. Jacopo's finest achievement was the victory in the contest between the archaeological school of Squarcione and the wider humanism of his own outlook, for which he won Mantegna's support. In his two sketch books, which his sons treasured and which passed from one to the other, he had laid down his experiments in space and linear perspective in wonderful·drawings of classical architecture and massed figures nobly balanced, which were to guide the compositions of his studio until well after 1460.

129. GENTILE BELLINI. *Portrait of Mohammed II.*
London, National Gallery (photo: National Gallery).

GENTILE BELLINI (1429-1507), the elder of his two sons, became the
head of the Bellini workshop after Jacopo's death. He had grown up
in the Paduan School and his early work is under the spell of Mantegna.
As a topographical artist and a master of massed figures, he is his
father's pupil. By 1468 he becomes the official portraitist of the
Venetian Republic in charge of portraying the successive Doges and
even the Roman Emperor on his visit of state. Ten years later he was
sent on a romantic mission to Constantinople in response to the Sultan's
129 request for a Venetian painter. His *Portrait of Mohammed II* shows
Gentile's subtlety of psychological penetration and the incisiveness of
his linear style. Under the mighty convolutions of his white turban,
the small head with the wily eye and sensual mouth, the large beak as of

130. GENTILE BELLINI. *Procession on Piazza San Marco:* detail. Venice, Academy (photo : Osvaldo Böhm, Venice).

a bird of prey, the set purpose of the man are all portrayed within the painted frame of a Renaissance arch.

Thus Gentile was well equipped to satisfy the Venetian demand for portraits of state, the solemn inscrutable dignity of her Doges and the pictures of pagentry with which he glorified the Republic in the last ten years of his life. In the narrative illustrations of the *Procession on Piazza San Marco* and the *Miracle of the Cross* he finds occasion for a crowded panorama of his native city, its Byzantine domes and Gothic palaces and narrow canals. Just so will Canaletto in the eighteenth century portray the glories of Venetian waterways, her marble pavements, and festive people. In the *Procession* Gentile painted the finest Square 130 in the world, with its oriental church-façade for a background of a great ceremonial occasion, where church and state unite in a proud display of their might and glory. Upon the vast receding Piazza the orderly train of white-robed clerics advances behind the canopy with the Cross, while from the palace nobles escort the Doge in solemn procession. Inside the Square dandies and casual groups of fashionable Venetians enliven the scene and help to define the recession of space.

The *Procession* and the *Miracle* were painted for the School of S. John the Evangelist in whose hall the relic of the True Cross was enshrined. This relic had been lost in the water and was recovered 131 by the warden of the school, while the monks throng upon the bridge

175

131. GENTILE BELLINI. *Miracle of the Cross.* Venice, Academy (photo : Osvaldo Böhm, Venice).

and the Venetian dignitaries kneel in prayer upon the banks of the canal. In the course of his story Bellini painted people swimming under water as in some amphibious sport : with gondoliers gracefully plying their craft, in a setting of narrowing canal and steep house-fronts, receding upward toward a high vanishing point, and picked out by the dazzling light. In the forefront he has inscribed the character-istic profiles of Venetian senators, and on the left their buxom ladies, richly dressed, lining the banks of the canal. In these pageant-pictures Gentile employed his knowledge of linear perspective and the effects of light with massed portraiture to perpetuate the architectural and the social reality of fifteenth century Venice.

His pupil VITTORE CARPACCIO (1455-1526) continued the narrative painting of saintly legends for the great schools of charity which abounded in Venice, a city which had to cater for travellers from many lands. He is above all renowned for his cycle of the legends of S. Ursula who with her ten thousand Virgins was martyred by the Huns, but not before she had married and converted an English prince and journeyed

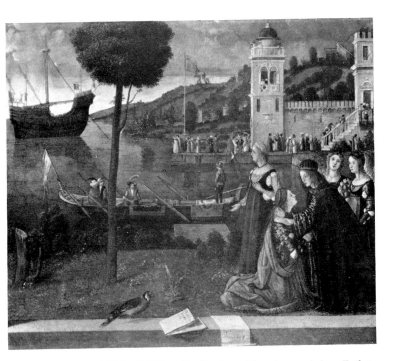

132. VITTORE CARPACCIO. *S. Ursula taking leave of her Father*.
London, National Gallery (photo : National Gallery).

to Rome to see the Pope. This subject gave Carpaccio a chance for describing in a continuous narrative the lands, the people, the gay costumes, the festive halls and turreted buildings of his imagination. This fairyland of his was composed of two elements, an imaginary Orient and an enchanting Venetian presence.

His picture in the National Gallery of *S. Ursula taking leave of her Father*, though not part of the main cycle, gives an idea of Carpaccio's 132 sense of decorative values : the dream character of southern shores, the fantastic shape of ships and buildings, the fusion of fair people in precious robes with the air and the landscape in which they move, and the Guardi-like touches of rich Venetian colour upon the feathered hats and turbans of the crowd assembled on the pier.

Carpaccio was a romantic lover of chivalry and Christian legend, and in his next great cycle, painted for San Giorgio dei Schiavoni, his hero is the dragon-slayer S. George. Already the *Young Knight* 133 in the Thyssen Collection seems like a prelude to the Venetian masterpiece. He stands mail-clad, with a slight tilt of the head, as if facing an

133. VITTORE CARPACCIO. *Young Knight*. Castagnolo, Thyssen Collection (photo: Ch. Schiefer, Lugano).

adversary. His hand is about to draw the huge sword, which continues the horizontal movement of the horse upon which another knight, clad in black and in yellow, is riding into battle. The landscape with a castle and a grey receding water is painted in brownish tones under a clouded sky, full of picturesque floral and animal life.

134 Carpaccio's *S. George and the Dragon* differs from Tura's by the light-hearted and fantastic character of the fight. Tura's hero is in deadly earnest, while Carpaccio's, though the earth is strewn with skulls and with limbs, seems to enter the lists of tournament. Tura's horse **118** and rider rear up in Gothic verticality; Carpaccio's knight charges along the whole width of the foreground—a heraldic profile—against the ferocious thrust of the winged dragon. Tura's background is

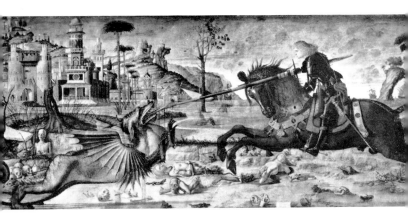

134. VITTORE CARPACCIO. *S. George and the Dragon.* Venice, S. Giorgio dei Schiavoni (photo : A.F.I., Venice).

blocked by the sombre threatening mound, while Carpaccio's oriental hill-city spreads peaceably by the sunny sea, where sails are swelling in the breeze.

For the same school of the Schiavoni, Carpaccio painted a *S. Jerome* 135 *in his Study*, a fine Venetian interior with panelled ceiling and the impeccable furnishings of a noble house. Here the saint in a moment of vision gazes up from his work, surrounded by his books, his music, his astrolabe : a scholar and prince of the Church, and not the anchorite of the desert. It is above all the portrait of a room of cool and noble proportions, with the rarefied light falling in from the side through the curtained windows upon the floor and the walls, picking up here and there the exquisite articles of domestic genre. The Venetian chair and lectern, the folio leaning against the wall, and the delicate bronzes upon the shelf, betray the exquisite taste of the humanist collector. An open door enlarges the view into another room. Only the central niche with an image of the Risen Christ reminds us of the presence of a great ecclesiastic.

As a senstitive and impressionable artist Carpaccio followed more than one master. From Gentile Bellini he inherited interest in geometry of space and perspective. In mid-life he witnessed the painterly innovations of Antonello da Messina and Giovanni Bellini and under their influence his work gained in depth and in volume. The wonderful figure of *A Saint Reading*, in a shimmering landscape of shore and lake, 136 has a breadth of design, a fullness of modelling, a richness of colour, and a tranquillity of mood which are truly Venetian. Here for the first time we see the rich pigments of orange and crimson actually modelling

135. VITTORE CARPACCIO. *S. Jerome in his Study*. Venice, S. Giorgio
dei Schiavoni (photo : A.F.I., Venice).

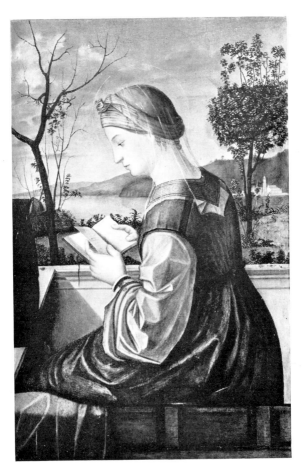

136. VITTORE CARPACCIO. *A Saint Reading.*
Washington, National Gallery of Art (photo : Courtesy
Duveen Bros. Inc.).

the shapes, the brush taking charge of the design and creating palpably
rounded forms, while the graded light surrounds the figure with air and
with atmosphere.

Once Carpaccio surpassed the limits of his narrative talent, when he
painted a *Meditation on the Passion* of Christ. The shadowless land- **137**
scape of hills and rocks and the classical ruins with Hebrew lettering
are in the style of Mantegna ; but the lassitude of the Christ, His bodily
form and counternance derive from a Pietà by Giovanni Bellini.
Indeed, during the third quarter of the fifteenth century no Venetian
painter of rank could fail to come under the spell of Bellini, and

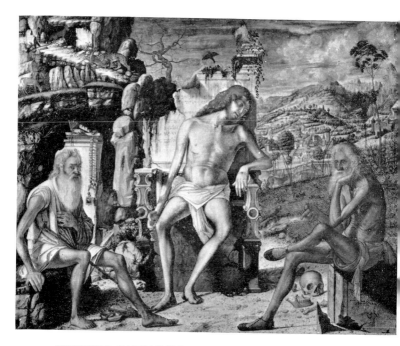

137. VITTORE CARPACCIO. *Meditation on the Passion.* New York, Metropolitan Museum of Art (photo : Courtesy Metropolitan Museum of Art).

Carpaccio has painted this solemn scene of mystical meditation in a devotional spirit. The two anchorites facing one another are S. Jerome with the penitent inward gaze, and S. Onofrio, lost in thought over the unfathomable sacrifice before him. In the stillness and radiance of the summery landscape, this meditation echoes with lingering melody the tragic chords of the Christian Epic.

XVIII. CUBIC FORM AND TRANSLUCENT COLOUR

Antonello da Messina

ANTONELLO DA MESSINA imparted vital momentum to Venetian painting. Through his Flemish oil-technique he released the painterly qualities inherent in the Bellini School, and through the example of his San Cassiano altarpiece and his 'volumetrical' portraits he showed the Venetians how to relate reality to geometrical form. It has been said that Antonello models with colour as Piero constructs with it. He unites modulation with a crystalline sharpness of contour and a gem-like translucency of colour. He uses light rather to isolate than to fuse form.

In 1475 ANTONELLO DA MESSINA visited Venice. He came to paint a great altarpiece, the Pala di San Cassiano, which had been commissioned by a Venetian nobleman, stayed for just over a year and probably went on to Milan. This altar of the Virgin and Child with two monumental saints standing on each side of the throne, became the canonical form of devotional pictures or *Sacre Conversazioni* in Venice. Antonello had been brought up in Flemish circles at the Court of Alfonso of Aragon at Naples and at first painted in the style of van Eyck. There he had learnt the technique of mixing quick-drying oils with colour. The new medium, which gave colours such strength and lustre and made possible the fusion of one colour into another, soon replaced the old tempera method and became the basis for the painterly style of Venice.

Before coming to Venice, Antonello had enlarged his Flemish realism by seeing the larger volumes and geometrical compositions of Piero della Francesca in Urbino and the Paduan Romanism of Mantegna. For in his great altarpiece the Dresden *S. Sebastian*, and in his portraits, the overwhelming impression is of the sculptural presence of his figures in the space, their cylindrical shape and his glowing colour. One of the results of Antonello's new oil-technique was the intensification of light and of tone which he used to isolate his figures from the architectural or neutral background. Their fusion with the surrounding space was to be the outstanding contribution to Venetian painting of Giovanni Bellini.

Antonello's early picture of *S. Jerome in his Study* was once attributed **138** to Jan van Eyck. It is Flemish in the minutiae of still-life, the effects of light and the rare surface-finish. The framing arch serves to gain depth and to detach the saint from the spectator, as do the cool green tiles of the floor and the wooden stage upon which he is placed. Jerome sits at his desk, turning the pages of a book, upright, a solemn, majestic

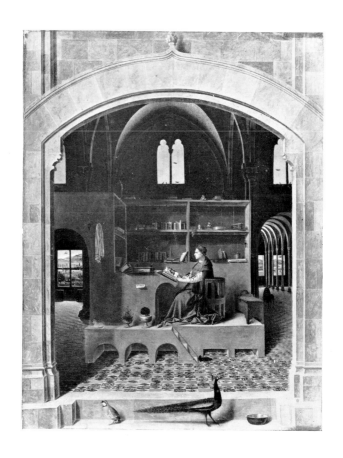

138. ANTONELLO DA MESSINA. *S. Jerome in his Study*.
London, National Gallery (photo : National Gallery).

figure, rapt in contemplation and study. To the left and right of the
wooden structure, along the tiled and lighted passage, space is enlarged
by a small view of open country with hills and buildings in the manner
of a Flemish miniaturist. The lion prowling in the shade, the peacock,
the sleepy cat or the towel hanging up on a nail are carefully placed in
the recession of space. There is a cool orderly stillness, a northern
sense of detail—the flowerpots, the casual slippers—within the intricate
maze of lines and of planes. But the unifying force is the light : light
which falls from above, flooding the foreground or causing soft shadows
in the middle-distance ; light that filters through the windows at the
back and isolates the imperious Renaissance figure of the saint.

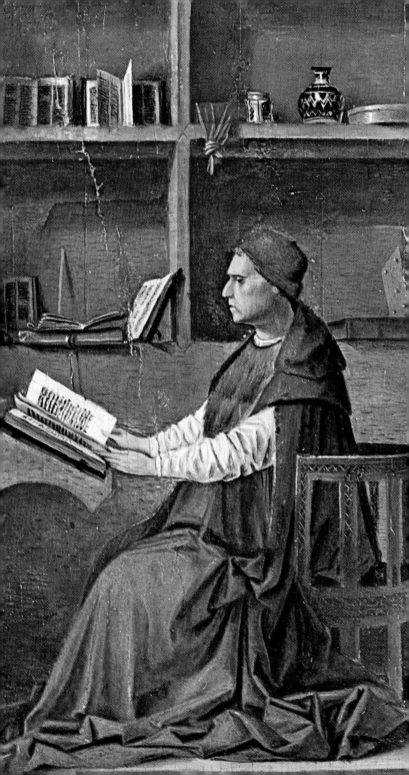

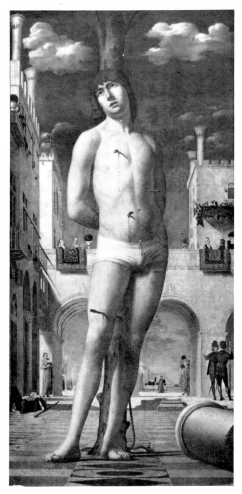

139. ANTONELLO DA MESSINA. *S. Sebastian.* From Dresden Museum (photo : Alinari).

It is a long road from Antonello's detailed essay in the Flemish manner, to the monumental *S. Sebastian* of his maturity, after he had **139** absorbed Piero's architectural form and the dazzling splendour of the Venetian light with its sensitive transitions. Here a human form of Roman mould stands in living relation to the architectural surroundings ; and the heroic nude, as a mere volume, is like the ruined column, the rounded arch, or the cubic buildings. Such power of limb, such physical presence, such soft modulations of the flesh with its brilliant light and

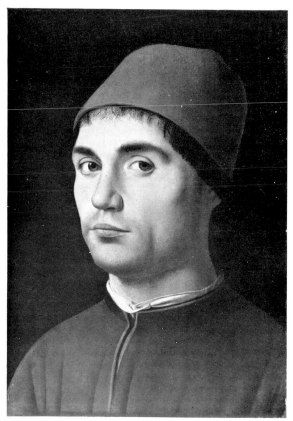

140. ANTONELLO DA MESSINA. *Portrait of a Man*
(self portrait ?). London, National Gallery (photo :
National Gallery).

fleeting shadows, were new in Venetian painting of 1476. In this
' Christian Apollo ' Antonello has endowed his ideal of the classical
nude with a lyrical sentiment—perhaps under the influence of Giovanni
Bellini. The powerful frame towers up in the forefront of the picture.
Firm, pillar-like, he stands on the ground, his heavy limbs of cylindrical
mould, dominated by a unifying movement of singular strength and
harmony. Behind him stretches a radiant infinity under the intense
blueness of the southern sky. Shaded house-fronts in bold foreshorten-
ing are thrust into space, contrasted by the ivory whites of the sunlit
buildings. Here on carpeted balconies ladies sit and watch. Below
on the cool pavement seen in geometrical perspective a soldier lies
asleep, while groups of men on either side of the Romanesque archway

help to define aerial perspective and space. Thus the vast central mass of the saint, in the swelling volume of body and limb, seems to dwarf the brightly lit buildings around him.

Antonello displays this sense of volume and imperious form even in his portraits upon neutral backgrounds. A head in three-quarter profile is modelled in the light, so that the ' elevations of the flesh ' are strongly marked. His portraits convey a singular strength of will and of character. In one of them the artist himself looks out with cool observing gaze from his grey, limpid eye. Rounded forms prevail : the **140** bushy brow, lids matchlessly drawn and shaded, the elegant curve of the crimson cap closely encircling the fine fringe of hair. As always in Antonello's best portraits, the realistic detail is subservient to the larger masses of the design : the searching eye, the slightly pursed mouth, the marked cheek-bones and stubbled jaw. Around the neck a crumpled edge of the shirt, painted in billiant impasto, sets up the columnar neck from the dark brown tunic. Such powerful impersonation left its mark upon Venetian portraiture from Giovanni Bellini to Cima and Giorgione, and more especially upon a close follower of Antonello—Alvise Vivarini. But in Bellini and Giorgione the impact of Antonello will be ennobled and softened by that high-poetical idealism and spirituality which their genius instilled into Venetian painting. In Antonello's portraits and in his great altarpiece, the sheer existence of figures in space, attained a last degree of expressive power. It was left to Bellini to give a soul to this perfect body.

XIX. THE CONSUMMATION OF THE PAINTERLY STYLE —FUSION OF TONES UNDER THE IMPACT OF LIGHT

Giovanni Bellini

In GIOVANNI BELLINI the painterly style of Venice attained perfection. A new soul inhabited a new body. Bellini's Christian humanism was as averse from his master Mantegna's heroic harshness of contour as from Antonello's robust plasticity. He wanted to unite objects with the surrounding space, not to detach them. This he achieved by means of colour graded by light, a 'complete painterly integration' of objects in the surrounding atmosphere by means of tonal transition and light. Bellini creates form by gradations of colour: his spaces are filled with air and with light, his volumes immersed in the colouristic and luministic whole.

GIOVANNI BELLINI is the Raphael of the Venetian School. In him the painterly style is refined so as to express the widest range of visual experience and emotions. His humanity, his Christian humanism, overflow into nature. Never has there been such unity of spirit, radiating from within and ennobling the human form, the humanized landscape and the very medium of paint. In Bellini's work the human figure lives in harmony with the surrounding space. Other artists had perfected the expressive function of line (Crivelli) or the definition of sculptural planes and contours (Mantegna, Piero, Antonello). Bellini reacted against all this. Brought up in the Paduan School and in his father's workshop, he united a sense of firmly constructed form with human tenderness and poetic sensibility. From the start he softened Mantegna's heroic harshness by his emphasis on the enveloping light and air. He composed his figures not in a vacuum, but in mellow, sun-warmed landscapes where they melt into the surrounding atmosphere. This he could do by his mastery over tonal gradations and direct sun-light, the fusion of figures in space by means of colour, modified by light.

With his perfected medium—oil colours superimposed over a design lightly sketched-in in tempera—Bellini could express the whole range of his feelings and sense perceptions. Instead of detaching his figures from the background in isolated and Mantegnesque grandeur, he created visual harmonies by his subtle gradation of coloured planes **141** under the impact of light. Already in his early *Agony in the Garden*, in compactness and finality of form inferior to Mantegna's masterpiece and dependent on it, Bellini unites the sleeping apostles by the caressing light, and envelopes the natural sweep of the landscape by the warm tints of dawn. The towering rocks and arid stone-facets of Mantegna

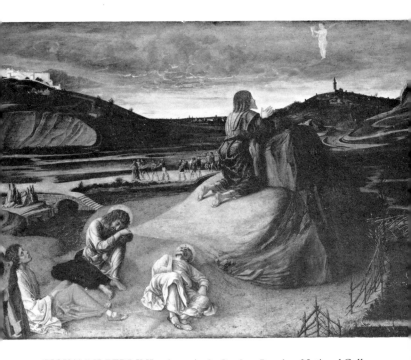

141. GIOVANNI BELLINI. *Agony in the Garden*. London, National Gallery
(photo : National Gallery).

are replaced by ranges of hills and flowing river, and the religious
mood is conveyed not by the drama impending from the approaching
legionaries led by Judas, but by the flaming sky, lighting up the hill-city,
and the gathering clouds (cf. Fig. 112).

The kneeling Christ is like Mantegna's, but in the reverse position,
and the folds of His tunic have the Paduan harshness. But how different
are Bellini's apostles in their gentle sleep from Mantegna's giants, lying
like fallen statues. Their rigid limbs, their heavy breath, are suggested
with stark realism. How beautiful is the troubled sleep of Bellini's S.
John leaning against the rock, or the shape of S. James resting his head
upon his arm ; and how softly the light plays upon his blue tunic so that
we feel the living body beneath it. Yet though the composition is loose
and the landscape bare, though the valley lies in shadow and the light
only skirts the hills, the apostles and the solitary Christ and the cup-
bearing angel in the clouds are united in a spiritual harmony.

In his early works Bellini made emotional use of the tints of dawn
and of dusk in pictures of Christ's Passion. During his middle-period,
after contact with Antonello and the Flemish manner had accustomed

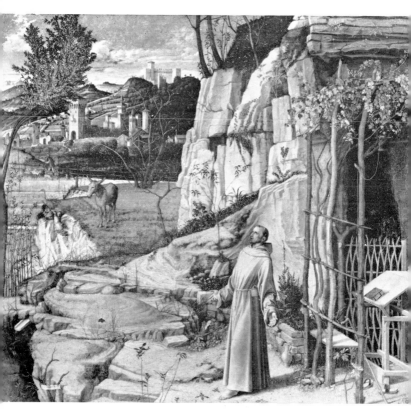

142. GIOVANNI BELLINI. *S. Francis in Ecstasy*. New York, Frick
Collection (photo : Courtesy of Frick Collection).

his eye to a more subtle vision of nature, he painted landscapes in full
daylight with a marvellous sense for plant life and animal detail. It is
as if Bellini was moved by a Franciscan sentiment, a love of blade and
tree which he inscribed with natural truth. Once he painted *S. Francis
in Ecstasy :* in the blazing light outside his rocky cell. This slender,
impassioned saint, his arms spread out as if to receive the stigmata, his
eyes raised as if he saw a vision behind the clouds, is different from the
S. Francis of Giotto or Sassetta. He is in unison with the landscape
of which he forms an integral part : like the windswept tree or the white
man-made city, like pebble or leafy plant or the shpherd with his flock
in the middle-distance. The light of day defines all forms : the slender
reeds by the brook, the arabesques of twig and branch, and the wooded
slopes of the Euganean hills, topped by the white castle. It is a unique
moment in Bellini's pictorial vision ; for in his ripest style he will fuse

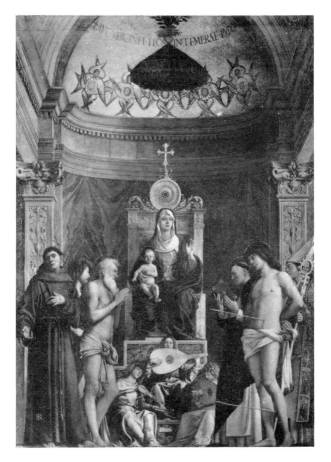

143. GIOVANNI BELLINI. *Pala di S. Giobbe*. Venice,
Academy (photo : Alinari).

all natural detail into 'those effects of coloured atmosphere' which
were to become the hallmark of Venetian painting in the sixteenth
century.

The first of the monumental altarpieces in an architectural setting is
Bellini's San Giobbe altarpiece painted in 1483-85. It is a *Santa* **143**
Conversazione, a communion of saints with the Madonna and Child,
full-length saints in contemplation or worship or intercession, grouped
around the marble throne of the Mother of God. Bellini adopted this
architectural form of sacred picture for the popular devotion after the
model of Antonello's altarpiece of San Cassiano. But his religous spirit
and his refined sense of beauty are different from the aggressive
plasticity of Antonello.

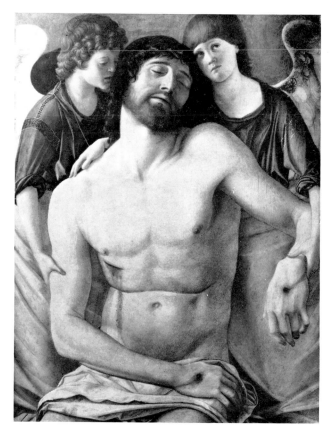

144. GIOVANNI BELLINI. *Dead Christ supported by Sorrowing Angels*. Berlin, Kaiser Friedrich Museum.

In a rounded apse of a church—with marble cornices and pilasters and a gilded vault decorated with Byzantine seraphs—the Virgin is seated upon a Renaissance throne. In hieratic solemnity she presents the Child to the worshippers, her hand raised in blessing. The spatial illusion is greatly increased by the painted architecture : the rounded marble wall behind the throne, the disc with the cross above the Madonna's head, and by the arrangement of many figures in depth. By the human warmth of their devotion the saints are closely linked with the Madonna and Child, to whom they turn in yearning and adoration ; only S. Francis, showing his stigmata and facing the spectators, draws them into the act of worship. Bellini's skill in the treatment of the nude is now at its richest and most supple. Large planes of light are integrated into the shaded parts of the body in sensitive transition. The Madonna, dominates the scene on her raised throne, robed in blue. At the foot of the throne angels in pale blue, olive green, and gold intone their music on lute and viol.

Bellini's sense of classical form and stance, combined with a spirit of Christian devotion, becomes even more poignant in his renderings of the Pietà, the *Dead Christ Supported by Sorrowing Angels*. The warm **144** tints of Christ's torso and the noble proportions of the body coming to rest at last in the arms of the angelic mourners, are Grecian. A great sense of peace is conveyed by the spaciousness and the natural poise of the martyred body, as His head falls back upon the slender shoulders of the boy angels supporting the lassitude of His arms and bleeding hands. Yet if Christ's body is antique, the foreshortened head be-calmed and serene, the upward glance of the angel on the right, the tender solicitude of his companion, are Christian. On their childlike forms the artist has lavished a wealth of colour and sensitive modelling. The auburn hair, the roseate flesh, the radiant wings tipped here with blue, there with fiery orange, the soft shadows, the brilliant light, all heighten the contrast of life and death in the language of atmospheric colour and living form.

The growth of Bellini from his Paduan beginnings to the freedom and poetic beauty of his maturity is that of Venetian painting from Antonello to Giorgione. The *Madonna of the Meadow* in the National **145** Gallery is one of the most characteristic among the late works of Bellini on account of her radiant colour and her Raphaelesque sweetness and humanity. The sprawling Christ lies asleep in her lap, and as she folds her hands over Him and tenderly worships the Child, she is a Madonna of humility, a quite human mother whose love is all serenity. The Madonna is sitting on the flower-starred meadow, her form composed within a triangle. The perfect oval of her head with its smooth auburn

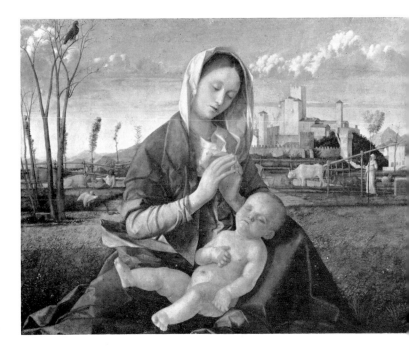

145. GIOVANNI BELLINI. *Madonna of the Meadow*. London, National
Gallery (photo : National Gallery).

hair parted over the immaculate brow, is covered by a veil in whose
shaded hollow her face lies sheltered. This kerchief is drawn with
the brush in silvery whites and greys, as are the luminous folds of her
blue mantle in which the Child lies embedded.

Behind the Madonna stretches an exhilarating pastoral landscape
which is the epitome of all Venetian landscapes of the Bellini School.
The brown pebbled earth, the barren tree, the limpid air, and sparse
leafage with the ' muffled shepherd ' leading his cows to the watering
place, speak of the bleakness of autumn. On the left a Virgilian Pastoral,
with the cowherd asleep by the wattled fence in front of the blue
Alpine ranges, is already Giorgionesque. The white morning light
strikes the perpendicular towers of the walled-in city, lights up the
banks of clouds, and softens the outlines of the foreground group.
Compared with the multitudinous detail of the earth in the *S. Francis
in Ecstasy*, the landscape of the *Madonna of the Meadow* is almost bare.
But a delicate harmony of tones unites the translucent blue of the
Virgin's cloak with the bright azure of the sky and Alpine peaks, or the
roseate flesh-tones with the pinkish brown of the sunlit buildings. As

142

146. GIOVANNI BELLINI. *Portrait of a Man.* Paris, Louvre (photo : Alinari).

the eye drinks in the sun-warmed distances and wanders over the beauteous earth, it becomes aware of the unifying power of light which melts all created things into one indivisible whole.

Bellini's Madonnas and saints attract by a gentleness which transforms nature, enveloping hills and fields and buildings with a shimmer of direct sunlight which his pupils Montagna and Cima da Conegliano adopted. Bellini's art was strengthened by Antonello. For a time he used the massive plasticity of rounded form, while his colour grew in intensity by a deep inward glow. In portraiture Bellini enlarged upon the astounding physical presence of Antonello by his wider humanity, his sensitive eye for individual form and character : endowing the statesman, the scholar, the warrior even, with something of his own poetic temperament ; never perhaps more than in the Louvre *Portrait* **146**

of a Man whose inscrutable face is marked by passion. Yet it is one of the most tenderly painted, most caressingly modelled of Venetian portraits before Giorgione. The ascetic face of the man in its three-quarter turn is framed by his long black hair, the bell-shaped ' zazzera ' of the noble Venetian. Bellini's brush has moulded the sensitive transitions of this face, shaded the chin and eye with purple touches, and placed highlights along the ridge of the nose. The corners of the shapely mouth are drawn in, the line of the cheek is set off against the hair. The weary lids, so tenderly fashioned, shelter the eyes which enclose their own secret. But the enigma and individual form of such a face are not only inherent in the sitter or in the painter's vision : they also belong to the city which bore him. In his high seriousness and spirituality, his suppleness, his restraint, this is a true representative of the most aristocratic city-state in Italy, the Venetian Republic, of which he is a noble scion.

Bellini's art dominated Venetian painting for fifty years. ' He found it crawling out of its Byzantine shell ', wrote Bernard Berenson, ' and left it in the hands of Giorgione and Titian, an art more completely humanized than any that the Western World had known since the decline of Greco-Roman culture.'

XX. THE UNIVERSE OF LEONARDO DA VINCI

LEONARDO spoke the new pictorial language of the sixteenth century in figures greater than life, liberated in movement and powerful dramatic gesture. By his universal inquiry into the laws of art and of nature he became the prototype of Renaissance man. The scientist's record of appearances is enhanced by a new subtlety of modelling, the delicate transitions of tone and his famous sfumato, *a veil of shadow, a haze of light which shrouds in mystery his figures and cosmic landscapes. ' The colossal outlines of Leonardo's nature can never be more than dimly and distantly conceived.' (Jacob Burckhardt)*

LEONARDO was born at Anchiano near Vinci, a small town in Tuscany. When his family moved to Florence in 1470, Leonardo was no longer at an age when a youth would be apprenticed to a master. On entering Verrocchio's workshop he seems to have taken a hand from the start in major commissions such as the *Baptism of Christ* which Verrocchio was painting for the monks of Vallombroso. Verrocchio's studio was then the foremost training ground for young artists in Florence, and during the years of his association with it Leonardo absorbed the new art and the new humanism of Florence. The kneeling angel and part of the landscape which are his share in Verrocchio's *Baptism* are the **147** first testimony of Leonardo's refined sense of beauty. This angel at whom a simpler more childlike companion gazes with such intent has the shimmering gold thread of hair, the beauty of raiment, the delicacy of idealised form. He is more complex, more subtle than Verrocchio's angel in the characteristic turn of his head, the forceful linearism of folds and the noble sweep of his whole figure.

The surviving works of Leonardo's first Florentine period are few ; one or two disputed portraits and Madonnas, and the Uffizi *Annuncia-* **148** *tion.* Leonardo's own handwriting can be discerned in the tempestuous angel who kneels before the Virgin in a flower-starred garden. His clear Grecian brow, his rich curly hair touched with light, the bird feathers of his great wings observed from nature, the writhing plants and fantastic ranges of hills under the luminous sky bear Leonardo's mark.

His early works like the portrait of *Ginevra dei Benci* are still painted **149** in the idiom of the Quattrocento. Leonardo has not yet evolved the hazy atmosphere, the disturbing smile, the majestic forms and the fantastic landscape of his maturity. He has placed the marmoreal face effectively before the dark needle pattern of the juniper tree and framed the impassive form with a garland of golden ringlets, reflecting Ginevra's mood in the dreamy landscape of trees and hills and water.

197

o

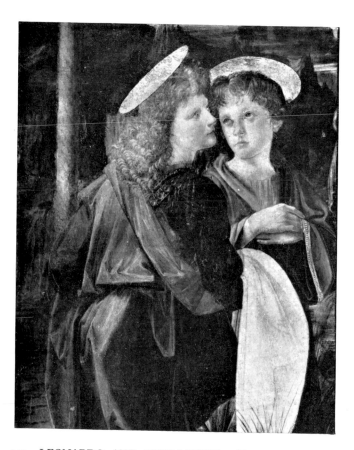

147. LEONARDO AND VERROCCHIO. Two Angels from the *Baptism of Christ*. Florence, Uffizi (photo : Soprintendenza alle Gallerie di Firenze).

Nothing more delicate and supple can be imagined than the soft and fluctuating changes from lighted flesh tints to grey shadows which modulate Ginevra's face, and the slender stem of her neck, the suggestion of rose upon her cheek, her pale and shapely lips. If the angel of the *Annunciation* was an ideal, Ginevra is an individual likeness.

Leonardo's most personal style appears for the first time in the unfinished *Adoration of the Magi*, painted in 1481 for the monks of San Donato a Scopeto. This great picture, of which only the brown underpainting remains, represents a break with the Florentine tradition of Adorations and is an anticipation of all that Leonardo was to accomplish in composition, light, movement, and human type. The dark and evocative panel, which at first glance seems chaotic and illegible, differs

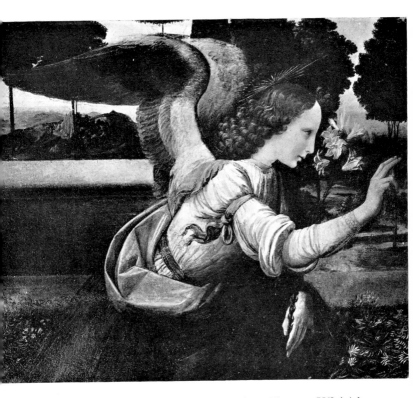

148. LEONARDO. Angel from the *Annunciation*. Florence, Uffizi (photo: Soprintendenza alle Gallerie di Firenze).

profoundly from the static and well-defined paintings of the fifteenth century.

Leonardo created order out of chaos by means of his new magic of light and fleeting shadow. The Virgin and Child in the centre form a beacon of light, around which figures sway and move in adoration. These ghostly forms emerge out of deep shadow; their bodies are lost in the impenetrable gloom, but their heads are lit. We discern a bearded man sheltering his eyes from the great light, and behind him the tragic mask of a man, with dark cavities of eyes and mouth like the Vatican *S. Jerome*, next to a romantic youth of rare and visionary beauty. Hands are raised heavenwards, and the impression is of wonder and ecstasy, of seeking to discover and adore. Such agitation of the spirit is countered by the gentle calm of the Virgin and by the two corner figures on left and right; the dark contemplative man, and a wholly detached youth in armour, opposite.

Nor is the tumultuous vision confined to the foreground: the

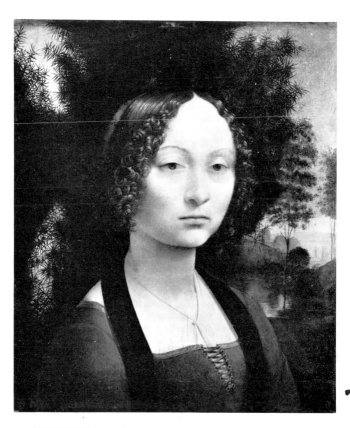

149. LEONARDO. *Ginevra dei Benci.* Formerly Liechtenstein Collection (photo : National Gallery, London).

agitation is carried beyond into the forecourt of buildings, where steps and arches lend firmness and structural form. But here also the static element is countered by horsemen on prancing steeds and by phantom figures in the middle-distance. Leonardo's fragment of the *Adoration* is like a summary of his achievement : the expressionist heads of kings around the tranquil shape of the Madonna, the contrast of aged wisdom and fair youth, the fervour of the mind carried over into the landscape, and the mysterious power of chiaroscuro enveloping all forms in deep shadow around the luminous centre.

Leonardo left the *Adoration* unfinished, because in 1482 he moved from Florence to Milan. Maybe the Medici had no taste for his genius. Leonardo's scientific bent was averse to the neo-Platonic philosophy of Lorenzo's circle, and the legend may be true that the ruler of Florence dispatched Leonardo to the Duke of Milan with the gift of a silver lyre

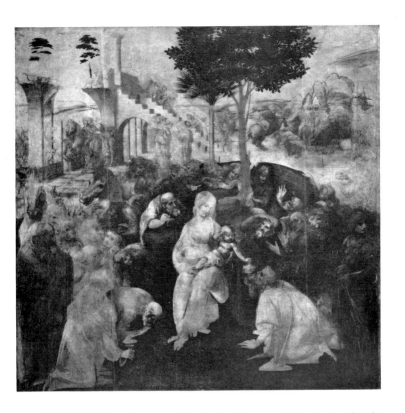

150. LEONARDO. *Adoration of the Magi*. Florence, Uffizi (photo Soprin-
tendenza alle Gallerie di Firenze).

fashioned in the shape of a horse's head. More likely that Leonardo
had been invited by Duke Lodovico Sforza to enter his service as a
result of the famous letter Leonardo had sent him in which he recom-
mended his multifarious skills. In it he wrote that he could build
bridges and machines of war, blow up rocks and fortifications, construct
mortars, divert rivers, erect public buildings and, almost as an after-
thought : ' I can carry out sculpture in marble, bronze, or clay, and also
I can do in painting whatever may be done, as well as any other, be he
who he may '. Moreover, he offered to make the bronze horse and
statue of Francesco Sforza, the great condottiere and ancestor of
Lodovico.

Apart from the portrait of the Duke's mistress Cecilia Gallerani,
perhaps the Lady with the Ermine in Cracow, and other portraits,
Leonardo's first major work at Milan is the *Virgin of the Rocks* (1483), 151
now in the Louvre. Leonardo lodged with the brothers Ambrogio

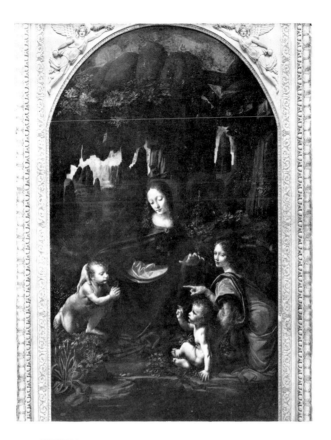

151. LEONARDO. *Virgin of the Rocks*. Paris, Louvre (photo :
Giraudon).

and Evangelista de Predis, painters of the old Lombard School,
and so the great altarpiece was commissioned to him and de Predis
by the confraternity of the Immaculate Conception. But the invention
is entirely his and only the later (London) version of the picture
is in large parts by the hand of de Predis and pupils.

In the *Virgin of the Rocks* the violent and dramatic effects of the anti-
classical *Adoration* have been resolved in a composition of deep solemnity
and mystical contemplation. Were it not for Leonardo's fantastic
landscape, the brown stalactite rocks, rising into the lunar sky, the water
flowing in the grotto, and the hazy blue of infinite distances—the
painting would be a paragon of Quattrocento art. The four figures are
perfectly poised within the triangular shape, with the Virgin and angel
of exquisite and delicate loveliness. The infant S. John, sheltering in
the Madonna's azure cloak, pays homage to the Christ, while the latter,

supported by the angel, responds to the act of adoration with blessing hand. There is a perfect correspondence, an intimate response between the four figures. The noble sweep of the Madonna, with head inclined toward S. John and protecting hand held over the Christ embraces both, while the angel gazing tenderly out of the picture points towards the Forerunner with his hand. The charm of the Madonna is matched by this languid and infinitely subtle angel in his billowing red cloak, his wan face framed by the golden curls, the hardly perceptible smile, the glance of unearthly desire.

From the dark brown penumbra of the foreground, writhing plants erupt with touches of golden light. The children are modelled in tones of golden bronze, the grooves and dimples of their flesh conveyed by soft chiaroscuro, their curly hair touched in with the same delicacy as the star-shaped leaves and grasses. The dimness and atmospheric haze of the grotto in the diffused sunset light of watery distances lend plastic relief to the radiant figures, whose outlines melt into the surround by dint of *sfumato*, the softness and vibrancy of paint, the imperceptible transitions from light to shade.

No other work by Leonardo is known until 1489, the year when Lodovico Il Moro asked the Duke of Florence to dispatch two able sculptors to help with the Sforza monument. Leonardo's work had been conceived on such a scale, that it could not be cast in bronze. Moreover, his scientific interests ranged far and wide and he only worked intermittently at painting or sculpture. His favourite studies at that period were perspective, mechanics, and aeronautics ; he wrote a treatise on painting and filled his notebooks with a thousand drawings and observations. These were his happiest years at the court of Milan. He was a peer of princes and scholars. Luca Pacioli, the greatest mathematician of the age, was his friend ; he was surrounded by pupils and imitators, like Marco d'Oggiono, Boltraffio and the beautiful model Salai. From 1495 to 1497 he completed the work for which he is most renowned, the *Last Supper*, painted for the refectory of the **152** monks in Santa Maria delle Grazie.

Here, Leonardo posed himself a very different problem : not a still life of human loveliness, but a violent tumult of twelve men around their Master, who has just revealed His coming betrayal. The static renderings of the *Last Supper* from Giotto to Andrea del Castagno and Ghirlàndaio, where the Apostles are self-contained, isolated members in space, could not satisfy Leonardo. He conceived the *Last Supper* as a psychological upheaval, an occasion for violent movement of human figures in the diminishing perspective of a painted refectory hall. He burst open the solid wall and conjured up a geometrical space, with

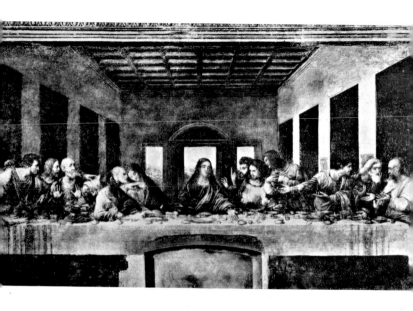

152. LEONARDO. *Last Supper*. Milan, S. M. delle Grazie.

coffered ceiling and vertical hangings to set off the characters and lead towards the central window, where Christ is silhouetted against the transparent evening light from without.

The psychological moment which Leonardo presented is not the breaking of the bread, but the announcement of the betrayal, which throws into confusion the staid gathering of the Apostles. But the agitation of the spirit had to be expressed in spatial relationship and dramatic movement and Leonardo conjoined four groups of three, varying their intensity in proportion as they are further removed from the Christ. The forces fleeing from the centre are balanced by those inclining towards it, and the language of raised hands and outstretched arms suggest the awful tension of the hour.

The greatness of Leonardo's creation does not only reside in the scientific skill of his grouping, the contrast between Christ's calm and the emotion of the Apostles, it rests above all in the gradation of human character. For the Apostles represented Leonardo's view of human type and behaviour and are worked out in significant contrasts. The dark menacing Judas combines with the youthful innocence of S. John, and the devoted S. Philip with S. James the Great who recoils in terror and seems to shout. These characters have been described in Goethe's classical essay, and their emotions—stupor, fear, disdain, faith, and affection—are revealed in their gestures. For the southern language

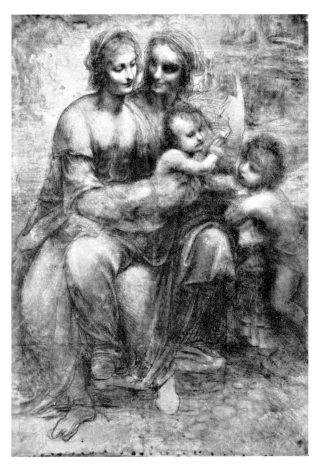

153. LEONARDO. *The Virgin and S. Anne*, cartoon. London, National Gallery (photo : Courtesy Royal Academy).

of hands and of faces contains all the drama, and the violent disquiet is enhanced by the contrast with the monumental tranquillity of Christ. About Leonardo's *Last Supper*, then in process of restoration, Bernard Berenson wrote in 1953 : ' when fresh it must have impressed with the bulk of the figures, perhaps the earliest to take up space to all but the exclusion of the surroundings, and with figures in themselves of impressive proportions. But why such villainous types ? The grouping in triplets one behind the other in depth altogether admirable and for seated figures especially. Below the tablecloth *terrain vague* '. (*Diary*).

Two years after the *Last Supper*, in 1499, King Louis XII of France invaded Lombardy. Lodovico Il Moro fell from power and Leonardo left Milan. He first went to Venice, then to Florence for a second stay of six years. From now on his chief interest becomes scientific. The agent of Isabella d'Este reported dolefully to the Duchess : ' His mathematical experiments have distracted him so much from painting that he cannot suffer the brush '. For a year or two Leonardo served Ceasare Borgia as military engineer. Only three works of art are recorded from these Florentine years 1500-1506 : the lost cartoon for the *Battle of Anghiari*, the cartoon for *The Virgin and S. Anne* and the *Mona Lisa*.

153 The cartoon of *The Virgin and S. Anne* (1500) differs profoundly from the painting in the Louvre. There, before a bluish green sea of rocks and glaciers, the Virgin, sitting on the lap of her mother, bends low to seize the Child Jesus who plays with a lamb. The London cartoon shows an earlier stage of Leonardo's invention. Here the two smiling women, in grandeur of limb and drapery, are seen at the same level, though Mary is seated on the knee of S. Anne, with one foot firmly placed on the ground. Both figures are turned inwards, and the Virgin presents the Child Jesus to the little S. John, whom He blesses, and whose upturned face He touches with His hand.

The fleeting smile of the women, the hand of S. Anne pointing heavenwards, the softening of all contours by the shadows encroaching upon lighted surfaces, are requisites of Leonardo's ripest style. But here he conceived a human group of such monumental breadth, so closely knit, so unified in the correspondence of bodily curves in the plastic amplitude of limbs, that spirit and outward form are one.

154 To understand why *Mona Lisa* is the consummation of Leonardo's portraiture one must examine her pose, her relationship to the space and the quality of paint. Mona Lisa sits rigidly upright, her body half turned towards the light. Her left arm lies along the parapet of the chair, and her right, strongly foreshortened, comes forward so that one hand may close upon the other. She towers above the brown rocks and bluish green waters and arctic ranges, and the sculptural quality is enhanced by the void and transparency of the background. Leonardo relates the position of Mona Lisa's body to the great recession of rocks and winding stream, so that human form and cosmic background are inseparably linked.

Mona Lisa is Leonardo's greatest advance into the sixteenth century fullness of the human figure, conceived as plastic volume in the surrounding space. As a painterly realisation she is supreme. Never before has the human flesh been so integrated in paint by ' that miracu-

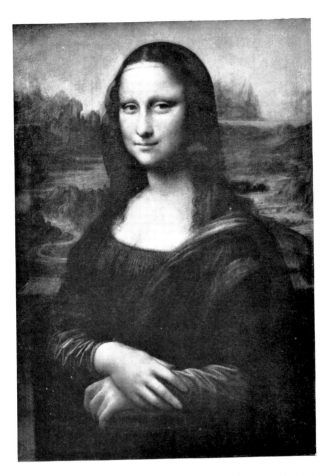

154. LEONARDO. *Mona Lisa*. Paris, Louvre (photo : Giraudon).

lous subtlety of modelling, that imperceptible melting of tone into tone, plane into plane '. (Clark). The nervous sensibility of her face is inscribed in the passages around her eye and mouth, and the undulating surface of the flesh is contrasted by pleated bodice and crumpled sleeve. As to the unity of spirit and outward form, her weariness, her ' unfathomable smile '—its classical interpretation must still be read in the pages of Walter Pater.

The outlines of Leonardo's being are manifold and illusive. In many ways he attempted the impossible. The huge bronze horse which he modelled in clay but could not cast, became a target for the French crossbowmen. His great wall paintings, the *Last Supper*, the

207

Battle of Anghiari were left unfinished or technically unsound. Painting for Leonardo was only an intermittent pursuit. Once he had sketched out a plan, expressed his ideas in rapid outline, he left the finishing work to a pupil, hastening away to new ventures of the mind. Countless drawings and preliminary sketches testify to Leonardo's unceasing inquiry into human as well as inanimate form, his love for violent action of horse or man, his interest in the movement of water, the shape of rocks, the writhing of plants. Leonardo is equally conversant with strength as with sweetness, with passionate movement as with the tender expression of soul. He will draw warriors engaged in mortal combat, their faces awry with anguish, and rearing horses with quivering nostrils, or the infinite grace of the Christian Madonna. But it was natural phenomena like a great storm in the Alps or the relentless fall of water as in the late Deluge drawings, which held the greatest fascination for Leonardo. These are in many ways related to his connotations of curling and plaited hair, and their nature is movement of an elemental and threatening kind, an eternal flow.

The red chalk drawing of Leonardo's head in Turin comes nearest to express his legend : the magician's gaze under the projecting brow, the sealed lips, the domed head and the calligraphic arabesque of the long flowing beard. It is the true effigy of the sage, the great self-conscious individual of the Renaissance who, prompted by an insatiable curiosity, enlarged man's knowledge to the outer limits.

In 1506 King Louis XII invited Leonardo to return to Milan. His second sojourn there lasted until 1513. In that year he went to Rome and Pope Leo X offered him residence in the Belvedere, within sight of Michelangelo's Sistine ceiling and Raphael's Stanze. His last work is a *S. John in the Wilderness*, a softly modelled effeminate half nude with ambiguous smile and upraised finger, emerging from the dark penumbra. In 1516 Leonardo turns his back on Italy and follows a call of King Francis I, to be his guest in the castle of Cloux near Amboise. There Leonardo dies in 1519.

Few of Leonardo's assistants and pupils attained a style of their own. The older generation like EVANGELISTA and AMBROGIO DE PREDIS, whose workshop Leonardo joined on first coming to the court of Milan, gave up their inflexible Lombard manner for Leonardo's *sfumato* and delicate facial tints. To de Predis, Leonardo left the task of completing 155 the London version of the *Virgin of the Rocks* and the two wings of angels with lute and viol. While these reveal the Leonardo touch only in their rippling folds and graceful stance, the enchantment of that other Angel in the London *Virgin of the Rocks* and his spirituality go far beyond the power of de Predis. Though the musican-angel has the

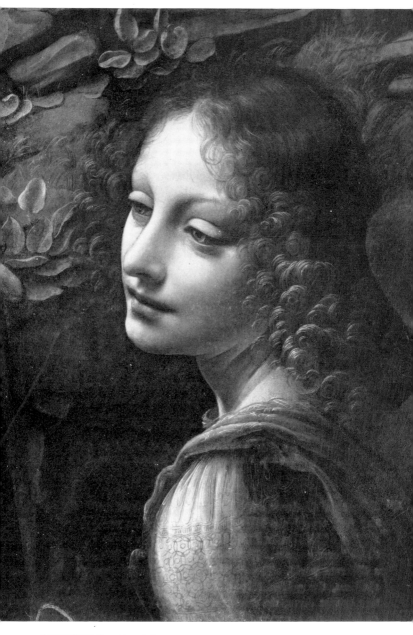

155. LEONARDO. Angel from the *Virgin of the Rocks*. London, National Gallery (photo : National Gallery).

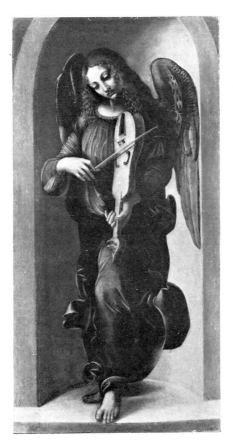

156. de PREDIS. *Angel playing a Viol.*
London, National Gallery (photo : National
Gallery).

156 litheness of the dance, and his tapering hands play the viol with exquisite
elegance, though the billowing folds of his olive green dress share the
rhythm of his slender form, the face has the wooden lifelessness of de
Predis' own manner. By the side of it the Leonardo *Angel* belongs to
a different world. The silvery pallor of his face, caressed by brown
shadows, the golden filigree of his hair and of the pattern on the
transparent dress, the tender curves which circumscribe his lowered
eyelids or the contours of cheek and chin are pictorial means of such
utter refinement and frailty, as none but Leonardo could accomplish.

If Ambrogio de Predis was an established master in Milan, who for a
time became his pupil's pupil, GIOVANNI ANTONIO BOLTRAFFIO spent

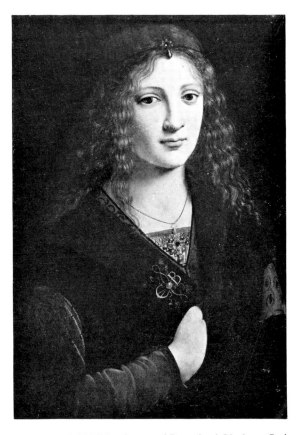

157. BOLTRAFFIO. Supposed Portrait of Girolamo Casio the Poet. Devonshire Collection, Chatsworth (reproduced by permission of the Trustees of the Chatsworth Settlement).

his formative years in Leonardo's workshop as his foremost assistant (1491-98). Boltraffiio added his own distinct note to Leonardo's pictorial language. Although he imitated his master's types, the smile of his Madonnas, the effeminate beauty of youth, the background of rocks and water, he created calm, monumental figures of Classical repose and loveliness.

L'unico allievo del Vinci—the incomparable pupil of Leonardo— was the somewhat excessive praise of Boltraffio by the poet Casio, whose supposed portrait is in the Chatsworth Collection. For in his best period Boltraffio painted male portraits in Leonardo's manner, the softly modelled face well lit and framed by the long gold thread of hair. And here the gifted pupil commemorates in his simpler idiom something

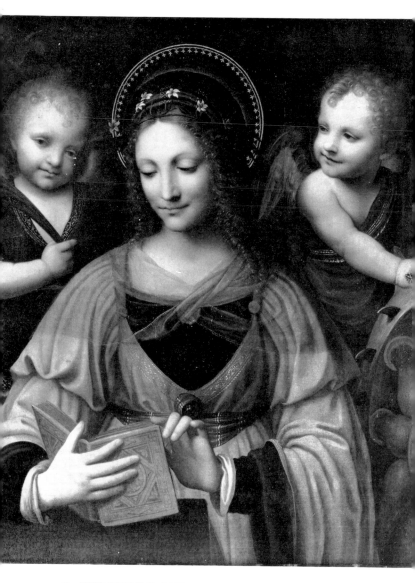

158. BERNARDINO LUINI. *S. Catherine of Alexandria.* London, National Gallery (photo : National Gallery).

of Leonardo's ideal, enhanced by the shimmering elegance of gems and brocades and the deep glow of his colours.

Other pupils imitated Leonardo's external manner and painted full scale pictures after his drawings, often in a coarse and blown up travesty of their master's style. Some of Leonardo's finest inventions only exist in his pupils' copies like the mythology of *Leda and the Swan* by Cesare da Sesto or the *Salvator Mundi* by Marco d'Oggiono, an ambiguous youthful shape, but beautifully drawn with golden ringlets and the soft chiaroscuro of facial modelling.

BERNARDINO LUINI was a more independent artist, formed by the old Lombard School of Foppa and Borgognone who, in contact with Leonardo enlarged his vision without losing his identity. In his firmly knit and appealing Madonnas he developed a style of his own and the innocent smile of his Virgins and female Saints—like that of *Catherine* **158** *of Alexandria*—has none of Leonardo's disturbing mystery.

The influence of Leonardo must be traced far beyond the confines of the Milanese School to the other great masters of the sixteenth century. These, like Giorgione, Raphael, and Correggio, were affected by the wealth of formal inventions, the mystery of his hazes and half-lights, and the utter refinement of his modelling. His Florentine contemporaries Fra Bartolommeo and Andrea del Sarto develop further Leonardo's pyramidal grouping and expressive *sfumato*.

XXI. THE CLASSICAL IDEAL

Raphael of Urbino

RAPHAEL'S life divides into three phases: Umbrian youth, Florentine manhood, Roman maturity. He was a great assimilator. He learnt the mastery over space from Perugino, the softness and delicacy from Leonardo, the sculptural firmness from Michelangelo. His Florentine Madonnas combine grace, human tenderness, and solid form. He had the 'power of grasping the ideal through the senses'. In the Vatican frescoes he evolves his humanistic vision, where the Christian mysteries and the life of Antiquity attain visible form in monumental figure compositions which are the quintessence of the High Renaissance and of the ' Grand Manner '.

We turn to RAPHAEL for the harmony and perfection he gave to man and his universe. Leonardo delved more deeply into the mysterious forces of life, Michaelangelo expressed spiritual states by the sublimity and grandeur of athletic bodies ; Raphael bore within him a world of unruffled serenity and calm. In him the Antique craving after an ideal of the human form had come to fruition, a norm of perfection in which the spirit and the senses were evenly balanced.

Raphael's life unfolds flower-like in organic stages : childhood and youth in Umbria, young manhood in Florence, maturity in Rome. The image of the boy and of the youth can be traced in the picture cycles of his Umbrian wanderings. His father Giovanni Santi was a painter of local fame in his native Urbino. Here the boy grew up within reach of the ducal palace and famous collections, friend of Bramante and pupil of the best Umbrian masters. Perhaps in 1497 he met Pietro Perugino, who invited him to Perugia, where together with Pintoricchio he worked at sacred pictures for provincial churches.

159 Among Rapehael's earliest known paintings is the *Dream of the Knight* where a youth in armour lies asleep on his shield, while twin goddesses stand over him with their gifts of valour, wisdom and love. In the landscape of winding river and rolling hills under the roseate sky Raphael's knight, dreaming under the laurel tree, is the poetic image of his own young glory.

In 1500, the seventeen year old master painted his first altarpiece for **160** Città di Castello, the *Coronation of S. Nicholas di Tolentino* of which only fragments remain. One of them is a youthful Angel, in the Museum of Brescia, of infinite loveliness in the slight incline of his head, firmness of curves and glowing clarity of colour. The oval face, the golden curls tipped with light, the ruby lips are foiled by the green wings, the paler green of his tunic and the red mantle. Perugino's

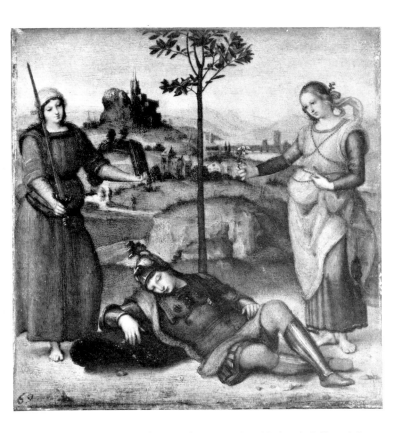

159. RAPHAEL. *Dream of the Knight*. London, National Gallery (photo : National Gallery).

type and sentiment are here ennobled by a seriousness and distinction, and, as in all Raphael's early figures, beauty of earthly raiment blends with an appealing humanity.

Also for Città di Castello Raphael painted in 1502 the large *Crucifixion*, which is now in the National Gallery. Though he employs Perugino's types of yearning Saints, he surrounds them with a new vastness of luminous sky and assimilates his master's feeling for space, aerial perspective, and transparent atmosphere.

But the masterpiece of Raphael's Umbrian youth is the *Marriage of the Virgin* (1504) in the Brera Museum. In the forefront of a vast architectural prospect, crowned by a distant temple in the style of Bramante, the Virgin is betrothed to Joseph by the High Priest. The work derives from a similar composition by Perugino, the *Christ giving the Keys to Peter*, in the Sistine. But Raphael has changed the horizontal

91

215

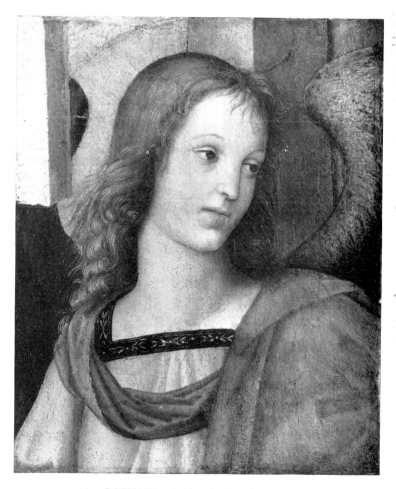

160. RAPHAEL. An Angel. Brescia, Pinacoteca.

grouping of his master into an upright composition (cf. fig. 80), where idealized figures in Classical symmetry converge upon the centre, before the long perspective of tiles leading to the steps of the dome and the infinity of Umbrian hills. In the familiar faces of Raphael's friends and masters here portrayed, his own immaculate draughtsmanship is joined to the yearning placidity of Perugino's saints.

In the summer of 1504, Raphael, now a fully fledged master, follows Perugino to Florence, and now under the impact of Leonardo and Michelangelo who were at work at their Battle cartoons in the Palazzo Vecchio, he begins to free himself from Umbrian conventions. He had

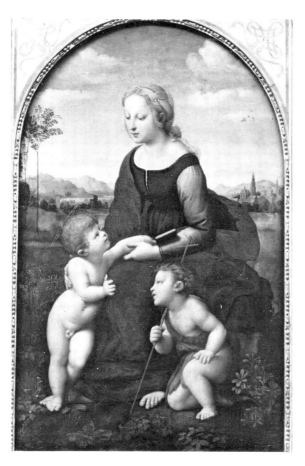

161. RAPHAEL. *La Belle Jardinière*. Paris, Louvre (photo: Giraudon).

learnt from Perugino a classical purity of design, a glowing richness of colour, the organisation of space. Now he was to develop a greater variety of inventions, a richer scale of expression, a more painterly style of modelling. In the Florentine Madonnas which he painted between 1506 and 1508, and more especially in the groups where the Madonna offers the Child to the worship of the little S. John, he uses to great effect the pyramidal grouping of Fra Bartolommeo, the compactness of Michelangelo, and the ' curvilinear softness ' of Leonardo.

Raphael, like Giovanni Bellini, found in the Christian Madonna the perfect vehicle for his Christian humanism. In the *Madonna with the Goldfinch* and *La Belle Jardinière* he evolved a structural design of **161** human loveliness and grace. The pyramidal pattern suggests itself

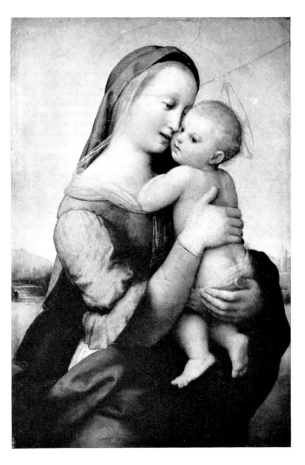

162. RAPHAEL. *Madonna Tempi*. Munich, Alte Pinakothek
(photo : Bayer. Staatsgemälde-Samm.).

by the grouping of the children, where the kneeling S. John worships
the Christ. The natural grace of young children who delight in one
another, and the tenderness of feeling of the Madonna are reflected
in the enveloping beauty of the Tuscan countryside. From the
Leonardesque plants and grasses in the foreground to the dream-like
hill ranges in the distance, from the single tree silhouette to the slate
grey houses and steeples of the enchanted city under the airy dome of
clouds and azure, it is Raphael's Classical landscape. Here, within the
enveloping folds of her mantle, he has placed the solid form of the
young mother, robed in crimson and greenish blue.

Simultaneously Raphael developed other forms of Madonnas, and
more particularly the half length with the Child upright in her arms like

163. RAPHAEL. *Deposition of Christ*. Rome, Galleria Borghese (photo
Anderson).

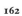

the *Granduca* and the *Madonna Tempi*, and here no young Baptist ¹⁶²
distracts from the mystical and the formal union of Mother and Child.
The *Granduca* is perhaps the most spiritual of the group. The influence
of Leonardo can be felt in the penumbra from which the shimmering
form is detached, and in the lowered eyelid of the Virgin, weary with
presentiment of the Child's fate. The *Granduca* is memorable for the
perfect oval of her face, the hardly perceptible smile upon her lips, and
the tender melancholy of expression.

While the *Granduca*'s grace and suffused colour are in the spirit of
Leonardo, the *Madonna Tempi*, the last of his Florentine Madonnas, more
passionate and more severe, bears the mark of Fra Bartolommeo. Here
too, the Child rests upon the Madonna's hand, but she does not merely
present it to the world, she clutches it to her breast as if in anguish,
while the Child looks earnestly out of the picture. This group rises

up steeply before a veiled landscape and is an anticipation of Raphael's Roman style.

163 Before leaving Florence Raphael painted his *Deposition of Christ* in which he attempted a coherent group of virile figures in movement. In a landscape of Tuscan beauty with dainty trees and the white clouds of summer, the three crosses on the hillside cast their shadow and the figures reverberate the emotion of Golgotha. The body of Christ, relaxed as if in sleep, was inspired by an Antique sarcophagus of the Burial of Meleager.

The Entombment receives its momentum from this central group and from the contrast in spirit and movement of the two bearers. The older man, straining every nerve as he steps backwards and looking with agonised yearning up to Heaven, is opposed by a Roman youth of athletic build, who gazes manfully at the Lord and seems to carry his burden without effort. The body of Christ, His shoulders thrust upwards, His head reclining conjoins the two groups. On the right three women support the swooning Mary ; and here, a maiden sitting on the ground swings her whole body around to receive the Mother of Christ in her arms, an obvious memory of Michelangelo's Madonna Doni, painted in 1504 (fig. 170). Vibrant emotion is expressed in all figures and in their contrasted movement around Christ's body. Yet the balanced design, so accomplished in individual parts, lacks the sustained and unifying force which transforms an academy of Classical figures into a work of tragic significance.

In the summer of 1509 Raphael arrived in Rome. He was at once employed in the Vatican, where a host of Italian artists were decorating the apartments of Pope Julius II. Bramante was designing the new S. Peter, and Michelangelo preparing to start on the Sistine Chapel. Raphael soon superseded the artists who had been summoned to decorate the ' Stanze '. He conceived a plan, by which he would represent in allegorical figures upon the vault, and in great narrative frescoes beneath, the highest faculties of the human spirit : Religion—Poetry—Philosophy and Justice. These form the subject of the Stanza della Segnatura, which besides the Sistine ceiling is the greatest mural decoration of the sixteenth century.

164 The centre of the *Disputa del Sacramento* is the symbol of the Eucharist, raised high upon the altar against the brilliant sky, and above it the Holy Trinity, in the vertical axis of the picture space. As the Madonna and the Baptist worship Christ, who has raised His hands with the stigmata in the act of blessing, so Apostles, Saints, and Patriarchs enthroned upon clouds, surround the Saviour in a wide circle. Beneath on either side of the altar, the four Doctors of the Church are seated in

164. RAPHAEL. *Disputa del Sacramento:* detail. Rome, Vatican (photo:
Gabinetto Fotografico Nazionale).

ecstasy or meditation, and behind them stand Popes and monastic
founders and a great surging throng of enthusiastic believers. Raphael's
skill in the *Disputa* lies in the variety of poses, the ' concealed symmetry ',
the secret balance of calm upright figures with others in spirited move-
ment, a continuous flow combined with a dignified stance.

The movement leads towards the centre from the left, and here,
at the lower extremity of the wall, leaning upon the parapet and
discussing the Scriptures, in sight of the square marble blocks of the new
S. Peter, is a bald headed man ; this is Bramante its architect, the
friend of Raphael. But the centre of the group, to whom he turns in
vivid discourse, is the radiant figure in a white mantle, who leads the
small company of friends towards the reality of the Sacrament, which
no book can fathom. To him points an older man, looking eagerly
over Bramante's shoulder, and from further back, the visionary
head of Fra Angelico da Fiesole also looks across to the young leader.

His counterpart is the dark rock-like figure in the great mantle at the foot of the stairs, who turns his back on him in solitary brooding. Thus the *Disputa* is at once a glorification of the Sacrament and a vast historical canvas, where the protagonists of the faith merge with the living realities of Raphael's own time and circle.

165 In his second mural, the *School of Athens*, Raphael presented Philosophy ; not an abstract of ideas, but Greek philosophy of the Schools, in a vision of their greatest protagonists, and the life of the palaestra, where Greek youths after their bodily exercises strove as strenuously for the training of their mind. Nowhere has the humanism of the Renaissance led more deeply into the very heart of Greek existence and made visible the reality of Greek life and learning. For here, under the lofty marble vault in Bramante's style and upon the wide marble steps of the School are the masters of antique thought and their pupils : the philosopher-kings in the centre : Plato, majestic visionary, his hand upraised to the realm of ideas, and Aristotle, the man of the world, surveying the Universe before him. As his arm sways over the assembly, he looks across to the youngest listener on Plato's side, perhaps his pupil Alexander. Near him is Socrates who, himself a stonemason, demonstrates with his fingers the points of his argument to another workman in a dark cloth cap, while youthful hearers, a devoted boy and a magnificent helmeted figure listen entranced. A bearded man in this group beckons to another master, perhaps a Sophist, to come and hear what Socrates has to say. A nude Apollo with his lyre is the patron of the wisdom of the Agora, as is Athene opposite, above the imperious ancient wrapped in a dark mantle, with the white beard and fiery eyes of Pope Julius, by whose patronage the great work lives. He looks across to the group surrounding Pythagoras who writes in a book, and to the gracious youth in a white mantle, perhaps the young duke of Urbino, who gazes out of the picture with the ineffable distinction of all Raphaelian youths. Laurel-wreathed, his book leaning upon a plinth, is Democritos, and behind him a ten year old boy with a rich crown of hair—Federigo Gonzaga who lived in the Vatican at that time and was the young favourite of Pope Julius.

The solitary figure, resting in deep thought upon his marble block, like one of the prophets of the Sistine Chapel is Heraclitos with the features of Michelangelo, the other great workman in the Vatican whom the glance of Pope Julius embraces. His shape and his monolithic block lend weight to the composition, and lead the eye inward and upward where Diogenes lies upon the steps which a youth hurriedly climbs. But perhaps the most varied group is on the right extremity, where Archimedes with the features of Bramante bends over his slate,

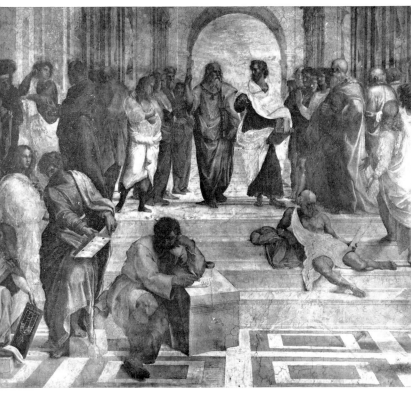

165. RAPHAEL. *School of Athens:* detail. Rome, Vatican (photo : Gabinetto Fotografico Nazionale).

encircled by a lively throng of Roman boys, in various states of comprehension. Behind these fiery youths of Antique comeliness, enthralled by their master's teaching, are the natural philosophers, the geographer Ptolomaeus and the astronomer Zoroaster, holding in their hands the symbol of the earth and the celestial globe. Zoroaster is a portrait of Pietro Bembo, the learned cardinal and friend of Raphael, who perhaps prompted his humanistic vision, and next to him is the painter's own countenance by the side of Sodoma, his associate in the work at the Vatican.

Beside the *School of Athens* in the Stanza della Segnatura, Raphael represented Poetry as the rhythmical coexistence of Apollo and the Muses on mount Parnassus. He conceived poetry as an assembly of noble figures in Antique garb, standing or reclining in lively groups, the lyric and epic poets of old, stirred to dignified animation by the music of the God and the inspired song of the highest poet.

Between 1511 and 1513 Raphael decorated the second stanza with

223

166. RAPHAEL. *Deliverance of S. Peter from Prison*. Rome, Vatican (photo: Anderson).

Histories glorifying Pope Julius II : the *Expulsion of Heliodorus*, the *Mass of Bolsena* and the *Deliverance of S. Peter from Prison*. The *Heliodorus*, painted in the wake of Michelangelo's Sistine Ceiling, introduces the Grand Style of the High Renaissance with figures in violent movement and balanced masses on either side of the altar, where Pope Julius kneels in supplication. The arrangement of the *Disputa* with its two-dimensional circles of hieratically disposed figures has been replaced by a construction in depth, and its gentle rhetoric by heroic action of figures greater than life. This is the monumental style of the classical tradition which has come to stay and is made more real by the illusionist architecture. It is an aristocratic art of the courts which will continue to flourish in the seventeenth and eighteenth century from Poussin to Pietro da Cortona and even to Tiepolo. The *Deliverance*

166 *of S. Peter* is of a different mould and spirit, composed within a restricted wall space, with a new magic of light and an unearthly calm and beauty of the protagonists. In the centre, behind the bars of the prison, S. Peter reclines in heavy sleep, while two guards in armour are leaning

224

against the wall. The angel in a great aura of light, gently touches the Saint on the shoulder and raises his arm towards the open doorway. On the right the Apostle with the transfigured countenance of Pope Julius, appears on the summit of the steps, as if walking in his sleep, guided by the great angel in a blaze of light. Beneath them two soldiers lie in huddled torpor, while opposite, the groping guards are awakening in the dim light of torch and crescent moon. In the guise of the *Deliverance of S. Peter from Prison*, Raphael painted here the solemn apotheosis of the Renaissance Pope, whom Death had released from his stormy and glorious life. After the *Dream of Constantine* by Piero della Francesca in Arezzo, this is the first nocturnal scene in Renaissance painting, but rendered with even greater subtlety in the effects of light : now a blazing halo around the angelic figure, now reflected in the armour of the dazed soldiers, or diffused in the moonlit clouds. It is in the Vatican Stanze that Raphael under the impact of Michelangelo evolved that Roman *gravitas* and sustained rhetoric which are the essence of the Grand Manner.

It is in the history pictures of the Stanze del Vaticano, the *Expulsion of Heliodorus* and the *Fire in the Borgo*, but even more in the Tapestry cartoons like the *Preaching of S. Paul at Athens*, the *Sacrifice at Lystra* and the *Blinding of Elymas* that Raphael's grand classical manner reaches its apogee, without which the art of Poussin seems unthinkable. Here for the first time appears that blend of heroic figures in clear dramatic action and an expressive language of form and gesture and classical costume within a setting of antique temple and statuary which Poussin will re-live in the seventeenth century. Here the grouping of the principal actors, foiled by the balanced mass of crowds recalls the chorus in Antique tragedy. *The Blinding of Elymas* quite literally anticipates Poussin's *Judgement of Solomon* and the *Pasce Oves Meas* with its majestic throng of apostles, echoed in the outlines of the hilly landscape is a prelude to Poussin's *Sacrament of Baptism*. His paintings of Roman and Old Testament scenes are in direct succession to Raphael's histories, and nowhere is their effect of deeper and more lasting consequence than in the French classical revival—an echo of Raphael which reverberates through the ages and reaches us in the learned abstractions from Roman antiquity and transformed by the formal austerity of Nicholas Poussin.

From the new Pope Leo X Raphael received the commission to prepare the cartoons for ten tapestries with stories from the Acts of the Apostles, glorifying the vocation, the miracles and the preaching of SS. Peter and Paul. One of the most poetic, and the most ingenious is the *Miraculous Draught of Fishes*. Before a wide expanse of tranquil **16**

167. RAPHAEL.
Miraculous Draught of Fishes. London, Victoria and Albert Museum (photo: Victoria and Albert Museum)

168. RAPHAEL. *Pope Leo X and two Cardinals.* Florence, Uffizi
(photo : Soprintendenza alle Gallerie di Firenze).

water in their small flat-bottomed boat filled with the great haul of
fishes, Peter and Andrew worship the Lord. In a second boat, the
sons of Zebedee, athletic half-nude fishermen, strain their muscular
bodies to draw in the net, their hair and drapery fluttering in the breeze.
Excited herons on the nearby shore mirror the agitation in the boat,
and the hills and creeks on the distant bank echo the rising and bending
shapes of the fishermen. The bearded helmsman with the oar is like
an antique river god. In *Christ's Charge to Peter* memories of Masaccio's
Tribute Money are still present in the virile shape of Christ commanding
Peter with forceful gesture: FEED MY SHEEP. The noble group of
Apostles reflect a variety of emotions : affection, awe, doubt, and dismay.

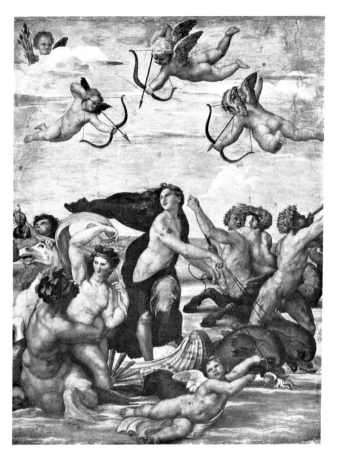

169. RAPHAEL. *Galatea*. Rome, Villa Farnesina.

The rock-like solidity of Masaccio's men appears softened by the
expression of soul and of spirit, which Raphael translates into movement
and facial expression. In the figures of the Tapestries as in those of the
Stanze, Raphael speaks the pictorial language of the sixteenth century,
where human figures raised to heroic stature, convey concentrated
emotion with power, dignity, and restraint.

The Roman Raphael had developed a degree of expressiveness, a
mastery of composition and a luxuriance of colour which overflows into
his portraits, such as the *Donna Velata*, the *Castiglione* and that of *Pope
Leo X and two Cardinals*. The massive shape of the Epicurean Pope,
the connoisseur, the man of letters is here portrayed, but also the
ruler, the diplomat, and the wit. The sensuous mouth and mobile

face, the strong nose and imperious gaze, the flickering lights upon the large and supple planes of the flesh convey a powerful blend of strength and desire. The upright Cardinals are like pillars which frame the seated Pope who is so securely planted in the three-dimensional space, his aristocratic hands laid before him upon the book. The velvety texture and glowing scarlet of the papal robe and the golden white damask of the sleeves are a stupendous feat of pictorial realisation. Here, as in other works of his maturity like the *Mass of Bolsena* Raphael's colour assumes that deep inner glow of the Venetians, which he had adopted from Sebastiano del Piombo who had come to Rome in 1511.

After the death of Bramante, Raphael added to his vast commitments the office of architect to the new S. Peter and surveyor of Roman antiquities, and yet found time to decorate the Loggias of the Vatican with stories from the Old and New Testament or the Villa Farnesina with the pagan mythology of Galatea, and to paint his last great altar-pieces, the *S. Cecilia*, the Sistine *Madonna*, and the *Transfiguration*.

Galatea riding the waves in a shell, drawn by dolphins and accom- **169** panied by other divinities of the sea, is Raphael's freest fantasy on an antique theme. It is what the *Birth of Venus* was to Botticelli, what the *Bacchanal* will be to Titian. Here is movement in a classical composition ; for Galatea is the centre of the lively design, where the groups are subtly balanced, the tritons and nymphs riding inwards, while the horn and conchblowers strain outwards upon the grey blue surface of the sea. They all take part in the exuberance of the scene. Galatea, immaculate Roman Venus, looks longingly towards the shore, her radiant body foiled by the dark red cloak, fluttering in the wind. The athletic, bronze-coloured Triton and the other mythological creatures of the deep, strain their bodies in dionysiac abandon, their heads crowned with ivy, their looks inspired ; for this is a feast of Venus, as winged Cupids from up high shoot their arrows into the fray. Never has Raphael painted more lightheartedly and with greater feeling for an Antique reality than in this decoration of Agostino Chigi's Villa. Raphael had many assistants, but he formed no school worthy of the name. Foremost among his followers were Giulio Romano, Francesco Penni, and Pierino della Vaga.

XXII. THE SCULPTURAL VISION OF MICHELANGELO

In MICHELANGELO the sculptural ideal of the Florentines attains a dynamic expressiveness and power. His rare easel pictures, like the 'Madonna Doni', have the incisive contour of high relief. They are the greatest contrast to Leonardo's soft enveloping sfumato. In the ceiling of the Sistine Chapel he creates a heroic race of primeval strength and Olympian beauty. But his 'Last Judgment' and the decorations in the Cappella Paolina burst all confines of Classical painting, engendering Mannerism and Baroque in the writhing, sinuous movement of figures and tempestuous surge out of indefinable depth.

In MICHELANGELO, the third of the master spirits who form the culmination of the Renaissance in Italy, the sculptural ideal of the Florentines came to fruition and finally over-reached itself. He was averse to the soft transitions of Leonardo's pictorial manner and to Raphael's Apollonian ideal of Classical art. His solitary genius created a world of sculptural grandeur and of spiritual expressiveness and power. To Leonardo's *sfumato* he opposed his dynamic energy, his clear incisive contours, his bright local colours. He first entered Ghirlandaio's workshop, but his real education began in the Medici Gardens, where under Bertoldo's guidance he was allowed to copy antiques, and where at the table of Lorenzo de' Medici he met the Florentine humanists of the day, Poliziano, Ficino, and Pico della Mirandola.

After the fall of Piero de' Medici from power in 1494, Michelangelo withdrew to Bologna and then to Rome. Here he sculptured his youthful masterpiece, the small *Pietà* in S. Peter, perhaps the most harmonious of all his works and the most serene. From 1501 to 1504 he is back in Florence, where he fashions the gigantic *David* and paints the *Holy Family* for Angelo Doni. In the cartoon of the *Bathing Soldiers*—' dynamic movement of nude men, caught unawares in the panic of surprise '—he competed with Leonardo's *Battle of Anghiari*. In his pyramidal group of the Madonna reaching out for the Child which S. Joseph holds, he reacts to Leonardo's contemporary cartoon of *The Virgin and S. Anne*.

His avowed aim was to approximate painting to the sculptural
170 decisiveness of relief, and the *Holy Family* (the Doni Tondo) is marked by this excessive plasticity, its clear cut design and bright colour. It is indeed a ' painted sculpture ' in its marmoreal compactness, the brilliant planes modelled in the round, the latent energy of the unified group. The impression of coloured stone is enhanced by the dazzling light which bleaches the cherry red of the Madonna's cloak, the pale

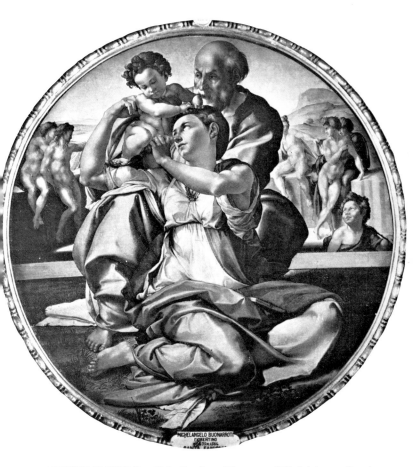

170. MICHELANGELO. *Holy Family*. Florence, Uffizi (photo: Soprintendenza alle Gallerie di Firenze).

blue mantle upon her knee, the steely blue of S. Joseph's tunic and the opalescent gold of his mantle. As the Madonna turns to receive the Child, the giant form of her bare arm and neck, her very bones and muscles stand out in the clear light and shade of modelling and graphic contour. The Madonna Doni, as she sits precariously on the ground, displays none of Raphael's maternal sentiments or charm. The strength of her powerful limbs suggests the Antique heroine, not the Christian mother of God. For Michelangelo's figures belong to an ideal world of Antique beauty and valour, like the young athletes in the background, poised upon great blocks of golden marble. Here the Antique statuary of the Medici Gardens has come to life and Michelangelo's nudes are the true emissaries of the Agora, in no obvious

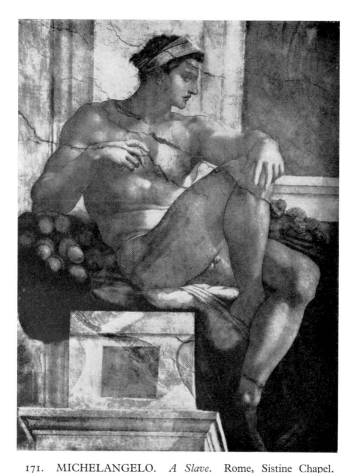

171. MICHELANGELO. *A Slave*. Rome, Sistine Chapel.

contrast to the Olympian grandeur of the *Holy Family* whose companions they are.

In 1505 Michelangelo returned to Rome, to begin work on the gigantic tomb which Pope Julius II had ordered for himself, a mausoleum adorned with forty statues, for which he travelled at once to Carrara to select the marble. But in the following year the Pope's enthusiasm cooled and he conceived the idea of asking Michelangelo to decorate the Sistine ceiling instead. The tragedy of the tomb which embittered Michelangelo's life and to which only three statues, the *Moses* and the two *Slaves* in the Louvre bear witness, is well known. Michelangelo who was of a distrustful nature, wrongly believed that his rivals Bramante and Raphael had persuaded the Pope to employ him in the Sistine Chapel with the uncongenial work of fresco painting.

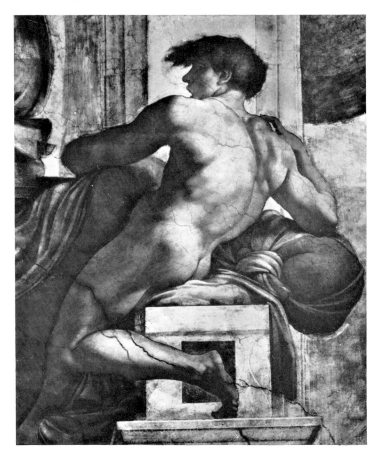

172. MICHELANGELO. *A Slave.* Rome, Sistine Chapel.

For four years (1508-1512) Michelangelo laboured at the titanic task
of the Sistine ceiling aided by only two assistants in the mechanics of
the transfer of his designs and in the preparation of the colours. At
first he intended to paint the Twelve Apostles ; but as the Pope gave
him full freedom to range over the flat and curved parts of the ceiling,
he devised a complex pictorial organism, where architectural features,
plinths and spandrels, triangular and oblong fields are closely packed
with human figures and biblical story. For Michelangelo the ultimate
goal of art was the human nude, and the most prominent figures of the
ceiling are twenty nude youths, arranged in pairs and facing one
another, in a variety of contrasting postures. These heroic youths
have a decorative function, dragging garlands or carrying fruit. Some
are in repose, some in violent action, displaying their muscular bodies,

171,
I

233

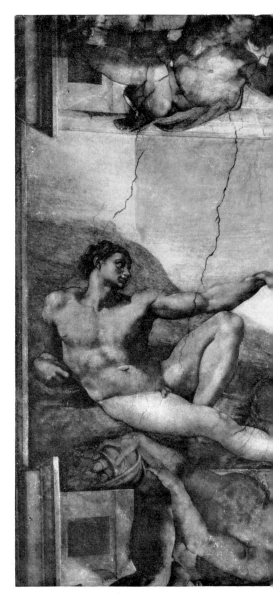

173. MICHELANGELO
Creation of Adam. Rome,
Sistine Chapel.

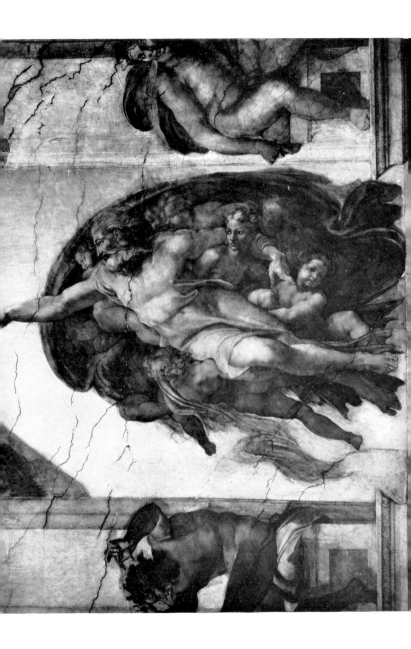

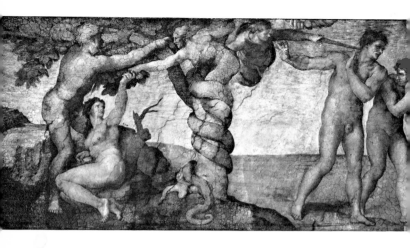

174. MICHELANGELO. *Garden of Eden.* Rome, Sistine Chapel (photo: Anderson).

the parallelism or the *contrapposto* of herculean limbs. Their grandiose anatomies increase in violence, from the early symmetrical groups, breathing a ' noble calm ', to the wild ecstasy of the later nudes in complicated foreshortening.

These Classical Dioscuri which Michelangelo linked together in rhythmical groups, frame the central fields with stories from Genesis, whose subject is Humanity before the Redemption : the wrathful God of the Old Testament creating Man and the Universe, the Expulsion from Paradise, the Deluge and the Sacrifice and the Drunkenness of Noah. One of the most powerful among the Histories is the *Creation of Sun and Moon,* and here Jehovah appears twice in a tempestuous onrush of divine majesty, with a simultaneous movement of both arms : the foreshortened right thrusting into space to create the sun, while the whole length of his left arm is thrown back towards the moon. The whirl of movement is heightened by a second appearance of God seen from the back, a compact yet articulate bodily mass, as he ' rushes into the depth of the picture like a cyclone '. No artist before Michelangelo has painted so powerful a vision of the Old Testament God and expressed the divine fury of cosmic creation with comparable force.

In the creation scenes of which there are four, God sweeps the heavens like lightning, in a chasm of clouds, and fills the whole space with His dynamic presence. Thus He appears in the *Creation of Adam,* floating in a great cloud cavity, ringed by angels ; the touch of His finger gives life to Adam who reclines in utter lassitude upon a barren

173

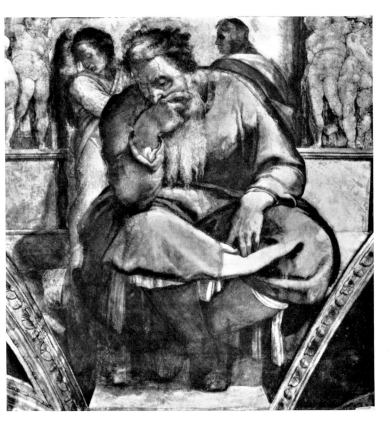

175. MICHELANGELO. *The Prophet Jeremiah*. Rome, Sistine Chapel
(photo: Gabinetto Fotografico Nazionale).

rock, his heroic body relaxed, awaiting the vital force that will soon
flow in his veins and give him strength to rise. The contrast between
God's omnipotence and man's weakness, the longing and apprehension
of Adam's gaze and his potential power are represented in the great
curves and planes of his recumbent body, the drooping hand, the half
raised head. It is the moment preceding the life-giving touch. Man
is awakening from cosmic sleep. Primeval strength and beauty are his.
The knee is drawn up, the muscular body about to lift itself from the
ground; in an instant man's ardent desire to be, will be answered by
contact with the divine spirit.

In the next field Michelangelo portrays the fall of man and the
expulsion from the *Garden of Eden*. The great leafy trunk, which the **174**
serpent with a woman's head and body entwines, is in the centre.
Beneath its foliage Eve indolently reclines, like a fertility goddess,

176. MICHELANGELO. *The Prophet Jonah*. Rome, Sistine Chapel (photo : Gabinetto Fotografico Nazionale).

the titanic mother of man, her arm raised to receive the forbidden fruit, her massive shape composed into the hollow of the body of Adam, who reaches up into the branches of the tree. Opposite, in a barren land, Masaccio's first parents of man, fleeing from the sword of the avenging angel, have grown to full Renaissance stature. Adam, his face tragically distorted, walks upright, warding off the blow with a gesture of his arms, which also expresses lament over his misfortune, while Eve cringes and seeks protection. The desolate earth separates them from the luxuriant tree of Paradise, and the two figures seem to walk right out of the picture.

177. MICHELANGELO. *The Delphic Sibyl*. Rome,
Sistine Chapel (photo: Gabinetto Fotografico Nazionale).

The Prophets and Sibyls, seated in square niches upon thrones
beneath the nude youths are the largest figures of the ceiling and the
most sculptural. Their three-dimensional form in arrested or violent
movement or deep meditation, aspires to the colossal. Each one reflects
a different spiritual experience or mental state, from the solemnity of
Jeremiah's pondering and enclosed figure to *Ezekiel's* agitation or the 175
vehemence of *Jonah*, who in the throes of divine inspiration thrusts 176
his whole body backwards and counts out the argument on his fingers.
Jonah, by the upward twist of his head, the sharp changes of direction
between arm and leg, as he throws his whole body backwards to see the
vision, conveys that superhuman energy which does not shrink from

178. MICHELANGELO. *Last Judgment:* detail. Rome, Sistine
Chapel (photo: Gabinetto Fotografico Nazionale).

violent distortion. Perhaps no other figure in the Sistine is so anti-
Classical, and in the violence of his diagonal movement, the furious
energy of foreshortened limbs, the contrapost of head and body, it
anticipates the Baroque.

No such violence is encountered among the Sibyls, whose powerful
figures are shown at rest, reading or reaching out for a book or unrolling
177 a scroll. Only *The Delphic Sibyl* gazes up in a moment of wide-eyed
inspiration, and her heroic frame, enclosed by the circular sweep of her
mantle, is vitalised by contrasting movements. As she swings her left
arm across in a sharp angle, her right arm comes to rest heavily upon her
lap. Prophets and Sibyls are incarnations of a superhuman state,

240

intermediaries between God and Man. They are grandly individualised in expression, movement and gesture and linked in powerful corresponding rhythms to form the human architecture of the ceiling, a decorative whole of unsurpassable grandeur and spirituality within the tectonic frame of the vast composition.

Pope Julius had died in 1513 and Michelangelo took service with the Medici in Florence, without abandoning the work at the Tomb. In 1516 he completed the gigantic *Moses*, who has the same dynamic force and *terribilità* as the Jehova of the Sistine Ceiling. But it is the Medici Popes Leo X and Clement VII who desired Michelangelo to abandon work on the Tomb for their own Funerary Chapel in the Florentine church of San Lorenzo. This chapel with the seated statues of Lorenzo and Giuliano de' Medici and the human symbols of *Day* and *Night*, *Dawn* and *Evening* at their feet, occupied Michelangelo until 1534. Then the new Pope Paul III Farnese, commissioned the *Last Judgment* for the great wall behind the altar of the Sistine Chapel, **178** measuring 48 feet by 44, the largest fresco in Rome, which was to occupy Michelangelo for seven years (1534-1541). With it a new style of mural painting was introduced into Italy. It engendered sixteenth century Mannerism and the subsequent Baroque, bursting all known confines of picture making by its mountains of nude bodies in writhing movement within the incongruous space.

Michelangelo had been deeply affected by the Sack of Rome by the Imperial troops in 1527, and by the lawlessness and corruption of the Eternal City. He was profoundly religious, a friend of Vittoria Colonna, of Cardinal Pole and other members of the Oratorio del Divino Amore, who worked for a reform of the Catholic Church. The *Last Judgment* is a Dantesque vision of the punishment by which mankind is threatened for their sins, the consummation of Signorelli's still mediaeval frescoes at Orvieto. Christ now appears not as the loving teacher of man who atones on the Cross, but as the Giant Judge, His right arm raised in condemnation of fallen humanity. This Christ has grown to colossal proportions, a square and un-Grecian shape with thickened limbs and the heavy tread of an avenging God. In the hollow of His flanks shelters the Virgin Mary, writhing in a sinuous movement, like a figure by El Greco or Tintoretto.

The huge wall space is divided into four parts. In the upper zone, beneath the two arches, Angels bring the instruments of the Passion, the Cross and the Pillar, in a tempestuous downward swoop. In the second zone, at each side of Christ, are the Patriarchs and Apostles, nude athletes, crowding in upon the centre. Beneath Christ-Jupiter, upon an island of clouds, the Judgment Angels blow their trumpets,

179. MICHELANGELO. *Conversion of Paul*. Rome, Capella Paolina (photo : Alinari).

and the third zone is filled with the Saved, aided by angels in their Resurrection (left) and the Condemned, nude colossi in the clutches of demons (right). In the lowest sphere is Charon in his barque, and Minos the Prince of Hell, snake entwined, committing the sinners to the eternal fire.

Dante's description of the Inferno has found in Michelangelo's work its terrible visualisation in a holocaust of nude figures, three zones of surging humanity in a primordial chaos of cloud and fire. The three upper zones are divided by intersecting diagonals of which Christ is the centre. Within this order the human masses writhe and move, distorted in shape, an inexhaustible variation of gesture, and the *Giudizio Universale* transcends all laws and conventions of pictorial art.

Contemporary critics, like Pietro Aretino, objected to the excessive violence of Michelangelo's work and called it a hotbed of nudes, and the Council of Trent decreed that the nudes should be partly draped by Daniele da Volterra.

After the Sistine and the *Last Judgment* the frescoes of the Cappella Paolina, the *Conversion of Paul* and the *Crucifixion of Peter*, constitute Michelangelo's third and most anti-Classical style. Baroque and Mannerism derive from the dynamic massing of unshapely figures overbalanced on one side of the picture and from the exploration of diagonal depth. The motivating source of the turmoil is the appearance of Christ in a glory of light swooping down from Heaven, the vision and the voice which strike Paul with blindness. The flash of lightning which emanates from above, splits asunder the cohorts of the Apostle in two asymmetrical groups, and the great void between them is filled by the rearing horse. As the blessed spirits and angels float towards Christ in the heavenly sphere, so the figures below flee from the centre, and the effect of Paul's vision is conveyed by zigzagging movement of distorted bodies in contrasting directions. The architectural build-up of Classical figures in harmony and proportion has been abandoned and Michelangelo's *Conversion of Paul* heralds a new phase in Italian painting. It is from these late works of Michelangelo that the ' *gigant-ismo* ' of Giulio Romano in Mantua derives, of Pellegrino Tibaldi in Bologna, and other Mannerists like Rosso Fiorentino, Salviati and ultimately also the colossi by Pietro da Cortona in Palazzo Barberini.

XXIII. THE GRAND MANNER

Fra Bartolommeo — Andrea del Sarto

FRA BARTOLOMMEO worked in the Grand Style of the sixteenth century. He favours heroic figure compositions of an austere but not sentimental religion, in settings of landscape or architecture. His volumes and emphatic poses combine with painter-like treatment and balance of mass. ANDREA DEL SARTO'S style is also monumental, but softened by rich shading and a Venetian sense of colour. Many of his figures are distinguished by noble lassitude and elegance, a fastidious sense of beauty.

FRA BARTOLOMMEO was one of the chief protagonists of the Grand Style in sixteenth century painting. A deeply religious man and a fervent follower of Savonarola, he took to heart the reformer's teaching which condemned the painting of the nude and of luxurious ornament. Fra Bartolommeo's paintings proclaim a demonstrative and somewhat austere religion. At the time of Savonarola's martyrdom he became a monk and for six years gave up painting altogether. His first work after
180 this period was the *Madonna appearing to S. Bernard*. In contrast to Perugino's and Filippino Lippi's renderings of the scene, he conceived the Madonna as a heavenly apparition, surrounded by a group of floating angels. S. Bernard kneels before her with two other saints, and the spirit is of earnest devotion, free from sentimentality ; emphatic, yet also restrained. The robes of the large figures flow with a new ' dignity of line ' in harmony with the rhythmical movement of the two groups facing one another. The Madonna appears remote and majestic, supported by the choir of angels and received by the saint with awe and humility.

In 1512 Fra Bartolommeo painted his masterpiece, the *Marriage of*
181 *S. Catherine*, now in the Pitti Palace. This type of *Sacra Conversazione* —the Madonna and Child surrounded by Saints in the apse of a church under a canopy of angels—had been created in Venice by Antonello da Messina and Giovanni Bellini. In 1508 Fra Bartolommeo had visited Venice, and its influence can be felt in his altar of S. Catherine. The saints who surround the Madonna and Child in the middle distance are diminishing in scale as they follow the curve of the rounded apse. Great planes of shadow and light suggest depth and spaciousness, in which the figures act boldly and with great freedom of movement. The brightest light falls upon the Child Jesus, and the radiance of this group is balanced by the light upon the opposite wall. The exuberant cherubs holding up the curtain of the canopy will be met again in Lorenzo Lotto. They lend animation to the stern symmetrical picture

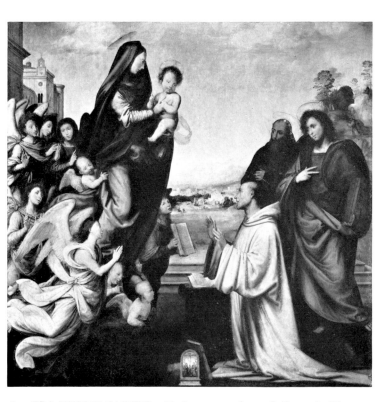

180. FRA BARTOLOMMEO. *Madonna appearing to S. Bernard*. Florence, Academy (photo : Soprintendenza alle Gallerie di Firenze).

which is framed by two powerful saints—S. George holding a banner not unlike Giorgione's S. Liberale at Castelfranco, and S. Bartholomew who has Michelangelo's strength and Classical *contrapposto* : as he swings his bare arm across his body to hold the book, his head is turned in the opposite direction. He stands rock-like upon the ground, and his heroic form proclaims the might and power of Renaissance man. The two musician angels at the foot of the stairs, one singing as he plucks the strings of his lute, the other listening to see whether his viol is in tune with his companion, relieve the solemnity of the picture. With it Fra Bartolommeo created the Florentine prototype of the Renaissance altar piece, where grandeur of figures and balanced mass and space are moulded into a triumphant expression of religious feeling.

But even when he composes on a smaller scale as in the *Holy Family* **182** at the National Gallery, Fra Bartolommeo builds up a human group of sculptural unity, in perfect interrelation with the architectural

R

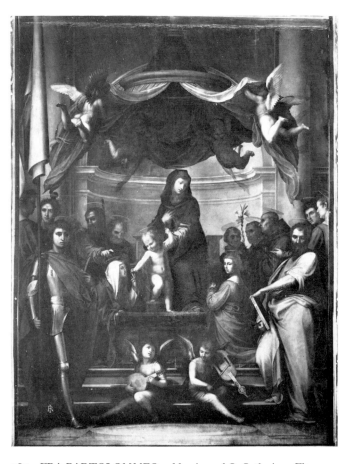

181. FRA BARTOLOMMEO. *Marriage of S. Catherine*. Florence,
Pitti Palace (photo : Anderson).

background. The Madonna kneeling before the Child is sweet and
maternal and less sentimental than some of Raphael's Madonnas. S.
Joseph, sitting wistfully on the ground, has credible weight and power,
his face is softly modelled in chiaroscuro. The heavy folds of the
Virgin's blue mantle have the same structural firmness as the figures,
and the solidity and compactness of the group are foiled but not dwarfed
by the Roman ruins in the middle distance. The sculptural effect is
obtained by a painter's methods : the rich volumes and warm
tonality of the figures which melt into the surrounding atmosphere.

The architectural and painterly values of the picture, weighty though
they are, are relieved by a landscape of great delicacy and luminous

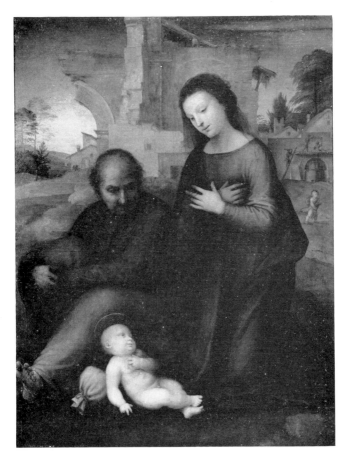

beauty. The airy distance between the Holy Family and the ruined
building is strongly felt, and the dainty trees, seen against brilliant
sky and rolling hills, restore the balance. Thus the London *Holy
Family* epitomizes Fra Bartolommeo's art : the organisation of volumes
in the space, combined with a painterly handling of glowing colour and
a modelling in chiaroscuro, worthy of Leonardo, as shown in the softly
shaded face of S. Joseph, contemplating the Holy Child.

ANDREA DEL SARTO'S work is conditioned by a yearning after the
monumental, in which he follows Michelangelo and Fra Bartolommeo,
and by a Venetian sensibility of colour. A fastidious sense of beauty
and elegance distinguished the work of Andrea, together with a sense
of robustness and grandeur, veiled and softened by Leonardo's *sfumato*

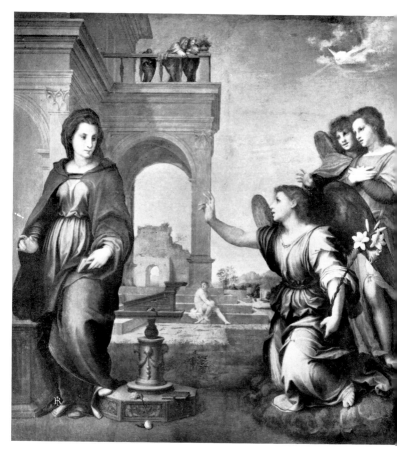

183. ANDREA DEL SARTO. *The Annunciation.* Florence, Pitti Palace
(photo : Anderson).

and ennobled by rhythmical movement. In his youth he painted
frescoes in the Annunziata, representing the *Birth of the Virgin* and
later the *Life of the Baptist* in the cloister of the Barefooted Friars. His
Last Supper in S. Salvi (1519) vies with Leonardo.

183 An early work of Andrea, *The Annunciation* in the Palazzo Pitti,
displays his refined sense of beauty in the Classical poise of the Madonna
and the rapture of the Annunciation Angel and his companions.
Dignity and restrained emotion are the hallmark of Classical figures,
and Sarto's Virgin Annunciate in the lassitude of her stance, the
gentle turn of her face is of exquisite loveliness. Surprise and humility
mingle before the impact of S. Gabriel's message. In his gaze and
gesture, the turn of the wrist which holds the lily, his bare arm raised

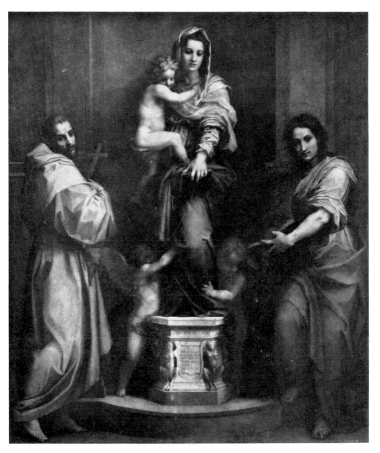

184 ANDREA DEL SARTO. *Madonna delle Arpie*. Florence, Uffizi (photo :
Soprintendenza alle Gallerie di Firenze).

in salutation, is something of Michelangelo's power ; but in the counten-
ance of the other angel with the dark hair and shaded eyes is an almost
Venetian ideal of beauty. The figures stand out before the luminous
sky, and the delicate landscape and Classical arch on whose steps a
nude youth is reclining.

Andrea endowed with a sense of tonal gradations and effects of colour,
combined something of Michelangelo's muscular strength with
Leonardo's *sfumato*. The modelling of his heads and figures is due
to the envelope of shade which throws into relief the lighted passages
and gives illusion of volume and movement in the three-dimensional
space. It is a painterly style which aims at monumental effects by
veiling and softening the surface planes and eschewing all linear
harshness.

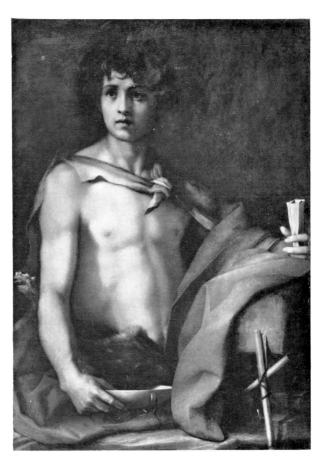

185. ANDREA DEL SARTO. *S. John the Baptist*. Florence, Pitti Palace (photo: Soprintendenza alle Gallerie di Firenze).

The *Madonna and Child with S. John the Baptist* in the Galleria Borghese has something of Raphael's charm; yet the eyes of the Mother are darkly shaded cavities, as are S. John's, contrasted by the light upon forehead and cheeks. Andrea's modelling is based upon this surround of shade, giving relief to the radiant vitality of the bodies. The colour harmony is restrained, tones of dull blue and pale purple, and the lively group is seen against the dark woodland background.

Then in 1517 Andrea painted his mature masterpiece, the *Madonna delle Arpie*, vying with Fra Bartolommeo in the monumental style. The Madonna is placed upon a pedestal and dominates the accompanying Saints Francis and John the Evangelist. As she holds the Child lightly

184

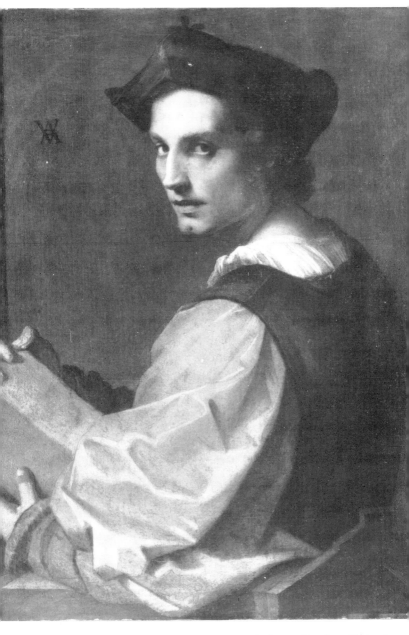

186. ANDREA DEL SARTO. *Portrait of a Sculptor*. London, National
Gallery (photo : National Gallery).

upon her arm and a book against her thigh, hers is a magnificent pose, remote and regal and free from all genre accessories. Two winged cherubs embrace the Madonna's knees and the curly haired Child is as lovely as a Correggio. The whole is composed as a statuary group of three figures in Classical *contrapposto*, and the voluminous drapery suggests a three-dimensional fullness of appearances by its changing planes of colour. For Andrea was almost Venetian in his rich painterly quality, his shaded softness of colour, which shuns contours and the linear definition of Florence.

185 Perhaps the most famous of del Sarto's single figures is the youthful *S. John the Baptist* in the Pitti, a beautiful half-nude, his adolescent body foiled by the dark background and the crimson loin cloth. Renderings of the young Baptist preaching in the wilderness have often engaged artists, from the impassioned beauty of Raphael's Roman boy, now assigned to Giulio Romano, to Caravaggio's alluring young wood creature holding a lamb. Andrea del Sarto's *Baptist* is more static and monumental than these, in the soft raiment of his body, the richness of rounded limbs, caressed by shadows and emerging from the surrounding darkness in volumetrical fullness. Softly modulated with fleeting shadows, he stands boldly erect, gazing into the distance and clasping a bowl with a well defined twist of his hand.

186 By the softness of his chiaroscuro, the volume of his bodies, the amplitude of his robes, the refined spirituality and rhythmical poise of his figures, Andrea was the foremost Florentine painter after Raphael. He was also a considerable portraitist, and the *Portrait of a Sculptor* in the National Gallery reveals some of his own serious and sensitive mind. The lighted face under the three-cornered hat is turned towards the spectator. The large bust emerges from the grey green background. The sculptor clasps an octagonal block of marble, and his arm in a grey sleeve rests upon a table. This sleeve is masterly in its large, sculptured folds, and the radiant pleats of his shirt, and there is a rich Venetian feeling for painterly texture and a sculptor's sense of form. But more than the poise and presence of the figure, the felicitous contours and soft lights, it is the serious expression of the face which attracts, the quivering lips, the searching eye, which one observer has called tragic.

Portraits such as this are found in sixteenth century Venice, and Andrea's *Sculptor* with the delicate contours of the face, the structural form of nosebridge and cheekbone and the modelling in Leonardo's *sfumato*, is a work of great distinction ; not the least in the sculptured breadth of the grey sleeve and the material density of chairback and ledge, where the portrait is anchored in the three-dimensional space.

XXIV. NEW TRIUMPHS OF MOVEMENT, LIGHT AND SEDUCTIVE COLOUR

Antonio Allegri da Correggio — Federico Barocci

Exuberant movement and sensuous charm are the main springs of CORREGGIO'S art. His is a painterly rather than a sculptural style. He employs Leonardo's sfumato *and a veiled softness of surface textures. In his cupolas at Parma he anticipates the ecstasies and illusionism of the Baroque*

ANTONIO ALLEGRI (1494-1534), called CORREGGIO after his native town, presents yet another summit in Rennaissance painting. If he is not of the same stature as Michelangelo, Raphael, and Leonardo, it is because he lacked their structural vigour, their Classical purity of form and universal spirit. Correggio stands for enthusiasm in art, for the joy of living and the rapturous emotions. ' He was not destined to create new types or new subjects ' (Berenson), but he endowed painting with a new delicacy of colour, a new mystery of light, with feminine grace and exuberant movement. He became for Parma what Raphael had been for Florence : a painter of the Madonna and Child, not as a religious icon, but as an appealing image of human bliss.

His youth is veiled in mystery. A local master, one Bianchi Ferrari of neighbouring Modena, probably taught the boy. His early work shows affinity with Lorenzo Costa who became Mantegna's successor in nearby Mantua, and to Dosso Dossi the fanciful Ferrarese. In his first great altarpiece, the *Madonna with S. Francis,* in Dresden, he seems to combine Costa's design with Dossi's colour and light. The strangeness and poetry of his early work is strongly felt in the London picture of *Christ taking leave of His Mother.* From the first, Correggio **187** developed the gift of bringing his figures in harmony with the surrounding landscape. The slender auburn-haired Christ in a silvery white robe kneels humbly before His mother, whose contorted hand and pallid face express her grief. She is supported by Magdalene, while the youthful S. John wrings his hands in compassion. The sustained emotion of the figures reverberates in the landscape, where the light dawns over the lake of Gennesaret. The turquoise colour of the Madonna's robe recurs in the hillside, and clouds of purplish grey, broken by streaks of light, envelop the scene with a mysterious haze.

In 1518 Correggio received his first important commission : to decorate the private apartments of the abbess of San Paolo at Parma

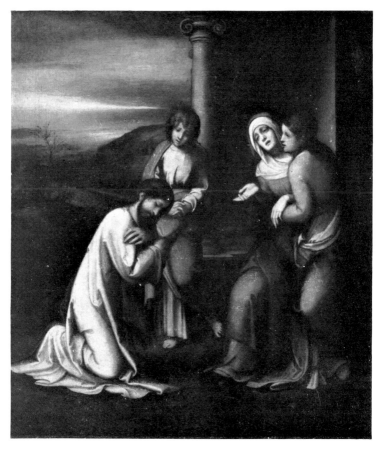

187. CORREGGIO. *Christ taking leave of His Mother*. London, National Gallery (photo : National Gallery).

with frescoes representing Diana, the goddess of the chase. And here between the sixteen ribs of the vaulted ceiling the artist devised a pattern of garlands and fruit hanging down from the trellis work of the miniature dome ; and in the widening space a whole world of frolicking putti in wholehearted abandon to the joys of the chase. Beneath them in concave lunettes Correggio fashioned Diana on her chariot and other gods and goddesses like small sculptures or cameos in grey monochrome. But it is in the oval skylights, filled with the train of nude children, gambolling with the instruments of the chase, clutching dogs or a quiver of arrows or triumphantly holding up the head of a stag, that Correggio expressed a pagan exuberance a riot of life and a

8,
189

254

188. CORREGGIO. Putti from frescoes in the Camera di San
Paolo, Parma.

new freedom of movement. These children, harnessing one another
or sitting astride their favourite dogs, their hair flying in the breeze,
their small sturdy limbs foreshortened, blowing the hunter's horn or
feigning to stop their ears or holding up garlands to the victor, play the
game of the chase with gaiety and abandon. Never before has the
rapture, the eagerness and vitality of children found a more striking
expression.

Correggio was the first modern painter who in his Holy Families
and Madonnas glorified maternal delight and childish charm. The
National Gallery *Madonna with the Basket* is simply a pretty young **190**
mother rocking her baby who almost slips from her lap. But this small

255

189. CORREGGIO. Putti from frescoes in the Camera di San
Paolo, Parma.

picture has a gaiety of colour and litheness of movement, a grace and
sweetness which we associate with the eighteenth century. But in
the handling of paint, the softness of pearly flesh, the pale blues and
rose of flowing garments, Correggio shows his consummate skill.
He opposes the sculptural ideal of the Florentines with a new painterly
vision, the sensuous charm of fluent colour, the dazzling radiance of
light. In his many representations of the Mother and Child he prefers
the youthful type of Madonna, intimately human and wholly dedicated
to maternal love, her eyelids lowered, her lips smiling, caressing the
Child or otherwise rousing His attention.

Correggio's Madonnas are Leonardesque in expression and in the

190. CORREGGIO. *Madonna with the Basket*. London, National
Gallery (photo : National Gallery).

infinite suppleness of painterly texture, the soft haze which covers
the oval of their smiling faces. Leonardo's *sfumato* modulates the
shaded half of the face and the neck, but also the hollow of the eye
and softens the smooth transition from light to shadow. There is
greater vigour in the brushwork which models the Child's white linen
and the folds of the Virgin's dress. Curves and spirals, but no contours
define the figures. Forms are defined by painterly means without
linear harshness of definition.

Correggio's grandest work which occupies his best years (1520-1524)
are the frescoes in apse and cupola of San Giovanni in Parma. In the
apse he painted the *Coronation of the Virgin* with saints and the angelic

191. CORREGGIO. *Ascension of Christ*. Parma, San Giovanni Evangelista
(photo : Anderson).

191 host, and in the cupola the *Ascension of Christ*. In these frescoes he
attempted the monumental style of the Sistine ceiling, though it is not
known whether Correggio ever visited Rome. The titanic shapes
and poses of Michelangelo's nudes have inspired Correggio's Apostles,
sitting on banks of clouds in a wide circle around the ascending Christ.
They accompany by their movements and ecstasy Christ's upward
surge into the splendour of the Empyrean. The *Ascension* is framed
by a spherical stone cornice, and Correggio filled the inner circle of his
celestial landscape with voluminous clouds, where Olympic nudes are
embedded like gods, two by two, with angels at their feet or filling
the spaces between them. They sit astride the clouds in contrasted

192. CORREGGIO. *Assumption of the Madonna*. Parma, Cathedral (photo: Anderson).

193. CORREGGIO. *Madonna with S. Jerome.* Parma, Pinacoteca (photo: Gabinetto Fotografico Nazionale).

postures of limbs and heads, with shoulders thrust upwards and arms reaching across their bodies, with hair and beards flying in the breeze, like Bernini's fountain deities of the next century. Above, in the luminous centre, ringed by cherubs, in a blaze of light and transparent air, Christ ascends to heaven. His right arm raised to the Father, His left blessing the earth which He is leaving. The Christ of Raphael's *Transfiguration* comes to mind, but in Correggio's Redeemer the supernatural is made more real by aerial perspective and bold fore-shortening, and by billowing robes and flowing hair. Correggio's advance from the graceful decorative fancies of San Paolo to the weighty individualisation of the Apostles in San Giovanni is astounding; for

these are rendered in varied poses and a new freedom of ecstatic move-
ment. Moreover, the technical skill of presenting figures seen from
below, in transparent air and light, is a feat of spatial illusionism which
will become the main vehicle of the Baroque.

Correggio devoted the years between 1526 and 1530 to the frescoes
of the octagonal cupola of the Cathedral of Parma, and here in the
Assumption of the Madonna, his dionysiac frenzy transcended all known 192
limits of pictorial art. Saints and angels are arranged in two circles
amidst billowing clouds, and the tangle of limbs, the rapturous move-
ment is such that no individual figure can be discerned. In the enthusi-
astic abandon, the rotating dance of the angelic host around the
luminous centre, to the clangour of cymbals, the laws of gravity are
abandoned and the celestial bodies sway and swirl in indissoluble
clusters. The Madonna, borne aloft by cherubs, has spread her arms
wide and thrust her head upwards in exultation. Nowhere in the
painting of the Cinquecento was the spatial illusionism, the ecstatic
movement and the suspension of all physical laws so triumphantly
realised. But the first Roman cupola of the Full Baroque by Giovanni
Lanfranco in S. Andrea della Valle, composed nearly a century later
in three great wreaths of rapturous figures embedded in clouds and
unified by light, took its inspiration from Correggio's *Assumption*.

During the same years he painted his finest altarpieces like the
Dresden *Nativity* and *Pala of S. George*, the Parma *Rest on the Flight
into Egypt* and the *Madonna with S. Jerome*. Here he created one of the 193
liveliest compositions in art, between the cornerstones of contrasting
figures, the lofty and virile S. Jerome and the blond Magdalene,
who bows her head with such loving abandon towards the Child, to
kiss His tiny foot. The Child, sprawling upon His mother's lap, strains
to grasp the pages of a book which a smiling angel holds up to Him.
Under the crimson tent, which shelters this group from the rays of the
sun, stretches a wide landscape in the silvery light. The elegance and
languid charm of the figures is matched by the harmonies of pale red,
pale blue and opalescent yellow before the greyish blue distances.
The Madonna has something of Leonardo's smile and lowered lids.
Behind Magdalene a red faced boy-angel holding the cup, looks out
with touching sadness.

The last years of Correggio's life were spent in painting mythological
subjects for a new patron, Duke Federigo Gonzaga of Mantua. For
him Correggio explored the field of pagan legend, of *Danae* and *Leda*,
Io and *Ganymede*. The handsome boy, spreading his arms wide to 194
hold fast to the wings of Jupiter's eagle, who will bear him aloft to
Olympus, looks over his shoulder. His slender body is modelled by

261

194. CORREGGIO. *Ganymede*. Vienna, Kunst-
historisches Museum (photo : Arts Council of Gt. Britain).

chiaroscuro, his garment flutters in the breeze, and his buoyant movement suggests the weightless effort of flight. The silhouette of boy and eagle is set against a radiant sky, and the depth is enhanced by the rugged tree trunk and the yelping dog. The illusion of space is carried beyond by the receding hills, which lose themselves layer upon layer, in the hazy blue of infinite distances. Thus Correggio, by the utter refinement of pictorial means, creates a new beauty, where landscape and the human figure melt into one. He opposes the Classical calm and dignity of composition by his rapturous movement of figures into the limitless space, their iridescent colour and shimmering light, and by his illusionist painting he anticipates the Baroque.

FEDERICO BAROCCI (1526-1612) is only in a limited sense a follower of Correggio. Urbino born, he spent there most of his life, except for a visit to Rome. With Correggio he shares the idyllic and genre character of his Holy Families, the soft forms, veiled in shadow and the sweetness and prettiness of his Madonnas and holy children. Living in the age of Mannerism and the incipient Baroque, he shares their composition in depth and the perpetual movement and action of figures. His vision is eminently pictorial with soft contours and pastel-like, oscillating colours and changing tones of azure and yellow and rose. His forms and compositions are unified by light. Moreover, he drew after nature, and in spite of the sentimental suavity of his religious genre, his figures are well defined and constructed. Later in life he abandoned the homely idylls for the passionate and dramatic, especially in his *Martyrdom of San Vitalis* (1583) in the Brera, a monumental canvas of many figures in violent movement and contortion, a true, though theatrical expression of the Counter Reformation.

XXV. MANNERISM—THE BEGINNING OF
AN ANTI-CLASSICAL MOVEMENT

Pontormo — Rosso — Bronzino — Parmigianino — Niccolò dell' Abbate
— Giulio Romano — Pellegrino Tibaldi

The experimental style known as Mannerism started in Florence as a reactionary movement of some artists who were young around 1520 and found themselves thwarted by the great example of the Classical masters. PONTORMO, ROSSO, BRONZINO and others were ardent intellectuals eager to start a modern movement in art which was often bizarre and ' surrealist ', always imaginative and anti-Classical. Some like PARMIGIANINO affected elongated and serpentine forms to which they bent a graceful and elegant human ideal. Some painted sophisticated literary conceits or, like Giulio Romano, exaggerated the titanic aspect of Michelangelo. Mannerism spread to other lands and in France begot the School of Fontainebleau.

With the death of Raphael in 1520 the untroubled summer of the Italian Renaissance had passed. The Classical equilibrium, the reincarnation of the Hellenic ideal which lay in Raphael's genius had become unattainable, and the young artists in the second decade of the sixteenth century fought shy of it. Besides Raphael there was Michelangelo ; the Michelangelo of the Sistine, and his heroic world of passion and of torment was equally intimidating for the young. An Italian scholar spoke of the ' golden prison of Classicism ' from which the experimental artists of the period were wont to escape. Moreover, time itself was against them. Italy was convulsed with foreign invasions, Church and Papacy threatened by northern revolt resulting in spiritual and moral uncertainties and upheaval. This was the situation into which were born the young Tuscan artists who created the new Mannerist movement: Pontormo, Salviati, Rosso, Bronzino and Beccafumi. For them the art of Raphael and Michelangelo signified the summit and the end of the Renaissance, and in search after new forms of expression it was only natural that they should adopt an anti-Classical attitude.

Though not of the front rank, they were gifted artists, especially in the field of imaginative design and formal experiment. They had common bonds and a common purpose. Pontormo, Salviati, Rosso derived from Andrea del Sarto, and their spiritual restlessness, their impassioned search for a new style produced works which, though often fantastic, and even distortionist, were not entirely outside the Classical schemes of composition. If he was tormented, it was not Michelangelo's tragic but Dürer's troubled and expressionist form, which influenced PONTORMO. In Vasari's biography he is described as an eccentric, an

195. PONTORMO. *The Seasons:* left half. Poggio a Cajano, Villa Reale
(photo : Soprintendenza alle Gallerie di Firenze).

introspective, a solitary, obsessed with his vision. In his work the
substance and proportion of human figures, their harmonious balance
and spatial relationship were disregarded in favour of new formal and
decorative solutions.

His *Joseph in Egypt*, an early work, is a fantastic stage-like invention,
de-centralised, with groups of large and small figures in the same field
of vision, swiftly moving and gaily coloured, in a setting of cardboard
architecture. Pharoah in a golden mantle welcomes Joseph amidst
kneeling suppliants. A winding staircase with hurrying figures
leads to an open temple where Jacob lies dying. The street is filled
with beggars, monks, cherubs, and at the foot of the steps two spirited
lads converse. One of them in a loose mantle and artist's beret, with
long hair, looking up to his companion, is Pontormo's pupil Bronzino.
Slender nudes and a lively cupid on pillars and pedestals enliven the
irrational scene.

Pontormo was at his poetical best when he could paint fancy subjects
without narrative contents, like *The Seasons* in the Medici villa at **195**

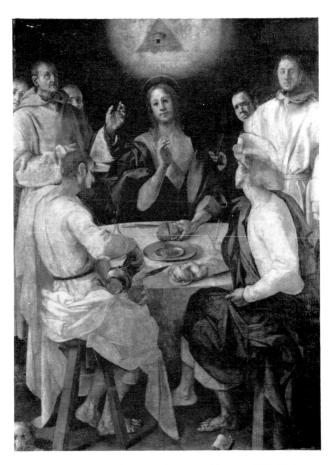

196. PONTORMO. *Supper at Emmaus.* Florence, Uffizi (photo : Rijksmuseum, Amsterdam).

Poggio a Cajano. Here he decorated a lunette with the airy dreams of a pastoral; picnicking peasants and a dog, ladies in pretty costumes and nude boys climbing a wall to pluck laurel twigs. In order to fill the given space with the great central window, he created a screen of spreading foliage and slender branches and beneath it an evocative scene of rustic divinities in a sylvan setting, exuberant in spirit and flexible in form, a subtle equilibrium. Two female figures reclining in ample clothes turn away from each other. Nude children sitting astride walls pull garlands. A leafy pattern is silhouetted against the sky. It is an Arcadian dream like Watteau's, a lyrical evocation of

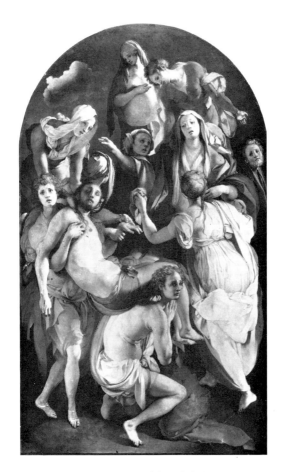

197. PONTORMO. *Deposition of Christ*. Florence,
S. Felicità (photo: Soprintendenza alle Gallerie di
Firenze).

spring, where rustic figures and youthful nudes deport themselves
in the interval of space in rhythmical movements and resilience.

In their search after new expressive modes in order to free themselves
from the Grand Manner of the Renaissance, Pontormo and Rosso
Fiorentino found in Dürer's Passion cycle the anti-Classical forms which
suited their purpose. The lengthening of the human figure, the linear
sharpness, the tortured expressionism of northern art held out a new
promise. By 1525 Pontormo had absorbed Dürer's style and in the
same year he painted his own most personal religious pictures, the
Supper at Emmaus and the *Deposition of Christ*, for Santa Felicità.
Supper at Emmaus derives from a wood-engraving by Dürer, which **196**

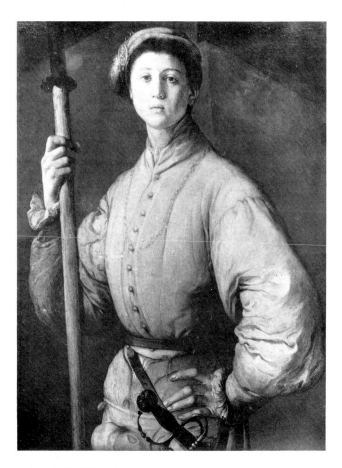

198. PONTORMO. *Halberdier*. Cambridge, Mass., Fogg Museum of Art, Chauncey D. Stillman loan (photo: Fogg Art Museum).

accounts for its expressive linearism, the northern twists and angularity of its lengthened and closely arrayed figures, the pietistic sentiment of the Christ and the nervous contours in the profile perdu of the Apostles seated at the near side of the table. Two Carthusian monks fill the empty spaces by the side of Christ, and above, in an aura of light appears the Eye of God, a characteristic element of abstract symbolism.

197 In the *Deposition of Christ* in S. Felicità, Florence, the lowering of Christ from the Cross becomes an arabesque of nude and lengthened bodies interlaced with others in diaphanous robes, performing a kind of ritual movement. This interplay of limbs, those curves of smooth and tenuous bodies with eyes wide open and ecstatic, this cluster of

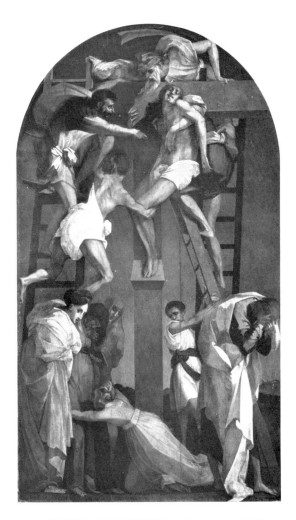

199. ROSSO FIORENTINO. *Deposition of Christ.*
Volterra, Pinacoteca (photo: Soprintendenza alle Gallerie
di Firenze).

figures in sinuous movement built up in tiers, this harmony of rose and
blue and turquoise is a strangely compelling formal invention. Pont-
ormo no longer aims at the logical sequence of figures in comprehensible
space. He is not concerned with reality or verisimilitude, but with new
formal solutions, a tangle of curves, a compact arrangement of smooth
and elongated bodies with wide open eyes and flowing hair, an expression
of emotional states. The artist's vision is set down with a supreme
disregard of probability or of Classical order and works its spell by
new harmonies of delicate colour, new accents of light and a new

compositional freedom, bending pliable human figures to the rhythm of his Gothicising and sinuous shapes.

It is perhaps surprising that an artist so averse to reality could be a portraitist in his own right. But Pontormo approached his sitters not as a realist, but as an artist bent on extracting the greatest definition of character by formal means such as pose and costume, incisive **198** contours, strong light and rarefied colour. His young *Halberdier* rises up steeply before us, and his shapely body with the small head is marked by an aggressive pride and nervous tension. The colour harmony is of yellow and red, and the character of the youth is expressed in his poise as much as in his dress. It is an exquisite stylisation of form, at once bold, tense and elegant. Even in his portraits Pontormo transforms reality by means of selective design and purity of form, and his smooth faced young men with their challenging eyes bear something of his own restless spirit.

Mannerism has many facets. Reacting against Classical serenity and order, it insists on compositions which are dynamic and have no **199** centre. In the *Deposition* by ROSSO FIORENTINO (1494-1541) a northern expressionism of mien and gesture breaks up the last vestiges of Raphaelesque grace by the angularity of linear design. Rosso has rendered the group of mourners under the Cross by silhouetting lofty vertical figures in circumscribed planes of light and strident colour upon an abstract sky of golden intensity. The three Marys have something of the Gothic austerity of mediaeval wood carving, and the Magdalene in flaming red, prostrate at the foot of the Madonna, a new dynamic of colour and geometrical form. Her body forms a link with the weeping S. John, a figure of more than human size, a stereometrical design of expressive force. Despair and anguish under the Cross are contrasted by the agitated figures above, and here the interlacing of limbs, the curves of straining bodies, the grimaces and exertions convey the physical agony of the Deposition. A far cry from the Classical stance of Raphael's *Entombment* in the Borghese—this expressionist concept of figures and their calculated unbalance, which is countered by accents of violent movement and light.

It was Rosso Fiorentino who in 1530 left Florence, following a call of King Francis I to decorate the castle of Fontainebleau. Together with the Bolognese painter Primaticcio, who came in 1532, he introduced Mannerism to the French and became the founder of the School of Fontainebleau.

ANGELO BRONZINO (1503-1572) was Pontormo's pupil and attained to fame as the impeccable portraitist of the Medicean Grand Ducal Court at Florence. In his stylish portraits of the aristocracy his

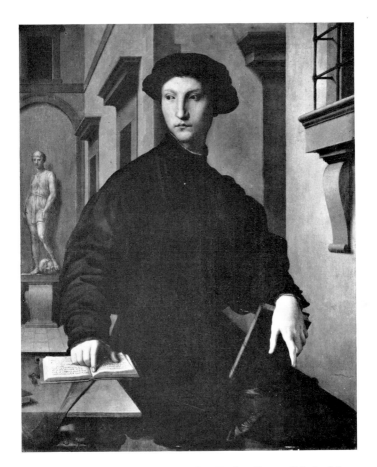

200. BRONZINO. *Ugolino Martelli*. Berlin, Staats Galerie (photo: Walter Steinkopf).

maniera freezes the soul into an impenetrable mask, and a static light throws into pallid relief the lengthened bodies and small heads of his sitters. The portrait of *Ugolino Martelli*, the humanist and future **200** bishop, is a picture of great distinction in the economy of its two principal colours—black and grey—the lofty shape and pensiveness of the scholar, foiled by the verticals of the Renaissance architecture. There are some brilliant passages of paint, as in the dazzling white of the hands emerging from the dark sleeves or the blue book reflected in the black robe. Tonal refinement is matched by the intellectual refinement and natural dignity of the young humanist.

Bronzino's portraits present character, as well as the externals of dress and ornament, with a dispassionate objectivity. The lyrical element

and vibrant light, which made Pontormo's sitters intensely human, are absent from his pupil's stylish abstractions. To him a necklace, a pattern of flowered silk have the same artistic significance as a human face, the same impassive and fixed immobility. When he painted the Duchess *Eleanora of Toledo* in her resplendent costume against a deep blue background, he raised her icy presence to monumental form.

201 More personal is the half-length of a *Girl holding a Missal*. Here the distinction of her dress is subsumed to the serious expression which speaks from her closed lips, her raised brow and sad eyes. The lofty forehead of the girl, the sculptured form of brow and nose are fashioned by planes of pearly light, which lend to her face the ivory perfection. As a portraitist Bronzino reflects appearances with the taut, metallic incisiveness of contours, giving to all parts of body and costume the same clear definition.

In middle life Bronzino changed his allegiance from Pontormo to Michelangelo, painting mythological and allegorical pictures like the **202** London *Venus, Cupid, Folly and Time*, where a learned conceit is illustrated in a pagan and hedonistic language of form. It is an allegory of the human passions, where sophistication and luxury vie in a composition of smooth and alluring or violently enraged figures. In the centre a stylish figure of Venus is embraced by an adolescent Cupid. A cherub scatters rose leaves on their path. Above, Father Time with outstretched arm draws a blue curtain. Below, Jealousy tears her hair and Folly, whose body ends in dragon's claw and tail, offers a honeycomb to Venus ; in her concealed hand she holds a viper. Masks lie scattered on the ground. Allegorical figures fill the whole canvas with supple movement, drawn in metallic relief and bright colour. It is a picture of agitated and writhing figures, a two-dimensional pattern without recession, a disquieting allegory of the senses.

Mannerism was not confined to the initial band of Tuscan artists. As a movement of self-defence against the overpowering inheritance from the great Classical masters, it was not bound to one place, but affected other schools and other cities. It even spread abroad to France, Germany, the Netherlands and to Spain. At Parma, a pupil of Correggio, PARMIGIANINO (1503-1540), who had met Rosso in Rome, developed one of the most characteristic expressions of Mannerism, the *forma serpentinata* or gracefully undulating shapes in which he modelled his elegant and rather worldly Madonnas and angels.

Parmigianino took part in the mural decorations of San Giovanni Evangelista where Correggio had painted the ceiling, and later went to Rome where he fashioned his style after Raphael and Michelangelo. In his works Mannerism assumed that formal elegance and sophistica-

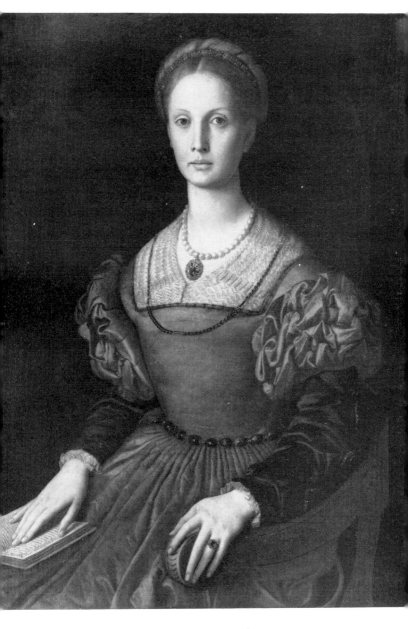

201. BRONZINO. *Girl holding a Missal*. Florence, Uffizi (photo: Soprinten-
denza alle Gallerie di Firenze).

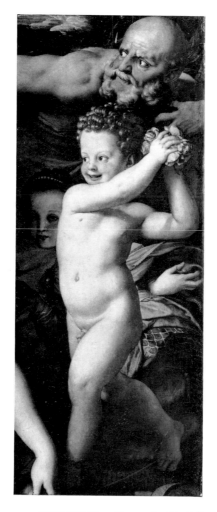

202. BRONZINO. *Venus, Cupid, Folly
and Time:* detail. London, National
Gallery (photo : National Gallery).

tion which resulted in those long necks and small heads of his Madonnas
and in their affected poses. In one of them, the *Vision of S. Jerome* in
the National Gallery, the Virgin, a lofty superhuman form, is enthroned
upon clouds and the beautiful Child stands between her knees, like the
Christ in Michelangelo's Madonna at Bruges. S. Jerome kneels in the
foreground, facing the spectator, but his body is swung around in a
twisting movement, and his hand points upwards like Leonardo's
S. John.

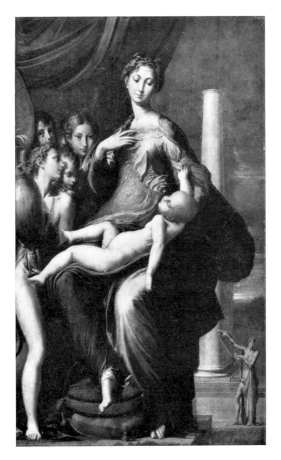

203. PARMIGIANINO. *Madonna del collo lungo*.
Florence, Uffizi (photo : Soprintendenza alle Gallerie
di Firenze).

His Mannerist masterpiece is the *Madonna del collo lungo* in the 203
Uffizi. Stylisation in art could not surpass the haughty grandeur of the
Madonna who, robed like a Queen in turquoise and silvery grey,
constrains the sinuous curve of her body into the lofty vertical of her
aristrocratic stance. The formal perfection and preciousness of her
movement, the affectation of gesture and the restraint of her lowered
glance upon the rather waxen Child on her lap are such, that even the
angels by her side express curiosity and wonder. One of them, holding
an urn, is more like one of the Antique genii than a messenger of
Heaven. The elongated verticality of the group is strengthened by the
grey column, and the pearly flesh tones and opalescent colours are

204. PARMIGIANINO. *The Mystic Marriage of S. Catherine.* Parma, Museum (photo : Variati).

foiled by the vinous red of the curtain. The twisting movement of the Madonna, her long neck and small head seem to derive from Michelangelo's statues in the Medici Tombs. The descending line of her shoulder, flowing into the great loop of her sleeve, broadens her shape and makes her slender head appear like a crest upon the waves.

As an artist Parmigianino appears intellectual and contrived. His is an abstract linearism of form with an emphasis on elegant contour, on tapering fingers and intricately draped bodies. *The Mystic Marriage of S.* **204** *Catherine* in the Parma Museum is painted in tones of pale silvery grey and great fluency of impasto as of movement. The profile figures and curly haired cherubs are arranged in one plane, in close proximity. Parmigianino was capable of great loveliness, and his proud Madonnas, his dark-eyed, fair-haired angels with the Grecian profile created a new and appealing type of mundane elegance, an over-all pattern of sweet flowing harmony.

Parmigianino influenced another Mannerist painter from neighbouring Modena, NICCOLO DELL'ABBATE who in 1552 went to reinforce the colony of Italian painters in Fontainebleau. He was also affected by

276

205. NICCOLO DELL'ABBATE. *Conversion of Paul.* Vienna,
Kunsthistorisches Museum (photo: Rijksmuseum, Amsterdam).

the fanciful Dosso Dossi, court painter at Ferrara. Niccolò's *Conversion of Paul*, sometimes attributed to Parmigianino, illustrates what transformation the grandeur of Michelangelo, seen through the eyes of Giulio Romano, suffered in Mannerist hands. Niccolò was a landscape artist of sweeping and fantastic panoramas, seen from above, with

205

Г

206. PELLEGRINO TIBALDI. *Visitation*. Urbino, Pinacoteca (photo :
Rijksmuseum Amsterdam).

shimmering mountain ranges and promontories, painted in a magically
unreal light. Into one of them he composed his *Conversion of Paul*, a
fallen giant, writhing in the foreground, beneath a rearing speckled
horse with shining crupper and small head. He lends to biblical
story the theatrical and acrobatic suppleness of the ballet.

Niccolò had also been an assistant to GIULIO ROMANO, Raphael's
pupil, who completed the *Transfiguration* and worked in the Vatican
Stanze. In 1524 he became court painter to Federigo Gonzaga at
Mantua. There he built in the Dorian style the famous summer house
of the Duke, the Palazzo del Tè, and covered the whole wall-space and
ceilings with voluptuous and pagan mythologies. In the Sala dei
Giganti Giulio overreached himself and outdid Michelangelo by the
excessive illusionism which assails the viewer of this enormous tangle
of huge and repugnant nudes interlocked in battle. Here chaos
reigns, and though the energy and the skill are tremendous, the
result is a complete reversal of all Classical tenets, such as clarity
of composition or beauty of form and colour. Giulio who was also the
painter of some striking and sensuous portraits had coarsened and

dissipated Raphael's legacy and by his *gigantismo* had led Mannerism to a dead end.

Michelangelo's decorations in the Cappella Paolina became the point of departure for the last Roman phase of Mannerism. Here a number of artists of Tuscan origin were forgathered ; prominent amongst them were Giorgio Vasari, Francesco Salviati and Daniele da Volterra. They painted mythological, allegorical and even philosophical subjects on a monumental scale. One of the most original of these imitators of Michelangelo was PELLEGRINO TIBALDI from Bologna. His *Visitation* takes place upon the steps of a house before a wide stage-like piazza, where figures of more than human size, accompany the meeting of Elizabeth and Mary with dramatic and theatrical gestures. The two male youths seated in the left foreground recall Michelangelo, while echoes from Parmigianino are felt in the elegant and affected stance of the lofty figure above. But Tibaldi always maintains a forceful and original vision of his own. As an architect he looked upon painting as a decorative aid, and in his principal work, a ceiling in the Palazzo Poggio at Bologna, he painted stories from the life of *Ulysses* like easel pictures in an architectural frame (*quadratura*), foreshadowing Annibale Carracci's Galleria Farnese. In contrast to the heroic style of Florence and Rome, he introduces a more intimate element of sweetness and suavity into religious and mythological painting. The most fruitful developments of Mannerism, however, lay with Venetian artists of genius such as Tintoretto and Jacopo Bassano, and with El Greco from Crete, who had spent some years in Venice before settling in Spain.

cf. fig. 179

206

XXVI. THE SPELL OF GIORGIONE

Giorgio da Castelfranco — Sebastiano del Piombo — Vincenzo Catena — Palma Vecchio

Slow unfolding of GIORGIONE'S genius from the Quattrocento style of Giovann Bellini to the chromatic colour and atmospheric light of his maturity A new poetic concept of man and nature. The human figure is wholly integrated into the ambience by transitions of tone and chiaroscuro. Giorgione's colour modulates form without linear contour or sculptural isolation. From 1508, the year of the Fondaco frescoes, Giorgione develops a larger form of figure composition, adopted by SEBASTIANO DEL PIOMBO and Titian, while VINCENZO CATENA continued the romanticism of Giorgione.

Venetian painting of the Renaissance developed parallel to that cf the other great art centres in Italy and in the sixteenth century contested the lead with intellectual Florence by its painterly vision of man and universe. It aimed at presenting form not by plastic relief and delineating contour, but by glowing colour and light, the balance of mass and enveloping atmosphere. During the first decade of the sixteenth century Venetian painting made a sudden leap forward from the calm religious world of Giovanni Bellini and prepared the way for the dramatic vitality and chromatic colour of Titian. The vehicle of this evolution was GIORGIO BARBARELLI from Castelfranco, known as GIORGIONE. Yet, wrote Bernard Berenson, ' there is no softly gliding transition from Bellini to Giorgione as there is from him to Titian . . . Nor in fact is it easy to say where Giorgione leaves off and Titian begins '.

Nothing is known about Giorgione's masters except by conjecture, and as he lived at the time of Bellini and Carpaccio who had absorbed the message of Antonello, and as his early works still bear the mark of the Quattrocento, he must be assumed their follower. But modern research has shown that the young Giorgione also looked beyond the confines of Venice to the harmony between landscape and figures, the deep glowing colours of the Umbrian School. His early masterpiece, the Washington *Adoration of the Shepherds* points to the influence of artists from Umbria and neaby Emilia. The fact is, that the genius of Giorgione unfolded slowly and that his revolution in vision and pictorial style did not come to full fruition until he painted the *Tempest* in the later years of his short meteoric life.

207 In the *Adoration* the shape of the kneeling Madonna and the human sentiment are still Bellinesque ; but Giorgione reveals a new beauty in the gem-like purity of form and colour. The protagonists are placed

207. GIORGIONE.
Adoration of the Shepherds. Washington National Gallery of Art, Kress Collection

on one side, before the dark foil of the grotto, to make room for the winding landscape. This contains all the characteristic elements of the early Giorgione. The great overhanging rock in whose crevices grow grasses and ivy, balances alone the shimmering distances, the olive fields framed by tufted trees, the soft greensward and rustic buildings. The sunset glow lights up the foliage, and the minutiæ of a naturalistic vision are contrasted by the Nativity scene where rich colour constructs form as in the golden mantle of Joseph, the red and green of the Madonna's robe, the tattered rags of the shepherds. Nor is the Nativity without its mystic overtones through the unified vision of the dreaming landscape and the patriarchal bliss of the Holy Family, watched over by cherubs from the dark penumbra of the grotto.

Among the four or five certain works by Giorgione is the *Madonna* **208** *and Child Enthroned with Saints Francis and Liberale* in the Cathedral of Castelfranco. It was painted in 1505 for the condottiere Tuzio Costanzo, to commemorate the death of his son Matteo. The customary Venetian pala or *Sacra Conversazione*, representing the Madonna surrounded by Saints has been simplified and vitally changed by Giorgione. The Madonna is no longer encased in the apse of a church with a throng of saints pressing upon her, but dominates the earthly and heavenly scene from her raised marble throne. There are two points of vision and two horizons. The space is divided by a dark red parapet, and the saintly company is confined to two representative figures : the warrior saint Liberale in shining armour, to whom the Church is dedicated—*Divo Liberale*—and the spiritual form of S. Francis.

The landscape is steeped in the warm light of summer ; a pale blue sky lights up the horizon with roseate tints and envelops the blue mountain range, the distant lake in the diffused light of morning. The delicate light also invests the figures, the Madonna erect and remote, her eyes lowered in melancholy stillness. There is something regal in her composure and in the great scarlet mantle which spreads in generous folds over her knees. The Madonna unites the two worlds over which she rules, the Venetian landscape without and the sanctuary within, where the Saints keep vigil. The youthful S. Liberale stands firmly upon the ground, pensive and suave, resourceful, a heroic shape, more archangel than saint, in his shirt of mail, painted in smooth planes of black pigment and white highlights. Beside him S. Francis in his cowl of dark grey and brown, showing his stigmata, appears gentle and meek, the Saint of the Christian legend. Thus Giorgione's altar retains Bellini's pyramid of figures, but raises the Madonna up into the recession of space. Her immutable shape is the link between the two spheres : the full daylight of the extending landscape and the twilight below,

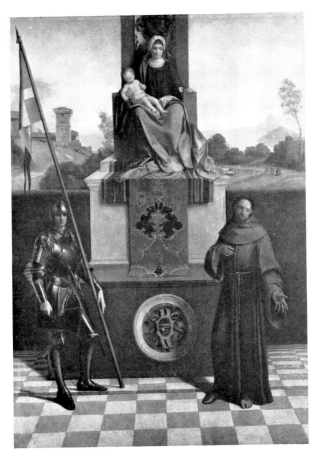

208. GIORGIONE. *Madonna with SS. Francis and Liberale.*
Castelfranco, Cathedral (photo : Fiorentini).

which modulates the contemplative saints in this strictly Classical composition.

The Three Philosophers is neither a religious nor a mythological picture, but altogether a new genre, a dream or idyll of three resplendent figures, meditating in a landscape of rocks and trees, painted in rich glowing tones, which burst out from the dark foliage under an orange sky. The human mind, anxious to discover some hidden meaning in the philosophical co-existence of a stern patriarch, a melancholy oriental and a poetic youth, has deeply probed into the significance of this picture. For Giorgione lived close enough to the humanistic circles of Venice and Padua, to have used scholastic concepts suggested to him by his patrons.

209

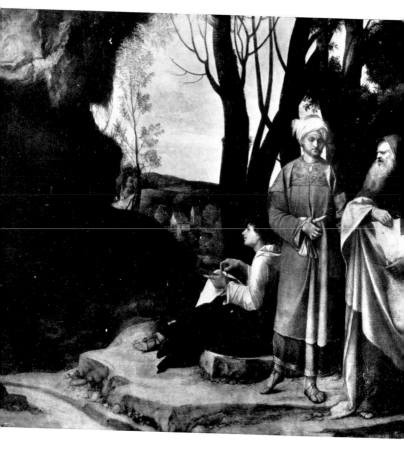

209. GIORGIONE. *The Three Philosophers*. Vienna, Museum (photo: Kunsthistorisches Museum).

Giorgione favoured such enigmatic subjects. He gave comeliness and fervour to the dark seated youth who measures nature with compass and sextant, a wistful gravity to the turbaned man and a wrathful dignity to the bearded sage who holds an astronomical scroll. These representatives of the Schools he placed in a solitary spot where nature inspires quiet discourse, a monumental Symposium. Between the solid rock and the pattern of interlacing trunks lies a delicate landscape, rising from mill stream and meadowland to the deep blue mountains beyond, under the light of the setting sun. Painting in the dominant key of green and red and gold, but no longer applied in Bellini's circumscribed planes of colour, Giorgione freed Venetian painting from

the tyranny of line by modelling his large figures in roundness of form. The magic of his brush, an inward glow, opalescent and broken tones and evocative light are enhanced by their emergence from the dark opposing masses of rock and foliage.

Only with *The Tempest* does Giorgione become a revolutionary. 210 Vasari wrote in his life of Titian that in 1507 Giorgione began to counterfeit nature only with the colours, *senza disegno*. It is the crucial moment in Venetian painting, the birth of the painterly style, where chromatic colour and vibrant light and atmospheric space create pictorial form, and linear design is absorbed in the tonal gradations of paint. Now ' everything loses its plastic consistency and becomes pure pictorial impression ' (Zampetti). *The Tempest* exalts the elemental forces of nature and creates spatial depth by fluctuating light and composite colour. The thunderous, cloud-ridden sky is torn by flashes of lightning, turquoise and greenish blue, above the broad sweep of cubic houses and the luxuriant landscape. The ghostly buildings with their silvery sheen, the flickering lights and deep shadows reflected in the pool, the tall swaying trees and the surging water beneath the bridge contribute to the romantic mood of nature. Yet while the grand cirque of houses and turrets lies ablaze in the sulphurous light, some pastoral idyll seems enacted in the foreground. The two figures that dwell on the mossy bank by the pool show no awareness of the storm, have no fear. These two strangely detached figures, a youth lightly leaning on his staff, who looks over his shoulder, yet not at his companion, and the nurturing mother with her child, tell no story and have an ineloquent and dreamlike existence.

The landscape of *The Tempest* is not merely an echo but assumes the leading role ; the human figures form part of the earth, are wholly equivalent to rock and tree and stream, and share the unconscious life of nature, a perfect link in the pantheistic world-picture of Giorgione. The nimble upright youth, in leisurely *contrapposto*, is like a shepherd in Arcady ; and the female nude by the brook, wistfully gazing into space, suggests the fruitfulness of the earth.

The Tempest is a pastoral symphony, a strange blend of human shapes fantastic buildings and nature, at once a Venetian reality and a dream. ' Near a city, in a solitary place with ruins and buildings, isolated by tall trees, a man and a woman dream '. Nothing could seem more simple, more existentialist. Yet all the feverish life of the picture is in the complexity of colour and atmosphere, the reflected lights on houses and column, the turbulent flaming sky and the blending of turquoise and crimson and white with the browns and pastel greens of the cosmic surroundings.

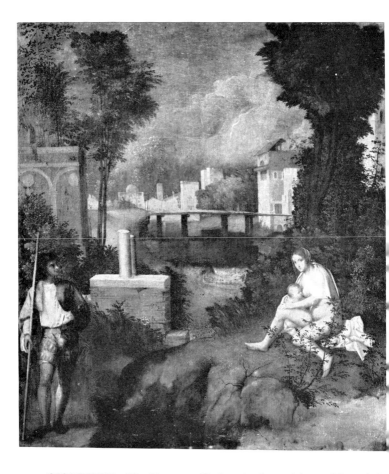

210. GIORGIONE. *The Tempest*. Venice, Academy (photo: Fiorentini).

In Giorgione's portraits the substance and primitive strength of Antonello have become spiritual and transparent. The slender form of the face, in the *Portrait of a Young Man* framed by the long flowing hair in the Venetian style, the delicate flesh tints dissolving in the soft light and fleeting shadows, the highlights on forehead and neck, the rose-coloured face and auburn hair harmonise with the shimmering dress of pale lilac and blue. In the rounded folds of the tunic bluish tints are laid over pale lilac to obtain a fluctuating incandescence, which lends to matter a strange spiritualisation. Yet from the painterly use of broken colours and changing tones emerges bodily form in the radiation of folds, the heavy stuffs that clothe and reveal a noble shape behind the grey stone parapet upon which rests the strangely incon-

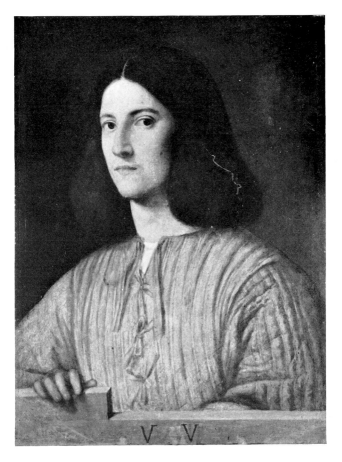

211. GIORGIONE. *Portrait of a Young Man*. Berlin, Museum.

gruous hand. The character of Giorgione's sitter is revealed with the utmost reserve in the sealed lips, the open gaze and the firm, impassive stance of the Venetian nobleman.

Giorgione's supposed *Self Portrait as David* is a supreme example of modelling ' without design ' by means of tone and of light. The powerful head, lit by the burning facial tints under the great crown of chestnut hair which flows down to the shoulders, is wholly immersed in the neutral background. The lofty spirituality, the firmness and comeliness of the heroic countenance are reflected in the substance of paint which moulds the generous forms, the light which illumines the face, the shadow which modulates neck and chin.

212

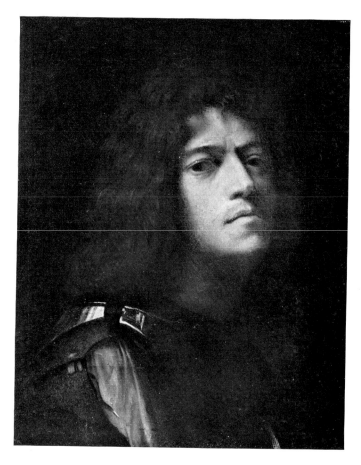

212. GIORGIONE. *Self portrait as David*. Brunswick, Museum
(photo: Rijksmuseum, Amsterdam).

Giorgione died young and his pupils like Titian and Sebastiano del
Piombo may have completed some of his unfinished works : Sebastiano
the *Three Philosophers* and Titian the Dresden *Venus* and other paintings.

The *Venus* in a landscape is Giorgione's most perfectly integrated
work and the prototype of many variations by Titian, Palma and other
Venetian followers. But she alone has Classical equilibrium and is
quite unconscious of her chaste and immaculate beauty ; and though a
living, palpitating form, she is free from sensuality and sophistication.
Among other famous ascriptions to Giorgione is the Louvre *Concert
Champêtre*, precariously poised in that border land, where Titian's
brush operates under the impact and in the romantic spirit of Giorgione.

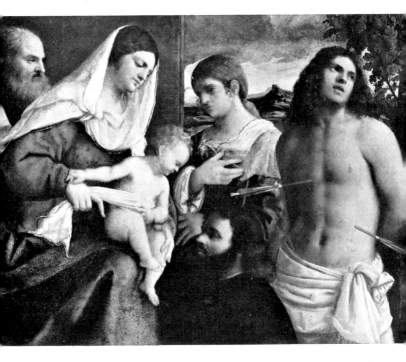

213. SEBASTIANO DEL PIOMBO. *Holy Family with SS. Ursula and Sebastian*. Paris, Louvre (photo : Rijksmuseum, Amsterdam).

Here in an open woodland glade under the effulgent light of the sun two opulent nudes are seen drawing water or listening in the interval of music, while two young gallants are seated on the grass in eager conversation ; another poem of sheer existence and of the contemplative life so dear to Giorgione, yet painted in the luscious idiom of the young Titian.

Among the ' Giorgioneschi ' SEBASTIANO DEL PIOMBO is the oldest, whose early works were painted in the rich impasto and the Classical language of form of the Fondaco frescoes. Born in 1485, he remained in Venice only until 1511, when he accepted an invitation to Rome, where he was to end in Michelangelo's ' Herculean arms ' (Longhi). His Venetian masterpiece is the altar of *San Crisostomo and other Saints*, in an architectural setting of receding columns and a distant landscape. In this modernised form of *Sacra Conversazione* Sebastiano combined sculptural mass and glowing colour with the dreamlike spirit and tonal harmonies of Giorgione, unified in the sunset light. These qualities prevail in the Louvre *Holy Family with Saints Ursula and Sebastian*, which is one of the most Giorgionesque paintings of the 213

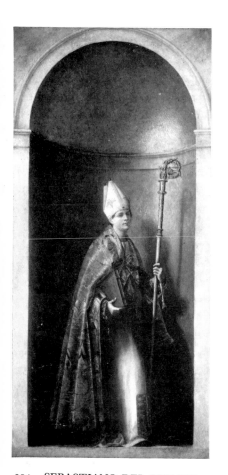

214. SEBASTIANO DEL PIOMBO. *S. Louis of Toulouse.* Venice, S. Bartolommeo a Rialto (photo : Fiorentini).

215. SEBASTIANO DEL PIOM[*S. Sebastian.* Venice, S. Bartolomm[Rialto (photo : Fiorentini).

School. For here a peaceful co-existence of figures before a Venetian landscape of greenish blue mountains is conveyed by a glow and warmth of rich colour, a dazzling impasto which models form without linear contour in smooth transition of planes. These blues and reds and whites have Giorgione's tangible resonance, as in the great loop of the Madonna's mantle or the silvery white of her coif. The athletic S. Sebastian with the ardent gaze and the fullness of limb has the serenity of youth. This Venetian form of Madonna and Saints in a landscape, which Palma, Lotto, and Catena will paint for the domestic devotion, is very close to Giorgione's spirit, transformed by the robustness and luxuriance of Sebastiano.

216. VINCENZO CATENA. *Warrior adoring the Infant Christ.* London, National Gallery (photo : National Gallery).

Sebastiano moves Venetian painting out of the fifteenth century restraint into the realisation of powerful presence and breadth of the human figure. Already in his four full length Saints, painted upon the organ shutters at S. Bartolommeo a Rialto, he had combined Giorgione's tonal values and sensitive light with his own sense of mass and of movement. He placed his monumental Saints before a Roman archway with barrel vault, where the heroic nude of *S. Sebastian* is **215** chained to a Corinthian column. Inside the shutters he painted *S. Louis of Toulouse*, in an embroidered pluviale of red velvet and gold, **214** projecting a shadow upon the wall. The regal form of the Saint has something of Giorgione's spirit and stands out from the hollow niche. The monumental effect is obtained by pictorial means: the fusion of tones, the shadows cast by book and sleeve upon the white tunic, the streaks of light which modulate form. Sebastiano gives predominance to the human figure—sometimes indolent and sensuous—in contrast to Giorgione's unified vision of man and universe.

VINCENZO CATENA is another of Giorgione's followers whose best work reflects the quality of dream and the 'sweetness of human relationship' of his master. During the greater part of his life Catena painted large formal altarpieces and Sacred Conversations in the style

217. VICENZO CATENA. *Judith with the head of Holofernes.*
Venice, Galleria Querini Stanpalia (photo : Osvaldo Böhm).

of Giovanni Bellini, until his friendship with Giorgione, whom he met
in humanist circles at Venice, resulted by 1506 in a sort of partnership.
But even then he continued to use the broad simple planes, the clarity
and precision of the Quattrocento. Only in his later works like the
Martyrdom of S. Cristina, the *Judith* and the *Warrior adoring the Infant
Christ*, does he seem imbued with Giorgione's style and spirit.

216 The National Gallery *Warrior adoring the Infant Christ*, translates
the Giorgionesque into the romantic imagery of the Age of Chivalry.
Before a Venetian landscape of luxuriant summer a young knight from
the East in shining armour and crimson hose, kneels before the Madonna
and Child, while outside the parapet a handsome page in a dress of pale

218. PALMA VECCHIO. *Violante*. Vienna, Kunsthistorisches
Museum (photo : Rijksmuseum, Amsterdam).

purple looks on in wonder. The bright blue of the Madonna's mantle
and the golden orange of S. Joseph's, the clear cut linearism of generous
folds are set against the hazy blue of descending hills under the luminous
sky. But the dreamlike beauty of the young groom is the most
Giorgionesque figure of this romantic Adoration.

It is curious that towards the end of his life, twenty years after
Giorgione's death, Catena reverts again to the formative influence
of his youth, when he paints the *Judith with the Head of Holofernes*. 217
The young woman clasping the jewelled hilt of her sword and leaning
calm and composed upon the parapet where the head of Holofernes
lies severed, is hardly a heroine. She belongs to the type of Venetian

beauty which the followers of Giorgione evolved, Palma above all, whose distinction lies in the unruffled spirit clothed in a perfect human form and conveyed by shimmering colour.

The upright half-length of Catena's *Judith* is foiled by the grey wall into which a window is cut with a mountain view. As the volume of the figure occupies half the picture space, the balance is restored by the opening vista, the great sword and the head of Holofernes. The correspondence of verticals and horizontals is of the simplest. But the life-giving force, within the purity of Classical proportion, is the dignified form and the sumptuous colour with its subdued radiance of soft whites and deep red. Catena does not portray an emotional state, but a human still life of great loveliness, a Venetian reality under the spell of Giorgione.

218 PALMA VECCHIO'S *Violante* is indeed more sensuous and more resplendent in the golden opalescence of her flaxen hair, the glowing fleshtints and the ultramarine dress. But she too is of Giorgione's lineage, only more worldly and opulent so that some have ascribed her to the young Titian. Palma Vecchio is chiefly remembered for his *Sacre Conversazioni* in a setting of Virgilian landscapes or of Old Testament subjects like the *Meeting of Jacob and Rachel*. Here the two lovers embrace in the centre of the foreground stage with shepherds and their flocks milling in the middle distance, while luxuriant woods rise on either side of the far-flung valley. It is still the romantic land-scape of Giorgione and Titian but with a new emphasis on the rustic and animal life, whence the pastoral genre of the Bassano family is to evolve.

XXVII. HEROIC DRAMA AND CHROMATIC COLOUR

Titian of Cadore

The early work of TITIAN is often indistinguishable from that of Giorgione. With the dramatic 'Assumption' (1516-1518) he breaks free from the contemplative vision of Giorgione. Titian's art is expressed in dynamic and sensual mythologies, sacred and profane. His colour develops from the tonal harmonies of Giorgione to the symphonic orchestration of glowing red, deep blue and golden brown of his middle-period. In old age he employs a thick grainy pigment which constructs form, embedded in atmosphere. From lyrical beginnings Titian evolved the heroic and monumental style of the High Renaissance in Venice, universal in scope and forward looking. By his dramatic use of colour, mass, light and movement in depth, he superseded the Classical mode of composition.

But the greatest of all the followers of Giorgione was TITIAN. Born in the mountain village of Cadore, probably in 1487, he came to Venice as a boy of nine and served his apprenticeship in the Bellini workshop. By 1508 he is Giorgione's assistant at the Fondaco frescoes, and after the latter's death in 1510 he competes with Sebastiano for the succession in Venice of Giorgione's position, a contest which he won, aided by Sebastiano's early departure for Rome. He completes several of Giorgione's unfinished pictures like the landscape with rustic buildings in the Dresden *Venus*, which recurs in the London *Noli Me Tangere*, and probably also the famous *Concert* in the Pitti Museum. In 1511 he was called to Padua to paint frescoes in the Scuola del Santo.

It is the poetry of Giorgione which so coloured the early works of Titian that for many years he could not free himself from the spell, and Bernard Berenson saw in the two great Venetians ' but one artistic personality '. Nowhere is this kinship more strongly felt than in the central figure of the Pitti *Concert* and in the human relationship of the 219 group. The impassioned spirituality of the monk, whose ascetic head is turned questioningly to his companion, as he listens to the music, transcends the power of the young Titian and must derive from the concept of Giorgione. Yet the strong emphasis on structural form, the taut bony fingers, the shaded neck and strong jaw, the articulation of planes suggest a more vigorous brush than that of the master of Castelfranco. But the spirit is his, the overtones, the momentary suspense, the spark kindled, the sound reverberating in the room. The head of the monk reveals a powerful intellect; and the hollow eyes, the lean cheeks, the compressed lips a burning passion.

The youth with the plumed hat and light brown doublet serves as a foil to the virile monk ; but the clerk with his viol looks responsively

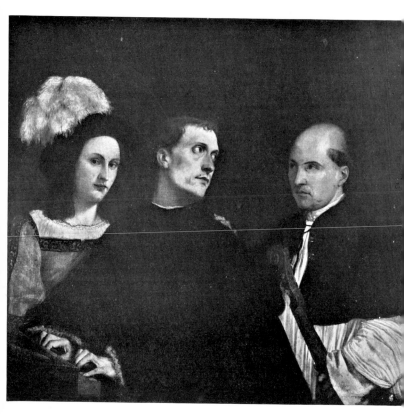

219. TITIAN. *Concert.* Florence, Pitti Palace (photo : Soprintendenza alle Gallerie di Firenze).

at his companion and lightly touches his shoulder. All forms emerge softly from the dark surround, conveying ' that calm unearthly glow, the skill which has caught the waves of wandering sound and fixed them for ever on the lips and hands ' (Walter Pater).

Another variation on a Venetian theme, where sound stirs affection is the Giorgionesque pastoral in Lord Ellesmere's collection : *The Three*
220 *Ages of Man.* It is a pause in the concert, a moment of rapture and recognition, where the flutes are no longer raised to the lips, and the beautiful girl, flower-wreathed, in her white and rose coloured dress, gazes at the enchanted shepherd. While the lovers represent the short bloom of life, two putti are asleep upon a second plane, and a third playfully climbs the trunk of a willow which is as yet barren and without foliage. Farther afield an old man, robed in pale lilac, is seated upon the greensward, meditating between two skulls, withdrawn into himself

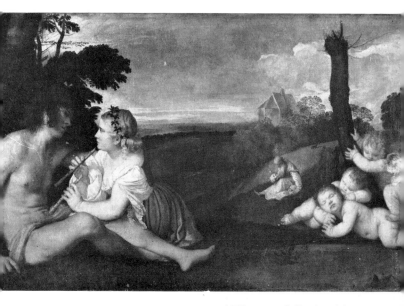

220. TITIAN. *The Three Ages of Man*. Lord Ellesmere Collection (photo Courtesy Lord Ellesmere).

and his solitude, unaware of the white clouds of summer and the blue mountain distance under the luminous sky.

When Titian returned from Padua to Venice in 1513, he applied for the coveted post of official painter to the Republic. This he did not obtain until 1516 on the death of Bellini ; but for the next sixty years he ruled supreme. His genius his range, his versatility were universal. He attracted the patronage of great princes and ecclesiastical bodies. Side by side he would paint great religious altarpieces like the *Assumption* at the Church of the Frari and the pagan mythologies for Duke Alfonso of Ferrara. His vitality, his exuberant fantasy found simultaneous expression in the glorification of the Christian Virgin and in the *Feast of Venus*, and the wreath of cherubs in the one becomes a rapturous army of small Cupids in the other.

In the *Assumption* Titian's art is liberated from the static and contem- 221 plative vision of Giorgione. Its keynote is dramatic and abandoned movement, with great accents of colour and light. A pervasive glow emanates from the red robe of the Madonna who, wrapped in a blue mantle, spreads her arms wide to be received by the Eternal Father in the luminous Empyrean. Below upon the earth, but straining after the Madonna who has left them, is the solid group of Apostles, dark silhouettes of men with upturned heads and pointing hands. Never

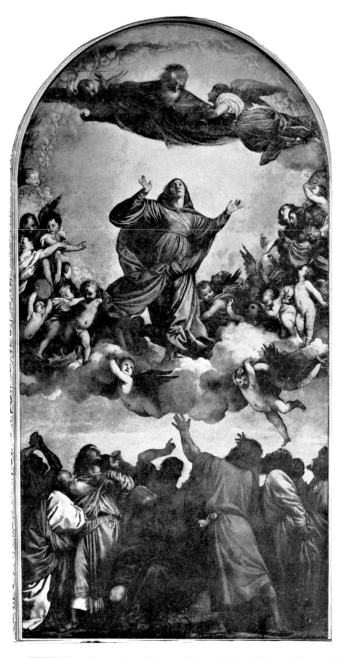

221. TITIAN. *Assumption*. Venice, S.M. dei Frari (photo: Fiorentini)

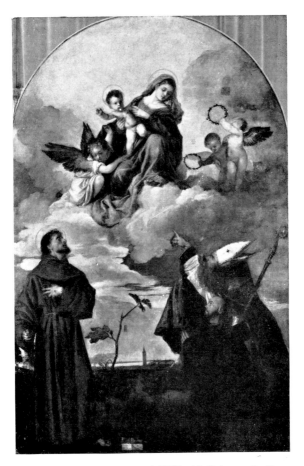

222. TITIAN. *Madonna and Child with Saints and a Donor*.
Ancona, Pinacoteca (photo : Rijksmuseum, Amsterdam).

before in Venetian painting has the freedom and movement of monu-
mental figures interlaced by gesture been organized on such a scale
by the balance of shaded and lighted mass and glowing colour. By its
full blooded vitality and exuberance the Classical *Assumption* of 1518 is
a complete break with the Quattrocento and anticipates the Baroque.

Only a few years later, inspired by the same dynamic energy, he
painted the *Madonna and Child with Saints and a Donor* at Ancona. 222
And here the explosive movement is given to the bishop Aloysius who
with emphatic gesture indicates the miracle of the Madonna and Child
appearing in the clouds to the kneeling donor. The low horizon, with
the flat expanse of Venetian lagoon and Campanile, leaves scope for the

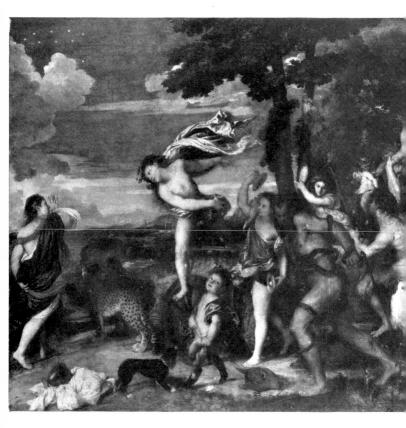

223. TITIAN. *Bacchus and Ariadne*. London, National Gallery (photo: National Gallery).

great skyscape, deep blue and chrome-yellow with mounting grey clouds, where the Virgin appears in blue and roseate garments. As she looks down upon the saintly bishop, so the Child bends with blessing towards S. Francis. Two putti of the Assunta type offer garlands to the Madonna and a Baroque angel completes the pyramidal design of the upper sphere. These figures are seen against the radiant sky, and the dramatic effect of the composition lies as much in the structural force of colour as in the vitality of the figures.

223 Red and blue form the dominant key in all Titian's paintings of this period. The London *Bacchus and Ariadne*, the third of the mythologies painted for Duke Alfonso of Ferrara, is no exception. Walter Pater speaks of the strange romantic god ' himself a woman-like god ', for it was ' on women and feminine souls that his power mainly fell '. Bacchus inspires not only the maenads with their wild music and yearn-

ng, following in his train with satyrs and snake-entwined Silenus, but
.s himself of soft and volatile beauty. As he leaps from his tiger-drawn
:hariot, ivy-wreathed, with a sudden twist of the body and passionate
glint of the eye, Ariadne moves towards the shore. She flees like the
nymph Daphne from Apollo's pursuit, her hands raised to the blue
mountain distance, her eyes lifted up to the god, hastening on, yet
already yielding with lagging steps.

Titian's power of subsuming infinite detail to the larger masses of
the design, painted with such breadth and vitality—inlets and promont-
ories and steeples, ranges and wooded slopes, or the single flower that
blooms in the foreground—never impairs his glorification of dionysiac
joys, his creative energy and sensuous beauty.

In the middle twenties other religious compositions of great import
follow, like the Louvre *Entombment* and the Pesaro altarpiece. The
Entombment simplifies and vitalises Raphael's scheme and lends to the
bearers heroic form and credible weight, compactness and strength to
the horizontal group. The figures tread the earth firmly, Christ's body
is relaxed in the silken shroud, and the tragic emotion of the protagonists
is conveyed by compassionate gesture and movement. The sonorous
chords of colour, Venetian red and blue and inky-green, give to the
painting its solemnity and power.

More revolutionary is the *Altarpiece for the Pesaro Family* in Santa **224**
Maria dei Frari. Here the traditional form of the Venetian Pala has
been abandoned and the figures are arranged in diagonal depth like
a great human pyramid. The Madonna and Child are no longer in the
centre, but enthroned on the steps of a church, before a portico of
monumental columns. Three generations of the Pesaro family,
admirals and seafaring folk kneel in measured adoration, in contrast to
the mild ecstasy of S. Francis and the impetuous movement of Peter.
Behind Jacopo Pesaro in gold embroidered crimson, the youngest and
fairest of the family robed in white silks looks out of the picture with
frank and inquiring gaze. The figures fan out from the throne of the
Madonna. Depth is conveyed by the contrast of lighted and shaded
zones of colour—the golden mantle of Peter, the Madonna's carmine
and blue—and the light upon the Madonna and Child which also
illumines the cherubs in the clouds. By the diagonal placing of figures
in depth Titian breaks with the Classical tradition and hails in the
dramatic and oratorical style of the Seicento.

From about 1530 Titian develops a new grandeur of landscape-
backgrounds and allows the heroic scenery an equal share with the
figure composition. The solid group of the *Madonna and S. Catherine*,
in the National Gallery, with its bright accents of blue and lemon

224. TITIAN. *Altarpiece for the Pesaro Family*. Venice,
Frari Church (photo : Anderson).

yellow, is almost superimposed upon the solitary landscape—a sweeping
valley of the Alps, with the impressionist painting of flocks and
shepherds, wisps of cloud and bursts of light drifting amid the deep
azure of the distant ranges. Thick pigment constructs the successive
folds of undulating meadows, the rich foliage tipped by light, and the
deep blue of cloudcapped mountains. It is the prelude to Titian's
ripest style where colour constructs form, without contour, and depth
is created by variations of tone.

In his portraits Titian combined psychological penetration with
an utmost reserve and a supreme command of pictorial means. The
Admiral Pesaro is portrayed as a dignitary of the Venetian state, but
also as a powerful Renaissance individual. The earlier *Man with Glove*

225. TITIAN. *Man with Glove*. Paris, Louvre (photo: Giraudon).

in the Louvre, still Giorgionesque in the inscrutable calm of his young manhood, is a masterpiece of pictorial realisation. He emerges in black from the dark background by means of tonal gradations and light which is strongest in the gleaming eye and the perpendicular pleats. His gloved hand is a still life of great painterly skill in the crumpled leather of greyish-brown, contrasted by the glowing fleshtints of the other.

In 1532 Titian had met the Emperor Charles V and now begins the spate of official portraiture, culminating in the equestrian portrait and in the seated likeness of the Emperor, painted in 1548 after the battle **226** of Mühlberg. The Emperor is relaxed in a moment of political respite. He has overcome his protestant foes in Germany. It is a moment of

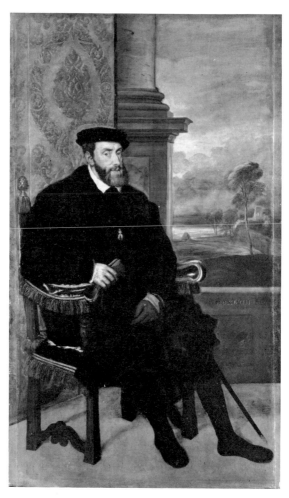

226. TITIAN. *Portrait of Charles V.* Munich, Pinakothek
(photo : Bayer. Staatsgemälde-Samm.).

conquest and of triumph. But Titian sees beneath the surface, and his
likeness of Charles is at once a portrait of state and a human document.
The conqueror is not flushed by victory, but weary, saddened, resigned.
His ascetic face is marked by suffering, physical and spiritual. The
wisdom, the experience, the great will, are resolved into melancholy.
Titian has inscribed all this and painted the Emperor as a dark tragic
figure before the red and gold tapestry, while the projecting column
and plinth lead the eye to the solitary landscape without.

Returning to Venice from the Imperial Court at Augsburg, Titian
had still a quarter of a century of creative work before him. In the

227. TITIAN. *Boy in a Landscape*. D. G. van Beuningen Collection (photo : Rijksmuseum, Amsterdam).

ate 1550's he painted his monumental mythologies for King Philip II of Spain, *Diana and Actaeon, Venus and Adonis, The Rape of Europa* and others, and in these he developed his last pictorial manner where the Renaissance ideals of form and space are transformed by a cosmic vision of vibrant colour and light. A new painterly fullness of form is embedded in flaming colour and mysterious light. The younger Palma who completed Titian's last work in Venice, the tragic *Pietà* of the 229 Academy has recorded his method : ' He gave the last touch to his pictures by adjusting with his fingers the transitions from the highest lights to the half tones, or he would apply with his fingers a spot of black in one corner or heighten with a dab of red, like a drop of blood the liveliness of the surface ; and thus he gradually brought his figures to completion. In the last stages of the work he painted more with his fingers than with the brush . . . '

This final technique of the octogenarian Titian, a summary style of grainy colour, where forms fall into shape only when seen from

a distance, can be studied in a fragment representing a *Boy in*
227 *Landscape*. The child in his smock of Venetian red, who clings to hi
big white mastiff, is said to be a young prince Serbelloni who wa
saved by the dogs from a burning castle shown in the middle-distance
The picture divides into a clouded landscape, painted in stormy brown
and dark blues, with a gleam of light on the square tower, blotchy an
suffused, and the foreground with the massive shapes of the child an
his dogs. Here the magic of Titian's ripest style does not lie in th
conjuring up of heroic form, but in its easy confluence with the back
ground, the perfect absorption of individual shapes by the vibran
atmosphere. The very density of pigment, chromatic scales of yellow
blue and green, a flaming synthesis of diffused colour and light, create th
magical space. Expressionist colour transforms the formal beauty c
the Renaissance, and a conflagration of light dissolves the darkness c
the cosmic landscape.

In sixteenth century Venice Titian had been the representative artis
as Michelangelo was in Rome. The detached vision which gave hir
the power to express the ideals and passions of his age is inscribed upo
228 his own countenance. The Berlin *Self Portrait* is a fragment. Painte
mainly in monochrome with brilliant touches of pure white, the brow
fur and background are relieved only by the triple chain of coral. Th
hands are merely sketched in, though their weight and volume, as tha
of the right arm—a lion's arm and paw—are apparent even in thi
most summary technique. But what human grandeur is expressed i
the face, the imperious look, the great cavities of the eye, the lighte
dome of the forehead with the prominent temples and brow! It i
rock-like, a rugged form, commanding and marked by the fevers c
creation. Whether looked at as expression of mind or as pictori;
form, Titian's self portrait with its chiaroscuro, its hazy colour, it
simplification of form—the oblong face, the spherical shoulder, th
bold thrust into space—is a final act of self-revelation.

In his last works, the *Crowning with Thorns* and the Venice *Piet;
Titian presents with disillusioned realism the tragic moments of Christ'
229 Passion. In the *Pietà*, the Virgin holds the dead Body of Christ upo
her lap before a massive stone vault of Roman solidity—at onc
triumphal arch and altar of immolation. Magdalene with raised hand
and parted lips, her hair dishevelled, her gaze distracted, seems to ca
others to the scene with wild lament. The violence of her movemen
her moss-green robes flying, is heightened by the solemnity of th
central group, the stillness of the Madonna in a dark blue mantle, th
devotion of Joseph of Arimathaea, whose athletic form is half veile
in a rose-coloured cloak. This poignant *Pietà* is Titian's largest essa

306

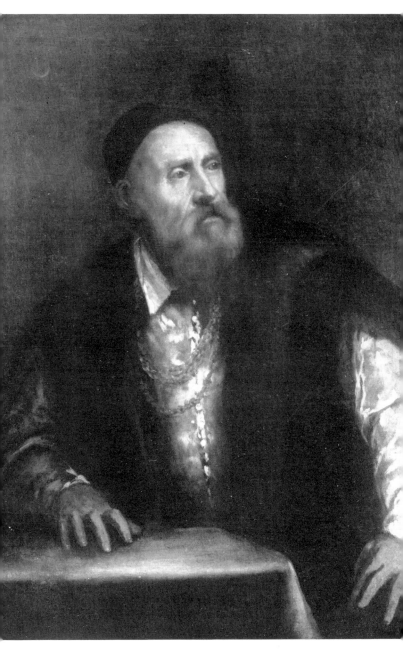

228. TITIAN. *Self Portrait*. Berlin, Museum.

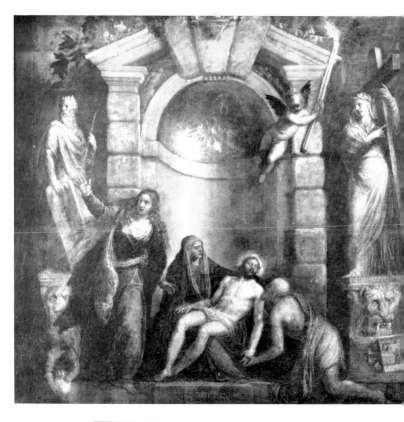

229. TITIAN. *Pietà*. Venice, Academy (photo : Anderson).

in monumental form, where cube, sphere and triangle frame and contain the superhuman statuary. The expression of human suffering is gone from Christ's countenance ; the tormented eyes are closed for ever ; humbled, broken and brutalised the pallid flesh has succumbed to the resistance of man, and an aura of light around His head tells against the grey monochrome of the cyclopic wall. With this work of tragic significance, simplicity and power the octogenarian Titian lays down his brush.

XXVIII. THE PAINTERS OF BERGAMO AND OF BRESCIA

Lotto — Dossi — Savoldo — Romanino — Moretto — Moroni

LOTTO: a Correggio in Venice; rapturous movement and cool colour supported by restless light. Pre-Baroque exaltation. Intensity of feeling and formal elegance; flower-like grace. Consciousness of human personality in his psychological portraits. Around 1530 a Titianesque phase; greater breadth, richer impasto. SAVOLDO: Giorgionesque fantasy, but opalescent colours and luministic contrasts. Landscape as dark foil for brilliant figures. MORETTO: Aristocratic portraits; romantic, yearning, lyrical. Lotto influence. Breadth of modelling; harmonies of black and grey. MORONI: The only mere portrait painter in North Italy. Impeccable draughtsman; subtle psychologist; no idealiser of his bourgeois sitters in domestic surround.

The only painter who challenged Titian's ' impersonal grasp of the world ' and his triumphant expression of religious certainty by an almost northern inwardness and ecstatic fervour, was LORENZO LOTTO, a native of Bergamo. He was born around 1480, and through his master Alvise Vivarini became a pupil of the Bellini School. His early altarpieces and half-length figures of the Madonna and Saints still have the upright stiffness and immobility of the Quattrocento, but lightened by a tender humanity, a gem-like purity of colour and a restlessness of effects of light. Among his formative influences, apart from Titian and Giorgione, were the sumptuous and arcadian Palma Vecchio and some northern master like Dürer who visited Venice in 1506. After his early years, spent in Treviso, Lotto made his pilgrimage to Rome (1509) and there was attracted by Raphael rather than Michelangelo, but in 1513 he was called to Bergamo and in the following years painted his three great altarpieces for Bergamasque churches, in which he found his own most personal style. His sense of beauty and grace, his rapturous movement and cool colour liken him to Correggio, whose work, though contemporary, was probably unknown to him.

The San Bernardino altarpiece of the *Madonna and Child with Saints* 230 (1521) is anti-Classical by dint of the somersaulting angels who spread a dark-green canopy over the Virgin's throne. These figures hold up the tent-like curtain in a refulgent movement of their foreshortened bodies ; the daring tumult of shining limbs tossed in all directions, have their analogy in the joyous whirl of Correggio's angels in the Cathedral of Parma. The same fervour informs the old bearded Saints below, S. Anthony Abbot with his bell, leaning forward upon his staff, and the ecstatic S. Bernardino. The dark-eyed Madonna, expounds with demonstrative gesture the mystery of the Child to the weighty Saints below and to the beautiful angel who at the foot of the

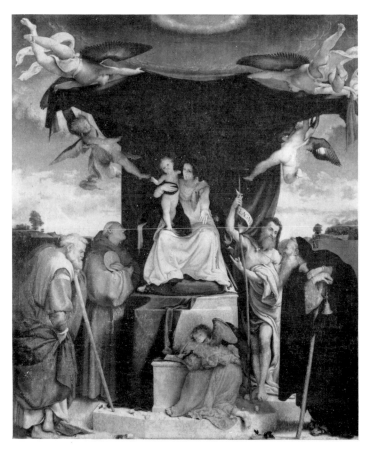

230. LORENZO LOTTO. *Madonna and Child with Saints*. Bergamo,
San Bernardino (photo: Courtesy Istituto Italiano d'Arti Grafiche, Bergamo

throne writes down her words in an open book. The suppleness of al
forms, the transparent colours, the tempestuous movement of the
angels foreshadow the seventeenth century Baroque, but the yearning
Saints, the lyrical earnestness of the Madonna betray a deepening o.
religious feeling which transforms the traditional altarpiece of the pas
into a work of lyrical ecstasy.

Lotto's modernity is even more conspicuous in the expression o:
mood and individual character with which he endows his portraits. He
has a profound consciousness of human personality. The *Portrait of c*
231 *Young Man* in the Vienna Museum offers an example of human
interpretation. 'There is an unsure, inquiring look in this face with
its vibrating nostrils, deep-set thoughtful eyes and quivering mouth'

231. LORENZO LOTTO. *Portrait of a Young Man.* Vienna, Museum
(photo : Courtesy Arts Council of Gt. Britain).

wrote Bernard Berenson who saw the novelty of Lotto's portraiture
in contrast to that of Titian, in the effort to convey ' not only what the
sitter is, but what he feels '. The beauty of the portrait resides not
only in the stern penetrating look of the youth, but in the contrast
between the luminous planes of his senstive face, framed by the silky
mass of hair, and the pearly white of the damask curtain.

In his Madonnas and Saints, Lotto attains an intensity of feeling
and formal elegance, a grace and feminine beauty which are expressed in
vibrant line and rarefied colour. The *Sacra Conversazione* is composed **232**
in the manner of Palma Vecchio, but the litheness of the figures, and
affectionate humanity are Lotto's own. The solidity of the figures is
made transparent by the coolness of colour and light, the pale blue

232. LORENZO LOTTO. *Sacra Conversazione*. Vienna, Museum (photo : Courtesy Arts Council of Gt. Britain).

of the Madonna's robe, the golden green of S. Catherine's pleated dress and the purple grey of the angel. The Madonna is the same as in the San Bernardino altarpiece, and the golden haired angel, himself of languid and flower-like grace, holds a wreath of blossom over her head. S. Catherine turns away from the Child who clasps the pages of her book, and forms a link between the kneeling S. James and the Madonna. A great spreading oak with thick foliage shelters the holy personages before a landscape of blue foothills in the diaphanous light of summer.

Around 1530 Lotto appears to have been closest to Titian, and the works of this period reveal a richer impasto, a bolder fusion of tones and a greater breadth of composition. The Portrait of the *Sculptor* **233** *Odoni* at Hampton Court and the so-called *Lucretia* in the National Gallery illustrate this phase. The ample Venetian form of Lucretia in the sumptuous dress, where russet is heightened by the olive green of the puffed sleeve, is strangely poised between chair and table. As her body leans back to reveal the line of the neck, so her head and arms restore the balance of contrasting movements, which her self-conscious gaze out of the picture diverts again to the lady's self. Light constructs mass and volume of the figure with fleeting shadows upon the flesh

and the opalescent silk in the golden grey ambience. Among Lotto's portraits *Lucretia* approximates closest to the Venetian beauties of Titian, and is his finest achievement in breadth and elegance and in the delicate fusion of light and of tone.

The London *Family Group* of Lotto's landlord, his wife and two children is not only a portrayal of a bourgeois family in rich Venetian costume, but a genre scene of domestic intimacy and psychological innuendo. Beneath a window with a large expanse of sea and sky, lit up on the horizon, the husband and wife are posing for their portraits. The young mother in a dress of Venetian red, well modelled bodice and rich jewels, looks out earnestly and almost sullenly, while her little daughter in a long blue robe has climbed upon the table to help herself to some cherries. Her husband opposite, wearing black over paler blue, looks more kindly though a little resigned, while the smaller child strains after the cherries in his hand. Externally Lotto portrayed these

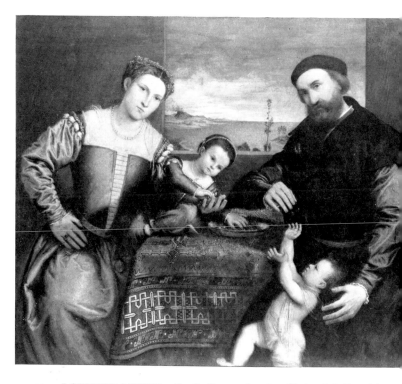

234. LORENZO LOTTO. *Family Group*. London, National Gallery (photo
National Gallery).

burghers in all their finery, and clothed them in the colours of hi
Venetian palette, bright chords of vinous red and graded blues on eithe
side of the Turkish carpet, with the grey blue seascape behind. Bu
the inner life of the portrait lies in the contrast between the cool
limited and still pretty wife and the warmer and more melancholy
husband, whose countenance inspires more sympathy. Thus Lotto
working in the provinces, broke free from Titian's all-pervading
example and, in his more loosely constructed altarpieces with thei
restive saints and angels and in his psychological portraits, evolved
style less vigorous and monumental, but more personal and appealing
than that of the Venetian metropolis.

A master who grew up close enough to the Venetians to be deeply
affected by Giorgione's fancy and Titian's colour was Dosso Dossi
court painter of Ferrara at the time of Alfonso d'Este. His romanti
spirit was allied to a feeling for magic light and gorgeous colour, an
his favourite subject was the enchantress Circe and her Lovers, transfixed

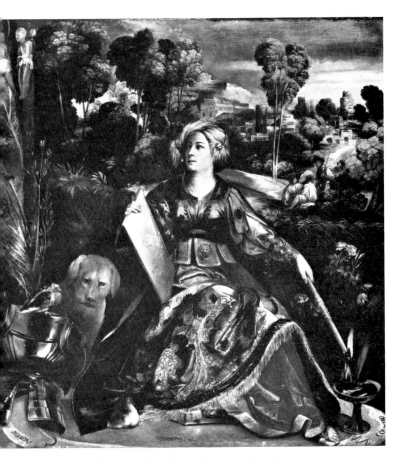

235. DOSSO DOSSI. *Circe*. Rome, Gallerie Borghese.

into animal shapes in a landscape of sulphurous lights and exotic trees. In Dosso the poetry of Giorgione and the Bacchic elements of Titian assume a fantastic licence which is nearer to the Arabian Nights than to Classical mythology. His imagination ranges freely over a world of high romance, where the nude enchantress with her magic scroll holds stag and dog and parrot—her transformed lovers—listening spellbound at her feet.

In the other *Circe* at the Borghese Gallery she is a grand and bewitch- **235** ing sibyl in a sumptuous costume of deep crimson and opalescent green, ruling the enchanted world around her with the magic of her glance and of her wand. Behind her lies a dream landscape of glades and feathery trees, where Giorgionesque lovers recline and to which incandescent

lights lend real magic. ' Before her we lose ourselves in a magic of strange lights and mysterious colours which make us sink deeper and deeper into a world which is as entrancing as it is far away ' (Berenson). Nowhere in the wake of Giorgione has the romantic spirit, liberated from all bonds of reality, indulged in such triumphs of the imagination as in Dossi's poetic incantations.

GIROLAMO SAVOLDO—like Lorenzo Lotto—worked at the fringe of the Venetian centre. Born at Brescia, the twin city of Bergamo at the foothill of the Alps, he was formed by Lombard as well as Venetian influences. He is Giorgionesque by the fantastic quality of his invention, his romantic landscapes, his mysterious light, but he differs from the great Venetians by his use of cool colour, his chiaroscuro, his search after luministic effects. The half figure of *Mary Magdalene*
236 *approaching the Sepulchre* is an epitome of his highly original art. Her face is half veiled and shaded by the cloak of silvery grey which sparkles in the moonlight. Opalescent colour creates the form as well as the silky sheen of the robe, with its glittering creases and structural folds. The silvery light lends mystery to the figure which is foiled by the nocturnal background of dark blue sky and water under the purple clouds of the sunset. For formal invention, luministic contrasts, and breadth of design Savoldo's *Magdalene* is an impressive shape.

237 No less original is the *Tobias and the Angel*, a late work of the master. Here the figures are less solid, the folds more mannered and restless, the light even more brilliant. Other than in the Giorgionesque paintings, Savoldo's figures do not merge into the landscape, which is a mere foil to detach them more vividly in their intensely luminous quality. As Tobias kneels down by the water's edge, the Angel, borne by his great bird's-feather wings painted in liquid silver, alights upon the rock. The head of Tobias is shaded, as he listens to the Angel whose face and silken robe gather the light. The subtle lace-work of trees is not a solid impenetrable mass as in Venetian painting; it serves as a ' screen ' for the sparkling splendour of blazing colours—the slate blue and rose and golden orange of the two figures. Thus Savoldo attains his effects by the fluency of his colours in a chiaroscuro background, the opposition of the greatest light and the deepest shadow.

The painters of Brescia excel in the portrait genre, with the exception of ROMANINO who painted large Titianesque altarpieces and frescoes for provincial churches. These have breadth and amplitude of form and a boldness and fluency of colouring which show his Venetian upbringing. These qualities combine in the London *Madonna and*
238 *Child* with a background of Impressionist swiftness and brilliance. The great blue pyramid of the peasant Madonna, ringed by an aura of light,

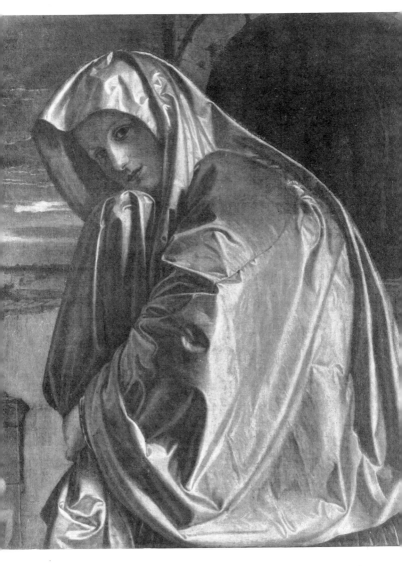

236. GIROLAMO SAVOLDO. *Mary Magdalene approaching the Sepulchre.*
London, National Gallery (photo : National Gallery).

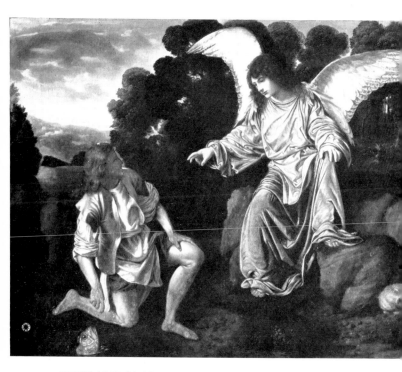

237. GIROLAMO SAVOLDO. *Tobias and the Angel*. Rome, Galleria Borghese
(photo : Anderson).

is foiled by the intense blueness of sky, and the spaciousness of her
bodily form results from the perspective of graded blues in the ' steady
glory of broad Italian noonday '. Such breadth of figurative design
is allied to a Giorgionesque intimacy of the surround, the duck pond
and farmhouse with rustic figures, and the armed horseman outside the
city gate. The swift notations of colour and light, the blue cupola
and grey spires, the silvery white crescent of the old city wall, the long
triangular roofs, these shafts of light, have a nervous sensibility of the
brush and a freshness of momentary vision unique in the sixteenth
century.

Moretto and his pupil Moroni continue Lotto's tradition of the
psychological portrait, the former with a romantic lassitude of expression
in his aristocratic models, the other, a naturalist, who combines direct-
ness of observation with significant pose and surrounding. MORETTO'S
239 portraits, like that of *Count Sciarra Martinengo Cesaresco* reveal a
monumental placidity of the sitter, a romantic yearning, a poetic
contemplation. The pose is pensive and grave, a moment of relaxation

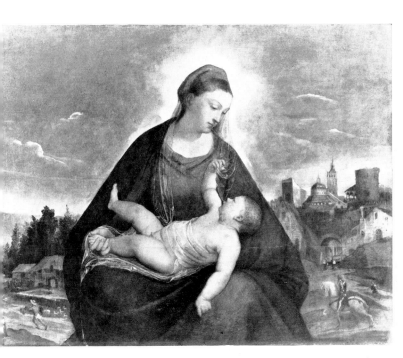

238. GIROLAMO ROMANINO. *Madonna and Child*. London, National
Gallery (photo : National Gallery).

and weariness, matched by the breadth of modelling, the richness of
stuffs, of blue velvet and ermine before the red and gold curtain.
Elsewhere Moretto aspires to Velazquez-like harmonies of blacks and
silvery grey, a subtle economy of light, which models form in the
mellow atmosphere, in which his sitters stand or move with princely
ease.

If Moretto is humane and lyrical, his pupil MORONI is a realist. His
best work, like the *Portrait of a Tailor*, is of impeccable draughtsman- **240**
ship in the significant action and attitude of the man. To the senti-
mental overtones of Moretto's sitters he opposes a directness of
characterisation and verisimilitude, unique in Italian portraiture. He
combines Lotto's subtlety of interpretation with Moretto's cool and
hazy colours. The *Tailor* is a harmony of greyish yellow and dull red,
heightened by the sparkling light upon the doublet, and fused with the
greenish grey background. Moroni does not embellish, is not rhetorical.
He paints the sitter and his surroundings, the knights of Bergamo with
plumed hat and sword, the local squires in all their finery, or the
professional men, school-master, lawyer, tailor, wistful, limited, life-like.

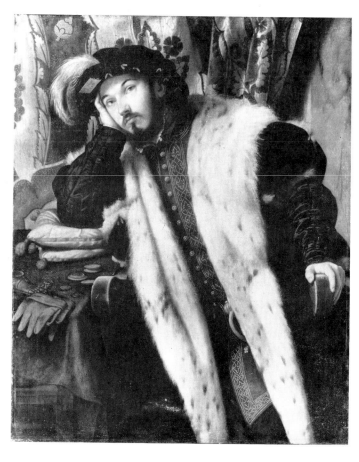

239. ALESSANDRO MORETTO. *Count Sciarra Martinengo Cesaresco*. London, National Gallery (photo : National Gallery).

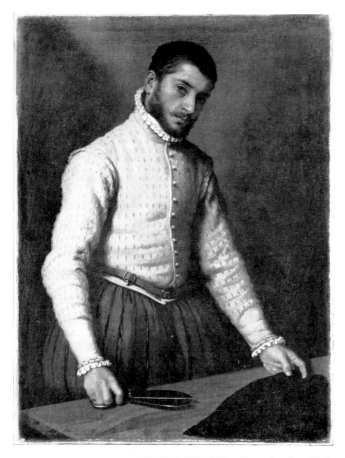

240. GIOVANNI BATTISTA MORONI. *Portrait of a Tailor*.
London, National Gallery (photo : National Gallery).

Titian commended Moroni's portraits, *che gli faceva naturale*, which is
to say that he had an eye for the character of his bourgeois sitters, and
that he knew how to paint human type and station with the utmost
veracity.

XXIX. COLOUR CONSTRUCTS FORM

Jacopo Bassano

Painter of rustic genre and Biblical scenes. At first he employs clearly defined zones of clear colour and a certain linearism of figures. Later his colours are of exceptional glow and southern intensity. After 1560 his contours lose their incisiveness and become fused with the atmosphere. He develops the ripest painterly style of Venice where modelling with the brush effects changes of tone and of light. Human and animal shapes are embedded in the twilight of a luxuriant landscape. His elastic and sinuous figures, influenced by contemporary Mannerism, retain a measure of naturalism, even in his fantastical nocturnes.

The greatest provincial master of the Veneto, who developed apart from the main stream of figurative art at Venice, was JACOPO BASSANO. Born in 1510, the year of Giorgione's death, in the little mountain town that figures in so many of his canvases, and from which he took his name, Jacopo da Ponte ran the whole course of the Cinquecento and died in 1592, two years before Tintoretto who had so strongly coloured the last phase of his style. He had come to Venice as a young man of twenty-five, and there attached himself to Bonifazio's studio. By 1540, he appears to be settled for good in Bassano. And now there issued from his workshop that rich harvest of religious genre and pastoral, Nativities and Adorations and Good Samaritans, that homely blend of Biblical story and local lore of the Bassanese, of peasants and their flocks among the foothills of the Venetian hinterland. A painter of his mettle would by necessity absorb the best that other masters had already achieved : Titian's range of colour, the Mannerist forms of Parmigianino, and the heroic vastness of Tintoretto.

The surprising fact about Jacopo Bassano is not that he paints the countryside, or that he introduces idyllic genre and pastoral into the heroic trend of the sixteenth century, or that his colour is jewel-like, but that he develops from a linear beginning to the richest pictorial expressionism, where colour begins to compose and to construct form. Verci, a seventeenth century writer, wrote about Jacopo : ' Leaving detailed finish alone, Bassano employed only massive brush strokes, freely and well placed, with warm and luminous tints, and is all truth, nature and pictorial fire, full of shrewdness, where the figures stand out in full relief from the canvas. Viewed from nearby, his paintings appear an indistinguishable confusion of colours, but from the right distance they make that stupendous effect to which his masterly art and intelligence inspired him '.

322

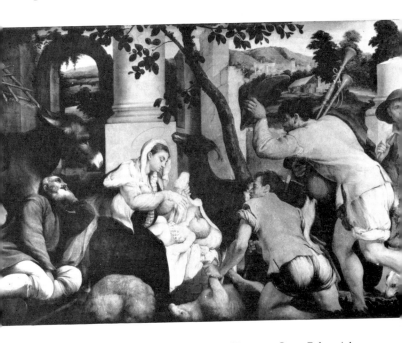

241. BASSANO. *Adoration of the Shepherds*. Hampton Court Palace (photo :
By gracious permission of Her Majesty the Queen).

The Hampton Court *Adoration of the Shepherds* is a significant work **241**
of Bassano's early style, where sparkling colour and linear movement
convey the rustic poetry of his favourite subject. In front of sombre
arch and lit-up column, in full view of the landscape around Bassano
with the Montagna del Grappa and the little township perched on the
bluish hills, the Holy Family has come to rest. The light brown tints
of the masonry are a foil for the dark foliage of the fig tree and for the
rose-streaked blue of the sky. But the main fascination rests in the
contrast of luminous colour and the dark shaded passages of the picture :
the pale buff of Joseph's coat, the purplish red of the Madonna, the
orange brown smocks and blue hose of the shepherds and the reddish
glow of the flesh ; stored sunlight of the Veneto. The sinuous shapes
and slender proportions of the figures, their rhythmical movement and
correspondence illustrate this stage of Bassano's work.

Bassano's middle-period culminates in the *Rest on the Flight to* **242**
Egypt at the Ambrosiana. Elements of the *Adoration* at Hampton
Court have been unified into a balanced masterpiece. The kneeling
shepherd and the recumbent S. Joseph are borrowings from the earlier
pictures. But now the design is more concentrated, the compact
figures are gathered beneath the diagonal which descends from the

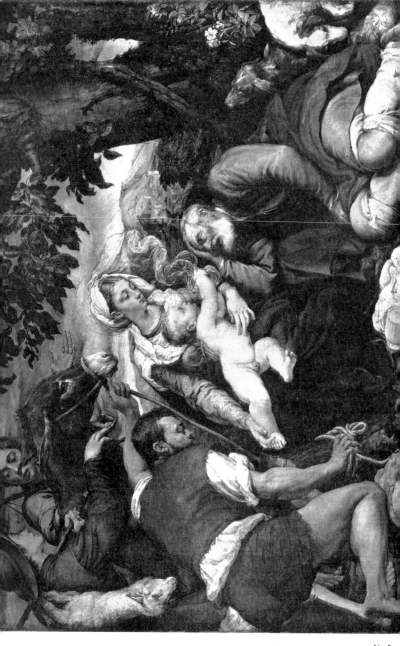

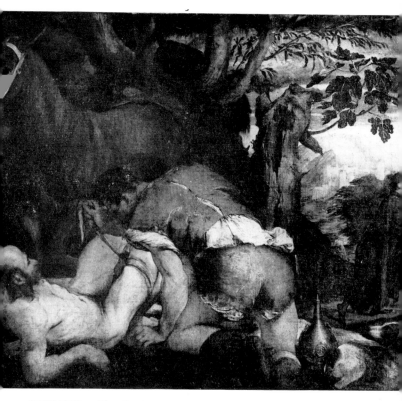

43. BASSANO. *The Good Samaritan*. Hampton Court Palace (photo:
By gracious permission of Her Majesty the Queen).

wo young shepherds to the exquisite dogs, and the upper half is left
ree for the familiar landscape of the Bassanese. The balance is
estored by the mighty tree which spreads its shapely leaves across the
zure sky. The great curving figures on either side of the Madonna,
he lively Child who strains after the veil fluttering in the breeze, and
he splendid shepherds coming in from the left are great zones of
uminous colour in the mosaic of the design. Colour of exceptional
rilliance reverberates in deep chords of moss green and cherry red and
hestnut, individual tints laid on without chiaroscuro. By the instinctive
ontrast of warm and cold hues, confined within the vigorous contours
f his figures, Bassano is on the way to becoming the greatest colourist
f the Venetian School.

Contours begin to lose their incisiveness, lines soften, drawing
ecomes suffused in colour in *The Good Samaritan* at Hampton Court. **243**
3etween 1540 and 1560 Bassano discovers that the brush will draw,

v

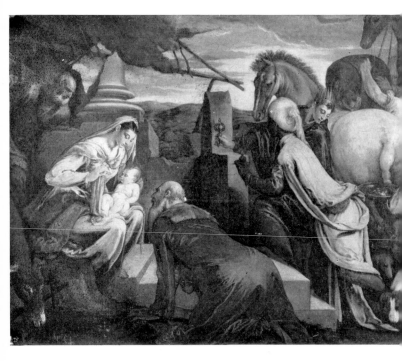

244. BASSANO. *Adoration of the Kings.* Vienna, Museum.

that tints graded by light will yield greater depth and atmosphere than linear confines of colour. The main impression in this picture is that of the deep glowing russet of the Samaritan, burning with an interior fire, where the flesh tints are only a shade lighter than the man's doublet and hose. All the modelling is now merely a change of tone and of light, a twist of the brush, as in the brilliant tracery of the man's shirt.

This furnace of colour is made more prominent by the darker hues of the background. The donkey, the mound, the trunks, are all shades of lighter and darker brown. Light grades the colour of the stump with its single branch of dark green leafage thrown across the turquoise blue of the sky. This shady grove, from which the Levite escapes with his book, is set against an airy distance, where the town of Bassano is lightly sketched in the hazy whiteness of its buildings and turrets.

When in 1560 Jacopo da Ponte painted yet another *Adoration of the* 244 *Kings*, he had reached supreme mastery in the handling of rich colour. A transformation had taken place in his approach to painting, a return to an extreme clarity of design and a Mannerist lengthening of the

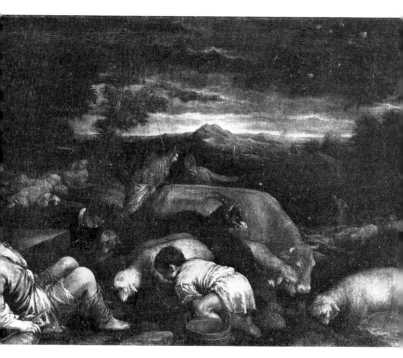

245. BASSANO. *Landscape with Shepherds.* Cambridge, Fitzwilliam Museum
(photo : Fitzwilliam Museum).

human form as in El Greco and Parmigianino, combined with a gorgeous
scale of colour, of moss green, rose and gold, and luminous blue. A
curious sophistication of all forms attracted Bassano for a time, and this
precious design with its towering horses of nervous elegance, its over-
sized modish figures with their conspicuously small heads, their
precious robes, their sinuous movements, is his contribution to the
style of Mannerism.

During the last twenty years of his life Bassano had evolved that
pictorial manner which placed him beside El Greco and Tintoretto.
He saw the rustic world around him not as a mosaic of neatly defined
objects, but as a unified whole of colour, now subdued, now blazing
from the enveloping chiaroscuro of his luxuriant landscape. *Jacob's
Journey* at Hampton Court and *Landscape with Shepherds* are supreme 245
examples of Bassano's late nocturnes, where colour and design are
conceived together, in the soft gleam of moonlight or sunset hues. All
the brilliance is concentrated in the left half of the picture, in the pale
lilac splendour of the graceful girl, where the brush modulates the

girl's bodice and skirt in the shimmering light. The painting of the boy with the significant forward slant of his body reveals the elastic and sinuous quality of Brassano's brush, which seems here to be dipped in liquid silver. The very movement of sheep and trees and men is enhanced by a prodigious colour harmony, where gold oranges gleam out of the turquoise blue of the distant dawn.

Bassano was perhaps the boldest colourist of the Venetian School, whose treatment of light and atmosphere aided the jewel-like accents of colour : his *pittura di tocco*. In painting patriarchal subjects in forms at once naturalist, mannered and fantastic, he and his sons, Francesco and Leandro, his close imitators, created the Impressionist style of Venice, a provincial art but ennobled by scintillating bursts of colour and light.

XXX. THE TRIUMPHANT CLOSE OF THE VENETIAN RENAISSANCE

Paolo Veronese

Splendour of Venetian life in a setting of Palladian architecture. Monumental decorations. Aristocratic feasts and banquets. No drama, no spiritual depth. Rhetorical figure compositions in one foreground plane. Noble gestures, reserve, ceremonial. Opalescent colour and transparent shadows. Scenic idealisations of an opulent reality. Fullness of life combined with refulgent colour and light.

With PAOLO VERONESE the art of the Renaissance comes to a triumphant close. Veronese was a Classical artist who painted the festive life of Venice, a ceremonious world of great splendour, in a setting of Palladian architecture. For his monumental decorations he favoured the great banquets of Christian history, the Marriage Feast at Cana, or Christ in the House of Simon the Pharisee, where he glorifies the sumptuous life of the Venetian aristocracy, a princely society in their festive gatherings, in great marble halls with Classical arches and columns. The religious life in these vast decorative paintings has become externalised. The figures are massed in one plane within the architectural order, in rhythmical groups, according to a contrast of lighted and shaded zones, in a harmony of opalescent colour. These are pictures of joyous existence, glorifying beauty, decorum, pomp and opulence. They are scenic and rhetorical idealisations of life.

In front of a Venetian balustrade of grey marble supported by columns and arches the captive *Family of Darius* is presented to **246** Alexander who welcomes them amidst his warriors. The decorative display in one horizontal plane is based upon the bold juxtaposition of complementary colours like the crimson of Alexander's robe between the deep gold and russet of his generals. The kneeling blond and roseate Venetian beauties robed in deep blue velvet and opalescent brocades, are not humbled in their pride. With such decorum a noble family would be received in audience by a king. The pageant of the scene is resolved in the splendid accents of red and blue before the silvery white of the marble arcade. Each figure is linked to the other in *contrapposto*, and the fullness of colour is matched by the fullness of light, without recession of space or atmospheric depth.

Veronese was born and bred in Verona. Before he became a true Venetian painter in 1555, he had absorbed the grey and silvery tones of Moretto, the Mannerist elegance of Parmigianino and the Michelangelesque schemes of Giulio Romano in nearby Mantua. In 1560 he

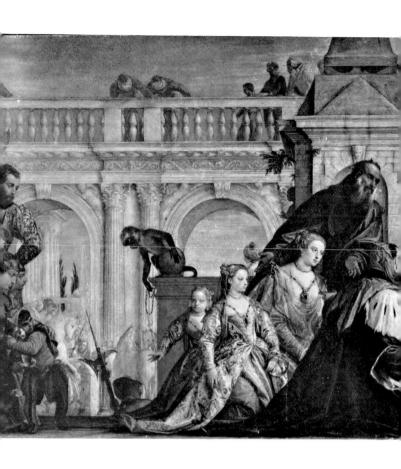

visited Rome, and soon after decorated the Villa Barbaro at Maser, built by Palladio. He painted mythological scenes in the style of Raphael : pagan gods and goddesses, disporting themselves upon clouds, in a setting of feigned architecture and garden landscape. His airy illusionism, the ease with which figures stand out from the delicate air or from a marble wall, his blazing sunlight and transparent shadows, his contrasts of rich and diaphanous colours, the graceful demeanor of his figures anticipate Tiepolo and the eighteenth century.

In an early work of his in the Galleria Borghese, Paolo created a **247** Watteau-like decoration, where *S. John the Baptist* steps into the picture, but points back to the Christ, who, an evanescent shape in pale Venetian rose, comes walking over the brow of the hill. The pale key of colours, of rose, pastel green, and shimmering yellow, and the impressionist shapes in the middle-distance, contrast with the stronger hues of the

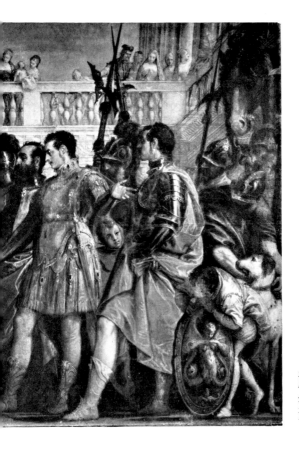

246. VERONESE.
*Family of Darius be[fore]
Alexander*. Lond[on,]
National Gallery (pho[to]
National Gallery).

foreground, and here S. John's more than human shape is enhanced by his turbaned disciples in their opulent brocades. From the kneeling woman in the foreground the eye wanders into the depth of silvery distances, where windswept trees bow and shelter the diaphanous Christ. The right arm of the Baptist and the diagonal trees enhance this depth, and the airy landscape is sketched in with the palest tints of green and ochre and blue.

During the second half of the sixteenth century Veronese and Tintoretto dominate the art of Venice. But there could be no greater contrast than that between the Olympian calm of Veronese, detached and serene in its Glorification of the Renaissance world and the dramatic expression of Tintoretto, who with his magical light and depth, his decentralization of space came to destroy the Classical tradition. Veronese rarely penetrates into depth of space or of the human mind.

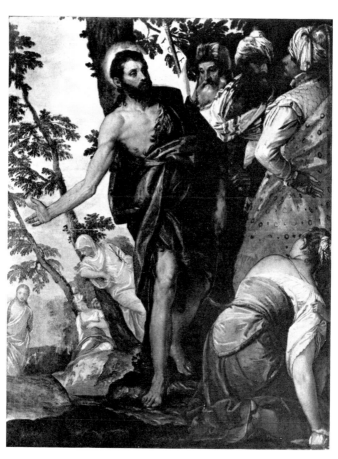

247. VERONESE. *S. John the Baptist*. Rome, Galleria Borghese.

248 When he paints the *Supper at Emmaus*, now in the Louvre, he deviates
little from the Classical order. Christ in a pale rose tunic, blessing the
bread, is foiled by a dark doorway. With the two pilgrims by his side,
the scene is composed within a flat triangle, whose apex is the pedi-
ment of the door. But this central group dissolves into the phalanx
of people who crowd the room, servants and children and Veronese's own
family standing for their portraits, his buxom wife with the youngest
child in her arm, his brother Benedetto, foiled by the column, and
the painter himself looking out from the shadow. Veronese's family
and the two children in their patterned taffeta, playing with their
spaniel, are there for no other reason than that which Veronese gave
to the Inquisition, challenging his liberty of inserting worldly detail

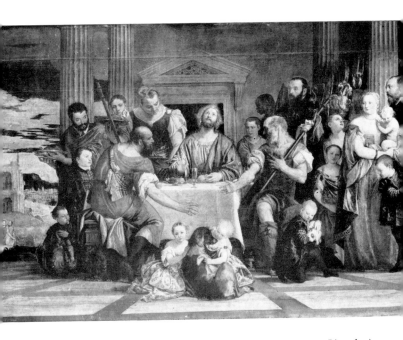

248. VERONESE. *Supper at Emmaus.* Paris, Louvre (photo: Giraudon).

into sacred pictures : ' Who do you really believe were present at that Supper ? ' (*Supper at the House of Levy*, in the Venice Academy) ' I believe Christ and the Apostles were present ; but if in a picture there remains unfilled space, I adorn it with figures according to my invention '. A bold and conclusive answer which goes far to explain Veronese's decorative purpose.

There is in Veronese a Classical sense of decorum, of seemliness and reserve in the poise of his figures which separate him from Tintoretto's northern expressionism. When he painted *Christ and the Samaritan Woman at the Well*, he composed a large oblong frieze, where the **249** protagonists in the foreground plane are distinguished by their dignified stance. To the beauty and seriousness of the Christ, wearing a dark green mantle over pale rose, corresponds that of the Samaritan woman in her opalescent silks of pale blue and gold. The centre is left free for the fantastic landscape under the deep grey blue of the sky, and there in the hollow under the windswept trees the Disciples approach from the city. The cool light, falling in from the left throws into relief the resplendent figures, inclining towards one another, and tips the foliage with ghostly silver. In the emotional restraint, the nobility of gesture of his principal figures Veronese creates the decorative form

333

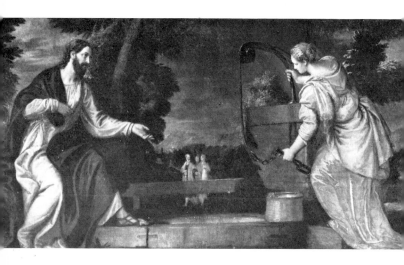

249. VERONESE. *Christ and the Samaritan Woman at the Well*. Vienna, Museum (photo : Rijksmuseum, Amsterdam).

and pattern for subsequent presentations of Christ's meeting with the Samaritan woman.

Apart from his rare portraits, Veronese did not work from a model and his art remains anti-naturalistic. In the Palazzo Ducale he created those vast decorative fancies like the *Triumph of Venice*, or *Venice enthroned between Peace and Justice*, in which his pictorial genius culminates. Equally imposing are the four Allegories in London, broadly conceived figures in harmonies of dark olive green, dull gold, rose and grey, silvery arabesques, patterned againt the grey sky.

Classical composure and serenity inform the graceful figure of **250** *S. Helena* in the National Gallery. The decorative complexity of the Venetian feasts and banquets is now resolved into one calm and monumental figure, standing out in the delicate air or from a grey marble wall. The melancholy of the Saint, enclosed in the rectangular framework of the great window is contrasted only by the turbulent cherubs, illustrating her vision of the discovery of the Cross, and emphasizing the diagonal of the composition. Presence and formal dignity of S. Helena are enhanced by the envelope of generous folds in the subdued tonality of her dress, matt gold and shimmering rose. Yet even in his most refulgent fancies Veronese remains an artist of the Renaissance, a stylist, a decorator, by his large and stately designs, his elegant opulence. Human relationship resolves in types, in noble gesture,

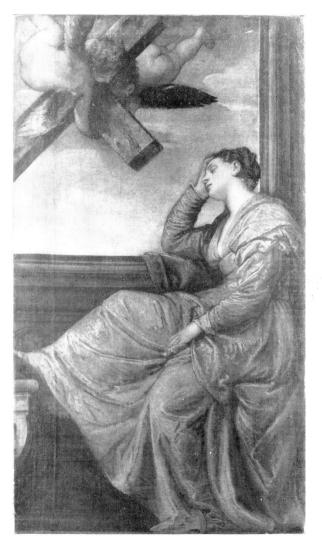

250. VERONESE. *S. Helena*. London, National Gallery (photo : National Gallery).

reserve, ceremonial, the preciousness of costume and patterned stuffs, enveloped by the diaphanous air of Venice, and foiled by the marble architecture of Palladio.

XXXI. MAGIC LIGHT AND THE DISSOLUTION OF FORM
AND OF SPACE
A VENETIAN MANNERIST

Jacopo Tintoretto

Venetian colour combines with chiaroscuro. Dramatic accents of light. Tempestuou
movement inward and outward of the picture plane. Diagonal thrust into space
End of the Classical conventions of giving equal value, clarity, and detailed finish t
each figure. Summary, often sketchy painting. Mobile forms set in an infinity o
space. Religious impetus of the Catholic Revival. Hallucinatory lights and phantom
figures of his late style preclude El Greco as his portraits have the profundity o
Rembrandts' and his magic of light.

To the Classical clarity of Veronese, where figures exist side by side
in the foreground plane of the picture, TINTORETTO opposes the Baroque
concept of movement into the depth of space. To Veronese's silvery
tones and radiant daylight, he opposes the rich broken colour of Titian
and his own power of shadow and magical light; to Olympian serenity
his Mannered expressionism of form. Tintoretto's originality as a
space composer, breaking away from the Classical tradition can be seen
251 in his *Presentation of the Virgin* (1552), for which he had Titian's version
in the Scuola della Carità. Titian had organised a grand narrative in
breadth, with Mary ascending alone the profiled steps of the Temple,
followed by a long train of Venetian dignitaries, all portraits, and foiled
by mountain peaks and Renaissance architecture. Tintoretto translates
the broad horizontal scene into an upright composition, viewing the
rounded ' mountain of steps ' from the side, with Mary, small and
solitary facing the towering priest on the summit. He divided the
picture into zones of light and shadow, placing his figures in the interval
of space, like the woman pointing upwards and the group sitting upon
the stairs. Other figures clinging to the shadow of the wall continue
the movement into the depth of the picture and up to the top, where the
Virgin is silhouetted against the sky. Tintoretto's vision combines
something of Michelangelo's sculptured bodies with the Mannerist
elegance of Parmigianino, but is wholly original in the organisation of
space and in the arbitrary accents of light and of dark, within the Vene-
tian harmony of dark rose, lilac and grey.

The tempestuous movement inwards and outwards of *S. George*
252 *slaying the Dragon* and the Princess fleeing from it, is enhanced by the
windswept trees, the rolling folds of the countryside, and the fleeting
shadows upon the castle. The story unfolds not in breadth as in
cf. Carpaccio's profile narrative of the fight, but in depth, which extends
125

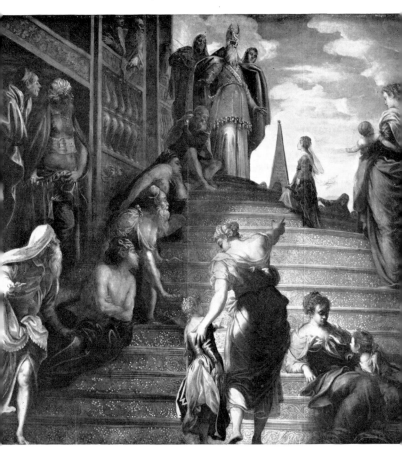

251. TINTORETTO. *Presentation of the Virgin.* Venice, Madonna dell'Orto
(photo : Fiorentini).

across the greenish sea to the luminous horizon and the elliptic whirl
of light forming in the cloud-swept sky. Accents of colour, deep blue
and rose, heightened with white in the fluttering robes of the princess,
ring out upon the pastel green and light brown of the landscape ;
and the rotating movement of sky and earth accompany the agitation
of the figures. In the unequal vastness of Tintoretto's work the legend-
ary scene stands out by the novelty of the design, the fantastic shore
seen from above, the exquisite elegance of the princess and the blazing
light in the bluish green atmosphere of sky and sea.

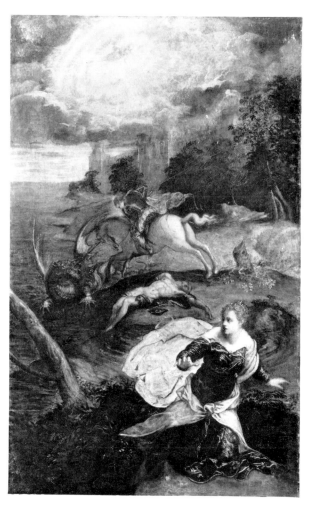

252. TINTORETTO. *S. George slaying the Dragon.* London, National Gallery (photo : National Gallery).

Tintoretto combined Venetian colour and heroic form with a predilection for strange lights and floating movement. In his youth he had experimented with waxen figures suspended in boxes, and drawn them by the light of candles. This may explain his odd angles and viewpoints and circular movements, for he was used to seeing figures from above or below in fantastic effects of light. He studied in this way the intricacies of space, the aerial void in which bodies move, the light that hits flat and rounded surfaces. He broke with the Classical convention, with balance and clarity of each figure and set his mobile

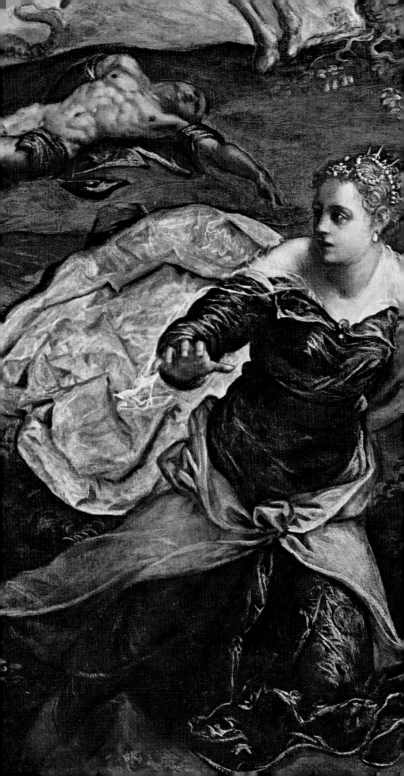

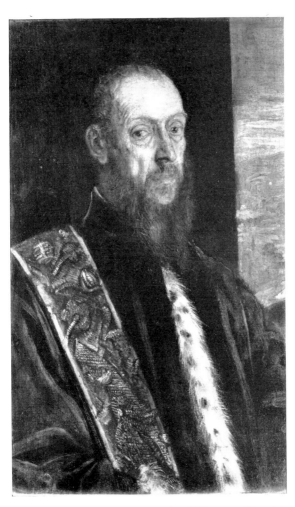

253. TINTORETTO. *Portrait of Vincenzo Morosini.*
London, National Gallery (photo : National Gallery).

forms in an infinity of space. He conceived crowded compositions of vast
dimensions. But if Tintoretto's manner was revolutionary, his subject
forms in an infinity of space. He conceived crowded compositions of un-
limited vastness. But if Tintoretto's manner was revolutionary, his sub-
ject matter, drawn from Christian religion and pagan antiquity, lay
within the cultural orbit of his age. He was a passionate Catholic of the
Counter Reformation, a champion of the *Ecclesia Triumphans*, whose
symbols he glorified in countless narratives from Holy Script and the
miraculous lives of the Saints.

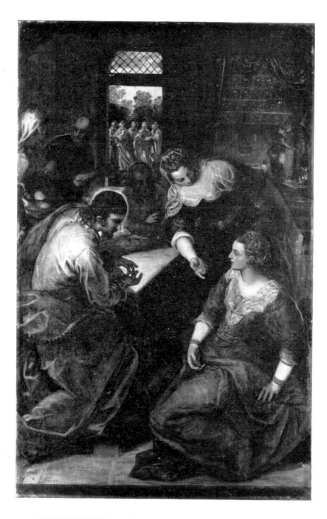

254. TINTORETTO. *Christ in the house of Martha and Mary.*
Munich, Museum (photo : National Gallery).

His portraits reveal a more summary style than Titian's. They are more haunting and penetrating, like the grandiose half-length *Portrait* **253** *of Vincenzo Morosini* in the National Gallery. The face of the Venetian Senator in his velvet robe of dark crimson and gold-embroidered stole, is modelled by chisel strokes of the brush in the bright frontal light, and the unyielding character of the man who commanded the Venetian forces in the Turkish war, is powerfully inscribed. His wintry shape with the strong nose, sealed lips and puckered brow stands erect before

he dark vertical foil, while his left shoulder slants towards the open vista of a greenish blue landscape, sketched in rapid impressionist swirls of the brush.

The Munich *Christ in the house of Mary and Martha* is perhaps 254 simultaneous with the decorations of the Upper Hall of the Scuola di San Rocco with episodes from the life of the Saviour. The intimate scene takes place in a darkening interior open at the back, with a servant busy at a cupboard of Venetian glass. This is a sombre foil for the rotating movement of the three principal figures at the table. The vital moment of Christ's words—BUT ONE THING IS NEEDFUL AND MARY HAS CHOSEN THAT GOOD PART WHICH SHALL NOT BE TAKEN AWAY FROM HER— is reflected in the emphasis of His gaze and gesture, and in the arabesque of His hands, silhouetted against the brightly lit table. Mary, a Venetian lady in sumptuous dress, listens entrancedly and does not heed her sister's request to come and serve. Outside the Apostles are waiting, phantom shapes sketched in with nervous zig-zagging strokes like Magnasco's hermits.

For twenty-three years Tintoretto served a religious confraternity in Venice, the Scuola di San Rocco. Here he painted, for their newly built church and house, scenes from the Old and New Testament (1564-1587). It is his *magnum opus*, in which he expressed his most personal vision of the Bible, a complete Christological cycle, comparable to that of the Byzantine mosaics. On the ceiling of the upper hall he painted episodes from the Old Testament, *Moses striking the Rock*, or the *Gathering of Manna*, and these correspond with the panels on the wall, drawn from the Gospels. The story of Christ, His miracles and His Passion, from the Nativity to the Ascension, is told with a visionary force and creative fury which reveals the new religious impetus of the Catholic Revival. The language of form, the hallucinations of Tintoretto's invention, his spectral use of light to convey mystery, are without parallel before the coming of El Greco. For Tintoretto employs light and shade to blot out or illuminate at will. It is his main vehicle of expression and serves his dramatic purpose and his presentation of the supernatural. Rapid light—Longhi's *scrittura di luci*—transforms the Biblical scenes into a luministic network, where the protagonists emerge out of pools of shadow. In the *Agony in the Garden* half the picture space is impenetrable darkness ; but from it the heroic Christ, succoured by a huge cup-bearing Angel, stands out in a wheel of light, which reverberates on the phosphorescent leaves, beneath which the Apostles lie in a huddled heap. Behind them, phantom-like, Christ's captors approach out of the forest darkness, led by Judas.

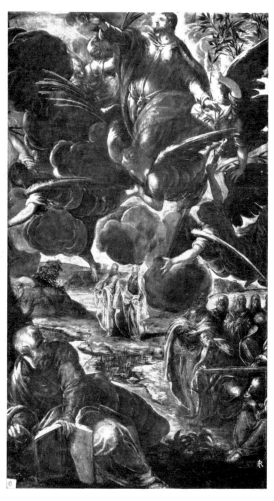

255. TINTORETTO. *Ascension*. Venice, Scuola di
San Rocco (photo : Anderson).

255 In the *Ascension* a wholly fantastic lunar landscape of caves and rock
harbours isolated groups of Apostles like disembodied spectres who
gaze up in dismay, where Christ has risen upon black convolutions of
cloud ringed with light. Amidst these explosive vapours large angels
float, their wings and arms spread wide, swinging branches of olive and
palm. And here the contrast between the scattered Apostles—ghostly
shapes seen in arbitrary perspective in the incongruous space—and the
superhuman Christ borne aloft upon giant wings, is such that the

256. TINTORETTO. *Christ carrying the Cross.* New York, A. R. Ball Inc.
(photo : Rijksmuseum, Amsterdam).

Mannered theatricals of the *Ascension* outweigh and outbalance the
earthly desolation.

Movement is the soul of the Baroque, and the *Christ carrying the
Cross* becomes in Tintoretto's hallucinatory fancy a cavalcade of riders **256**
and lancers up the winding slope of a hill. The movement is not into
depth of space, but upwards in spiral fashion, and the relentless proces-
sion of horsemen and pikemen and standard bearers with banners
unfurled diminishes in scale until it disappears over the brow of the
hill. Below in the theatrical light the drama unfolds with Christ breaking
down under the cross, Veronica wiping His brow, the Madonna
swooning, and S. John wringing his hands in despair. The actors of the
Passion are arrayed along the huge beam of the cross, and the upper

train moves parallel to it but in the opposite direction. The artist of the Catholic revival arouses the religious emotion by contrasting the cruel haste of the executioners with the agony of the sacred personages.

The final word of Tintoretto, the *Last Supper* in Santa Maria Maggiore, painted in the year of his death, is also his supreme essay in the spiritualization of form by the supernatural light. No Last Supper is further removed from Leonardo's Classical symmetry and its individualization of the human form. As a fore-runner of the Baroque, but by his fierce anti-Classical reaction really the chief exponent of Mannerism, Tintoretto composes in the diagonal. He has flung out the diminishing plane of the table into the depth of the room and dissolved the wall on the side of the Apostles by cascades of diffused light which radiate like a wheel of fire in all directions. In this luminous haze angels beat their wings, and their spectral bodies float in the vast ambience of the scene. There are two sources of light : the hanging lamp with the flames leaping over its border, and the haloes around the small dark heads of the Apostles. There is no action, no announcement of the coming betrayal. Christ in a circle of blazing light gives the Host to a disciple. But there are two contrasting spheres : the servants who busy themselves with the meal throw into stronger relief the row of Apostles, experiencing the supreme Christian mystery. These are no longer individuals of marked conduct and character like Leonardo's Apostles, but nameless abstractions whose substance is light and shadow. The Byzantine symbolism of gesture resolves into a ' surrealistic nocturne ' of expressionist force.

XXXII. THE BIRTH OF A NEW STYLE—THE ROOTS OF THE BAROQUE AND THE MODERNISATION OF THE CLASSICAL IDEAL—THE SCHOOL OF BOLOGNA : I

Lodovico and Annibale Carracci

The Carracci Academy was founded in the fifteen-eighties to put an end to Mannerism by a direct inspiration from nature. LODOVICO CARRACCI who remained in Bologna, was prompted by the Counter Reformation and painted religious pictures in the emotional and luministic style of the early Baroque. ANNIBALE CARRACCI created the new style of the Seicento by his Roman frescoes in the Palazzo Farnese. These are inspired by a study of the Antique, by Michelangelo's nudes and Raphael's mural decorations, but breathe a new freedom of the senses and a Baroque exuberance. Naturalism, fantasy, and the painterly style of Annibale create in the Farnese frescoes a new language of form which is Classical as well as Baroque.

The Mannerist experiment had proved an impasse in Italian art, and the reaction against its abstractions—apart from the new realism of Caravaggio—came from a great family of artists, born and bred in Bologna : the Carracci. The three principal members of the family Lodovico, Agostino, and Annibale, formed a joint workshop in Bologna in the fifteen-eighties, with the idea of giving painting a new start by breaking with the current formulae of Mannerism. That the study of nature played a prominent part in this endeavour must have been due in great part to the youngest and greatest, Annibale. The Carracci were able to sweep away the artificialities of Mannerism because they were above all experimentalists, just when that quality was most needed.

The eldest, LODOVICO CARRACCI, always lived in Bologna, and so was unaffected by the powerful Classical influences encountered by his cousins : Agostino, chiefly noted as an engraver, and Annibale, who both went to Rome in the fifteen-nineties. Lodovico was a visionary, whose new imagery in treating religious themes was in tune with the Counter Reformation, which sought to harness the visual arts to the service of a militant and rhetorical church. Painting, wrote Cardinal Paleotti at Bologna, when Lodovico was still in his twenties, should penetrate far deeper into the minds of men than words, and Lodovico's pictures owe their emotional impulse to sincere participation in the Catholic Revival. Lodovico's art is accordingly devotional and even austere—in contrast to Annibale's glorification of the physical prowess of pagan antiquity. Lodovico appeals to the popular emotion by a new poignancy and directness in his religious compositions, often aided by

346

258. LODOVICO CARRACCI. *Trinity with the Dead Christ*. Vatican
(photo : Gallerie Musei Vaticani).

a mysterious and romantic luminism, which was to be the seed of an
important element in Baroque art.

In his picture of the *Trinity with the dead Christ* he speaks the pictorial 258
language of the Catholic revival. The figures are boldly composed
into an intricate pattern based upon two diagonals. The religious
emotion is roused by the radiant body of the dead Christ in the lap of
the Father, who is surrounded by sorrowful angels bearing the instru-
ments of the Passion. Planes of deep shadow alternate with brilliant
light coming from an invisible source, and sculptural form is combined
with pictorial fluency. The tonality is subdued : Venetian red and gold
and a large sapphire adorn the Eternal Father, and the dark angel on
the right is clothed in russet. Great swirling brushstrokes define his

259. LODOVICO CARRACCI. *Flight into Egypt*. Bologna, Casa Taccon
(photo : A. Villani & Figli).

wings, and it is in the pictorial manner as much as in the billowing
clouds and folds and the restless light, and its spiritual accents that the
Baroque is made manifest. Lodovico's art is here very much in tune
with that of his greatest follower Guercino.

But Lodovico is not always as compassionate and emphatic, and
259 his poetic imagination transforms the *Flight into Egypt* into an idyllic and
intimate story. The Holy Family is seated in a barque which a youthful
boatman guides across the water, while behind them and unknown to
them two angels hoist the sail. Lodovico has not forgotten the ass
nibbling in the shadow of the boat, while the evening sun lights up the
low horizon and the silhouette of town and wood.

ANNIBALE CARRACCI provides a striking contrast to Lodovico. He
was endowed with an unquenchable curiosity, and was far more
interested in exploring and mastering natural appearances than his
visionary cousin. In certain early works, notably in the almost Cezanne-
like *Bean Eater* in the Colonna Gallery, he achieves a degree of elementa
realism which was at the time unique. He is usually thought of as ar

dealizing artist—on account of the Classical flavour of his greatest work, the Farnese frescoes in Rome, but he was also the inventor of portrait caricature—the precise reverse of idealization. His range and originality were in fact considerable ; a study of his achievements as a draughtsman on paper abundantly testifies to this.

When Annibale was painting his great altarpieces in the decade preceding his Roman residence, he had already studied Correggio in Parma (about 1585), and he followed this up with a visit to Venice around 1587-88, which brought him under the influence of the works of Titian and, above all, of Veronese. His religous paintings, except towards the end of his career, do not stir to sadness or contrition, but are joyful hymns of festive splendour. This spirit is visible at an early stage in the *Baptism of Christ* (1585) at Bologna, where angelic choirs play on flutes and viols in a luminous heaven.

The sensuous beauty and naturalness of copse and river are Annibale's vision of the Christian Universe, and they too were not inacceptable to the Counter Reformation. Indeed he never lost his special interest in landscape, a field which was purely marginal to Lodovico. Pagan subjects—the exception with Lodovico—were well suited to Annibale's temperament, and he had tried his hand at a number of them when he received the summons to ' recreate Antiquity ' at the Palazzo Farnese in Rome. Equipped with a love of colourful richness, fostered by his contacts with Venetian art, and a sense of order amid variety, he set out for Rome around 1595 to carry out his greatest task. This, commissioned by a Prince of the Church, Cardinal Odoardo Farnese, had for a subject a cycle of pagan mythologies illustrating the Power of Love ; of *Bacchus and Ariadne, Polyphemus and Galatea*, of *Paris and Mercury* and other legends of Antiquity. It enabled Annibale to take his place in a tradition of monumental fresco decoration which already included Michelangelo and Raphael.

It is in these decorations of the Palazzo Farnese that Annibale comes into his own with paintings derived from Michelangelo's nudes and from Roman statuary, but endowed with a new freedom, a new life likeness and a passionate sensuality. Never before has an artist filled Antique fable and statuary with a more modern spirit, a more personal lightness and gaiety ; and though his gods and heroes are a race of Olympians, they move with the joy and ecstasy of figures in a Classical frieze in the fullness of the senses.

Annibale's triumphal trains and chariots of *Bacchus and Ariadne* with **260** horned Pans and flying putti have exchanged the Classical serenity and calm of Raphael for the dynamic drama, the all-pervading glow of life of Rubens. With the Galleria Farnese begins a new mode of mural

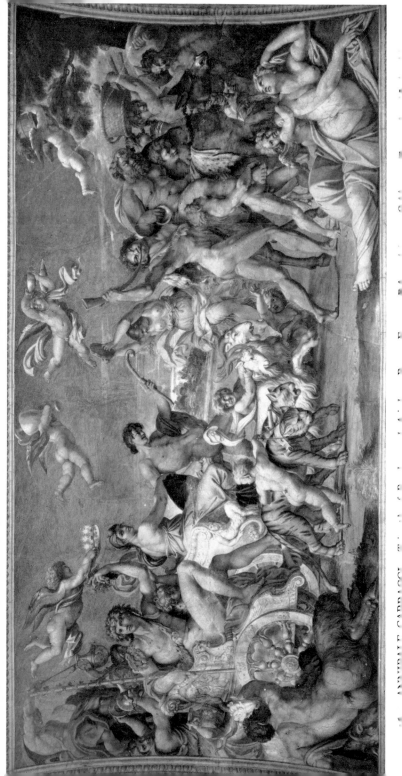

ANNIBALE CARRACCI, *Triumph of Bacchus and Ariadne*. Rome, Farnese Gallery.

261. ANNIBALE CARRACCI. *Polyphemus and Galatea*. Rome, Farnese
Palace (photo : Gabinetto Fotografico Nazionale).

decoration : a great illusion of bronze, stone, and flesh colour, a feigned
architecture, a feigned world of Antique heroes, a romantic dream of a
Classical past. It is a decorative coexistence of sculptured nudes,
seated on low thrones like Michelangelo's Slaves, of athletic Atlases
and Caryatides, and of winged genii fluttering around cameo-like reliefs
of mythological scenes. These closely packed and overlapping forms,
by their airy illusionism, their ripeness, their radiance, are a fantastic
reincarnation of a pagan world. As they blossom out between vaults
and stone cornices, they are Annibale's full-blooded anticipation of the
Baroque.

The sculptural illusion of the Farnese ceiling is obtained by the
setting off of colours, all bright, but graded. A bronze coloured faun
reclines in front of the golden chariot of Bacchus, and the god's darker
hues are seen against Ariande's roseate flesh, before the pastel green
of the countryside. The Bacchic train reaches its height in the wild
ecstasy of the dancing nymph and the satyr blowing his horn. Anni-
bale's ceiling is a half-way house between Titian and Rubens in its
Classic composure and controlled exuberance.

262. ANNIBALE CARRACCI. *Paris and Mercury*. Rome, Farnese
Palace (photo : Gabinetto Fotografico Nazionale).

In the smaller panels and feigned corners mythological love scenes
framed in gold to look like canvases, alternate with medallions, caryatides
and stone-coloured nudes ; gigantic anatomies in postures of arrested
movement, where all is daylight brightness, luminous fleshtints, sunlight
262 and azure. In *Paris and Mercury* the god floating through the sky is
seen *di sotto in su*, a heroic shape, the whole length of his body extended,
and beneath him Paris reclines, blond and roseate like the dawn, with
his huge staff and dog. This painting and the sylvan Pan opposite are
the most sculptural and grandly conceived divinities of the Galleria,
261 besides the mythology of *Polyphemus and Galatea* on the short side of
the ceiling. Here Polyphemus, a gigantic shape with swelling thigh

63. ANNIBALE CARRACCI. *Bacchus playing to Silenus*. London, National Gallery (photo : National Gallery).

foreshortened, plays the reed-pipe to Galatea, who approaches the shore on her dolphin-drawn shell, her rose coloured veil arched in the breeze like sail or canopy. The nude youths appear less strained than Michelangelo's in the Sistine ; yet they are painted with enhanced naturalism, their muscular bodies, sinews, chests, backs built up of swelling flesh. But if they are true to nature, they are greater than life ; they are Roman sculpture translated into a Baroque medium of paint, and by this transformation they have received a new soul.

Two small canvases from the time of the Roman frescoes, *Silenus gathering Grapes* and *Bacchus playing to Silenus* are in the National Gallery, and these invoke the same world of pastoral poetry of a Golden Age, where gods and wood-creatures people the sunlit earth in unselfconscious existence. In the *Bacchus playing to Silenus* the ruddy flesh-tones of the Arcadian figures are set against the pastel shades and ochres of undulating folds, the silvery leaves and russet trees under the green streaks of the limpid sky. It is an idyll of primeval times, where reed-pipe and flute are hanging on the trees and the musical colloquy of the gods melts into the harmony of the spheres. 263

Then in the *Domine Quo Vadis*? Annibale created a mature composition in which Classical form and religious emotion are perfectly balanced. The moment is represented when Peter, fleeing from persecution, encounters the Lord bearing His Cross. Christ's swift advance, His arm raised, His great Cross shouldered, is reflected in the start of Peter who recoils in terror. The heroic form of Christ is conveyed by the vigour and radiance of His body and enhanced by the roseate mantle and the great Cross which thrusts into space. The deep ultramarine of Peter's tunic is in harmony with the lighter azure of the 264

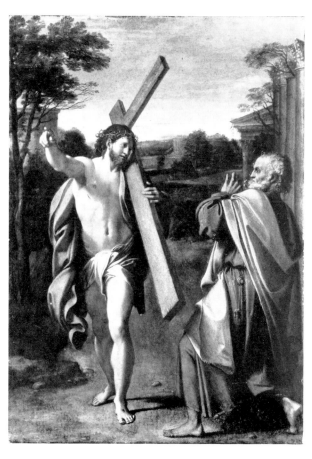

264. ANNIBALE CARRACCI. *Domine Quo Vadis* ? London,
National Gallery (photo : National Gallery).

midday sky. The white rays of the sun cause short shadows as firm
as the bodies. The two solitary figures are framed by the Classical
temple and columns, and behind this lies a landscape of receding
meadows and dark foliage in the softer light of the middle-distance.
Antique and modern elements mingle in a composition which by its
balanced design, its plastic sequence, and its emotional content, is like
a summary of Annibale's Roman achievement. In these ripest works
of his short life Annibale attains a Raphaelian classicism of form and a
refinement of all pictorial means which point the way through Domeni-
chino, whose evocative landscapes owe much to his example, to that
consummate Classicist Nicolas Poussin.

354

XXXIII. THE BIRTH OF A NEW STYLE —

THE SCHOOL OF BOLOGNA : II

Guido Reni — Domenichino — Lanfranco — Guercino

In GUIDO RENI a reaction to the religious rhetoric of the Baroque leads to a refined and sensual Classicism and a neo Hellenistic beauty and purity of the human form in the wake of Raphael. DOMENICHINO combines Classicist tendencies of elaborate and balanced design with the religious iconography of the Counter Reformation. In his Classical landscapes with figures he creates a new genre before Poussin and Claude Lorrain. GUERCINO, the foremost religious painter of the Catholic Revival, is Lodovico Carracci's follower. Later, in Rome he overcomes a certain realistic harshness and the contrasts of restless light and powerful shadows of his Baroque is painterly by a more Classical mode of composition.

A flourishing school of younger painters received tuition in the Carracci workshop. Of these the eldest and most celebrated was GUIDO RENI (1575-1642) who, yearning after a Raphaelesque and indeed almost Grecian ideal of the human form, rejected the demonstrative illusionism of the Roman Baroque, to find refuge in a highly personal world of refined elegance. At about twenty he had entered the Carracci workshop, or academy as it came to be called, at Bologna, which by that date was run by Lodovico alone. At twenty-five he reaches Rome. After the briefest flirtation with a somewhat attenuated form of Caravaggesque realism, he returned for a short stay in Bologna, where he came again into contact with Lodovico. The young Reni possessed that innate sensitiveness to the subtleties of singing line and rhythm which Lodovico lacked. Henceforward he dreams of a neo-Hellenistic beauty and purity of the human form—an abstraction which distinguishes his Classicism from the more substantial, more earthbound version of Annibale.

Reni was an artist for art's sake. He deifies man and distils from his imagination an ideal humanity in balanced and rhythmical compositions. He seems to have lived in an aristocratic sphere of his own dream creations, divorced from nature and from the main streams of contemporary art. He was equally averse to Caravaggio's realism as to the formal abandon of the Roman Baroque. Born half a century after the Classical age, his nostalgia for Raphael's antiquity turns him not into a Classic but a Classicist artist.

His women are antique heroines of rich and luxuriant beauty, as in *Lot and his Daughters leaving Sodom*, and here he reveals his power as a **265** great colourist in the glowing scarlet of Lot's mantle, the mauve grey

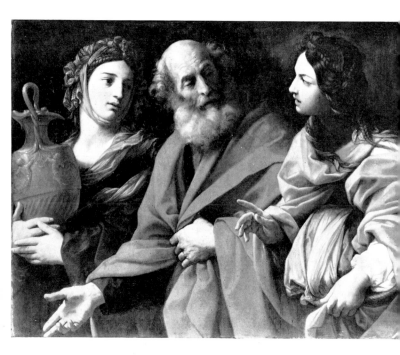

265. GUIDO RENI. *Lot and his Daughters leaving Sodom.* London, National Gallery (photo : National Gallery).

of the daughter carrying the pitcher, and the opalescent gold of her sister's voluminous robe. These sumptuous and glittering textures are matched by the richly graded colour in the radiant light, and the marmoreal beauty of the daughters of Lot. Moreover, Reni combined the effects of movement with psychological innuendo and enlivened the Classical symmetry and grandeur of his figures by persuasive looks and expressive gestures.

In the *Massacre of the Innocents* he endowed a Christian subject with a sense of Classical order and Raphaelesque form. This composition is so closely knit, so firmly held in its dramatic correspondence of figures, the tempered violence of the executioners, and dignified grief of the mothers, that it becomes a symbol of the historical scene. By his architectural build up of figures, the emotional restraint and the beauty of the human form, Guido ' raised the subject from the horrific to the level of tragedy ' (Burckhardt).

Europa and the Bull was painted in Reni's late period. In her sweet melancholy, her sentimental abandon, her voluminous form, she is one of Reni's significant shapes. Titian's Europa is more dramatic,

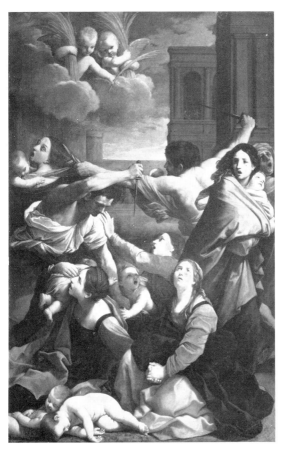

266. GUIDO RENI. *Massacre of the Innocents*.
Bologna, Pinacoteca (photo : A. Villani & Figli).

assionate and fierce ; Veronese's more decorative and festive ; but
Reni's goddess has the languor, the largeness, the lassitude of his
Classicist ideal. As she sails on the grey crests of the waves, sitting
astride the gentle bull, her robe billowing in the breeze, her eyes lifted
up to heaven, she is a memorable invention in the ordered complexity of
the design, the silvery transparency of tones. Reni no longer employs
the forceful design and glowing colours of his youth. Forms are softly
modelled, tones evanescent and graded, golden yellow and pale purple
and bluish grey. Her loose and abandoned pose, her musical rhythm,
her restrained emotion are more Christian than pagan. Europa's softly
gliding shape in the ' clear diffused light, transparent paint and graceful
linear rhythm ' (Mahon) illustrates the late style of Guido Reni.

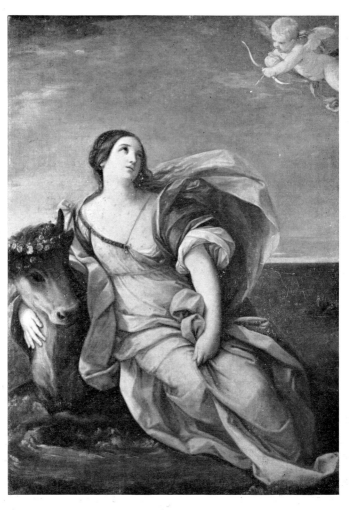

267. GUIDO RENI. *Europa and the Bull*. London, Denis Mahon
Collection (photo : Courtesy Denis Mahon).

In 1614, after completing his famous *Aurora*, Guido left Rome and
made Bologna his headquarters. He remains anti-Baroque in the
slender grace of his figures and in the clear transparency of his colour
especially in the last decade of his life. The Dulwich *S. John the*
268 *Baptist preaching* reveals a mastery of design, colour and light, a style
as lyrical and poetic as Raphael's or del Sarto's S. John in the previous
century. The prophetic character of the preacher in the wilderness is
expressed in his lean body, his possessed gaze, his savage hair. The nude
figure is poised upon its rock, so that the subtle balance of uprights

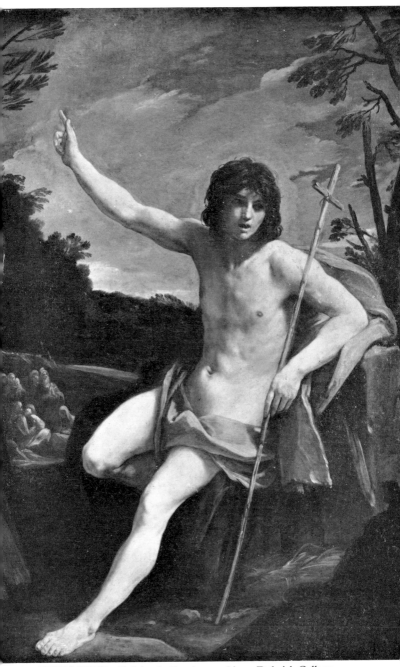

268. GUIDO RENI. *S. John the Baptist preaching.* Dulwich Gallery.

and horizontals is maintained. The raised arm of the prophet repea
the gentle curve of the forest, and the slender cross which he holds
continued in the tree. The adolescent form of S. John is modulate
by soft light and flickering shadows, and set against the chiaroscuro o
the woodland glade where his pupils are forgathered. The shadow
dissolve into the roseate flesh tones of the body, which is tense and tau
like his spirit. In harmony with this radiant figure is the woodlan
clearing, where the disciples huddle in the half light, with its touche
of mauve and of blue. The colour sensibility of Guido shuns the lou
tones, and the prophet's loincloth is painted in a dull silvery greer
almost the colour of the rock. The Dulwich *S. John* in his transparenc
of tints is a work of such refinement and delicacy that Reni appears a
an antidote to the more robust and naturalistic members of the Bolognes
School.

DOMENICHINO (1581-1641) was coeval with Guido Reni. Lik
him he was born and bred in Bologna and trained under Lodovic
Carracci. When he went to Rome in 1602 to join Reni and Alban
he worked as Annibale's assistant in the Palazzo Farnese, and later wa
employed in decorative paintings by Roman Cardinals. He wa
essentially the heir of the Classicism of Annibale's last period. Th
Counter Reformation promoted a new iconography with specia
emphasis on the cult of the Virgin, of Saints and sacraments, th
penitential and the ecstatic character of the Christian religion. I
269 *The Last Communion of S. Jerome* (1614) Domenichino created one o
the most significant paintings of the Catholic revival. The dying Sain
supported by his disciples, receives the Eucharist from the hands of th
priest, in pious ecstasy, while angels pray and frolic in the sky. Th
spirit of the great altarpiece, its emotional warmth, the awe an
solemnity with which the Sacrament is administered and received
denote the new religious vitality in the art of the Roman Baroque. Bu
the elaborate and balanced design, so firmly held by the great centra
arch in front of the architectural landscape, his idealised clearly define
figures, their grace and gravity, show the Classicist tendencies o
Domenichino.

The subdued tonality, the sacramental dignity of the great pictur
are heightened by powerful chords of colour : the bright crimson o
Jerome's loincloth, the dull gold of the ministering priest and th
deacon's purple. The light from above illumines the grey withere
flesh of the anchorite, plays brightest upon the joyful cherubs an
comes to rest upon the kneeling acolyte. The religious mood i
reflected in the restrained gestures of the attendants.

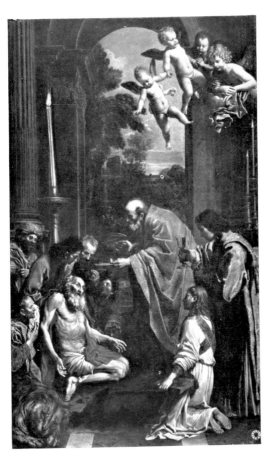

269. DOMENICHINO. *The Last Communion of S. Jerome.* Vatican (photo : Anderson).

In his Roman paintings Domenichino assimilated influences from Raphael and from Titian, but in one field he became himself a fore-runner of other great masters : in the Classical landscape with figures, and the architectural build-up of all its elements. The *Landscape with Fortified Buildings* (in the collection of Denis Mahon) is a masterpiece **270** whose relation to Annibale Carracci's setting of the *Flight into Egypt* needs no emphasis. It is a Roman landscape with a prospect of the luminous sea and a great central pile of rocks and castle. The breathless beauty of southern shores, the hazy distances, the blue mountain peaks and framing trees will find their future poet in Claude Lorrain, while the architectural synthesis of Roman buildings and wooded folds in

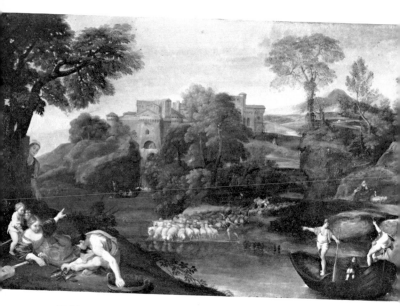

270. DOMENICHINO. *Landscape with fortified Buildings.* London, Denis Mahon Collection (photo: Courtesy Denis Mahon).

their gradations of warm greens and browns foreshadows the landscape art of Poussin. But if the design derives from Annibale, the Classical serenity and composure, the breadth and fragrance are Domenichino's. His heroic landscape with figures is the new genre of the seventeenth century, a unified architectural whole, an Arcadian aspect of nature, subsuming a wealth of colourful detail in the foreground, but reaching out to infinite distances, where azure mountains dream and melt into the limpid air.

The importance of Domenichino is in his balanced and spacious design, where forms have linear definition and figures are idealized and graceful. He is averse from painterly effects and movement. His Roman Classicism foreshadows Nicolas Poussin.

GIOVANNI LANFRANCO of Parma (1582-1647) was, with Domeni-chino, an assistant of Annibale Carracci during the latter's final years. But unlike Domenichino, he—as a true compatriot of Correggio—was attracted by the Baroque rather than the Classic potential of the Carrac-cesque movement. Lanfranco became the first great decorator of the fully developed Baroque in Rome with his airy and illusionistic cupola of Sant Andrea della Valle where a whirl of clouds and figures move in concentric circles. Through him the tradition of Correggio became part and parcel of the Baroque, with which it had so many affinities.

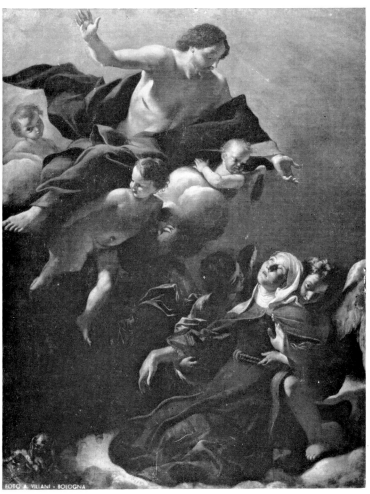

71. GIOVANNI LANFRANCO. *Ecstasy of S. Margaret of Cortona.*
Florence, Palazzo Pitti (photo: A. Villani & Figli).

Buoyancy of the spirit as well as the effects of mass and movement
and dramatic light with something of Correggio's sensual charm are
to be found in Lanfranco's *Ecstasy of S. Margaret of Cortona* **271**
c. 1620). It has been called one of the most convincing pictures of
ecstasy in existence, and preceded by many years Bernini's famous
culpture in Santa Maria della Vittoria, Rome. Lanfranco and Bernini
leveloped the Roman Baroque simultaneously and the Ecstasy of S.
Margaret is one of its most characteristic expressions by the mystical
apture of the swooning saint, the concentration of light and the
loating movement. As S. Margaret lifts up her pallid face, so the

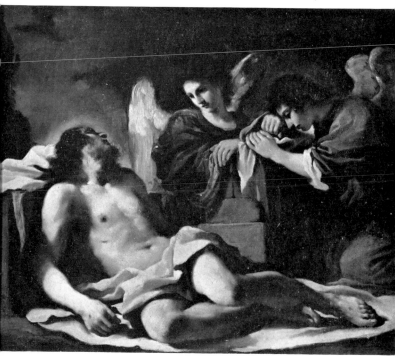

272. GUERCINO. *Angels weeping over the Dead Christ*. London, National Gallery (photo : National Gallery).

Saviour opens His arms to receive her and earth and heaven are united in the moment of vision.

GUERCINO (1591-1666) was born in the small town of Cento, lost in the countryside midway between the flourishing artistic centres of Bologna and Ferrara. He was virtually self-taught, but freely confessed his debt to the example of an altarpiece in his native town which Lodovico Carracci had painted in 1591, the year of his birth. There is indeed a kinship between the earlier works of Lodovico and Guercino's interest during the first decade of his activity, in rich colours and powerful effects of light and shade. The latter characteristic, together with a propensity for the realistic portrayal of somewhat rustic models, has led to the supposition of Caravaggesque influence. But Guercino did not see the major works of Caravaggio until his visit to Rome in 1621, when his early style was already approaching its end. His type of atmospheric luminism is in fact different from Caravaggio's and is a typical North Italian and ultimately Venetian phenomenon. The use of simple types was ' in the air ' at the time, though Caravaggio must have done much to render them more acceptable to contemporaries.

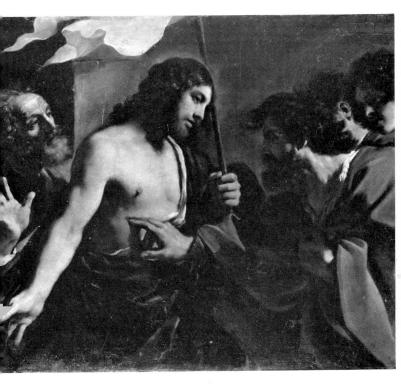

273. GUERCINO. *Incredulity of Thomas*. London, National Gallery (photo: National Gallery).

Guercino in his early works revealed a vigorous natural talent, instinctive and unschooled by precept. There is a feeling of movement and impermanence in these paintings, which is aided by his rendering of atmosphere, and by his specks of light which tend to break up the individual forms and fuse them into the larger unit of the composition as a whole. A relative lack of sophistication did not, in the case of Guercino, mean a lack of breadth or even of dignity.

The National Gallery has two of the most expressive religious pictures of his early period, which illustrate these qualities and also Guercino's place in the Catholic Revival. The *Angels weeping over the dead Christ* is a noble composition, expressing compassion without sentimentality. The soft flesh tones of Christ's recumbent body are modulated with the help of *sfumato*, and His radiance is contrasted by the gloomy background and by the vinous red and grey-purple of the Angels, whose wings are painted with a Venetian impasto. 272

In the *Incredulity of Thomas* the hazy softness of the *Pietà* has yielded to a noble sense of form and of rich glowing colour, enhanced 273

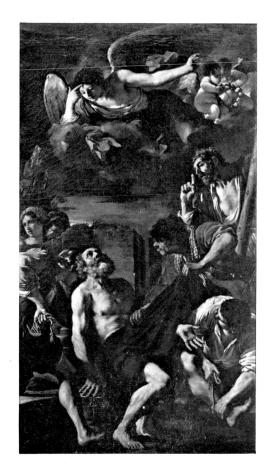

274. GUERCINO. *Martyrdom of S. Peter*. Modena,
Galleria Estense (photo: A. Villani & Figli).

by the clear light and the neutral grey background. The dark blue of
Christ's robe tells against the silvery radiance of His body, and the
verve of Guercino's brush is felt in the voluminous folds of the Apostle's
robe. An aura of light foils the smooth brown hair of Christ in contrast
to the jet black curls of S. Thomas. The disciple behind Christ raises
his palm in awe. The large hands are glowing with life, naturalistically
portrayed, with wrinkled skin and shining surfaces. All the light is
gathered upon the face and body of Christ and upon the expressive
head and hand of the disciple behind Him—a dramatic light which
dissolves into shadow and half light and lends mystery to the scene.
It seems to emanate from the upper right, skirting the group of Apostles

behind Thomas and leaving the head of him in darkness who must touch in order to believe.

During 1621-23 Guercino worked in Rome, where he painted his famous fresco of the *Aurora* in her cloud-borne chariot drawn by two powerful steeds, seen from below, a symposium of rich colour, movement and light. But it is by his great altarpieces for the Catholic devotion that Guercino won for himself a leading role in the Seicento. These are scattered throughout Italy and especially in the churches of his native Emilia. A fine example, still from his early pre-Roman period, is the *Martyrdom of S. Peter* in the Galleria Estense at Modena. **274** A vaporous blue veils the heavens from which a great floating angel beckons to Peter who suffers his last agony. Dark blue is also the colour of the mantle which a ruffian pulls away from the ecstatic saint. The main vehicle of Guercino's early Baroque and anti-Classical way of composing is the light; his patchy, arbitrary light which picks out forms apparently at random and leaves part of the figures in darkness, connecting them with one another. This restless, impressionist light is strongest on the right half of S. Peter's athletic body and on the angel's face and arm; it skirts the plebeian countenance of the executioners and steeps the painterly contours of all figures into darkness, ' impairing their structural solidy and losing them in their environment ' (Mahon). The composition descends to a deep hollow, a kind of triangular crater. S. Peter's executioners are brutal and unkempt savages. The naturalism of coarse legs with swelling veins and muscles and enormous feet is emphasized by the concentration of light upon these parts, foiled by deep shadows, resulting in a monumentality greater than life. A splendid passage of paint is in the crinkled shirt of the young executioner. His turned head is seen from below. His ruddy face and neck are strongly foreshortened, his squatting posture is concentrated and compact. A Baroque vitality informs the act of martyrdom; the exaltation of the Saint, the swoop of the angel, the spectacular gestures, the spatial depth, the restless light and inky shadows make it into an eloquent manifestation of the religious revival.

Guercino's visit to Rome was a significant landmark in his career. There he became fully familiar with a language of expression diametrically opposed to that which he had hitherto employed; and from having been very much of a Baroque artist, he gradually veered in the direction of Classicism. His change of style, which seems to have begun at the end of his stay in Rome (1623) took a considerable time to develop completely; the examples of the paintings of Domenichino and (later) Reni appear to have played some part in it. His pictures become lighter in tone, the individual forms more clearly defined, the compositions

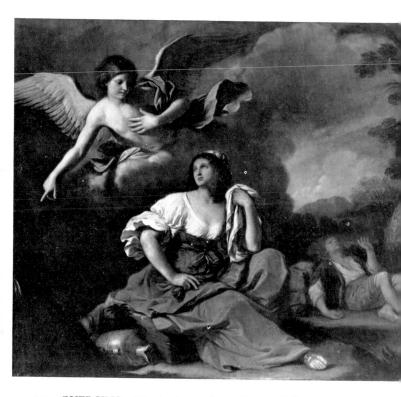

275. GUERCINO. *The Angel appearing to Hagar and Ishmael*. London, Denis Mahon Collection (photo : Courtesy Denis Mahon).

more balanced and logical—and much less broken up by violent contrasts of light and shade. This late, more sophisticated, style has a charm of its own which (as also with late Reni) must have appealed to the eighteenth century, particularly in England and France. A typical **275** example is *The Angel appearing to Hagar and Ishmael* of 1652-3 in the Mahon Collection.

In the soft raiment of the angel and of the melancholy Egyptian, lightly poised upon the rock, who has ' cast the child under one of the shrubs ' is something of Reni's refined sense of beauty and exquisite elegance. The deep contrasts of light and shadow are now resolved into pastel-like tones and silky sheen, a harmony of pale blue, bright red, russet and green, foiled by the dark drifting clouds and hazy atmosphere which softens all forms. The sensuous beauty of the figures and their compositional balance, the calculated poise of Hagar, re-echoed on a smaller scale in Ishmael and contrasted by the downward swoop and pointing hand of the angel, conform to the Classical tradition.

368

XXXIV. THE REALIST REVOLUTION

Michelangelo Merisi da Caravaggio

CARAVAGGIO'S new realism is a reaction against the formalism of the Mannerists and the learned idealizations of the Classicists. In his plebeian types he scorns Classical grace and nobility. His naturalism is the antidote to the idealists of the School of Bologna and Mannerist abstractions from real life. His strong light builds up forms of structural solidity and clear contours. In his youth he invents his own genre of half figures and still life. His stylistic development leads from mirror-like precision and daylight to the magical light and encroaching shadows of his maturity, which lend poignancy to his religious drama.

About the year 1590 or 1591 there appeared in Rome a young painter from the Milanese, poor, self-tutored and pugnacious who by the novelty of his vision and of his subjects was to challenge the Renaissance tradition of sacred and secular art. MICHELANGELO MERISI, a native of CARAVAGGIO near Bergamo, had been taught as a boy in Milan by a local master and trained his mind by studying such painters of the Veneto as were within reach in the Bergamasque province, and more especially Lorenzo Lotto, Savoldo, Moretto da Brescia, and Moroni. In a working life of no more than twenty years, interrupted by periods of riotous living and physical violence, Caravaggio caused a revolution in art, whose repercussions affected the greatest masters of the seventeenth century, from Frans Hals to Rembrandt and from Velazquez to Georges de la Tour.

The two main forces by which Caravaggio opposed the Mannerist modes of painting were his truthfulness to life and his new concept of light : his realism and his luminism. Like the scientific philosophers of his age, he had a burning passion for truth, a desire to pierce through the veil of appearances to the essence of things, and a dislike of formalism and mere decorum. He had come to destroy the Mannerist artifice, and he avoided too that romantic view of the past, so characteristic of the Classicists. In Rome he was just reaching maturity when Annibale Carracci decorated the Galleria Farnese with his mythological dreams and Baroque routs of Bacchus and Silenus. His realism was the antidote to the idealizing tendencies of certain of the Bolognese masters ; nor did he make any contribution to the formation of the full Baroque style. He never painted in fresco and never overcame a certain inability to convey movement successfully.

Caravaggio's only link with the Classical age is his sense of form, his plasticity, his exclusive interest in the human figure, in which he resembles Masaccio and Michelangelo. An artist so self-willed, so

spontaneous and independent had to invent his own visual language and his own genres of painting. Averse to the conventions of mythological and religious painting, and in order to attract new patrons in Rome, he chose his first subjects from his own experience, portraying the low-life world of street and tavern in his half-length figures and exquisite still lifes, attractive Roman youths with fruit or lute, card sharpers and gipsies. Later, when he was favoured by Roman cardinals and noblemen, he painted religious subjects, but with such a sense of their actuality and such an emphasis on the poor and lowly folk of the Gospels, that he sometimes encountered difficulties with his church commissions, though rejected works were invariably bought by collectors and connoisseurs, who included high ecclesiastics.

The new vehicle of expression which he developed was the light ' not the light of nature but of art, revealing one form and concealing another ' (Venturi) according to aesthetic necessity. An arbitrary light which often confounds spatial relationship and picks out the protagonists in dramatic contrast to the shaded parts of the composition finally weakened his colours and his contours. But this magic of light is the result of Caravaggio's ripest style. In his early works he aimed at realistic precision and daylight clarity, a *trompe-l'oeil* naturalism where fruit and figures have the same value in the objective rendering of appearances.

276 When he represented *Bacchus*, he took a dark-eyed youth from a Roman tavern and painted his portrait *dal naturale*, but with such a refinement of pictorial means—bright local colours, plasticity, linear design and light—that the still life of boy and fruit is a masterpiece in the beauty and harmony of sheer existence. There is no story to tell, no action in the static picture ; but the painterly realisation of the massive half-nude is perfect : his ivory body reclining in the silvery sheets, his cheeks flushed, his jet black hair with the shining grapes and sprawling vine leaves in all tints of autumn. Marchese Giustiniani reported Caravaggio's saying that ' it gave him as much trouble to paint a good picture of flowers as of figures '. He made credible the volume of bodies, the transparent beauty of glass, the shining roundness of fruit and the glossy outline of writhing leaves. He painted with utter refinement of tone the silvery cloth and the grey table, the stark shadow that falls from the simple bowl of red wine and the reflected lights in the glass, the graceful stem of the chalice and the elliptic pattern of the bowl. But because it was customary for paintings to have a subject he called his composition *Bacchus*, a Roman youth with finely arched brows and moist indolent eyes under the chestnut hair, a picture of ripeness and abundance.

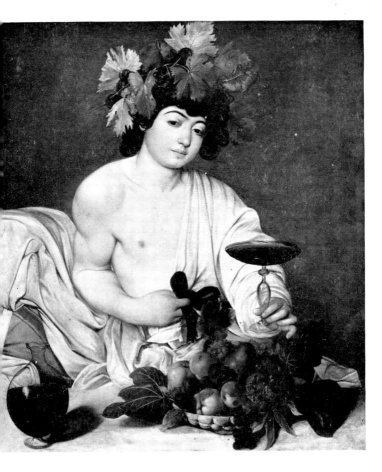

76. CARAVAGGIO. *Bacchus*. Florence, Uffizi (photo : Soprintendenza alle Gallerie, Firenze).

At Rome Caravaggio could not remain a painter of secular genre and, with the help of Cardinal del Monte who gave him refuge in his palace, he was soon to compete for the great ecclesiastic commissions. But if he must paint religious pictures, he would represent the men of the Gospel as he saw them, the poor in spirit, the down-trodden and humble, and not the hieratic aristocrats of the Roman Church ; he would transfer his portrait-realism into sacred pictures and draw his apostolic types from the streets of Rome. He would paint the real presence of bodies in the undefined space and then exalt them with the magic light of his art.

371

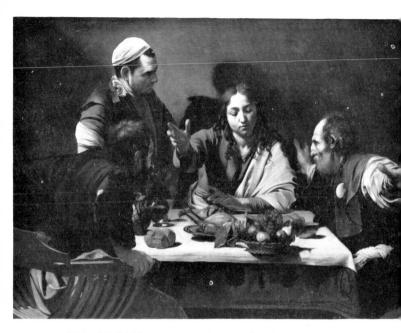

277. CARAVAGGIO. *Supper at Emmaus*. London, National Gallery (photo National Gallery).

277 He conceived the *Supper at Emmaus* as a tavern scene, with a beardless Christ revealing the Scriptures to excited companions, sitting at a table decked with the familiar requisites of his still lifes : the fruit basket precariously balanced at the edge, the withering leaves, the yellow grapes, beside the golden crusted bread and the incongruous fowl on platter. But a change of vision had occurred to Caravaggio during his early years at Rome. His figures are no longer bathed in the dazzling daylight, but emerge in dramatic accents of light from the penumbra of a room in the inn. Caravaggio's light plays upon the disciples' foreheads, picking out the smooth boyish countenance of Christ and enhancing the tension of the actors in contrast with the impassive portrait-character of the host. Caravaggio's illusionism of form now amounts to *bravura* in the way depth is suggested by arms and hands thrust into space, the firmness and solidity of all shapes and the ghostly shadow on the wall behind Christ. He presents *Supper at Emmaus* without sacramental overtones : not the breaking of the bread, but a wandering preacher addressing a group of labouring men and the shock of surprise.

Probably about the same time as the *Supper at Emmaus*, around the year 1599, in a period of transition from the still life style of his youth

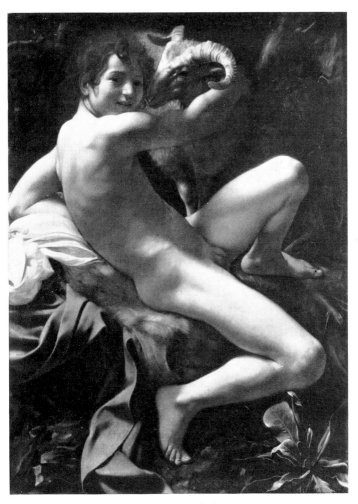

278. CARAVAGGIO. *S. John the Baptist in the Desert*. Rome, Capitol
(photo : Gabinetto Fotografico Nazionale).

o a more dramatic handling of the human figure, Caravaggio painted
a boy with a ram, who came to be called *S. John the Baptist in the
Desert*. The pose originally derives from Michelangelo's Slaves in the
Sistine. The youth gazing curiously out of the picture is the most
ambiguous of Caravaggio's ' Baptists '. As he caresses the head of a
ram, he reclines upon a sumptuous white sheet beneath which is another
of dull rose. His shoulders and taut thighs are well lit, but his torso is
in the shadow, brown shadow which merges with the light. His smiling
face is rose coloured, modelled in chiaroscuro. This shining form

278

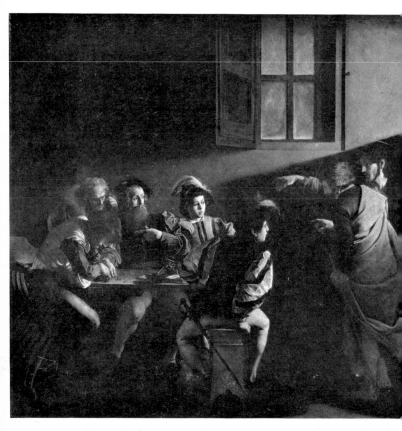

279. CARAVAGGIO. *Calling of S. Matthew*. Rome, S. Luigi dei Frances

(photo : Gabinetto Fotografico Nazionale).

emerges in full relief from a dark olive green thicket with a writhing
plant edged with light. The youth seems to be painted after the same
model as the *Amor Vincitore* in Berlin, and his pose and expression are
as challenging and as alluring. 'What Caravaggio has done' wrote
Denis Mahon, 'is to place a living model in as recognizably a Michel-
angelesque pose as could be sustained and paint him as a kind of genre
figure of a youth seated on a rock with his pet animal. Monumenta.
genre, with a facetious and equivocal twist.'

The highlights of this middle period of Caravaggio are the two large
lateral pictures in the Contarelli Chapel of San Luigi dei Francesi at
Rome, presenting stories from the life of S. Matthew. Mr. Denis Mahon
279 has emphasized that in the *Calling of S. Matthew* Caravaggio employs
for the first time the powerful lateral light to give accent, cohesion and

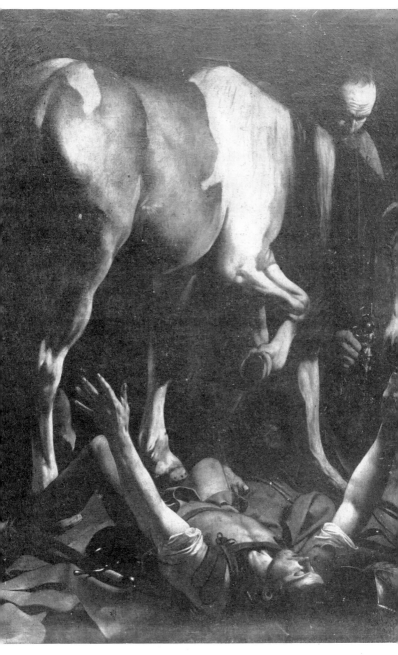

280. CARAVAGGIO. *Conversion of Paul*. Rome, S. M del Popolo (photo: Gabinetto Fotografico Nazionale).

movement to a picture which in its human types and costumes sti
recalls the romantic gallants of his earlier cardsharpers and soldiers c
fortune.

Caravaggio has placed the scene amidst gamblers and money-lender
sitting at table, playing dice or counting their gain. These dandyis
ruffians in multi-coloured doublet, tight hose and plumed hat are th
underlings of S. Matthew, himself refined like a Venetian noblemar
This worldly gathering, a monumental group, is set in a street, as ha
been recently shown : attractive Roman boys and thcir elders, familia
with vice and violence, the boon companions of dissolute living.

The rather sinister lane is steeped in darkness. Light skirts th
opaque window. But this is not the source of the great beam of artificia
light which strikes down from the right and passes along the wa
behind the men at the table, illuminating the face of the handsom
youth and coming to rest upon the Apostle who, with pointing han
seems to answer a call inaudible to the others : ' Lord, is it I ? ' For ii
the deep shadow on the extreme right Christ beckons to S. Matthev
with the commanding gesture of His arm suspended in the air, so tha
the light only illuminates His hand and the lower part of His face. Tw
of the gamblers remain unaware of the apparition ; but the bright youtl
with the firm oval face and reddish tints, who leans upon the Apostle'
shoulder, looks towards Christ in wonder.

Caravaggio's magic of light has come to fruition. It is not the ligh
of day or of night, but the spiritual light which lends dramatic momen
tum to the religious event ; light which we call magic, because it
source is not explained and its logic is hidden, a transcendental forc
which pierces the shadows and picks out the salient points of the story
This metaphysical light needs no natural justification. It is Caravaggio'
most vital discovery, an instrument which he uses at will to transforn
the worldlings' back street into a place where the divine is mad
manifest.

Shortly afterwards, in 1600-1601, Caravaggio painted for th
280 Cerasi Chapel of Santa Maria del Popolo the *Conversion of Paul* and th
Crucifixion of Peter. In the former he frees himself from all distractin
elements of genre in a grandiose concentration on actual facts : the hug
piebald horse which has thrown its rider who, dazed by the light fron
above, lies groping, rigid, dumbfounded upon the red trappings o
which he has fallen. The religious drama is wrapped in the darkness c
the undefined background, though the shining plasticity of the horse, th
tangled pattern of arms and legs enhance the illusion of depth. Th
simplicity of invention, the stark contrast between the dumb beast an
the spiritual experience of the Apostle, struck blind by his vision, ha

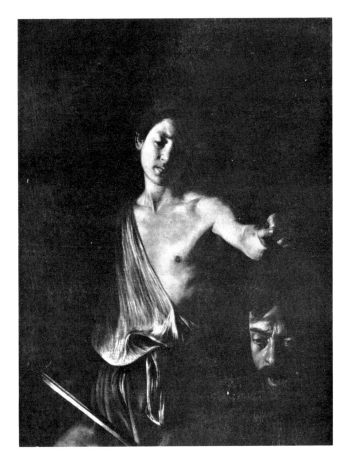

281. CARAVAGGIO. *David with the Head of Goliath.* Rome,
Galleria Borghese (photo : Gabinetto Fotografico Nazionale).

an unparalleled dynamic power although movement and space are
restricted and the monumental still life of figures is enlivened chiefly
by the mysterious light.

The sadness, the despair even of Caravaggio's vagrant life, marked
by homicide, imprisonment and hair-breadth escapes in the intervals
of inspired and feverish work, and a streak of violence are revealed in
his choice of subjects : the *Flagellation of Christ*, the *Decapitation of S.
John the Baptist*, *Judith beheading Holofernes*, and *David with the Head
of Goliath*. The *David* is painted in the monochrome of his last years,
where a tortured face and a radiant body with contours corroded by
shadows, emerge from the darkest penumbra. The adolescent hero

281

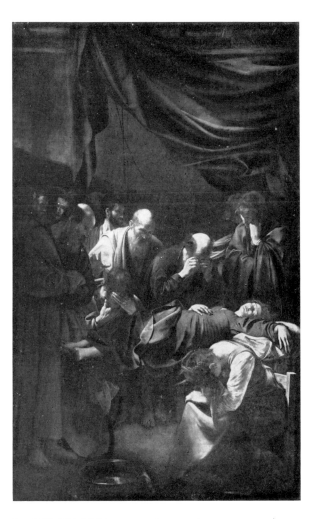

282. CARAVAGGIO. *Death of the Virgin.* Paris, Louvre (photo : Alinari).

holds the giant's head suspended, saddened and ill at ease, his gleaming sword in his invisible hand. Goliath is perhaps a portrait of the painter, distraught and swarthy, but more autobiographical still is the expression of David, who looks ' bitterly unhappy ', despairing in victory, regretful and weary.

Then, towards the end of his Roman stay (cut short by an act of homicide in 1606), Caravaggio painted one of his supreme religious **282** pictures : *The Death of the Virgin.* His stark, yet in the last analysis

deeply reverent conception was misunderstood by the clergy of Santa Maria della Scala, who rejected it as lacking in decorum ; but on Rubens' strong recommendation it was immediately acquired by the Duke of Mantua. Here the light from above creates and conceals figures, the swollen rigid body of the Virgin, the sorrowing apostles with their bald heads and workaday hands, and the beautiful form of the Magdalene ' broken with grief '. Caravaggio is most successful when treating a subject in terms of stillness rather than motion. Each of the mourners around the deathbed of Mary is infinitely lonely in his despair, each has his own sorrowing gesture and the atmosphere is one of ' stately solemnity '. The procession starting from the depth of the room reaches its tragic climax in the figures nearest to the bier and resolves in the monumental statuary of individuals frozen in grief. These are greater than life and intensely moving by their naturalness and sincerity.

Caravaggio was still to paint some of his greatest religious pictures, the Naples *Scourging of Christ*, the *Raising of Lazarus* in Messina and the Malta *Decollation of the Baptist*, where the realism of his youth is transformed in a compelling gravity of figures, a barrenness of space, absorbed by shadows, distorted by light. Yet this world of martyrs and executioners is as mystical as El Greco's and as solid as Masaccio's.

In the history of art Caravaggio occupies a position of great consequence. As a result of his contribution Caravaggesque painters sprang up everywhere, though the real depth and scope of his work could not be grasped and assimilated immediately. The reverberations of his new attitude spread rapidly beyond Italy, and more especially to the Netherlands—the School of Utrecht—France and elsewhere. In Rome Gentileschi and Saraceni derived from Caravaggio's early period. He had a considerable following in Naples, largely based on the late works which he left there. Carracciolo was one of the first and most impressive of his followers there, which also included the great Spaniard Jusepe de Ribera. Indeed in Naples there grew up a school whose lineage was ultimately traceable back to him, even when transformed by later generations and fresh blood, as the delicate Cavallino and the Guercinesque Mattia Preti. Thus it was Caravaggio's achievement to have changed the whole artistic climate of Europe to such an extent that the great European masters mentioned at the beginning of this chapter, owe him a real if distant debt.

XXXV. THE FULL BAROQUE AND ITS MODERATORS

Cortona — Sacchi — Maratta — Castiglione — Rosa — Gaulli —
Pozzo — Preti — Giordano — Solimena

Baroque painting is massive, spectacular, dynamic and illusionistic. It favour.
continuous movement of dramatic figures into the depth of space. The emotiona
impulse of this theatrical art which uses painting to evoke sculptural and architectura
deceptions and the luministic illusion of Infinity comes from the ecstatic religion of the
Counter Reformation. Its chief protagonists in large-scale decorations were PIETRO
DA CORTONA, BACICCIO, PADRE POZZO, and LUCA GIORDANO. Their
attitude towards landscape and the Antique tends towards the romantic.

Baroque painting in Italy reaches its fullness in seventeenth century
Rome, and becomes in the Barberini Ceiling by PIETRO DA CORTONA
an apotheosis of all its elements. It belongs to the first phase of the
anti-Classical movement, inspired by the new wave of apologetic
religion ; a massive, spectacular, illusionistic art, which worked upon
the senses and the emotions by all the visual deceptions of the stage.
To the ordered cosmos and equilibrium of Classical art it opposed the
dynamic eruptions and the strenuous ecstasies of continuous movement ;
to static dignity and confined space it opposed a new vision of the
Infinite, a fanatic desire to thrust into depth by means of violently
foreshortened bodies surging upwards in a blaze of light. ' The
plane,' wrote Heinrich Wölfflin, ' is devalued by a sequence of figures
and by accents of light.' The illusion of depth becomes most effective
when it is expressed as movement, and the Baroque uses plastic and
pictorial means to cast moving crowds into the third dimension.

283 In the Barberini Ceiling (1635-39) Pietro da Cortona, vying with
Michelangelo's Sistine and with Annibale Carracci's Galleria Farnese,
organised the enormous vault according to its architectural semblance
and created monumental effects by the dramatic accumulation of
masses in movement. The result is a Wagnerian build-up of heroic
figures and mythological scenes which have their luministic centre in
the glorification of Divine Providence—and of the House of Barberini.
Here the allegorical figures surge up into the aerial space, the Heavens
burst open, and in a golden blaze of light female impersonations of the
Christian Virtues float in the celestial void, crowning the Goddess of
Providence with huge garlands.

 In the four corners of the ceiling Cortona painted huge medallions
borne by caryatides, and Annibale Carracci's model is everywhere

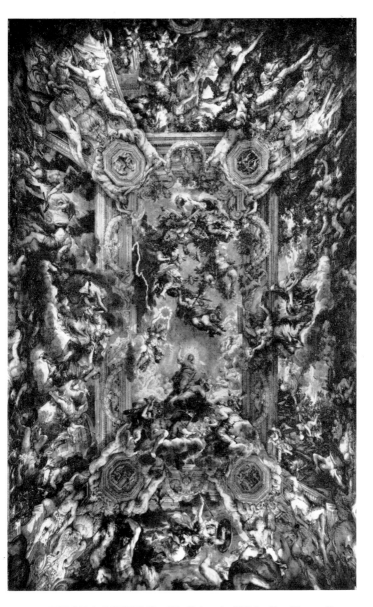

283. PIETRO DA CORTONA. *The Triumph of Divine Providence*. Rome,
Ceiling in the Barberini Palace (photo : Gabinetto Fotografico Nazionale).

remembered. But this is the height of the Baroque, and the agglomeration of figures has become vaster and heavier, indeed gigantic. The colours too are no longer pastel shades, but rich and opulent, with splendid whites and opalescent blues and purple and gold. But above all it is the rhythmical movement and amplitude of figures, the convolution of robes and the mountains of clouds which convey the grandiloquence of the Baroque. It is indeed an Italian equivalent of Rubens, on a scale somewhat larger than he ever had an opportunity to employ Beneath the central field are airy landscapes with mythological scenes where amidst foliage and fountains Venus reclines or Silenus feasts among satyrs. More boisterous are the *Forge of Vulcan* or the *Fall of the Giants*, and here the Baroque sense of the colossal, where a celestial warrior hurls down the toppling giants, seems to overreach itself in the materialism of coarse bodies and sprawling limbs. The Barberini Ceiling is conceived on a monumental scale and in an orgy of the imaginative faculties and of the senses. It is the expression of a new life-force which found its pictorial equivalent in symphonic decorations of incomparable power and magnitude. The Baroque is a style in which painting, sculpture and architecture combine to produce a total illusionism of form reflecting the highest aspirations of the age, Antique as well as Christian, and its curiously sensuous yearning for the Infinite.

But beside the work of Cortona and his followers there was in seventeenth century Rome also a more restrained and sober form of Baroque decoration. The Classical element stemming from the late Annibale Carracci, inspired ANDREA SACCHI and his pupil Carlo Maratta, to oppose Cortona's creative fury by a greater clarity and simplicity of composition. Moreover, Sacchi had been to Venice and made his own the tonal atmosphere and rich colour of the Venetians. His masterpiece is the *S. Romuald* of the Vatican Gallery; and here, in a landscape made wide and airy by tonal gradation, beneath the Titianesque trees, painted with a full and saturated brush, the ponderous figures of the white monks of Camaldoli are grouped around the old recluse.

In a balanced composition like this, the Baroque element, apart from the distant figures ascending inwards and upwards as if on Jacob's ladder, is confined to the voluminous quality of paint which constructs folds and writhing trees. The tempestuous whirl of Cortona's inventions is opposed by the quiet stance and equilibrium of weighty figures, and Sacchi infuses into the High Baroque a measure of Classical dignity and calm. These large white figures, slow moving and austere, are bound together by the same spirit and unified by the same compositional rhythm. Their varied expressions of listening and meditation have been observed with meticulous care.

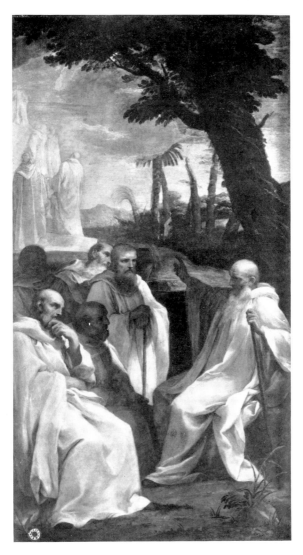

284. ANDREA SACCHI. *S. Romuald*. Vatican (photo : Anderson).

CARLO MARATTA (1625-1713), Sacchi's pupil, who after the death of Bernini became the artistic dictator of Rome, guided the creative vitality of the movement into more academic channels. With an ample rhythmic sweep' of his mellifluous figures, derived from Raphael, he endeavoured to oppose the Baroque exuberance of Cortona and Baciccio. Maratta had a sense of design and decorum and prepared

285. CARLO MARATTA. *S. Augustine to whom a Child reveals the Mystery of the Trinity*. Rome, S.M. dei Setti Dolori (photo : Gabinetto Fotografico Nazionale).

the way for the neo-Classicism of the eighteenth century. He was much esteemed as a portraitist for his aristocratic refinement and grandeur.

An impressive work of Maratta's early style is *S. Augustine to whom a Child reveals the Mystery of the Trinity*, painted in 1655. Here it is not only the largeness and human grandeur of the saint, towering up in the forefront of the picture, but also the vigorous chiaroscuro which lend a Baroque impetus to the composition. Later on Maratta's palette lightens to tones of grey and silvery blue, but the *S. Augustine*

285

384

6. G. B. CASTIGLIONE. *Discovery of Cyrus.* Dublin, National Gallery of Ireland (photo : Courtesy of National Gallery of Ireland).

in the Guercino tradition of dark mass and vibrant light and Venetian colour. The effects of light are directed upon points of dramatic interest in the narrative of the painting : the bronze coloured head of the saint, his hand raised in wonder and the shining pages of the open book. The gigantic figure of S. Augustine, recoiling before the wisdom of a child and rising up to the level of the clouds, his dark sinuous form outlined against the luminous sea and sky have great pictorial momentum.

Genoa and Naples were besides Rome the chief centres of the Full Baroque in Italy.

In Genoa, where Strozzi had been born who in mid-life transferred to Venice, a colourful and lively school of full Baroque painters arose

287. SALVATOR ROSA. *Landscape with Travellers asking the Way*. London,
Denis Mahon Collection (photo : Courtesy Denis Mahon).

and, as the century wore on, elaborate fresco decorations of great free-
dom became a feature in Genoese palaces and churches. Foremost
among the Baroque painters of Genoa, though not himself a frescoist,
was G. B. CASTIGLIONE (1610-1665), who started under Flemish
naturalist and Bassanesque influences as a painter of animal genre, but
became in Rome a painter of romantic mythology and the religious
Baroque. There Castiglione underwent the influence of a group in
which love of Venetian (above all, Titianesque) colour and romanticism
was paramount. This group included such artists as the great French-
man NICOLAS POUSSIN, during the sixteen-thirties, and PIER FRANCESCO
MOLA, whose attractive landscapes show a mixture of Venetian and
Guercinesque influences. Later on, Castiglione's compositions became
closely akin to those of Bernini. The slightly younger painter, Salvator
Rosa (1615-1673), who intermittently worked in Rome from 1635,
was affected by the picturesque genre of Castiglione.

A characteristic work of Castiglione's middle period is the *Discovery
of Cyrus* at Dublin, where in a Venetian landscape of great colouristic
beauty amidst Antique statues and ruins, a lively dramatic action shows
a synthesis of elements from Rubens and from Poussin. Castiglione's
earlier preoccupation with animals and still life is now countered by an

286

interest in the human figure, and upon the Classical elements of the composition is grafted a lively Baroque movement and flaming colour. The figures are laid in with great fluency, and the vitality of the brush, the warmth of tone, the brilliant flesh and the opalescent beauty of stuffs denote an artist who knew how to combine an original vision with the best that seventeenth century Rome had to offer.

In contrast to the idealised serenity of the Classical landscape SALVATOR ROSA reflects the romantic side of untamed nature. He was a passionate Neapolitan, accomplished musician and man of letters, brought up in the Caravaggesque ambience of Ribera, who painted historic and biblical subjects and above all picturesque landscape vistas. As the Classicists transformed the wildness of nature into a garden landscape of organised beauty, so Rosa selected aspects of elemental nature to play on the romantic emotions of fear and wonder. Bandits or mounted soldiers lurk in picturesque valleys or impenetrable wood interiors, and rocky mountains overhang crumbling bridges. A *Landscape with Travellers asking the Way* in the collection of Denis 287 Mahon is an early example, in which the figures show the influence of Dutch painters of Low Life working in Rome. Here the rocky hillside falls steeply away into the sunlit valley dreaming peacefully in the distance, a luminous foil for the fine tree silhouettes framing the entrance to the wood. By contrast the savage gorge with dead branches and sprawling tree trunks, the impenetrable thicket of wild nature, is the more threatening. Rosa seeks out aspects of chaotic nature with realistic truth, heightening its effects of gloom by shafts of light and specks of bright colour. His rich and graded pigment evokes the sunlit folds of the Roman Campagna, layers of juicy green and shimmering blue, and also the ochre foliage tipped with light, cyclopic rocks and splintered trees and stagnant pool As an artist of the Baroque he prefers irregular shapes, dark masses and ghostly light, and his romantic imagination reverberates not only in Magnasco's wood interiors, but throughout the eighteenth century, especially in England.

Perhaps the greatest painter of the religious Baroque was the Genoese G. B. GAULLI, called BACICCIO (1639-1709), the painter of the ceiling in the Jesuit Church at Rome. Formed by the study of Barocci and Rubens, he had come to Rome as a boy of eighteen, where the ageing Bernini influenced him deeply. In 1661 he studied Correggio in Parma and returned to Rome, ready for the supreme task of decorating Il Gesù (1669-1683). Forty years had elapsed since Pietro da Cortona's Barberini ceiling, and Jesuit doctrine had been evolved to inspire painters with the idea that the vault of the church represented the very heavens.

288. BACICCIO. Ceiling in the Church of Il Gesù in Rome (photo : Alinari)

289. ANDREA POZZO. Ceiling of S. Ignatius Rome (photo: Anderson)

Baciccio no longer divided the ceiling into structural compartments. **288**
For him the aerial conquest of the Empyrean and the refined sensual
elegance of his angelic figures, wafted into the upper spaces, was
perfected by the Rubensian richness of his palette and the illusionism
of *controluce*.

In Baciccio's ceiling in the nave of Il Gesù the heavenly host surges
triumphantly into the golden light of the Empyrean. And here the
impulse of soaring bodies and tortuous robes, the skill of foreshortening
and the silhouetting of figures against the light are such, that weight
and density are denied, and the flight moves across cornices where
painted and stucco figures alternate, and through the airy vault of the
church into the boundless ether. Baciccio's *Triumph of the Name of
Jesus* is also the triumph of the Baroque painter: a perfect make-
believe in the reality of the Christian Heaven.

After Baciccio it was ANDREA POZZO (1642-1709) who advanced into
the ultimate regions of Baroque illusionism by obliterating the last
borders between painted and real structures. He was an architectural
scenographer, a painter of the *theatrum sacrum*, who, by his cunning
use of perspective could make a small church look like a great cathedral.
He had been brought up in the Jesuit Order and in 1681 was called to

290. MATTIA PRETI. *Feast of Herod.* Toledo, Ohio, Museum of Ai
(photo: Colnaghi).

289 Rome to decorate the whole Church of S. Ignatius with frescoes creating the supreme *trompe l'oeil* of the century. 'This is the logica continuation of Baciccio's ceiling in the Gesù,' wrote E. K. Waterhouse of the enormous ceiling fresco of the nave (1691-1694); 'stucco ha disappeared altogether and the fresco comes right down to the great flat band of moulding which runs along the top of the sidewalls of the nave'. Padre Pozzo with splendid artifice and bold perspective continued the architecture of the Church by the illusionistic painting of giant arches and foreshortened columns, rising up with concentrate momentum into the Empyrean. He created a wholly imaginary space opening the Church to the vault of Heaven, where the celestial fir radiates around Christ bearing the Cross, and God the Father holding the Globe. Beneath them, borne by angels upon banks of clouds, i S. Ignatius, the founder of the Jesuit Order, who sent his missionarie to the four corners of the earth. As he rules triumphantly in Heaver so the four continents are represented below in symbolical figure: rising upwards on the strength of their faith. Padre Pozzo painted thi ambitious concept in a glory of colour and light, where amidst cloud and azure, above a magnificent forecourt, the celestial personage reside in an ideal space.

390

291. LUCA GIORDANO. *Allegory of Agriculture*. London, Denis Mahon Collection (photo : Courtesy Denis Mahon).

In Naples the chief exponent of the full Baroque together with Luca Giordano is MATTIA PRETI (1613-99) from Calabria. All the influences that had shaped the Neapolitan School flowed together in his work, but more especially Guercino's restless light and pools of shadow, Cortona's grand manner and Veronese's silvery colour. Preti, like Caravaggio and Ribera, inclined towards the tragic and violent aspects of biblical story, where magic light plays upon the pallid bodies of martyrs in the surrounding gloom, evoking pity and compassion. He was deeply stirred by the religious emotion of the Catholic Revival. His votive pictures painted after the plague which ravaged Naples in 1656 are perhaps his most brilliant essays in the pictorial language of the full Baroque. In his biblical banquets like the *Feast of Herod* **290** Preti presents opulent figures in sumptuous attire at the moment of emotional tension. Silent drama is enacted by means of controlled action and sustained movement of oriental figures, not unworthy of Rembrandt in their existentialist weight and gravity. Light is the protagonist which models figures and heavy stuffs and still life objects in silvery tones against an architectural background reminiscent of Veronese. Compared with his more agitated paintings of conspiracy and assassination like *Belshazzar's Feast* and the *Feast of Absalom*,

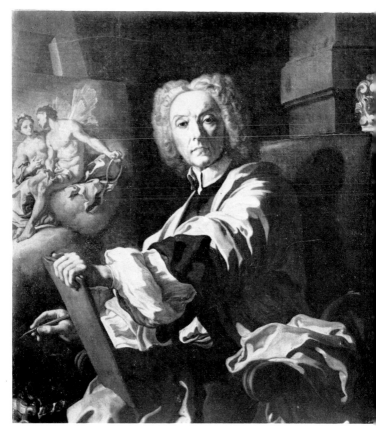

292. FRANCESCO SOLIMENA. *Portrait of the Artist.* Naples, Muse
Nazionale di San Martino (photo: Soprintendenza alle Gallerie, Napoli).

painted around 1660, the *Feast of Herod* has a classical composure an
clarity. The horrific is only suggested in Herod's glance and gestur
and in the group of frightened page and turbaned courtier, the onl
passage of sombre and suggestive half-light. The singular beauty c
this painting lies in the grandeur of formal arrangement, the weigh
and volume of imposing figures and the sparkling splendour of Venetia
colour.

With LUCA GIORDANO (1634-1705) the Baroque moves to the brin
of the eighteenth century. As a Neapolitan he started as a followe
of Ribera ; then of Reni, the sketchy almost eighteenth century styl
of the late Reni, notably in the enormous *Adoration of the Shepherd*
in the Certosa di San Martino at Naples. He certainly admired Pietr
da Cortona's decorations at Rome and Florence, and such works o
Rubens as were accessible to him. A visit to Venice accounts for th

richness and fluency of his brush, the intensity of his colour, the thick impasto applied with sparkling freshness.

These qualities combine with a joyous temperament in the ceiling frescoes painted in 1682-1683 for the Palazzo Medici Riccardi in Florence, representing mythological and allegorical scenes. A number of completed preparatory studies in oil for sections of these are in the Collection of Denis Mahon, and one of them is the *Allegory of Agriculture*. 291 In Luca Giordano the painterly inheritance of Venice is wedded to a Baroque exuberance of movement, and his fertile imagination is matched by the lightness and energy of his figure composition. In the *Agriculture* nymphs and deities and cherubs mingle freely with ploughman and sower, and the river god with his silvery hair by the diaphanous stream is worthy of Tiepolo. Indeed Luca Giordano influenced Sebastiano Ricci, the leading Venetian painter of the transition, and by his sense of colour and light anticipates the atmospheric painting of the eighteenth century. In Naples Giordano was, together with Mattia Preti, a formative influence on the principal Neapolitan master of the transition to the eighteenth century, Solimena, a very able frescoist and painter of altarpieces and mythologies.

FRANCESCO SOLIMENA (1657-1747) is the Piazzetta of Neapolitan painting and forms the transition from Baroque to Rococo. He constructs firmly and boldly forms which have density and substance, using alternately bright and sombre tones and stark contrasts of light and shade. His principal works are frescoes on a monumental scale, crowded and spectacular scenes, full of movement and turbulent drama like the *Fall of Simon Magus* or *Heliodorus driven from the Temple*, painted for Neapolitan churches. He was essentially a decorator, heir to Cortona and Giordano who deeply influenced the Venetian and Neapolitan Rococo. Our *Portrait of the Artist* demonstrates the 292 *bravura* of his brush and the boldness of his colour like the bright green tunic set against the red upholstery of the chair. Even in the small compass of the self portrait the brilliant and tempestuous style of Solimena, his fluid impasto and dramatic chiaroscuro can be felt. The sitter's pose is as complex and anti-Classical as possible. He looks full-face at the spectator, but the body is turned in the diagonal. Space is not defined except by the geometrical shapes leading into the dark background. The expression is proud, grave and tense. The brightly lit mythological picture on the easel alone balances the slender form of the painter, so self-possessed, so full of impetuous energy.

XXXVI. FORERUNNERS OF THE VENETIAN REVIVAL

Strozzi — Fetti — Liss — Magnasco — G. M. Crespi

During the seventeenth century Venetian painting took second place.
Venice produced no painter comparable to the Carracci, Reni, Guercino
in Bologna, or the great decorators in Rome and Naples. Her local
genius was exhausted after the efflorescence of the sixteenth century
and immigrants from northern and central Italy like Strozzi from Genoa,
Fetti from Rome, the German born Johann Liss, and G. M. Crespi a
visitor from Bologna, upheld the colouristic tradition of Venice.

BERNARDO STROZZI (1581-1644) who spent the last fourteen years of
his life in Venice must be accounted one of the pioneers of her artistic
revival. There he encountered the work of such modern painters as
Saraceni, Fetti and Liss which helped to mature his own dynamic
and luminous style. His own affinities were with Rubens and van Dyck
and above all with the great Venetians of the sixteenth century; it
was under their impact that he developed the festive colour of his
maturity, his vigorous modelling and naturalistic tendencies, being also
affected by the Caravaggesque movement. Paintings like the *S.
Sebastian* or the *Almsgiving of S. Lawrence* in Venetian churches are
already triumphs of the Baroque by their large imposing figures, their
generous chiaroscuro and their sustained movement. In our *David
with the head of Goliath* the young hero appears on the brow of the hill
dragging the giant's head by the hair. As in Veronese's *Baptist* in the
Borghese, diaphanous figures appear lower down in the middle-
distance and the tree bends back into space. It is a striking invention
painted in rich, opalescent tones. David wears a russet smock over
olive green hose and a red beret with plumes. A golden sash is
fluttering in the blue sky. His strong limbs are modelled in the round
like the tree whose grey bark is crisply painted with spiral brush strokes.
A Rubens in Italy, Strozzi painted the tangible human body in move-
ment, opulent forms and glittering objects with the directness of the
realist. By his vivid response to the experience of Venice, by his
robustness of form and the succulence of his colour he prepared the way
for the rebirth of Venetian painting at the end of the Seicento.

DOMENICO FETTI was born in 1589 and had come to Mantua in 1613
to succeed Rubens as court painter of the Gonzaga Duke. There he
absorbed the art of Rubens and of Titian. In 1621 he went to Venice

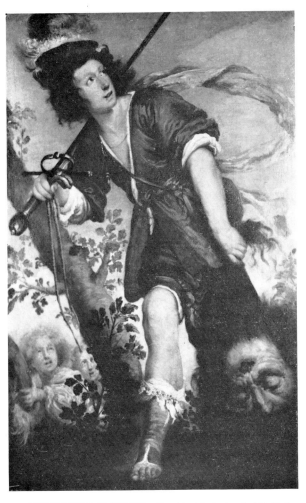

293. BERNARDO STROZZI. *David with the head of Goliath.*
D. G. van Beuningen Collection.

and remained there until his early death in 1624. Although he painted
some large-scale pictures like the *Melancholia* in the Louvre, Fetti's
genius excelled in a smaller kind of religious genre, where he developed
his spirited manner of composing, his grainy colour and magical effects
of light. Fetti achieved his greatest mastery in a homely genre of
Christian parables, where human poignancy combined with a poetic
rendering of landscape and a painterly use of colour and light which
owed a debt to Titian and Tintoretto, but also to Bassano and the
German Elsheimer. His subjects were the Good Samaritan, the Return

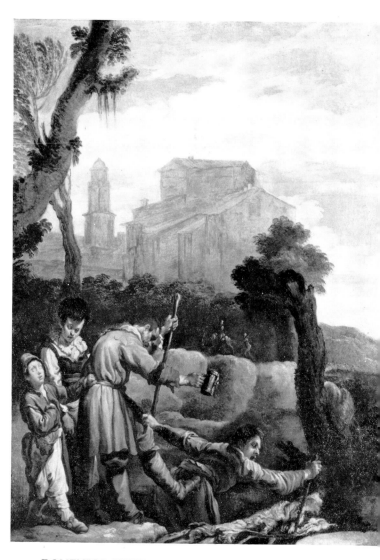

294. DOMENICO FETTI. *The Blind leading the Blind.* Birmingham, Barber Institute (photo: Birmingham University).

294 of the Prodigal Son, the Flight into Egypt or *The Blind leading the Blind.*
This scene recalls Breughel's tragic painting, but Fetti transforms it
by the idyllic landscape with Titianesque trees and the lightly sketched
buildings of the middle-distance. In these parables the human figures
are related to the landscape. Fetti shared with the northern masters
not only the *maniera piccola* but also the poetry of his feathery trees

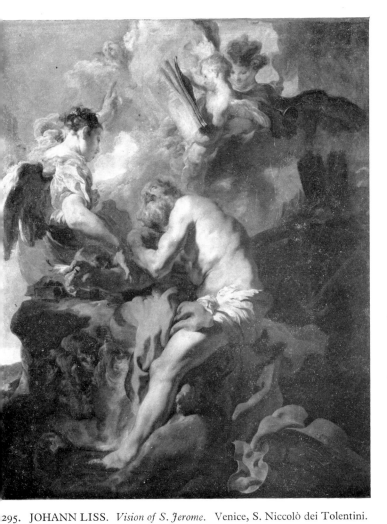

295. JOHANN LISS. *Vision of S. Jerome.* Venice, S. Niccolò dei Tolentini.

swaying in the breeze and the realistically observed human scene. His singular importance for the continuity of Venetian painting lies in the sparkling quality of paint, the quivering, serpentine brush strokes and the Impressionist touches of light. At a time when the 'dark manner' of the Caravaggio followers was still flourishing, Fetti kept alive the colour tradition of Bassano and the diaphanous light of Veronese.

Domenico Fetti influenced JOHANN LISS who moved Venetian painting towards 'an ever increasing turbulence and freedom of handling'. He was born in Oldenbourg before 1600 and trained in Holland. Liss came to Venice in the same year as Fetti (1621) and died there of

the plague in 1629. Besides the impact of Hals and Rubens and the sixteenth century Venetians, he experienced in Rome Caravaggio's naturalism and expressive use of light. During his rapid and brilliant career in Venice he painted a group of mythological and religious pictures in light and broken tones and luminous impasto and with a new softness and lusciousness of the human form reminiscent of Rubens. This development reaches its climax in his *Vision of S. Jerome* (S. Niccolò dei Tolentini) which is far ahead of its time in the explosive handling of paint, the vigorous brushwork and the eruptions of light. The old hermit gazes intently upwards at the Caravaggesque angel who indicates a cherub in the sky, reading to him from a large book. Here is the source of the inspiration and of the greatest light breaking through a chasm of clouds. The Baroque character of the work is not only in the complex design, the riot of colour and light, it is felt as much in the vigorous naturalism of the saint's body, the nacreous sheen of the flesh, the brilliant stuffs and mounting clouds setting off the human form. S. Jerome and the angel guiding his hand are fully realized in space and the Venetian manner of drawing with the brush and of saturating colour with light, as well as the opalescent and silvery tones lend a new lightness and airiness to material things. These painterly qualities of Liss' mature art bridge the gap between Titian and the eighteenth century Venetians, preparing the way for the atmopsheric painting of Tiepolo and Francesco Guardi.

Into this context belongs another North-Italian painter whose eruptive and wholly eccentric pictorial manner had a formative influence on the Venetians, especially on Sebastiano and Marco Ricci. He was ALESSANDRO MAGNASCO from Genoa (1667-1749) who spent part of his life at Milan where he met artists from Lombardy, Venice and Emilia. His world was hallucinatory and fantastic and his vision not unlike El Greco's. He painted hermits in savage romantic landscapes reminiscent of Salvator Rosa or monks sitting in Refectory, in serried rows, seen from above, also scenes of martyrdom and ecstasy, of brigands and of fashionable garden fêtes. His shapes are elongated, mannered and de-materialized, their actions bordering on madness. He invented a painterly technique to match, made up of zig-zagging, serpentine strokes invoking gaunt, ghostly forms in grotesque movement, or silky stuffs with sudden flashes of light. Gone is the firmness, the solidity and the naturalism of the Baroque ; colour is used to suggest not to constitute form, mood, atmosphere. Of Magnasco's quite unfettered and explosive manner the turbulent *Storm at Sea* by Marco Ricci or his *Landscape with Monks* (at Edinburgh) are the direct result, as are at a further remove the evocative figure-paintings of Francesco Guardi.

296. G. M. CRESPI. *The Sacrament of Ordination*. Dresden, Gemäldegalerie.

Another *petit maître* who kept close connection with Venice and helped to prepare the eighteenth century revival of Venetian painting was GIUSEPPE MARIA CRESPI of Bologna (1665-1747). He forms a link between Lodovico Carracci and Guercino on the one hand and Ricci and Piazzetta on the other. He was a born painter, and like Chardin, a master of popular genre who painted with a loaded brush, creating

399

effects of strong colour and sparkling light out of powerful chiaroscuro. Like Bassano before him or Magnasco his contemporary, he develops that *pittura di tocco*, shaping forms out of rich pigment with nervous strokes of the brush. His principal works are *The Sacrament of Ordination* at Dresden, and here the human form seems carved out of the rich glowing paint with deft highlights on robes and faces amidst the surrounding shadow. Moreover, Crespi had psychological insight into human nature, religious sincerity and a sense of humour. His prelates are the Jesuits of the Catholic Revival, dark Spanish-looking youths observed from life. They are crisply painted in broken tones and fluctuating light which lends an aura of mystery to the sacramental scenes. In *The Sacrament of Ordination* it is not only the patchy light of Guercino and Venetian colour, the sweeping brush strokes of the surplice or the rich texture of the bishop's robes which fascinate, but also the skilful grouping of the priests with their related postures. Yet the chief attention is focused on the young Ordinand and the priest who presents him to the bishop with persuasive gesture, contrasting with the weight and solemnity of the seated prelate.

But Crespi lived far into the eighteenth century and his style became more suave and sensual in secular subjects like the famous *Luteplayer* (in a private collection) with her curvilinear rhythm of bust and neck and lute, the flow and verve of the voluptuous form anticipating Boucher. Irony was never far from Crespi's rendering of human nature. He forms a true link between the sombre strain of Bolognese Baroque and the light-hearted Venetian Rococo, profoundly influencing Piazzetta, who came to stay with him for a while—a loveable and intensely human artist, whether he paints religious ecstasy, the homely genre of Fair or Family or the Conversation Piece of the eighteenth century.

XXXVII. VENETIAN PAINTING IN THE EIGHTEENTH CENTURY

Sebastiano Ricci — Pellegrini — Amigoni — Pittoni — Piazzetta — G. B. Tiepolo — Gian Domenico Tiepolo — Carriera — Pietro Longhi — Alessandro Longhi

The Rococo is the elegant and elusive end-form of the Baroque. SEBASTIANO RICCI translated the festive style of Veronese into the language of the Venetian Rococo. PIAZZETTA, another forerunner of G. B. Tiepolo, forms a link with the Seicento and with the Baroque. He models form with strong use of chiaroscuro. TIEPOLO'S weightless figures float in an aura of iridescent air and light: his colours are transparent, his movements rapturous. He overcomes the dramatic massing and heaviness of the Baroque by dissolving form in a luminous infinity of space. ROSALBA CARRIERA and PIETRO LONGHI portray the delicacy and grace of the eighteenth century. Longhi records the social aspects, the foibles, ambitions and costumes of the upper classes.

As a painterly movement the Roman Baroque had been deeply affected by the great Venetians ; but Venice, recuperating as it were from her splendid sixteenth century effort, made no striking contribution to the Baroque before the coming of SEBASTIANO RICCI (1659-1734). Ricci had visited Florence and Rome and absorbed the art of Luca Giordano in the Palazzo Medici Riccardi. He introduced the Rococo style to Venice and became with Piazzetta the formative influence upon its greatest eighteenth century master G. B. Tiepolo.*

Ricci often imitates Veronese, indeed he borrows and copies his compositions ; but his fluency of form, his verve and elegance, his rich and nervous impasto are of the new century. Simultaneous with the early French Rococo he translated the style of Veronese into the language of the eighteenth century. Moreover, he was a draughtsman of the first order, and his drawings reveal a studied expressiveness of the human form and a rapid, illusive touch which are of the eighteenth century.

The *Ecstasy of S. Teresa of Lima* is a typical work by Ricci. The subject had been treated in sculpture by Bernini's famous group at S. Maria della Vittoria, where a smiling angel pierces the heart of the Saint, who is borne aloft in exaltation. But Ricci's angel is far less irresistible, and the ecstasy of S. Teresa, floating between clouds and

297

*Though the Venetian is the leading school in the eighteenth century, there are other important Rococo painters elsewhere, such as de Mura, carrying on the tradition of Solimena at Naples, and Giaquinto, also originally trained under Solimena, active in Rome and afterwards in Spain; Batoni producing mythological and religious pieces and, above all, portraits in Rome; Pannini, painting views of Rome and antique capricci, etc.

297. SEBASTIANO RICCI. *Ecstasy of S. Teresa of Lima*. Vienna
Kunsthistorisches Museum (photo : Arts Council of Gt. Britain).

298. G. A. PELLEGRINI. *Rebecca at the Well.* London, National Gallery
(photo: National Gallery).

supported by cherubs, is more like a swoon than the spiritual state of
mystical elevation. Yet it illustrates well the sensual sweetness and
verve with which the Venetian Rococo expressed religious themes, and
the painterly skill which bends draped and undraped bodies to a musical
rhythm. But Sebastiano's most forward looking work is the ceiling
in Palazzo Maruscelli, Florence, representing *Hercules, received in
Olympus.* Here he overcomes the darker and heavier monumental
style of his beginnings and paints free aerial fantasies of well arrayed
figures in dazzling colour, floating or recumbent on clouds in a vast

299. G. B. PIAZZETTA. *Madonna appearing to S. Filippo Neri* (oil sketch). Washington, National Gallery of Art, Kress Collection (photo : National Gallery of Art).

luminous space. The brilliance of the oval ceiling with gods and goddesses sitting astride the painted cornice or receding into the diaphanous heavens is at a far remove from Cortona's solid configurations, and truly anticipates Tiepolo's liberated and festive art.

Among the creators of the Venetian Rococo between Ricci and Tiepolo one artist stands out by the delicacy, the grace and the sensual

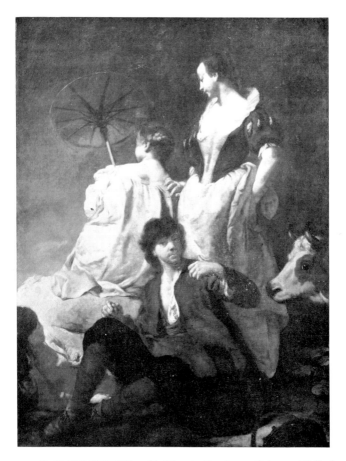

300. G. B. PIAZZETTA. *Idyll by the Seashore.* Cologne, Wallraf-Richartz Museum (photo : Rijksmuseum, Amsterdam).

erve of his decorative inventions. He is GIOVANNI ANTONIO PELLE-GRINI (1675-1741) who also painted gay and glittering fantasies on the walls of Kimbolton Castle. A favourite subject of his is in the *Rebecca at the Well,* now in the National Gallery, a painting more instantaneous and freer in handling than any of his master Sebastiano Ricci. The large Venetian belle in her pale blue silken dress and fair skin forms an imposing contrast to the bronzed Eliezer in his red smock, Abraham's servant who has come to offer her jewels on Isaac's behest. As Rebecca argues with Eliezer, resting her arm on the Renaissance urn, her servant looks shamefacedly away and a touch of light-hearted humour is introduced by the inquisitive and affectionate camel and the sterner glance of the fountain figure. The picture which anticipates Tiepolo's

298

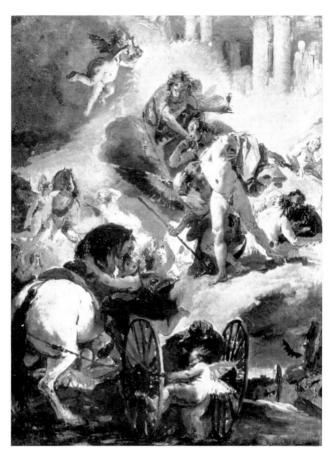

301. G. B. TIEPOLO. *Harnessing the Horses of the Sun.* Barnard
Castle, Bowes Museum (photo : Bowes Museum).

vibrant and impetuous brush is painted in vigorous impasto, moulding
crumpled sleeve and glittering bodice and creating solid form in front
of the diaphanous air and sky of Venice.

Other decorative scene painters in the following of Ricci are JACOPO
AMIGONI (1675-1752) painter of elegant and pastel-like frescoes of
mythological subjects in the suave and luscious style of Boucher, who
introduced the Venetian Rococo to Bavaria and Spain, and GIAMBAT-
TISTA PITTONI (1687-1767) who turned religious drama into sentimental
and bustling pageants like the *Miracle of the Loaves and Fishes*, favour-
ing effeminate forms of sensual grace.

But the greatest eighteenth century artist before Tiepolo, who
profoundly influenced his early work, was GIOVANNI BATTISTA PIAZZETTA

(1682-1754). Reacting against the elusive elusiveness of the Rococo, he forms a link with the art of the Seicento and the Baroque. As the Venetian Rococo dissolved form into movement and luminous atmosphere, Piazzetta retarded this process. He was 'the restorer of a robust and aggressive plastic form' (Pallucchini), which he sustained by a powerful chiaroscuro. He had spent his formative years at Bologna, where in 1703 he entered the workshop of Giuseppe Maria Crespi. From the Bolognese masters, and above all from Guercino, he took the violent naturalism of his early works, like the *Martyrdom of S. James*, expressed in terms of muscular bodies, dramatic contrasts of light, and an austere tonality. Later his colours become richer and sweeter, and a more coherent light unifies plastic form. In 1725 he painted an early masterpiece for S. Maria della Fava, the *Madonna appearing to S. Filippo Neri*. The imposing design is built upon an **299** ascending scale, which rises from the angel below to the kneeling saint, from him to the Madonna and, by means of her blue mantle suspended like a curtain, to the two putti above. The Madonna is a majestic sculptural form holding the Child proudly in her arms, while the head and figure of S. Filippo Neri are a study of individual character in the attitude of prayer. An aura of light surrounds the Madonna, modulates her shape and that of the saint, contrasted by planes of deep shadow, and the massive forms of the protagonists stand out in painterly relief of browns, creamy whites and blues.

Piazzetta painted only one ceiling, representing the *Glory of S. Dominic* in the church of SS. Giovanni e Paolo at Venice. 'Form still dominates over the atmospheric surround' wrote Pallucchini, and it will be left to Tiepolo to dissolve volume by light in an infinity of space.

Piazzetta, though imaginative and passionate, retained a certain robustness even in his compositions of the religious Baroque. A constructive energy informs his modelling. How closely he approaches a Chardin-like substance of paint and a fullness of the human form is evident from his pastoral subjects. In one of them, the *Idyll by the Seashore*, a youthful peasant, sitting on the ground, points to two **300** maidens behind his back; one of these, holding a sunshade, looks towards the blue distance, while the other stands by in a contemplative mood.

The composition is without narrative contents, a human still life or pastoral, an imaginative idyll. It is a closely knit group, richly and lusciously painted, of warm tonality, observed from life, where the unkempt rustic with his curious gesture, the girl touching the shoulder of her friend seen from the back, supple, suggestive, sensuous, gathering all the light, form an evocative group.

Thus Piazzetta must be seen as an antidote to the eighteenth century Rococo, a master of solid form who employs his ' obstinate chiaroscuro ' to give plastic relief to a wealth of human figures observed with an eye for natural appearances. These must be studied in his drawings, an eighteenth century galaxy of youthful types, maidens and lovers, rustics and gallants—natural and earthbound, drawn from the living model, yet raised by nervous line and flickering light and fleeting expression to a high level of artistic creation.

With GIOVANNI BATTISTA TIEPOLO the South European Baroque entered upon its refined eighteenth century phase of illusionistic fantasy with its emphasis upon formal elegance, rapturous movement and iridescent light. By the dissolution of static form, proportion and symmetry Tiepolo put an end to the Classical tradition. The art of the Baroque and Rococo is theatrical in that its aim is semblance and not existence, a cataract of movement in the infinity of space. Tiepolo's exuberant art came as a reaction against the heavier forms, the dramatic massing and the stark contrasts of light and shadow which he inherited from the Baroque. He began to refine his palette, to make his colour transparent ; he discovered how to paint the blazing light of the sun and diaphanous figures seen in aerial perspective. In mid-life his pictorial ideal became Paolo Veronese and by 1740 his work assumed ' a measured serenity and perfection '. In 1731 Tiepolo had received his first decorative commission to paint frescoes in the Archinto Palace at Milan. He chose the mythology of Phaeton and Apollo, of which the Bowes Museum owns a preparatory sketch representing the

301 *Harnessing of the Horses of the Sun.*

The heavens open above the solid earth and the grey rocks, and the cloud-filled ether reveals upon vapoury plateaux, horses and men in dramatic upward surge. The Baroque sweep of the design leads from the splendid bulk of the charger in the left foreground, where a small cherub strains to harness the horse to the chariot, in zigzagging tiers to the upper strata of the aerial realm. The Classical order of solid objects arrayed in symmetry, has been broken with some violence. A new life force has replaced the static order of the Classical age, creating a new pictorial pattern with dynamic power, where gods and heroes move in the unconfined space and the dazzling light.

As the great biblical banquets, the *Marriage at Cana* or the *Feast in the House of Levi*, inspired Veronese to his resplendent displays of festive people in a setting of Palladian architecture, so Tiepolo found his ripest style of composing in a kindred subject : the *Meeting* and the

302 *Banquet of Antony and Cleopatra*, of which he painted several versions. They earned him the title of Veronese Redivivus, so great is the

408

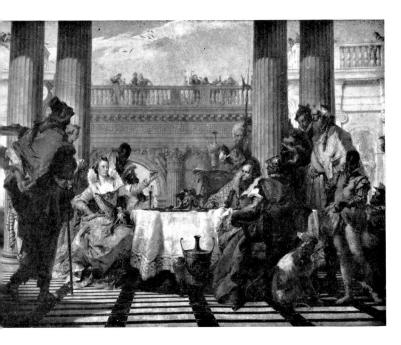

302. G. B. TIEPOLO. *Banquet of Cleopatra.* Melbourne, National Gallery of
Victoria (photo : Royal Academy of Arts).

ontinuity of Venetian painting and the unity of its spirit. Tiepolo too
omposed his banquets parallel to the picture plane, in the open air,
nder the luminous sky of Venice. Fluted columns and a marble
rcade in the middle distance with onlookers or minstrels are the
Renaissance foil to the banquet, where the Roman chieftain and his
uxuriant bride are attended by their gigantic bodyguard of major-
omos, ministers and negro servants. Veronese depicted in his
Marriage at Cana the Venetian reality of a rich man's feast ; but
Tiepolo used all the properties of the stage, a wholly imaginary Rome
f fastidious elegance and fantastical costume. The pictorial illusionism
f painted column and Classical decoration is at its height and the reces-
ion of space is enhanced by the marble tiles and the science of *controluce*,
ark figures silhouetted against the dazzling light.

After the decoration of the Palazzo Labia in Venice with figures and
eigned architecture, Tiepolo, between 1750-1753, painted the frescoes
n the new residence of the Prince Bishop of Würzburg, whose architect
vas Balthasar Neumann. And here upon the ceiling of the Kaisersaal,
he painted *Apollo conducting Beatrice of Burgundy to Barbarossa.* In **303**
his great Rococo medallion of the ceiling he evoked the vastness of the

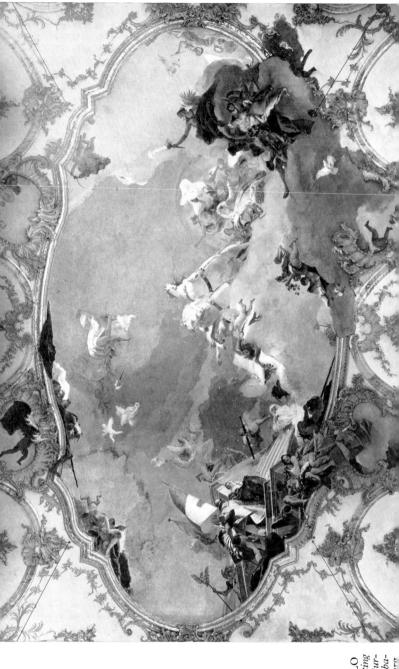

303.
G. B. TIEPOLO
*Apollo conducting
Beatrice of Bur-
gundy to Barba-
rossa, Würzburg*

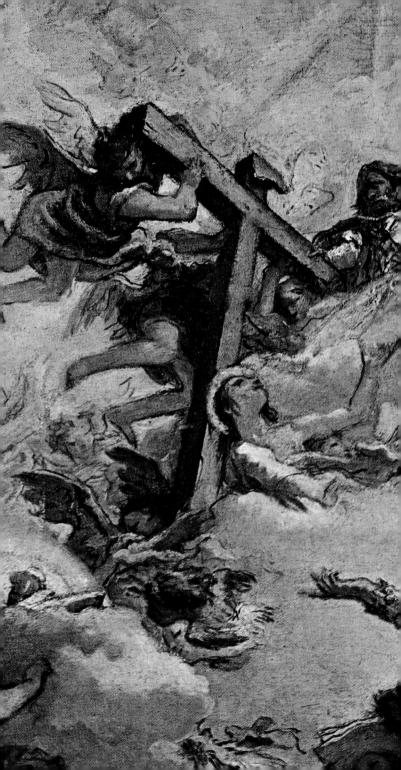

celestial blue, and out of it in a triumphant upward surge, the chariot of Apollo, drawn by four rearing steeds, their white cylindrical bellies seen from below. These magnificent chargers stride upon vaporous banks of cloud, led by winged cupids and genii, bringing the bride to the Emperor's throne. Tiepolo's ceiling is the climax of all Rococo decoration by dint of its tempestuous movement, the vastness and transparency of the aerial dome and the feats of illusionism. It is a wholly Mozartian splendour, a rhythmical division of mass, a joyousness of spirit, a translucency of colour, the greatest approximation of painting to music, at once effortless and ethereal, as if liberated from all bodily weight.

In his last period (1762-1770) the art of Tiepolo became ever more delicate and evanescent. In the decorations of the Villa Pisani at Strà or at the Royal Palace at Madrid he painted glorifications of a great family or of a Royal House—pretexts for vast luminous inventions, where the skies open in a blaze of light and symbolical figures toss and tumble amidst the vapours, erupted towards the outer confines of the celestial space. In this apotheosis of his own rapturous style Tiepolo thinned out ' his figures, freeing the radiant centres of the celestial ceiling and gathering them up along the architectural edges. Thus he avoided compact groups and opaque massing of figures and his painted ceilings assumed the lightness, the airiness, the radiance of the Empyrean. In this Paradisian world of his imaginings, tuba-blowing angels and winged cupids, by their own jubilant life-force, rotate around the invisible sun as in a wheel of fire.

GIAN DOMENICO TIEPOLO (1727-1804) who assisted his father in many decorative commissions and frescoed ceilings like that of San Lio (1783-4), was also an artist in his own right. As such he abandoned his father's grand mythologies and specialised in a humorous peasant genre—a kind of Jan Steen in the Veneto—representing picturesque crowds surrounding a quack dentist, clowns and mummers ; or an old country woman resting, a large egg basket in her lap, her witch-like withered profile almost obliterated by an enormous kerchief. But the landscape of slender trees and buildings and pastel blue distances is of the Veneto. Domenico's principal work in this genre is the decoration of the guesthouse or Foresteria at Villa Valmarana near Vicenza, where his father painted the heroic epic of Iphigenia's Sacrifice and other classical subjects. Nowhere is the contrast between the generations more vividly felt : the idealised fancy world of Giovanni Battista and the down-to-earth, the shrewdly observed and folkloristic low-life of Gian Domenico.

304. ROSALBA CARRIERA. *Portrait of a Young Man*. London, National Gallery (photo : National Gallery).

In the portrait genre ROSALBA CARRIERA's pastel portraits of noble Venetian youths anticipate Gainsborough. The Rococo portrait of young gentlemen and ladies and beautiful children in powdered wig and exquisitely modish dress, looking straight at us with the freedom and frankness of their class is in the lineage of Watteau and Greuze. Rosalba gained her greatest success, when in 1720-21 she spent time in Paris to portray King Louis XV and the *haute monde* of his court, just as in Italy the young lords on their Grand Tour were her principal sitters. Her pastel of Cardinal Polignac in the Venice Academy is not only the portrait of a great aristocrat, a prince of the Church, but also analysis of a refined and subtle human being, sensitive, cultured, licentious, a

305. ALESSANDRO LONGHI. *Portrait of Giuliano Contarini*. Rovigo, Accademia dei Concordi (photo: Rijksmuseum, Amsterdam).

man of the world. Rosalba, wrote Roberto Longhi, is a poetess who gives ' an illusive quintessence of her epoque '.

The National Gallery *Portrait of a Young Man* illustrates this point 304 and also the delicacy of her touch, the evocative skill which portrays character and outward form, the shapely eye and painted brow, the elegant poise of the face. Rosalba's contours are of the softest, yet the terseness of the human form is nowhere relaxed and the modelling and shading are gradations of greys and grey blues and whites. Her distinctive portraits in which a way of life, a mode of being has assumed pictorial form contribute to the European tradition of the eighteenth century.

But Carriera was not the only portraitist of the Venetian Rococo. ALESSANDRO LONGHI, Pietro's son, had a shrewd insight into character and painted citizens and dignitaries of Venice with a touch of sarcasm and with a fine feeling for texture. As Rosalba refined and embellished her sitters, so Alessandro was down to earth, establishing contact perpetuating a moment. Both artists reacted to the circumstantial Venetian portrait of state, like Nazari's Senator Tron in the National Gallery, richly robed and be-wigged, personified symbol of the Republic's power and pomp.

305 By contrast Alessandro Longhi's *Portrait of Giuliano Contarini* is a human document of appealing directness. Though the magistrate wears the fur-lined toga and curly wig, painted with subtle discrimination of texture in an exquisite harmony of grey tones, the paraphernalia of office do not conceal the individuality of the sitter, his Voltairean spirit and kindly humour.

Tiepolo and Sebastiano Ricci and Piazzetta were painters of religious and allegorical subjects; PIETRO LONGHI steps out of the Rococo Heaven into the Venetian drawing rooms and becomes a social commentator and painter of genre. He is in the European tradition of Chardin, and Goldoni. Exquisite artisan and subtle colourist and humorous recorder of the ambitions, the foibles, the costumes of the upper classes, he paints the elegant *demi-monde*, the amorous cavalier, the lovesick maiden, the gambler, Tartuffe and Bourgeois Gentilhomme.

Longhi's mild satire aims at the pompous burgher in wig and mantilla, proposing to the lady of the house in a well appointed drawing room, where figures sip coffee from dainty cups and flunkeys stand by with pewter trays. As an artist he prefers shadowless pastel tones of pale blue and pink and splendid whites and soft green, foiled by silk hangings, in his small and sparsely furnished rooms. He has a sensuous delight in the creamy density of paint, the texture of silks and velvet, the very fibre of wood. His humour is less sardonic than Goya's, less broad and boisterous than Jan Steen's. His cavaliers and young belles, amorous and genteel, enact Rococo comedy in the two interiors of the National Gallery.

306 In one of them, *A Nobleman kissing a Lady's Hand*, the lady seems obtuse and the Venetian gentleman in black gown and silky wig, protests his feelings with hypocritical effusiveness. These doll-like figures enact their *comédie d'amour* upon the drawing room stage with ceremonious dignity and comic abandon. The maid servant holds herself as still as a marionette, and the valet, robed in mauve velvet, moves with perfect decorum. The green tapestry and pinkish floor

306. PIETRO LONGHI. *A Nobleman kissing a Lady's Hand*. London, National Gallery (photo : National Gallery).

are a foil to the powdered mask of the lady and her lover, while the pictures on the wall are placed with the calculated finesse of a Pieter de Hooch. In the limited field of social genre Longhi is the first modern artist in Italy. He portrays the High Life, the dainty mummeries of the Venetian Rococo with humorous observation, and slick craftsmanship.

XXXVIII. LANDSCAPE AND VIEW PAINTING IN VENICE

Marco Ricci — Antonio Canale — Francesco Guardi

Landscape painting in eighteenth century Venice is chiefly architectural view painting, except for a group of pastoral idealizers working for the drawing-rooms of the genteel, and one painter of genius, MARCO RICCI whose wood interiors and violent seascapes combine the eccentric spirit of Rosa and Magnasco with the painterly style of late Titian. CANALETTO, BELLOTTO and GUARDI take up the glorification of Venice where Gentile Bellini and Carpaccio had left it. Canaletto transforms the topographical view of Venice by his luministic splendour and structural breadth, a heightened realism based upon perspective precision and limpid clarity. Guardi's vision is more painterly and subjective. He paints lyrical fantasies on Venetian themes with sparkling lights and delicate touches of colour.

Landscape painting in Venice, a city of marble palaces, canals and churches, evolved a special genre of view painting, *vedute* where the changing lights on lagoons and buildings were the principal agents. In the eighteenth century a group of artists, including Zuccarelli and Giuseppe Zais also developed idyllic landscapes with shepherds and their flocks or elegant garden fêtes in an elysian setting of eternal summer. But there was one genuine landscape artist who painted in the romantic vein of Rosa and Magnasco ; wild, untamed nature of towering rocks and dark tree silhouettes and cascading water. He was MARCO RICCI, Sebastiano's son and collaborator (1676-1729) who adopted Magnasco's impetuous use of colour and sudden bursts of light. His *Landscape with Monks*, small agitated figures in brilliant white habits, dotted over the foreground plane in groups or prostrate before a Crucifix, could be taken for a Magnasco. After his visit to Rome and contact with Pannini he developed another genre popular in the eighteenth century : the painting of monumental tombs and ruins, sometimes in collaboration with his father.

Although Ricci was not in the mainstream of the popular art of *vedute* he was the real founder of Venetian landscape painting of the Settecento. Besides Magnasco he had also assimilated the summary painterly technique of the later Titian. His *Storm at Sea* (Bassano Museum) is as fantastic as it is modern. There are no contours, only broad, irrational dabs and scumblings of the brush which convey the shipwreck, the foaming seas tossed against the rock, the raging tempest. The dynamics of the elements are matched by the fierceness and ruggedness of colour. Ricci is closer to Titian's sixteenth century tradition of landscape than to the sweet reasonableness, the linear precision and daylight transparency of the eighteenth.

307. MARCO RICCI. *A Storm at Sea*. Bassano, Museo Civico
(photo: Rijksmuseum, Amsterdam).

With Canaletto and Francesco Guardi the Venetian glorification
of their own city, waterways and people, which began in the fifteenth
century with the pageant pictures of Bellini and Carpaccio (see
fig. 131) emancipates into a special genre: the topographical and
the poetical city portrait. The passage of three hundred years had
not vitally changed the layout of the canals, palaces, churches, the
air and light of the lagoons, and a reaction against the fantastic extravag-
ance of the Baroque brought a demand for a more truthful vision of
the world. This had been answered by the Dutch portrayal of their
own country and architecture, and CANALETTO's first Venetian views
betray this influence.

He was a follower of Carlevaris from whom he learnt architectural
perspective. In 1719 he paid a short visit to Rome to draw ruins under
Pannini, the architectural draughtsman who untiringly translated the
interior of S. Peter's, Rome, into the pictorial language of the Rococo.
By 1720 he is settled in Venice to begin his systematic conquest of every
aspect of his native city. Canaletto's enormous output was spurred by
the demand of travellers from England and Consul Smith, the agent of
George III. He painted his finest work before coming to London in
1746. His early *Piazza San Marco* at Windsor Castle already shows 3

308. CANALETTO. *Piazza San Marco.* Windsor Castle (photo : By gracious permission of Her Majesty the Queen).

the spacious grandeur of Canaletto's design. The deep masses of shadow cast upon pavement and campanile by the boldly foreshortened Procuratie Nuove throw into strong relief the illuminated front of domed church and Ducal Palace. Along the whole wide piazza pictur-esque groups of people are painted in rich impasto, and not by linear perspective but by painterly means of alternating shadows and glittering surfaces. In their dramatic contrast Canaletto imbues a realistic view of Venice with a romantic spirit.

In course of time Canaletto lightens his palette ; the density of impasto, the grainy texture of paint, a certain heaviness after the style of the seventeenth century Dutch gives way to a more vibrant vision in pure dazzling colours. His prime vehicle becomes the light, the moving clouds and the vaporous air. In *S. Cristoforo della Pace and S. Michele looking towards Murano* the subject is a corner of the lagoon with a flat expanse of the sunlit island in the distance, and here the reflections of blues and greys and pinks in the stillness of the water, the warm tones

418

309. CANALETTO. *Regatta from Cà Foscari*. London, National Gallery (photo : National Gallery).

of light, the contrasting planes of shadow under the vastness of the sky endow this corner of the lagoon with a melancholy beauty.

Canaletto spent the best part of his life surveying his native city almost inch by inch, using the *Camera Ottica* for his immaculate perspective, and in his finest work he attained a delicacy of vision, a serenity and calm, in which the light and the vibrant air are the principal agents. In many of his vistas he aspired after an imaginative freedom and pictorial effect of buildings, squares, waterways and bridges, silhouetted against the sky and defined by the sharp vertical edges of palaces, their cubic consistency in the limpid air and all pervading light. He painted the wide opening of the Grand Canal with its house fronts contracted and foreshortened in the distance, and the gondolas plying their course across the rippling water ; and the tremendous festivals on the lagoon, the Doge's state voyage on Ascension Day, receptions of foreign diplomats and regattas. In the *Regatta from Cà Foscari* he combined a colourful fantasy with a detailed realism of presentation. The amorphous dots and blotches suggesting crowds in movement, the radiation of lines defining windows, chimneys, oars, and massed

309

419

310. CANALETTO. *School of San Rocco*. London, National Gallery (photo National Gallery).

gondolas are wholly modern, but the ideation of the picture goes back to Carpaccio and Gentile Bellini.

Canaletto's 'clear cold vision' and 'perspective mania' combine in the *Regatta* with blazing light and gay colours, bright reds and blues and gold of the state barges, window hangings and costumes. The water of the lagoon is a luminous green—and the white light on façades and clouds, the blue sky animated by breezes, lend graphic clarity to all forms. The whole length of the canal is made visible by the diminishing scale of houses and their abrupt foreshortenings, until it vanishes at the turn of the Rialto. The limpid air envelops buildings, barges, crowds, and the serried rows of people lining the banks, boats, balconies, and the skyline of spires and chimney-pots are a fantastical transformation of the same Venetian reality met in Bellini's *Miracle* 131 *of the Cross*.

To the luminous reality of the Venetian scene Canaletto added an element of painterly *bravura* in the summary treatment of the crowd watching the Regatta, where dabs of ochre suggest faceless heads of 310 people. The *School of San Rocco* represents yet another Canaletto,

420

PLATE XI. BERNARD BELLOTTO. *Capriccio*, detail. London, Victoria & Albert Museum (Courtesy: Victoria & Albert Museum)

who delights in rich impasto, an artist of the Rococo recording the ceremonious feasts of Venice, where stately dignitaries in grey curly wigs walk in procession in gowns of scarlet, purple, black and gold. This multi-coloured assembly is foiled by the grey stone of the luxuriant Renaissance Scuola, deeply shaded beneath the pediments and in the portals, flanked by the warm brown expanse of the Church façade and moulded by the dazzling light. For the sun blazes down in the centre and grades off to the sides where the Church casts its triangular shaft of shadow. The light brown awning, spread across the whole length of the picture and painted in delicate curving brushstrokes of rich pigment, provides the horizontal balance for the uprights of poles and columns.

The *School of San Rocco* shows Canaletto's place in the continuity of the Venetian tradition, a master of colour and light whose best work transcends the luministic topography of his popular genre. For here the colour is sensuous, vital and opalescent, giving relief to figures as well as buildings and depicting the eighteenth century scene with gaiety and abandon.

Canaletto's brilliant pupil in the topographical genre of city views was his nephew BERNARDO BELLOTTO, who at the age of twenty-seven left Italy for Dresden and Warsaw. There he applied the art of Canaletto to the portrayal of the architectural prospects of these cities.

In our *Capriccio* (plate XI) Bellotto paints a picturesque corner of the Venetian townscape, but with a greater emphasis on zones of shadow which delineate form than Canaletto was wont to use. He is no mere copyist of his uncle's *vedute* but endows this genre with his own personality, using less radiant skies and a more sombre range of tones.

The art of FRANCESCO GUARDI (1712-1793) is more subjective than Canaletto's, his vision more painterly, his light more sparkling, his touch more delicate. He often borrowed the designs of Canaletto, but he transformed them into lyrical fantasies. The linear precision of contour and perspective are submerged in the vibrant atmosphere, the magical light, the arbitrary shadows and the summary style of his brush. Where Canaletto defines and constructs, Guardi imposes his colouristic vision, his blurred outlines, his sparkling lights. By his nervous delicacy of touch, his rich impasto, his restless arabesques he is the supreme master of the Rococo.

In his view of *San Giorgio Maggiore* the Palladian church and its 311 angular pile of buildings cast their reflection into the stillness of the lagoon. Above, a burst of pink explosive clouds, shadows slung across buildings and turrets, the soft gleam of marble, splashes of pure white in the wake of ships, the glassy water a composite of reflected blues,

311. GUARDI. *San Giorgio Maggiore.* London, Wallace Collection (photo : Wallace Collection).

pinks and browns, sails relaxing in the calm air and the marionette boatmen straining at the oar are the elements by which Guardi conveys the indolent dreaminess of the lagoon.

A festive mood prevails in the teeming basin of San Marco with the 312 *Departure of the Bucintoro* for the ceremonious rite of wedding Venice to the sea. The gaiety of the scene with the countless craft swarming around the gilded galleon of the Doge, the movement of oars and fluttering banners are seen against the brilliant prospect of the Venetian waterfront. And here in the scintillating specks of colour, the white light upon façades and cupolas, merging with the soft atmosphere of sky and water, the contrast between the rich colour of watchers on the shore and the silvery haze of the interminable distance, Guardi's painterly impression of Venice takes its place beside the clear contours and definition of Canaletto.

Nor are his buildings set less firmly in the silver sea. *Santa Maria* 313 *della Salute* in dazzling grey and mother of pearl rules like a queen over the entrance of the Grand Canal, a Rococo queen with her slate-blue cupola, her coronal of convoluted stone and the dependent buildings flung starwise into the pale blue water. The restless variety of archi-

422

PLATE XII. FRANCESCO GUARDI. *San Giorgio Maggiore*, detail.
Another version. London, Wallace Collection (Courtesy: Wallace Collection)

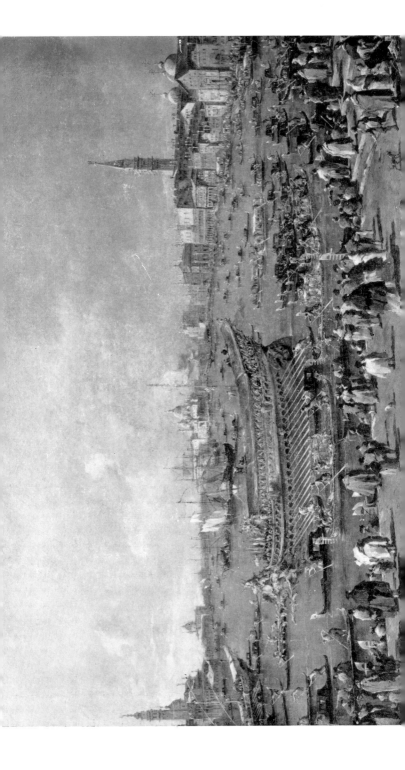

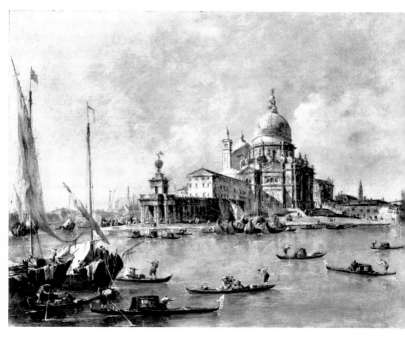

313. GUARDI. *Santa Maria della Salute*. London, National Gallery (photo: National Gallery).

tectural forms, coils, figures and pediments of the octagonal pile is matched by the delicacy of silvery tints, the white dots on the water, the red and yellow of the gondoliers. Yet the sparkling touches of jewel-like colour are subsumed to the larger design, the luminous complex of buildings with its alternating planes of shadow and light under the great azure dome of the sky. Guardi thrusts into the diagonal depth of space and fans out in all directions, from the picturesque sailing craft in the foreground to the roseate haze of the distant shore. By his sense of ' broken form ' and magical light, his sparkling colour, his fantastic spirit, Francesco Guardi is, beside Tiepolo, the leading master of the Italian Rococo.

Finally a note on Guardi's scenic paintings, the large backdrops from Tasso's *Gerusalemme Liberata*, recently discovered in England, with their mildly operatic figures, rapidly sketched before hazy back-grounds of pastel blue mountains and silvery water and the *Stories of Tobias* painted on the organ shutters in the church of the Angel Raphael in Venice ; these are Guardi's most evocative works and the least realistic. Forms seem to dissolve in air, light and water ; they are angular, weightless, even distorted. Mannered and elongated figures flutter across the scene ; tree trunks are split ; flashes of colour and bursts of light constitute form. The magic of Magnasco and Marco Ricci has become pure poetry in the leaping brushwork and refulgence of Guardi. The airiness and instability of form, medium, texture characterize the last chapter in the painterly art of Venice.

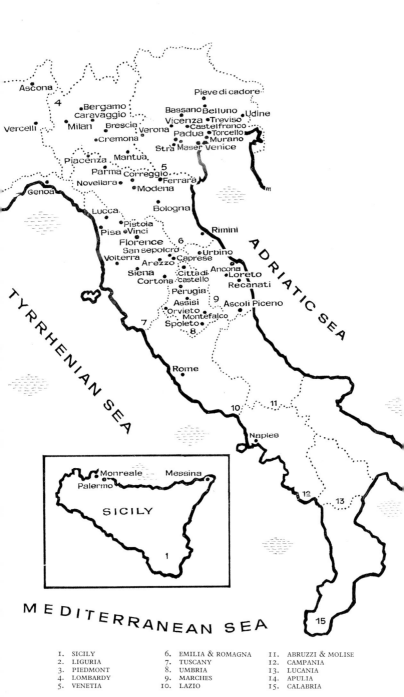

1.	SICILY	6.	EMILIA & ROMAGNA
2.	LIGURIA	7.	TUSCANY
3.	PIEDMONT	8.	UMBRIA
4.	LOMBARDY	9.	MARCHES
5.	VENETIA	10.	LAZIO

11.	ABRUZZI & MOLISE
12.	CAMPANIA
13.	LUCANIA
14.	APULIA
15.	CALABRIA

SELECTED BIBLIOGRAPHY

Ancona, Paolo d', *Umanesimo e rinascimento*, Torino 1948
(STORIA DELL' ARTE CLASSICA E ITALIANA)
Becherucci, Luisa. *Manieristi toscani*, Bergamo 1944
Berenson, Bernard, *The Italian Painters of the Renaissance*, Oxford 1952
Berenson, Bernard, *The Italian Pictures of the Renaissance*, Oxford 1932
Berenson, Bernard, *Italian Pictures of the Renaissance:*
 I. FLORENTINE SCHOOL, 2 vols, London 1963
 II. VENETIAN SCHOOLS, 2 vols, London 1963
Berenson, Bernard, *The Study and Criticism of Italian Art*, London 1901-2
Berenson Bernard, *Sunset and Twilight—from the Diaries 1947-58*, London 1964
Blunt, Anthony, *The Drawings of Castiglione and Stefano della Bella at Windsor Castle*, London 1955
Carli, Enzo, *La pitture senese*, Milano 1955
Cecchi, Emilio, *Trecentisti senesi*, Roma 1925
Chastel, André, *Italian Art*, London 1963
Coletti, Luigi, *Pittura veneziana del quattrocento*, Novara 1954
(STORIA DELLA PITTURA ITALIANA)
Davies, Martin, *The Early Italian Schools*, London 1952
 (catalogues of the Italian Masters in the National Gallery, 13th-15th centuries)
Friedländer, Walter, *The Anti-Classical Style*, New York 1957
Friedländer, Walter, *Mannerism and Anti-Mannerism in Italian Painting*, New York 1957
Fry, Roger, *Transformations*, London 1926
Fiocco, Giuseppe, *La pittura toscana del quattrocento*, Novara 1945
(STORIA DELLA PITTURA ITALIANA)
Gamba, Carlo, *Pittura umbra del rinascimento*, Novara, 1949, 1945
(STORIA DELLA PITTURA ITALIANA)
Godfrey, F. M., *Early Venetian Painters*, London 1954
Golzio, Vincenzo, *Seicento e settecento*, 2 vols, Torino 1960
Haskell, Francis, *Patrons and Painters*, London 1963
Ideale (L') classico del seicento in Italia e la pittura del paesaggio, Catalogo, Bologna 1962
Lavagnino, Emilio, *L'arte medioevale*, Torino 1949
(STORIA DELL'ARTE CLASSICA E ITALIANA)
Levey, Michael, *The 18th Century Italian Schools*, National Gallery Catalogue, London 1956
Levey, Michael, *Painting in 18th Century Venice*, London 1959
Longhi, Roberto, *Viatico per cinque secoli di pittura veneziana*, Firenze 1946
Lorenzetti, Giulio, *Venezia e il suo estuario*, Roma 1956
Mahon, Denis, *Studies in seicento art and theory*, London 1947
Mahon, Denis, and Denys Sutton, *Artists in 17th Century Rome*, Exhibition catalogue, London 1955
Mâle, Emil, *L'art religieux, XVII siecle*, Paris 1951
Nebbia, Ugo, *La pittura italiana del seicento*, Novara 1946

427

Nicholson, Benedict, *The Painters of Ferrara*, London 1950
Pallucchini, Rodolfo, *La pittura veneziana del cinquecento*, Novara 1944
Pallucchini, Rodolfo, *La pittura veneziana del settecento*, Venezia 1960
Panofsky, Erwin, *Studies in Iconology*, Oxford 1936
Pater, Walter, *The Renaissance*, London 1873
Pope-Hennessy, John, *Sienese Quattrocento Painting*, London 1950
Toesca, Pietro, *Il trecento*, Torino 1951
 (STORIA DELL'ARTE CLASSICA E ITALIANA)
Vasari, Giorgio, *The Lives of the Painters, Sculptors and Architects*, edited by
 Gaston de Vere, 10 vols. London 1911-15.
Voss, Heinrich, *Die Malerei des Barock in Rom*, Berlin 1924
Waterhouse, Ellis, *Baroque Painting in Rome*, London 1937
Waterhouse, Ellis, *Italian Baroque Painting*, London 1962
Wittkower, Rudolf, *Art and Architecture in Italy* 1600-1750, London 1958
Wittkower, Rudolf and Margot, *Born under Saturn*, London 1963
Wöfflin, Heinrich, *Principles of Art History*, London 1932
Wöfflin, Heinrich, *Classic Art*, London 1952

Monographs on individual artists

ANGELICO: Pope-Hennessy, John, *Fra Angelico*, London 1949
ANTONELLO DA MESSINA: Lauts, Jan, *Antonello da Messina*, Vienna 1943
BELLINI, GIOVANNI: Dussler, Luitpold, *Giovanni Bellini*, Vienna 1949
 Gamba, Carlo, *Giovanni Bellini*, Milano 1937
 Hendy, Philip, and Ludwig Goldscheider, *Giovanni Bellini*, London 1945
 Pallucchini, R., *Giovanni Bellini*, London 1963
BOTTICELLI: Bode, Wilhelm von, *Sandro Botticelli*, Stuttgart 1926
 (KLASSIKER DER KUNST)
 Venturi, L., *Botticelli*, London 1961
CANALETTO: Moschini, Vittorio, *Canaletto*, Milan and London 1955
CARAVAGGIO: Berenson, Bernard, *Caravaggio*, London 1953
 Friedländer, Walter, *Caravaggio Studies*, Princeton 1955
 Hinks, Roger, *Caravaggio*, London 1953
 Longhi, Roberto, *Il Caravaggio*, Milano 1951
 Venturi, Lionello, *Il Caravaggio*, Novara 1951
CARPACCIO: Fiocco, Giuseppe, *Carpaccio*, Milano 1931
 Lauts, Jan, *Vittore Carpaccio*, London 1962
CARRACCI: Gnudi, Cesare, *Mostra dei Carracci*, Bologna 1956
 Wittkower, Rudolf, *The Carracci Drawings at Windsor Castle*, London 1952
CORREGGIO: Bodmer, Enrico, *Il Correggio e gli emiliani*, Novara 1943
DOMENICHINO: Pope-Hennessy, John, *The Drawings of Domenichino at Windsor
 Castle*, London 1948
GHIRLANDAIO: Lauts, Jan, *Domenico Ghirlandaio*, Vienna 1943
GIORGIONE: Ferriguto, Alessandro, *Attraverso i misteri di Giorgione*, Castelfranco
 1953
 Fiocco, Giuseppe, *Giorgione*, Bergamo 1948
 Venturi, Lionello, *Giorgione e il giorgionismo*, Milano 1913
 Zampetti, Pietro, *Giorgione e i giorgioneschi, Catalogo della Mostra*, Venezia
 1955
GIOTTO: Gnudi, Cesare, *Giotto*, London 1962

GUARDI: Fiocco, Giuseppe, *Guardi*, Milan and London 1923
LEONARDO: Clark, Sir Kenneth, *Leonardo da Vinci*, Cambridge 1952
LIPPI: Pittaluga, Maria, *Fra Filippo Lippi*, Florence 1949
LOTTO: Berenson, Bernard, *Lorenzo Lotto*, London 1956
MANTEGNA: Fiocco, Giuseppe, *Andrea Mantegna*, Milano 1937
 Tietze-Conrat, E., *Andrea Mantegna*, London 1955
MASACCIO: Salmi, Mario, *Masaccio*, Milano 1948
PIAZZETTA: Pallucchini, Rodolfo, *G. B. Piazzetta*, Milano 1956
PIERO DELLA FRANCESCA: Longhi, Roberto, *Piero della Francesca*, 2nd ed. 1942
 Clark, Sir Kenneth, *Piero della Francesca*, London 1951
PIETRO DA CORTONA: Briganti, Giuliano, *Pietro da Cortona*, Firenze 1962
POUSSIN: Bazin, Blunt, Sterling, *Nicolas Poussin, Exposition*, Paris 1960
 Mahon, Denis, *Poussiniana*, London 1962
RAFFAELLO: Fischel, O., *Raphael*, 2 vols., London 1948
 Ortolani, Sergio, *Raffaello Sanzio*, Bergamo 1948
 Stein, Wilhelm, *Raphael*, Berlin 1923
RENI, Gnudi, Cesare, and G. C. Cavalli, *Guido Reni, Catalogo della Mostra*, Bologna 1954
SEBASTIANO VENEZIANO: Pallucchini, Rodolfo, *Sebastiano Veneziano*, Milano 1944
TIEPOLO: Morassi, Antonio, *Tiepolo*, London 1955
TINTORETTO: Colletti, Luigi, *Tintoretto*, Bergamo 1944
TIZIANO: Tietze, H., *Titian*, London 1950
UCCELLO: Pope-Hennessy, John, *Paolo Uccello*, London 1949
VERONESE: Pallucchini, Rodolfo, *Paolo Veronese*, Bergamo 1943

BIOGRAPHICAL NOTES

The Biographical Notes include (in brackets) page and figure references to those artists mentioned in the text. A considerable number of notes to other artists have been added to make the list more complete.

Abbate, Niccolò Dell' (*c* 1509-1571). Modena. Mannerist painter of intricate and panoramic landscapes, often with supple and elongated figures. Influenced by Dosso of Ferrara and Parmigianino. In 1552 he joins Primaticcio at Fontainebleau. (p. 276, fig. 205).

Alamagna, Giovanni d' (*Died* 1450). German born Venetian painter. Between 1440-50 shared workshop with Antonio Vivarini, founder of the School of Murano, later superseded by the Bellini studio.

Albani, Francesco (1578-1660). Bolognese Classicist, pupil of the Carracci Academy; followed Annibale to Rome in 1602 together with Reni and Domenichino. Painter of amorous mythologies in landscape settings often with dancing children.

Albertinelli, Mariotto (1474-1517). Florence. Imitator of Fra Bartolommeo and workshop partner since 1508. Cf. *Visitation* (Uffizi).

Allegri *see* Correggio.

Allori *see* Bronzino.

Allori, Cristofano (1577-1621). Florentine Mannerist. Pupil of his father Alessandro. Continued the Grand Style of Florence, combined with a sense of strong colour, and dazzling light upon precious stuffs Cf. *Judith with the Head of Holofernes* (Pitti).

Altichiero (*c* 1320-1385). The greatest Veronese master in the Giotto tradition. His chief work is a large *Crucifixion* in the Santo at Padua. With his associate Avanzo he decorated the Oratorio di S. Giorgio, in the same town, with stories from the lives of S. George and S. Lucy. (p. 43, fig. 35).

Altobello da Melone (*c* 1497-1530) Active in Cremona. Influenced by the Giorgionesque Romanino of Brescia. *Walk to Emmaus* (National Gallery).

Amigoni, Jacopo (1675-1752). Introduced Venetian Rococo art of Ricci and Pellegrini to the courts of Bavaria, painting mythological frescoes in Nymphenburg, Schleissheim and also in Madrid. He is the least poetical of the three. (p. 406).

Andrea del Castagno *see* Castagno.

Andrea del Sarto (1486-1531). Florentine. Pupil of Piero di Cosimo. Leads High Renaissance style to the brink of Mannerism. Rhythmical and monumental compositions, rhetorical and with richly developed draperies,

Venetian sense of tone. Northern influence besides that of Michelangelo, Raphael, Fra Bartolommeo. Cf. *Birth of the Virgin* and *Madonna del Sacco* in the SS. Annunziata. Giorgionesque portraits cf. *A Sculptor* (National Gallery). Pontormo was his pupil. (p. 247, figs. 183-186).

Angelico (Fra) da Fiesole (Guido di Pietro) (*c* 1386-1455). Born in the Mugello near Florence. In 1407 he enters the Dominican brotherhood of San Domenico near Fiesole. He probably started as a conventual painter of miniatures. From 1409 to 1418 the Dominicans of Fiesole were dispersed and Angelico may have gone to Cortona. Later he returned to Fiesole and from 1438 to 1444 he worked for the Dominicans of San Marco at Florence, decorating cloisters, cells, and chapter house with his murals. After 1447 he is employed in Rome (Vatican) by the Pope (*Legends of SS. Lawrence and Stephen*), and in Orvieto. (p. 61, figs. 48-52, plate III).

Anguisciola, Sofonisba (1530-1625). Cremona. Eminent portrait painter of Mannerist period. Also worked in Sicily and Spain.

Ansaldo, Andrea (1584-1638). Genoese. Baroque Painter influenced by Rubens and van Dyck.

Antonello da Messina (*c* 1430-1479). Active in Messina before 1456, then Naples (1473) where he made contact with Flemish painters at the court of Alfonso of Aragon. Gains knowledge of the van Eyck tradition of refining oils and varnishes. The *S. Jerome in his Study* (National Gallery) reflects Flemish influence. In his *S. Sebastian* (Dresden) and the monumental *Madonna and Saints* painted for the Venetian church of San Cassiano, he shows knowledge of Pietro della Francesca's work. His

visit to Venice in 1475-76 is of momentous importance for the Bellini school and for himself. He created a new style of realistic portraiture and of *Sacra conversazione*. (p. 183, figs. 138-140, plate VI).

Arcimboldo, Giuseppe (1527-1593). Milan. Mannerist; gained notoriety by his bizarre practice of composing human heads and figures out of fruit and vegetable forms. Court painter to Ferdinand I of Austria.

Assereto, Gioacchino (1600-1649). Genoa. Pupil of Ansaldo, master of the Early Baroque with a naturalist trend (Caravaggesque) and a strong feeling for colour and light.

Avanzo, Jacopo (fourteenth century). Pupil of Altichiero. (fig. 35).

Baciccio (Baciccia), G. B. Gaulli (1639-1709). Genoese. Great Baroque decorator. Comes to Rome as a boy of eighteen. Friend of Bernini. Influenced by Correggio, Pietro da Cortona and Rubens. His chief work: the decoration of Il Gesù, Rome (1669-1683). Fine portraitist; cf. *Pope Clement IX*. (p. 387, fig. 288).

Baglione, Giovanni (1571-1644). Rome. Since 1600 impressed by Caravaggio's light and genre subjects. Later became his enemy. More important as a writer than a painter. Famous source book of artists' lives between 1572-1642: *Le Vite de' pittori, scultori, architetti*.

Baldassare Estense (*c* 1437-1504). Ferrara. Painter and medallist at the Este and Sforza Courts.

Baldinucci Filippo (1624-1696). Florentine. Continues Vasari's *Lives* in his *Notizie de' Professori del disegno*.

Baldovinetti, Alessio (c 1425-1499). Florentine school. Pupil of Domenico Veneziano. Became member of the Painters' Guild in 1448. Completed frescoes in S. Egidio, Florence, in 1460-61. He is interested in the science of oils and varnishes. In introducing the landscape of the Arno valley into the background of his Madonnas, he shows dependence on Piero della Francesca. Delicate linearism. (p. 83, figs. 65, 66).

Banco, Maso di (Early fourteenth century). Follower of Giotto and of the Sienese. Works in S. Croce, Florence.

Barbarelli see Giorgione.

Barberi, Jacopo de' (c 1440-1516). Venice. Follower of the Vivarini, painter and engraver. Probably influenced by Dürer. Early still-life of *Partridge hanging on a Wall* (Munich).

Barbieri see Guercino.

Barna da Siena (fourteenth century). Follower of Duccio, Lorenzetti and Simone Martini. Frescoes in Collegiate Church of S. Gimignano with stark dramatic scenes from Christ's Passion.

Baroccio, Federico (c 1526-1612). Born and lived in Urbino, except for a stay in Rome between 1561 and 1563. Proto-Baroque painter of devout religious altar pieces of the Counter Reformation. Fine draughtsman and pastel-like colourist akin to Correggio. (p. 263).

Bartolo, Domenico di (c 1400-1447). Siena. Assimilates Florentine science and perspective (Uccello, Masaccio, Lippi). Naturalistic frescoes in the Hospital of S.M. della Scala cf.*Distribution of Alms*, Crowded scenes in architectural setting. Power-

ful sculptural nudes.

Bartolo di Fredi (c 1330-1410). Partner of Andrea Vanni, but more narrative and down-to-earth, looking back to the Lorenzetti.

Bartolomeo Veneto (*active* 1502-1530). Venice, Milan, Ferrara. Influenced by Bellini and Leonardo school. Distinguished portrait painter.

Bartolommeo (**Fra**) Baccio della Porta (1472-1517). Florentine, pupil of Cosimo Rosselli. In his Madonnas and Saints he favours the monumental and the grandiose. Friend of Raphael, influenced by Leonardo and Michelangelo. After Savonarola's death he gives up painting for six years. Visits Venice in 1508 and Rome in 1514. (p. 244, figs. 180-182).

Basaiti, Marco (c 1470-1531). Venetian, pupil of Alvise Vivarini. Altar pieces with Bellinesque landscapes. *Calling of the Sons of Zebedee* (Venice Accademia).

Baschenis, Evaristo (1617-1677). Bergamo. Painter of impeccable still-lifes with musical instruments.

Bassano, Jacopo da Ponte (c 1510-1592). Venetian school, born in Bassano. Pupil first of his father, then of Bonifazio Veronese at Venice. By 1540 he is settled for good in his native Bassano. Superb colourist, influenced by Titian, Tintoretto. Head of a fertile workshop in which his sons Leandro, Girolamo and Francesco continue to paint religious and rustic genre. (p. 322, figs. 241-245).

Batoni, Pompeo (1708 - 1787). Lucca. In Rome since 1760. Friend of Wincklemann and rival of Mengs. History and portrait painter; follows Raphael and the Antique. Opposes Late Baroque by Neo-Classicism.

Battistello, Giovanni Battista (c 1570-1637), called Caracciolo. Founder of Neapolitan seventeenth century school under impact of and contemporaneous with Caravaggio's work at Naples. His *Liberation of Peter* and its focus of light on the angel and the monumental *Washing of the Feet* (San Martino) illustrate his art.

Bazzi *see* Sodoma.

Beccafumi, Domenico (1486?-1551), Founder of Tuscan Mannerism with Pontormo, Rosso and Bronzino. Influenced by Michelangelo and Sodoma. Works and dies in Siena.

Bellini, Gentile (c 1429-1507). Venetian school. Elder son of Jacopo Bellini. In 1465 he paints the tempera portrait of *Beato Lorenzo Giustiniani*, and in 1469 he becomes the official portraitist of the Venetian Republic. From 1479 to 1481 he is sent by Venice to Sultan Mohammed II at Constantinople. Between 1496 and 1501 he paints the great pageant pictures such as the *Miracle of the Cross* and the *Procession in the Piazza San Marco*, portraying the contemporary life of Venice. His last work was the *Preaching of S. Mark*. He left his father's sketch books to Giovanni, provided he would finish that picture. (p. 174, figs. 129-131).

Bellini, Giovanni (Giambellino) (1430?-1516). Venetian school. Son of Jacopo and brother of Gentile. Educated in his father's workshop. In 1459 Giovanni has a studio of his own, but in 1460 he paints a Crucifixion together with his father and brother. Between 1460 and 1472 his works are influenced by Mantegna, his brother-in-law. But after 1475/6, the date of Antonello's visit to Venice, he follows that master; especially in his Pala of San Giobbe and Frari Triptych (1488). Warm, luminous colours and crystalline landscape backgrounds. As a portraitist he is influenced first by Antonello and then by Flemish masters like Memling. In 1505 and 1514, he paints his last great altarpieces for Venetian churches. His mythological *Feast of the Gods* of 1514 was completed by Titian. (p. 188, figs. 141-146).

Bellini, Jacopo (1397-1470). Venetian school. In 1423 he accompanies his master Gentile da Fabriano to Florence. In Ferrara he competes with Pisanello for the portrait of Duke Lionello d'Este. In Venice he heads the Bellini workshop with his sons Gentile and Giovanni, in rivalry with the retrograde studio of the Vivarini family at Murano. Jacopo left a few paintings and two famous sketch books from which his sons worked. (p. 173).

Bellotto, Bernardo (Canaletto the Younger) (1720-1780). Canaletto' nephew and most gifted pupil. Painter of precise and luminous city views and Roman ruins. Left Italy in 174? and went to Dresden and then to Warsaw (1770). (p. 421, plate XI).

Bernini, Gianlorenzo (1598-1680), Naples. Rome since about 1605, Leading sculptor of the Roman Baroque. Four portrait paintings are ascribed to him, three of them self portraits; also a David with the head of Goliath. Bernini's paintings are spontaneous and sketchy, classicising rather than baroque. They were once attributed to Velazquez. Cf *Portrait of a Boy* (Oxford, Ashmolean).

Berruguete, Pedro (c 1450-1504). Spanish born, working at the Court of Urbino, painting a portrait of Duke Federigo and four *Allegories of the Liberal Arts* (2 in London). Contact with Piero della Francesca and Justus van Ghent.

434

Bigordi *see* Ghirlandaio.

Boltraffio, Giovanni Antonio (1467-1516). Milan. Foremost pupil of Leonardo but with a distinctive style of his own. Sound portraitist and religious painter; cf. *Madonna with the poet Girolamo Casio* (Louvre). He favours youthful single figures, Narcissus, S. John the Baptist and the memorable *Christ Blessing* (at Bergamo). (p. 211, fig. 212).

Bonifazio de' Pitati (Bonifazio Veronese) (1487-1553). Venetian painter, pupil of Palma Vecchio and master of Jacopo Bassano. Bonifazio developed an outdoor genre of ' fashionable country life '; indebted also to Giorgione and to Titian.

Bono da Ferrara (*active* 1450). Padua, assists Mantegna at the Eremitani frescoes. *Martyrdom of S. Christopher*.

Bordon, Paris (*c* 1500-1571). Treviso. Titian's pupil, influenced by Giorgione and Palma Vecchio. Represents High Renaissance in Venice. Cf. *The Venetian Lovers* (Brera).

Borgianni, Orazio (1578-1616). Rome. Owed more to El Grego and Bassano than to Caravaggio. In his *S. Carlo Borromeo* he employs brilliant light and deep shadow (and a liquid *impasto* reminiscent of Bassano) to create one of the most memorable saints in ecstasy before the Baroque.

Borgognone, Ambrogio da Fossano (*c* 1445-1523). Milan. Foppa's pupil, chief master of Lombard School before Leonardo. Sincere devotional painter, often with monastic scenes and landscape insets.

Botticelli, Sandro (Alessandro Filipepi) (*c* 1445-1510). Florentine. Trained as a goldsmith, and in painting by Filippo Lippi. From 1474 he is in close contact with Lorenzo Medici and his circle. Influenced by Pollaiuolo and Verrocchio. He paints classical subjects inspired by the Medicean humanists, and portraits of the Medici as kings and attendants in the *Adoration of the Magi*. Fluent linear rhythms and poetic inventiveness. In 1481 Botticelli paints frescoes in the Sistine Chapel. His best work stems from his middle period *c* 1475-90: *Primavera*, *S. Augustine*, *Calumny of Apelles*, etc. After the fall of the Medici in 1494, and with the coming of Savonarola, Botticelli paints only religious works of morose puritanical character. His last work is the *Mystical Nativity* (London) which is of 1500. (p. 124, figs. 95-101, plate V).

Bramantino (Bartolomeo Suardi, *active* 1503-36). Lombard school. Follower of Foppa and of the architect Bramante, who invited him to Rome. One of his finest works is the *Ecce Homo* in the Thyssen Collection. (p. 169, fig. 126).

Bronzino (**Agnolo Allori**) (1503-1572). Florentine Mannerist. Pupil of Pontormo. Portraitist of Grand Ducal Florence under Cosimo I. Mythological and allegorical compositions influenced by Michelangelo. (p. 270, figs. 200-202).

Brusasorci, Domenico (*c* 1516-67). Verona. Transition from Renaissance to Mannerism. New painterly way of handling mass and texture, light and shade.

Bugiardini, Giuliano (1475-1554). Florentine. Assists Michelangelo in the Sistine ceiling. Also influenced by Leonardo and Fra Bartolommeo.

Buonaccorsi *see* Vaga.

Caliari *see* Veronese.

Cambiaso, Luca (1527-1585). Genoa. Prolific Late Renaissance decorator, influenced by Venetians. Frescoes, altars, mythologies in palaces and churches of Genoa.

Canaletto (Giovanni Antonio da Canale) (1697-1768). Venetian School. Started as Baroque scene painter in his father's workshop. Follower of Carlevaris. 1719 journey to Rome. In 1720 he paints his first Venetian view. 1746 journey to London on instigation of Consul Joseph Smith. 1756 probable return to Venice. 1763 election to Venetian Academy after previous rejection. 1768 death of Canaletto. (p. 417, figs. 308-310).

Canaletto the Younger *see* Bellotto.

Caracciolo *see* Battistello.

Caravaggeschi, *see* Orazio Gentileschi, Carlo Saraceni, Orazio Borgianni, and Bartoloméo Manfredi.

Caravaggio, Michelangelo Merisi da (1573-1610). Roman school. Born in Caravaggio near Bergamo. Lombard-Venetian upbringing. Goes to Rome around 1590. Lives in the palace of the Cardinal del Monte and through him is commissioned to paint scenes from the Life of S. Matthew for the Contarelli Chapel in San Luigi dei Francesi; and for the Marchese Vincenza Giustiani the *Conversion of Paul* and the *Crucifixion of Peter* for the Cerasi Chapel at Santa Maria del Popolo. In 1606 he committed manslaughter and fled to Naples; thence to Malta where the Grandmaster Alof de Wignacourt is his patron. After more trouble and imprisonment he escapes to Sicily.

436

In 1610 he dies on Italian soil. (p. 369, figs. 276-282).

Caravaggio, Polidoro da (c 1495-1543). Messina. Follower of Raphael and of the Antique. Roman Mannerist. With Giulio Romano and Pierino della Vaga he completes Raphael's late works. Also paints illusionist stucco architecture and landscapes.

Cariani, Giovanni de' Busi (c 1485-1547). Venice. Pupil of Palma Vecchio, but influenced chiefly by Giorgione.

Caroto, Giovanni Francesco (c 1480-1555). Verona. Leading master, pupil of Liberale da Verona, influenced by Mantegna and Raphael. Frescoes and altar pieces in Veronese churches.

Carpaccio, Vittore (1455-1526). Venetian school. Born in Torcello; follower of Gentile Bellini. Painter of sacred legend in Venetian setting. He paints for the Scuole or philanthropic societies: the Scuola di Sant Orsola, San Giovanni Evangelista, and Scuola dei Schiavoni in Venice. Between 1490 and 1498 the cycle of the legends of S. Ursula and the *Miracle of the Cross* (Venice Accademia), and after 1502 for San Giorgio dei Schiavoni *S. Jerome in his Study* and the legends of S. George In his late *Pietà* he shows the influence of Mantegna and Giovanni Bellini. (p. 176, figs. 132-137).

Carracci, Annibale (1560-1609). Bolognese school, Cousin of Lodovico and brother of Agostino. 1585-1588 journeys to Parma and Venice. 1595 summoned to Rome by Cardinal Odoardo Farnese to decorate his palace with pagan mythologies. He combines Classic and Baroque elements of seventeenth century painting

and is the presiding genius of the Carracci school; breaks with Mannerism by a return to nature, Raphael and Antiquity. (p. 346, figs. 260-264).

Carracci, Agostino (1557-1602). Bolognese school. Cousin of Lodovico and brother of Annibale. Vital journey to Venice in 1582 and to Parma in 1585. He was mainly an engraver and a scholar, but also frescoed in Bolognese places. His chief panel painting: *The Last Communion of S. Jerome* influenced Domenichino's work. (p. 346).

Carracci, Lodovico (1555-1619). School of Bologna. Founder of the Accademia degli Incamminati (1582) together with his cousins Agostino and Annibale. Other prominent pupils of the Bolognese school are Guercino, Guido Reni and Domenichino. While most of his pupils left Bologna for Rome, Lodovico remained in Northern Italy. Religious painter of the Counter Reformation; favours rich Venetian colour and chiaroscuro. Guercino is his chief follower. (p. 346, figs. 258, 259).

Carriera, Rosalba (1675-1757), Venetian school, painter of fashionable miniatures and pastel portraits of great charm. Visits Paris in 1720-21, and Vienna in 1730. (p. 412, fig. 304).

Castagno, Andrea del (Andrea di Bartolo di Simone) (1423-1457). Spent his youth in Castagno, but worked in Florence. Pioneer of the early Renaissance: influenced by Donatello; aims at monumental and sculptural figure compositions and vigorous realism. In 1442 he works in Santa Zaccaria at Venice. His chief works in Florence are the *Last Supper, Entombment, Resurrection* in Sant' Apollonia, the frescoes of famous men for the Villa Carducci and the equestrian portrait of Niccolò di Tolentino in the Cathedral (1456). (p. 100, figs. 76-78).

Castello, Valerio (1625-1659). Genoa. Baroque decorator, influenced by Correggio, Rubens, van Dyck. Great productivity in Genoese palaces and churches. Master of Magnasco.

Castiglione, Giovanni Benedetto (c 1610-1665). Genoese school. Influenced by Rubens and van Dyck. Painter of biblical and pastoral genre. Outstanding animal painter in Bassano's lineage; but lighter in colour pitch. (p. 386, fig. 286).

Catena, Vincenzo (c 1475-1531). Venetian school. Born probably in Venice, he started as an imitator of Giovanni Bellini. Later he befriended Giorgione and from 1506 was in close professional contact with him. At the back of Giorgione's *Portrait of Laura* in the Vienna Museum is the inscription ' 1506 the first day of June this was done by the hand of Master Giorgio di Castelfranco . . . colleague of master Vincenzo Catena '. He painted sacred pictures and some fine portraits. Was also influenced by Cima, Palma Vecchio and Titian. (p. 291, figs. 216, 217).

Cavallini, Pietro (1240/50-1320 ?). Leading Roman master before Giotto. Mosaicist and fresco painter. In 1291 he designs the mosaics in Santa Maria, Trastevere, representing scenes from the life of the Virgin. His frescoes of the *Last Judgment* in Santa Cecilia, Rome are of 1293. Sculptural and statuesque figures overcoming the Byzantine formula. From 1308 he works in the service of the King of Naples. (p. 2, fig. 1).

Cavallino Bernardo (1622-1654). Neapolitan painter of elegant and sophisticated easel pictures of great colouristic finesse. Pupil of Vaccaro

and Stanzioni. Though influenced by Caravaggio's light, his *S. Cecilia* (Naples) and *Immacolata* (Brera) have a Venetian fluency and richness of silvery tones.

Cavedoni, Giacomo (1577-1660). Modena, pupil of the Carracci and especially of Ludovico. Bolognese master of the Baroque, influenced by the Venetians. *Madonna with S. Alo* (Bologna Pinacoteca).

Cennini, Cennino (*c* 1370). Follower of Giotto. Author of famous *Trattato della Pittura* 1440.

Cerano *see* Crespi.

Cerquozzi, Michelangelo (1602-1660). Rome. Painter of battle pieces and street genre (*Bambocciate*). Influenced by Pieter van Laer.

Ceruti, Giacomo (*active c* 1725-1750). Milan. Realistic painter of low life, influenced by the Dutch, of tramps, beggars, idiots, down-and-outs.

Cesare da Sesto (1477-1523). Milan. Member of Leonardo's circle (1505-10) seeking sculptural effects by *sfumato*.

Cesari, Giuseppe (Il Cavaliere d'Arpino) (*c* 1568-1640). Rome. Mannerist decorator, favourite of three popes; frescoes on a grand scale (Lateran, Palazzo de' Conservatori). Caravaggio started his Roman career in Cesari's studio.

Cignani, Carlo (1628-1719). Bologna. Albani's pupil. Last important follower of the Carracci Academy.

Cigoli, Lodovico (1559-1613). Florentine Baroque master influenced by Baroccio and the Venetians. Cf. *Martyrdom of S. Stephen* (Pitti). In Rome since 1604, follower of

Annibale Carracci.

Cima da Conegliano (1459-1517). Venetian school. Born in Conegliano; active at Venice from 1492 to 1516. Pupil of Giovanni Bellini and influenced by Antonello da Messina. Mainly *Sante conversazioni* with landscape backgrounds in luminous *impasto*.

Cimabue (*c* 1240-1302 ?). Founder of the Florentine school. In 1272 he visited Rome where he met Cavallini. His chief works are a monumental *Madonna Enthroned* in the Uffizi (*c* 1260) and one in the Louvre. Between 1277 and 1280 he painted frescoes in the Church of S. Francis at Assisi. During 1301 to 1302 he is in Pisa, painting a *Maestà* for the Church of Santa Chiara. Precursor of Giotto in the liberation from Byzantinism. (p. 3, figs. 2, 3).

Conca, Sebastiano (1680-1764). Neapolitan. Late Baroque. Solimena's pupil.

Coppo di Marcovaldo (Second half of thirteenth century). Florentine primitive, prior to Cimabue. Austere Byzantism. Pistoia Crucifix (1274) and Madonnas Enthroned.

Correggio, Antonio Allegri (*c* 1494-1534). School of Parma. Born at Correggio. His masters are unknown; perhaps Bianchi Ferrari da Modena. His early works show the influence of Mantegna, Francia, Costa and Leonardo's *sfumato* and soft light. A journey to Rome has been surmised around 1518. Striking effects of movement prelude the Baroque. (p. 253, figs. 187-194).

Cortona *see* Pietro da Cortona.

Cossa, Francesco (*c* 1436-1477). Ferrarese follower of Tura. His chief

works are the frescoes in the Palazzo Schifanoia illustrating the life of Duke Borso d'Este. In 1472 settles in Bologna. Beside Tura and Mantegna, he was influenced by Piero della Francesca. For San Petronio in Bologna he painted the great altar dedicated to San Vincenzio Ferrer in 1474. The centre of this is in the National Gallery. Great altarpieces in Bologna and Milan: *Madonna enthroned surrounded by Saints.* (p. 162, figs. 120, 122).

Costa, Lorenzo (1460-1535). Mantua. Follower of Ercole Roberti in Bologna. Employed by the Bentivoglio princes for whom he paints an altarpiece in San Giacomo Maggiore, which is of 1488. The *Portrait of Giovanni Bentivoglio* in the Uffizi is of 1490. In that year he joins workshop with Francesco Francia. After the death of Mantegna he accepts the position as court painter in Mantua. For Isabella d'Este's studio there, he paints the *Reign of the Muses*, now in the Louvre. (p. 166).

Credi, Lorenzo di (1458-1537). Florentine school. Pupil and chief assistant in Verrocchio's studio (together with Leonardo). Accomplished painter of Madonnas in hard, metallic outline and bright colour and of an un-idealised but well modelled Venus (Uffizi).

Crespi, Daniele (c 1595-1630). Milan. Proto-Baroque. Spanish in piece: *S. Carlo Borromeo at supper* (Milan, Chiesa della Passione).

Crespi, Giovanni Battista, (il Cerano) (c 1557-1633). Late Mannerist. Painted four large panels on the life of S. Carlo Borromeo for Milan Cathedral, dramatic and emotional. (p. 399, fig. 296).

Crespi, Giuseppe Maria (1665-1747). Last of the great painters of Bologna. Studied Lodovico Caracci and Guercino and adheres to their chiaroscuro and Venetian *impasto*, which he hands on to Piazzetta. Essentially a painter of genre, but also of mythologies and of religious works like the *Seven Sacraments* (Dresden).

Crivelli, Carlo (1435/40-1492). Venetian school. Was in Venice in 1457. Leaves there for the Marches where he spent his life, mainly in the city of Ascoli. He was formed by the masters of Murano and of Padua: Vivarini, Squarcione, Mantegna. His style is harsh, linear, precious and gothicising. Among his chief works are the Demidoff Altarpiece, London (1476), and the Annunciation (1486) also in London. In 1490 he was knighted by King Ferdinand II of Naples. His last work is the *Coronation of the Virgin* of 1493, now in the Brera. He died in Fermo two years later. (p. 169, figs. 127, 128).

Daddi, Bernardo (c 1290-1350). Giotto's pupil as well as Lorenzetti's. Unites Florentine plasticity with Sienese decorative values. Cf. *Triptych* of 1328 (Uffizi).

Dolci, Carlo (1616-1686). Florentine. Late Baroque Classicism. Emotional religious paintings like his famous *S. Andrew adoring the Cross* (Pitti). Fine colourist.

Domenichino (Domenico Zampieri) (1581-1641). Bolognese school of Lodovico Carracci. Went to Rome in 1602. Worked in the Palazzo Farnese as Annibale's assistant. Painter of religious frescoes and altar pieces such as the *Last Communion of S. Jerome*. For Cardinal Scipione Borghese he paints in 1617 the *Hunt of Diana*. In 1631 he moves from Rome to Naples. As a painter of

Classical landscape he is the fore-runner of Claude and Poussin. As fresco painter in S. Andrea della Valle (Rome) and Cappella del Tesoro (Naples Cathedral) he is the Classicist rival of Lanfranco's exuberant Baroque. (p. 360, figs. 269, 270).

Domenico Veneziano (1410-1461). Florentine painter of Venetian origin. Working at Perugia in 1438 he wrote a letter to Piero dei Medici, asking for employment in Florence. He may have assisted Fra Angelico in his *Coronation of the Virgin*, now in the Louvre. His chief signed work is the *Madonna with Four Saints* in the Uffizi. In 1439 he painted the (lost) frescoes from the life of the Virgin in Sant'Egidio, Florence, probably assisted by the young Piero della Francesca. (p. 79, figs. 61-64).

Dossi, Dosso (Giovanni Luteri) (c 1480-1542). Ferrara. Court painter to Alfonso d'Este; influenced by Giorgione's poetry and Titian's colour. Fantastic landscapes and magical effects of light; cf. *Circe* (Rome, Galleria Borghese). (p. 314, fig. 235).

Duccio di Buoninsegna (1250?-1319). Founder of the School of Siena. First recorded as a miniaturist in 1278. In 1285 he visits Florence, perhaps to paint the *Madonna Rucellai*, once attributed to Cimabue. His chief work, the *Maestà*, executed for Siena Cathedral, was painted between 1308 and 1311. (p. 4, figs. 4-8).

Falcone, Aniello (c 1605-1656). Naples. Ribera's pupil. Specialises in battle pieces. Also frescoes Neapolitan churches.

Fattore (Il) *see* Penni.

Ferrari, Gaudenzio (c 1480-1546). Milan. Famous Passion cycle in

Varallo (Sacro Monte). Crudely coloured peasant art alternating with terracotta figures: *Teatrum Sacrum*.

Fetti, Domenico (c 1589-1624). Born in Rome. Influenced by Caravaggio and especially Elsheimer's small landscapes with figures. Developed small-scale popular genre, mostly parables. 1613 court painter to Duke Ferdinand at Mantua. There absorbs Titian and Tintoretto. Moves to Venice c 1621. With Liss and Strozzi he prepares the revival of Venetian painting. (p. 394, fig. 294).

Filipepi *see* Botticelli.

Fiorenzi di Lorenzo (c 1445-1525). Perugia. Early Renaissance. Became master of Pintoricchio. Provincial painter of second rank.

Foppa, Vincenzo (1427-1515). Born in Brescia. Founder of the Old School of Lombardy. He lives at Pavia from 1456 to 1490. Paduan education (Mantegna). Among his chief works are a *Martyrdom of S. Sebastian* (Brera), and a late work the *Adoration of the Magi*, now in London. (p. 166, fig. 125).

Francesco di Giorgio (1439-1502). Siena. Many-sided artist like Leonardo. Spontaneity and charm; also incisive contours as of sculpture; ingenuous and enchanting; cf. *S. Dorothy* (National Gallery). Partner of Neroccio dei Landi. (p. 35, fig. 28).

Francia, Francesco (Francesco Raibolini) (1450-1517). School of Bologna. In 1482 he entered the Goldsmith's Guild at Bologna. Associate of Costa. Employed by Giovanni Bentivoglio to decorate palaces and churches in Bologna. He inclines towards Perugino and the languid Umbrian style of religious art. Later influenced by Raphael. (p. 166).

440

Franciabigio (c 1482-1525). Florence. Pupil of Albertinelli. Shared with Andrea del Sarto the frescoes in the SS. Annunziata and in the Scalzo (Florence). Also at the Medici villa of Poggio a Caiano.

Furini, Francesco (c 1600-1646). Florentine. Baroque. Paints soft, alluring nudes under mythological guise. Fine draughtsman.

Gaddi, Agnolo (*active* 1333-1396). Florentine. Decline of the Giottesque tradition. Lack of order, surfeit of irrelevant detail. Gothicising.

Gaddi, Taddeo (c 1300-1366). Giotto's most important follower and leader of his workshop. Father of Agnolo. Frescoes Baroncelli Chapel in S. Croce, but without Giotto's monumental simplicity.

Galgario *see* Ghislandi.

Garofalo, Benvenuto Tisi (c 1481-1559). Ferrara. Influenced by Costa, Dossi and the Venetians.

Gaulli *see* Baciccio.

Gentile da Fabriano (1370?-1427). Umbrian school. Together with Pisanello he represents the courtly style of the International Gothic. Both painters were called to Venice to paint frescoes in the Palazzo Ducale (1408/9). His chief works painted in Florence are the *Adoration of the Magi* (1423) in the Uffizi, and the Quaratesi altarpiece (1425) of which the central panel with the *Virgin Enthroned surrounded by Angels* is in Buckingham Palace. (p. 43, fig. 36).

Gentileschi, Artemisia (1597-1651). Rome. Daughter of Orazio Gentileschi. Influenced by Caravaggio. Works also in Naples. Brutally realistic *Judith and Holofernes*

(Uffizi).

Gentileschi, Orazio (1563-1647). Born Pisa, a Tuscan Mannerist, knew Caravaggio in Rome who influenced him for a while; cf. his *David and Goliath* (Dublin). Since 1626 court painter to King Charles I. Fine draughtsman. Sense of precious stuffs. Famous *Rest on the Flight to Egypt* (three versions, one in the Louvre).

Ghirlandaio, Domenico (Domenico Bigordi) (1449-1494). Florentine. Pupil of Baldovinetti. In 1481 he paints frescoes in the Sistine in Rome. From 1483 he painted cycles of frescoes for the great Florentine families, reflecting contemporary life and costume of the Medici. Scenes from the life of S. Francis in the Sassetti Chapel at Santa Trinità and of the Virgin and S. John the Baptist for the Tornabuoni family in Santa Maria Novella. His frescoes and panel paintings abound in portraits and realistic detail and are important as historical documents. In his flourishing workshop Michelangelo was a pupil before moving on to the Medici Palace (1490). (p. 140, figs. 107-110).

Ghirlandaio, Ridolfo (1483-1561). Pupil of his father Domenico. Florentine. Influenced by Fra Bartolommeo and other High Renaissance artists, especially Leonardo. Flourishing workshop.

Ghislandi, Vittore (Fra Galgario) (1655-1743). Bergamo. Late Baroque, formed in Venice. Outstanding master of popular portrait genre, anticipating Hogarth and Chardin.

Giambellino *see* Giovanni Bellini.

Giambono, Michele (*died* 1462). Venetian. Painter and mosaicist of the International Gothic. Influenced by Pisanello and Gentile da Fabriano.

Courtly, chivalrous style of *S. Criso-gono* (Venice, S. Travaso).

Giaquinto, Corrado (1703-1765). Neapolitan painter, pupil of Solimena; worked in Rome and Madrid. Refined the airy transparency and spiralling movement of Rococo decoration.

Gimignano, Giacinto (1611-1681). Pistoia. Pupil of Pietro da Cortona in Rome. Also influenced by Poussin. Large scale frescoes.

Giordano, Luca (1634-1705). Neapolitan school. First influenced by Ribera, then by Reni, Rubens, Pietro da Cortona and the Cinquecento Venetians. One of his principal works was the Baroque decoration in the Palazzo Medici Riccardi, Florence, which foreshadows the eighteenth century. Widely travelled: Rome, Venice, Madrid (1692-1702). (p. 392, fig. 291).

Giorgione, Giorgio Barbarelli da Castelfranco (1477-1510). Venetian. Brought up in the city of Giovanni Bellini and Carpaccio. Likely influence by Perugino, Francia and Costa promotes his rich glowing colour and detaches him from the Bellini school. In 1508 Bellini nominates three artists, among whom are Carpaccio and Basaiti, to assess Giorgione's frescoes on the facade of the Fondaco dei Tedeschi. (p. 280, figs. 207-212).

Giotto di Bondone (1266/7-1337). Born in Vespignano, near Florence. He enters Cimabue's workshop in Florence. Between 1296 and 1298 he ideated twenty-eight stories from the life of S. Francis in the Upper Church of S. Francis at Assisi. In 1299 he went to Rome to work in fresco and mosaic for Pope Boniface VIII, leaving the completion of the Assisi frescoes to his assistants. His chief work is in the Scrovegni Chapel at Padua, where between 1303 and 1313 he painted scenes from the life of Christ and the Virgin. After 1322 he paints again the legends of S. Francis —this time in Santa Croce at Florence. By 1334 he is in charge of the Florentine Duomo and builds the Campanile. (p. 14, figs. 10-16, plate I).

Giovanni di Paolo (1403-1482). School of Siena. Pupil of Sassetta. He painted a series of scenes from the life of S. John the Baptist, around 1454. Four of these are in the National Gallery. Bizarre and surrealist, irrational space concept. (p. 34, fig. 27).

Giulio Romano (1492?-1546). Roman painter, pupil of Raphael who worked with him in the Vatican and completed his unfinished frescoes. Served the Gonzaga at Mantua after 1524 and built and frescoed the Palazzo del Tè. He also painted portraits and altarpieces. His portrait of Isabella d'Este is in Hampton Court Palace. He is one of the leaders of Mannerism in its Titanic aspect. (p. 277).

Giunta Pisano (middle of thirteenth century). Leading master of School of Pisa. Paints hieratic Crucifixes.

Giusto dei Menabuoi (*active* 1370-1393). Florentine. Main work in Padua Baptistry, frescoes of Paradise and the heavenly Glory.

Gozzoli, Benozzo (1420-1498). Florentine, educated in Ghiberti's studio from 1444 to 1447. Assists Fra Angelico in his frescoes at Rome and Orvieto. From 1450 to 1452 he paints a cycle of frescoes of the legends of S. Francis, in Montefalco. His chief work is the *Journey of the Kings from the East*, painted for Piero dei Medici upon the walls of the Chapel of the Palazzo Riccardi (1459). His largest,

but not his best work, is found in the mural decorations with stories from the Old Testament in the Campo Santo at Pisa executed between 1467 and 1487. (p. 138, fig. 106).

Granacci, Francesco (1477-1543). Florence; pupil of Ghirlandaio and of Credi. Master of the transition to the High Renaissance.

Guardi, Francesco (1712-1793). Venetian school. Starts as a religious painter of the Rococo in the Guardi family workshops. After 1760 he takes up Venetian view-painting (*vedute*). He borrows Canaletto's designs, first to imitate and then to transform the genre. 1784 election to the Venetian Academy. (p. 421, figs. 311-313, plate XII).

Guariento, Ridolfo (*active* 1338-1370). Padua. In 1365 he paints frescoes in the Doge's Palace in Venice. Combines influence of Giotto with Venetian Byzantinism.

Guercino, Giovanni Francesco Barbieri (1591-1666). School of Bologna. Follower of Lodovico Carracci. Visit to Venice in 1618. In Rome from 1621. He paints an *Aurora* for the Villa Ludovisi. He is one of the leading religious painters of the Baroque. (p. 364, figs. 272-275).

Guido da Siena (*active* 1262-1286). Sienese master before Duccio. Severely Byzantine stylisation especially of the Madonna Enthroned. Geometrical simplifications, but subtle colourist. Cf. *Hodegetria* (Siena, Palazzo Pubblico).

Jacobello del Fiore (*c* 1370-1439). Venetian. Pupil of Gentile da Fabriano. Transmits Gentile's international Gothic to the Venetians.

Jacometto Veneziano (*active* 1472-

1497). Venice. Influenced by Antonello da Messina. Miniaturist and painter of small exquisite portraits.

Lanfranco, Giovanni (1582-1647). Born in Parma; went to Rome in 1602. Assistant to Annibale Carracci in Palazzo Farnese. His chief work is the Cupola in Sant' Andrea della Valle, Rome (1621-25). He used Correggio's scheme and created the first decoration of the full Baroque. 1633-46 active in Naples. Illusionist cupola frescoes of the Cappella di San Gennaro in Naples Cathedral after ousting his rival Domenichino. (p. 263, fig. 271).

Lazzarini, Gregorio (1655-1730). Venetian. Late Baroque; master of Tiepolo.

Leonardo da Vinci (1452-1519). Florentine school. Born in Anchiano near Vinci. With Michelangelo and Raphael the summit of the High Renaissance. 1469-82 resides in Florence. 1472-76 assistant in Verrocchio's workshop. 1472 inscribed as a painter in the Guild of S. Luke. 1492-99 in the service of Duke Lodovico Sforza at Milan. *Uomo universale*, the complete man of the Renaissance. 1496-97 *Last Supper*. 1499 The French occupy Milan. Leonardo moves to Mantua, Venice, Florence (1500-1506). *Mona Lisa* 1503-6. Cartoon of the *Battle of Anghiari* for the Council Chamber of the Signoria in rivalry with Michelangelo's *Bathing Soldiers* (1505). Takes service with Cesare Borgia as military Engineer. 1506-13: second stay at Milan. 1513-16 Leonardo in Rome; lacks the patronage of Leo X. 1516: leaves Italy for France. Death in 1519 at Amboise in the service of King Francis I. As a painter (and scientist) Leonardo studied nature and combined ambiguity of the human type with an infinite subtlety of modelling and

sfumato to render sculptural form by painterly means. (p. 197, figs. 147-155).

Liberale da Verona (*c* 1445-1526). Verona: leading master. Influenced by Mantegna and Bellini. Cf. *Pietà* (Munich), *S. Sebastian* (Brera).

Libri, Girolamo dai (1474-1555). North-Italian Renaissance master influenced by Liberale, Morone, Mantegna. Religious works for churches in Verona.

Licinio, Bernardino (*c* 1489-1565). Venetian. Pupil of Pordenone under the spell of Giorgione.

Lippi, Fra Filippo (*c* 1406-1469). Florentine school. From 1421 to 1431 he stayed as a monk in the Carmelite monastery at Florence, where he modelled his style after that of Masaccio. Later he follows Angelico. In 1434 he works at the Santo in Padua and from 1437 again in Florence. His large *Coronation of the Virgin* (Louvre) was commissioned in 1447. From 1452 to 1464 he painted frescoes in the Cathedral of Prato and in 1467 at Spoleto. Expressive linearism of great purity and solidity. Botticelli was his pupil. (p. 67, figs. 53-55).

Lippi, Filippino (*c* 1457-1504). Florentine. Follower of his father Fra Filippo Lippi and pupil of Botticelli. From 1484 to 1485 he completes Masaccio's frescoes in the Cappella Brancacci at the Carmelite Church, Florence. His best known work is the *Vision of S. Bernard* (Florence, Badia), a work of his youth (1480). In 1488 he transfers to Rome and indulges in irrelevant Classical ornament. In frescoes of the Strozzi Chapel at Santa Maria Novella (Florence) with scenes from the life of S. John and S. Philip, he is restless and overloaded, a precursor of Florentine Mannerism. (p. 134, figs. 102-105).

Liss, Johann (1597-1629). Oldenbourg. Trained in Amsterdam and Haarlem. Came to Italy in 1619 and in 1621 to Venice; died there of the plague. With Fetti he prepared the revival of Venetian pictorialism. Baroque master of Rubensian sensuality and rich *impasto*. Cf. *The Fall of Phaeton* (Mahon Collection), *Vision of S. Jerome* (Venice). (p. 397, fig. 295).

Lomazzo, Giovanni Paolo (1538-1600). Milan. Painter and writer on art. Studied in Rome. *Trattato dell'arte della pittura, scultura ed architettura*, 1584.

Longhi, Alessandro (1733-1815). Son of Pietro Longhi; outstanding Venetian portrait painter of the Rococo. Contemporary with and friend of Carlo Goldoni. (p. 414, fig. 305).

Longhi, Pietro (1702-1786). Venetian school. Studied with Crespi at Bologna. From 1732 settled in Venice for life. Painter of genre and conversation pieces of the *haute bourgeoisie*, facile and only mildly satirical. (p. 414, fig. 306).

Lorenzetti, Pietro and Ambrogio, held the field in Siena with Simone Martini during the first half of the fourteenth century. Active between 1306 and 1348. Born around 1280, Pietro's chief work is a wall painting on goldground of the *Virgin between S. Francis and S. John the Apostle* (Assisi). Ambrogio's chief work is the cycle of wall paintings in the Palazzo Pubblico at Siena, representing Good and Bad Government (1337-39). A documentary of great importance, he is more influenced by Giotto than his older brother. (p. 28, fig. 23).

Lorenzo (Monaco) (Piero di Giovanni) (*c* 1372-1425). Born in Siena, he became a novice in the

444

Camaldolese Convent of Santa Maria degli Angeli at Florence in 1390, and took his vows in 1391. *His Coronation of the Virgin with attending Saints* in the National Gallery corresponds with that in the Uffizi which is of 1414 (the High Altarpiece of the Camaldolese Church). Pupil of Agnolo Gaddi, he develops towards the International Gothic. (p. 41, figs. 33, 34).

Lorenzo Veneziano (*active* 1357-1379). Venice. Pupil of Maestro Paolo Veneziano. Leads Venetian painting from Byzantinism towards the Gothic.

Lotto, Lorenzo (1480-1556). Venetian school. Pupil of Alvise Vivarini, follower of Giovanni Bellini; also influenced by Giorgione, Titian, Palma Vecchio and perhaps Dürer. Wandering life between Venice, Recanati, Treviso, Rome, Bergamo, Loreto. Rome in 1509, attracted by Raphael. In 1513 Alessandero Martinengo calls him to Bergamo where he paints many altarpieces for Bergamasque churches, especially S. Bartolommeo, S. Spirito, and San Bernardino. Lotto creates the psychological portrait. He retires as a lay brother to the Santa Casa at Loreto, where he dies. (p. 309, fig. 230-234).

Luini, Bernardino (*c* 1475-1532). School of Milan. Pupil of Borgognone, Bramantino and Leonardo. (p. 212, fig. 158).

Luteri *see* Dossi.

Maffei, Francesco (*c* 1620-1660). Vicenza. Leading Venetian Baroque master. Influenced by Tintoretto, Strozzi, Fetti and Liss.

Magnasco, Alessandro (1667-1749). Genoese school. Painter of fantastic landscapes with figures, continues the romanticism of Salvator Rosa in rich *impasto* and violent luminism into the age of the Rococo. He probably met Sebastiano and Marco Ricci during their visit to Milan. (p. 398).

Mainardi, Sebastiano (*c* 1460-1513). Florentine. Pupil and chief assistant of Domenico Ghirlandaio.

Manfredi, Bartolomeo (*c* 1580-1620). Mantua. Was a more literal follower of early Caravaggio, painting dissolute dandified youths at cards, drinking or making music.

Mantegna, Andrea (1431-1506). School of Padua. Adopted by Francesco Squarcione with whom he lived for six years (1442-48). In 1448 he was commissioned with Niccolò Pizzolo to paint half the Ovetari Chapel in the Eremitani Church in Padua. Scenes from the life of S. James and S. Christopher. In 1553 Pizzolo died and Mantegna completed most of the decoration, the other partners, Giovanni d'Alamagna and Antonio Vivarini had withdrawn from the work in 1450. Mantegna associated early with the Bellini family and married Nicolosia, Jacopo's daughter, in 1454. He severed his connection with Squarcione by litigation. Work in Padua retains him until 1459. Then he follows a call of Duke Lodovico Gonzaga to Mantua. His chief works there are the frescoes of the Camera degli Sposi and the *Triumph of Caesar*. Except for a stay in Florence and Rome (1488-90) Mantegna remained in Mantua for the rest of his life. Influenced by Uccello and Donatello in his geometrical perspective applied to antique architecture and Roman sculpture respectively. Supreme draughtsman: invents architectural illusionism (Camera degli Sposi). His Madonnas (Berlin, Bergamo), have a mystical bent. (p. 147, figs. 112-117).

Maratta, Carlo (1625-1713). Roman school. Pupil of Andrea Sacchi. Painter of Baroque decorations, altarpieces and portraits. Studied Correggio and Raphael, and exerted a moderating influence on the Baroque. (p. 383, fig. 285).

Margaritone d'Arezzo (*late* thirteenth century). Tuscan primitive. *Madonna Enthroned* in National Gallery.

Marieschi, Michele (*c* 1696-1743). Venice. View painter in Canaletto's manner.

Martini: Simone (1285-1344). Born at Siena. In 1315 he signs his *Maestà*. By 1317 he is in Naples, at the Court of the Anjou, where he paints his *S. Louis of Toulouse*. In 1328 he is back at Siena, painting *Guidoriccio da Folignano* in the Palazzo Pubblico. Before 1330 he painted the *Legends of S. Martin* in the Lower Church of S. Francis at Assisi, moving closer to the chivalrous French Gothic. His *Annunciation* is of 1333, painted with his assistant Lippo Memmi for a Chapel in Siena Cathedral, is his purest essay in linear arabesque. Around 1340 Simone went to the Papal Court at Avignon. Here he painted a miniature of Laura's portrait for the Virgil edition of Petrarch, and also the precious Liverpool *Christ returning to his Parents*. (p. 24, figs. 17-22).

Masaccio, Tommaso di Giovanni (1401-1428/9). Born in S. Giovanni near Florence. The greatest Florentine master since Giotto, half way between him and Michelangelo. Profoundly influenced by Brunelleschi the architect and Donatello the sculptor. 1426: Polyptych for Pisa; the centre piece, a Madonna and Child in the National Gallery. 1427: Masaccio takes over from Masolino the frescoes in the Brancacci Chapel in the Carmine Church in Florence, relating the *Life of S. Peter* and also the *Expulsion from Paradise* and the famous *Tribute Money*. Before leaving Florence he frescoed the monumental *Pietà* in Santa Maria Novella with its Brunelleschian architecture. In 1428 Masaccio leaves for Rome to paint frescoes in S. Clemente, sometimes attributed to Masolino. He died there probably early in 1429. (p. 52, figs. 42-47, plate II).

Masolino da Panicale (1383-1435 ?). Florentine master of the International Gothic. Commissioned by a rich silk merchant, Brancacci, to paint frescoes of the life of S. Peter in the Carmine Church in Florence. In 1427 he abandons this work (to go to Hungary) leaving it in the hands of Masaccio. Other documented work by Masolino is in Castiglione d'Olona (Baptistry). Though influenced by Masaccio his pupil and assistant, Masolino's work looks back to the International Gothic of Gentile da Fabriano and Fra Angelico in its purity of colour and simplicity of design, especially his *Madonna of the Snow* (Naples). (p. 49, figs. 40, 41).

Matteo di Giovanni (*c* 1430-1495). Siena. Vecchietta's pupil. Leading master. Naturalistic and sculptural; expressionist and monumental. Master of colour and light. Cf. *Assumption* (National Gallery) crowded and dramatic, with a landscape owing something to Piero della Francesca.

Mazzola *see* Parmigianino.

Melozzo da Forli (1438-1494). Born in Romagna. Perhaps a pupil of Piero della Francesca, but more likely he had a Paduan education with Mantegna. In 1465 Melozzo is in Urbino, but from 1471 mainly in Rome. His

contacts with Piero date from his frequent visits to Urbino. His most monumental work is the Vatican fresco *Pope Sixtus IV inaugurating the Vatican Library* (1481). Most of Melozzo's work for Santi Apostoli in Rome, famous for its musician angels seen from below in bold foreshortening, is now in the Vatican Museum. (p. 116, fig. 90).

Memmi, Lippo (*c* 1285-*c* 1360) *See* note above to Simone Martini.

Menabuoi *See* Giusto.

Merisi *See* Caravaggio.

Michelangelo Buonarroti (1475-1564). Florentine school. Born at Caprese near Florence. In 1488 enters workshop of Ghirlandaio at Florence, which he leaves in 1489. In 1490 Lorenzo Medici offers him hospitality in his palace. Contacts with poets, philosophers of the Platonic Academy. 1504: Cartoon for the *Bathing Soldiers*, in rivalry with Leonardo. Also *c* 1504 *Madonna Doni* (Tondo). In 1505 he is summoned to Rome by Pope Julius II. In his service he paints the Sistine Chapel (1508-1512). Other paintings include the *Last Judgment* (1534-1541) and the frescoes of the Cappella Paolina, the *Conversion of Paul* (1542-1545), and the *Crucifixion of Peter* (1546-1550), commissioned by Pope Paul III. As a painter Michelangelo is without precursors, unless it were Signorelli. His last frescoes in the Cappella Paolina by their tempestuous movement into undefined space engendered Mannerism and Baroque. (p. 230, figs. 170-179).

Mola, Pierfrancesco (1612-1666). Influenced by Guercino, Veronese and Titian. Painter of romantic landscapes with biblical or monastic figures in rich Venetian colour. Like

Pietro Testa he paints frescoes in the Quirinal Palace. Cf. *Joseph and his Brethren.*

Monaco *See* Lorenzo.

Montagna, Bartolomeo (*c* 1450-1523). Venetian school. Active in Vicenza, but trained at Venice, where he was living from 1459. Follower of Giovanni Bellini and Antonella da Messina. In his *Sacre conversazioni* he is a strong colourist with a powerful feeling for form.

Morazzone (*c* 1571-1626). Piacenza. Early Baroque master in Lombardy.

Moretto, Alessandro Bonvicino (1498-1554). School of Brescia. Influenced by Savoldo, Lotto, Romanino and Titian. Superb portraitist and poetic painter of sacred pictures. Cf. *Elijah and the Angel* in a shimmering landscape (Brescia). (p. 318, fig. 239).

Moro *See* Torbido.

Moroni, Giovanni Battista (1520/5-1578). Bergamo. Pupil of Moretto, influenced by Lotto in his psychological portraits of professional men, tailor, lawyer, school master; more prosaic and realistic than his masters. (p. 319, fig. 240).

Neroccio dei Landi (1447-1500). Siena. Pupil of Sassetta and Vecchietta; in partnership with Francesco di Giorgio until 1475. Perhaps the most poetic and aristocratic of Quattrocento Sienese. (p. 35, fig. 29).

Novelli, Pietro (1603-1647). Monreale and Palermo. Leading Sicilian Baroque painter, influenced by van Dyck, Ribera.

Oggione, Marco d' (*c* 1470-1530). Milan. Leonardo's pupil and imitator.

Orcagna, Andrea di Cione (c 1329-1378). Florentine school. His chief work is an altarpiece in Santa Maria Novella, Florence, painted between 1354 and 1357. He was the greatest Florentine master between Giotto and Masaccio.

Orsi, Lelio (c 1511-1587). Novellara. Late Mannerist painter of small cabinet pictures, taking Correggio as his point of departure.

Palma Giovane (1544-1628). Venice. Roman Mannerism and the Venetians (Tintoretto) influenced him. Prolific in large altar pieces and murals.

Palma Vecchio (1480-1528). Venetian school. Pupil of Giovanni Bellini, influenced by Giorgione and Titian. Painter of *Sacre conversazioni*. (p. 294, fig. 218).

Pannini, Giovanni Paolo (c 1692-1765). Studied architectural drawing at Piacenza, and in 1717 moved to Rome. Friend of Piranesi. Painter of Roman ruins and the interior of S. Peter.

Paolo di Giovanni Fei (*died* 1410). Pupil of Andrea Vanni and master of Sassetta. Miniature-like delicacy.

Paolo Veneziano (*active* 1333-1360). Founder of the Venetian School who Italianizes the strong Byzantine inheritance. Fine colours and linear arabesques, heightened with threads of gold. Cf. *Pala d'Oro* (S. Marks), *Death of the Virgin* (Vicenza Museum).

Parmigianino, Francesco Mazzola (1503-1540). School of Parma. In his youth influenced by Correggio, later by Raphael and Michelangelo. Works at Parma, Bologna and Rome. Leading Mannerist of Emilia. Elongated figures of great elegance and charm posing as Madonnas and angels.

In the end he gave up painting for alchemy. (p. 272, figs. 203, 204).

Pellegrini, Giovanni Antonio (1675-1741). Venetian Rococo painter, forerunner of Tiepolo. Came to England in 1708 to paint murals in Kimbolton Castle and Castle Howard. (p. 405, fig. 298).

Penni, Gianfrancesco (called Il Fattore) (c 1488-1540 ?). Florence. Raphael's most faithful assistant. With Giulio Romano, his junior by eleven years, he executes the frescoes in the Sala di Costantino (Vatican).

Perugino, Pietro Vanucci (c 144-5 1523). Umbrian school. Born in Città del Pieve. Formed his style in Florence. Pupil of Verroccio and Pollaiuolo. Worked 1481-82 at the Sistine frescoes in Rome: *Christ giving the Keys to S. Peter*. Influenced by Signorelli amd Piero della Francesca. In 1488-89 he painted the *Virgin appearing to S. Bernard* (Munich). His large triptych of the *Crucifixion* (fresco) in Santa Maria dei Pazzi is of 1496. His frescoes in the Cambio of Perugia are of 1500. Umbrian landscape backgrounds and skies express religious sentiment. Master of Raphael. (p. 118, figs. 91-93).

Pesellino, Francesco (1422-1457). Florentine narrative painter of biblical scenes and legends of saints. Influenced by Angelico and Lippi.

Piazzetta, Giovanni Battista (1682-1754). Venetian school. Studied with G. M. Crespi at Bologna. Specialised in religious and genre painting. His work influenced G. B. Tiepolo. (p. 406, figs. 299, 300).

Piero della Francesca (c 1416-1492). Umbrian school. Born in Borgo San Sepolcro. Probably assisted Domenico Veneziano in 1439 at the

(lost) frescoes of San Egidio, Florence. His first known work is the Madonna of Mercy (1445) painted for his native Borgo. His chief works are the *Legends of the True Cross* painted in the choir of San Francesco in Arezzo between 1452 and 1464. He also worked for the Este in Ferrara, the Malatesta in Rimini and for Duke Federigo da Montefeltro of Urbino, his chief patron. The Duke's portrait and that of his wife Battista Sforza are of 1466. The Brera Altarpiece commemorating Battista's death and the birth of her son Guidobaldo is of 1472. Piero was one of the greatest mathematicians of his day and wrote *De Prospettiva Pingendi*, dedicated to the Duke of Urbino, before 1482. (p. 86, figs. 67-75, plate IV).

Piero di Cosimo (1462-1521). Florentine school. Pupil of Cosimo Rosselli whom he assisted in the Sistine Chapel (1482). His early work is influenced by Leonardo, Signorelli and Pollaiuolo. He is a painter of a primeval and mythological world, of eccentric fantasy. Cf. *The Discovery of Honey, Hylas and the Nymphs* etc. Also a forceful portraitist. (p. 145, fig. 111).

Pietro da Cortona (1596-1669). Painter of mythologies and classical subjects. Baroque decorator and *capo scuola* of the Roman school. Cf. *The Rape of the Sabines* (Capitolina), the Barberini Ceiling, frescoes in the Palazzo Pitti (1641-47), decorations of the Chiesa Nuova (Rome) etc. He combines allegorical painting with illusionist architecture and stucco, and is with Bernini the leading master of the Roman full Baroque. Besides the vastness of the Barberini ceiling, Cortona decorated five rooms in the Palazzo Pitti for Grand Duke Ferdinand (1640-47) as well as the apse and cupola of Santa Maria in Vallicella (Rome)—between 1647 and 65—and painted numerous easel pictures of Roman and Christian subjects. He was the last universal artist in the Renaissance tradition; painter, stuccoist and eminent architect, and with Lorenzo Bernini the undisputed leader of the arts in 17th century Rome. His murals advance the manner of Correggio and Lanfranco into the age of the full Baroque. He brought to his task a powerful sense of the human form in movement, enhanced by rich colour and bold contrasts of lighted and shaded mass. But within the turbulence and the splendour of Baroque decoration, subservient to the demands of his princely patrons, Cortona maintained, in Professor Wittkower's words, ' a strange balance between effervescence and classical discipline '. (p. 380, fig. 283).

Pinturicchio, Bernardino di Betto (c 1454-1513). Umbrian school. Born in Perugia. Assistant to Perugino in the Sistine frescoes. His chief work is the decoration of the Borgia apartments in the Vatican (1493-94). A late work is the fresco decoration of the Library at Siena, glorifying the life of Cardinal Aenaes Sylvius Piccolomini, Pope Pius II. (p. 122, fig. 94).

Piombo, Sebastiano del (Luciani) (1485-1547). Venetian. Born at Venice he became a close follower of Giorgione up to 1511, when he left Venice for Rome in answer to a call from Agostino Chigi, Raphael's patron in whose Villa La Farnesina he painted mythologies. Later he succumbed to Michelangelo's influence and combined Venetian colour with Roman grandeur of form. Examples of his grand manner are the *Pietà* at Viterbo and the *Portrait of Pope Clement VII*. (p. 289, figs. 213-215).

Pisanello, Antonio Pisano (1395-c 1455). Leading Veronese painter

and medallist. Courtly art of the International Gothic. Serves many princes: the Gonzaga, the Malatesta, the Este. Early frescoes in the Palazzo Ducale, Venice. In S. Anastasia, Verona, he paints *S. George Liberating the Princess from the Dragon*. Later portraits of Lionello d'Este (Bergamo) and of an Este princess (Louvre). Courtly art of the late middle-ages. Realistic observer of animal forms: the *Vision of S. Eustace* (National Gallery). (p. 45, figs. 37-39).

Pittoni, Giovanni Battista (1687-1767). Venetian Rococo painter reacting against Piazzetta by his light-hearted, fluent and sentimental manner. Influenced by Sebastiano Ricci and Tiepolo. (p. 406).

Pollaiuolo, Antonio and Piero (*c* 1432-1498 and 1443-1496). Florentine masters, brothers. Sculptors and painters. Antonio was also a goldsmith, Piero mainly a painter. Pupils of Donatello and Castagno. In 1460 they painted together, for the Medici Palace, the *Labours of Hercules* (now lost). Their chief work is the *Martyrdom of S. Sebastian* (1475). They are the chief protagonist of Florentine interest in the human body in movement, and of topographical landscape. (p. 103, figs. 79-82).

Ponte, Jacopo da *see* Bassano.

Pontormo, Jacopo Carucci (1494-1557). Leader of Florentine Mannerism. Pupil of Andrea del Sarto. Master of Bronzino. Strong reaction against Renaissance proportion and equilibrium. Strange, angular, elongated forms and anguished expression. Strong northern influence from Dürer. Bright 'surrealist' colour and irrational space. (p. 264, figs. 195-198).

Pordenone, Giovanni Antonio

(*c* 1483-1539). Venice. Forceful provincial master of frescoes and altar pieces under the spell of Giorgione.

Porta, Baccio della *see* Bartolommeo (Fra).

Pozzo, Andrea (1642-1709). Roman school. Expert on perspective. Continues Baroque decoration in Rome where Baciccio left off. His chief work is the decoration of S. Ignatius, Rome (1689-1694). (p. 389, fig. 289).

Predis, Ambrogio de (*c* 1455-1508). School of Milan. Assistant and follower of Leonardo whose London version of the *Madonna of the Rocks* is largely executed by him (*c* 1506). (p. 210, fig. 156).

Preti, Mattia (1613-1699). Perhaps the greatest of Neapolitan painters of the full Baroque, influenced by and summarising the best of the schools of Bologna, Rome and Venice in a grand personal synthesis. Born in Calabria, died in Malta; visited Rome and northern Italy. Spent his best years in Naples (1656-1661). Besides the works of Guercino, Caravaggio, Ribera, contacts with Lanfranco and Luca Giordano formed his style. (p. 391, fig. 290).

Primaticcio, Francesco (*c* 1504-1570). Bologna. With Rosso Fiorentino leads the Mannerist School of Fontainebleau (since 1531).

Procaccini, Giulio Cesare (*c* 1570-1625). Bologna. In Milan becomes leading Lombard painter. Transition from Mannerism to Baroque. Influenced by Correggio and the Carracci.

Raffaello Santi (1483-1520). Florentine school. Born in Urbino. Pupil of his father Giovanni Santi until 1494. Met Perugino around

1497 and followed him to Perugia around 1499. Transfers to Florence in 1504 and to Rome in 1508. Assimilates the art first of Perugino, then of Leonardo (in Florence) and of Fra Bartolommeo, and finally, in Rome, of Michelangelo. Recommended to Pope Julius II by his Urbino contemporary Bramante. Decorates the Borgia apartments (*Stanze*) with frescoes (1509-1511) and for Pope Leo X he designs the cartoons for the Vatican tapestries. After Bramante's death becomes architect of S. Peter's. Great portraitist (*Castiglione, Donna Velata, Pope Julius and Leo with two Cardinals* etc.). Painter of Madonnas and altarpieces. His last work, the *Transfiguration* was completed by Giulio Romano. Other pupils were Pierino della Vaga and Giovanni da Udine, also Francesco Penni. (p. 214, figs. 159-169, plate VII).

Raibolini *see* Francia.

Raimondi, Marcantonio (*c* 1478-*c* 1534). Bologna. Engraver of Raphael's work. Influenced by Dürer whose style he introduces to Italy.

Reni, Guido (1575-1642). Bolognese school. At twenty he went to the Carracci Academy. 1602: first visit to Rome. 1603-7: he resides in Bologna. From 1607 to 1614 he again works in Rome and in the Palazzo Rospigliosi paints the *Aurora*. As a Classicist painter he modifies the agitated Roman Baroque, and the realism of Caravaggio. In 1614 he returns to Bologna, where for thirty years he ruled supreme. After his death Guercino takes over. (p. 355, figs. 265-268).

Ricci, Marco (1676-1729). Belluno. Founder of the Venetian landscape school. Developed the agitated romantic genre of Rosa, transmitted to him by Magnasco. Collaborated with his uncle Sebastiano Ricci and

came to England with Pellegrini. Cf. *A Storm at Sea* (Bassano), *Monks in a Landscape Praying* (Edinburgh). (p. 416, fig. 307).

Ricci, Sebastiano (1659-1734). Venetian school. He worked at Florence and Rome. Influenced by Baroque decorators like Luca Giordano and also by Paolo Veronese. In his turn he influenced Tiepolo and prepares the way for the Venetian Rococo. (p. 401, fig. 297).

Roberti, Ercole d'Antonio de' (1450-1496). School of Ferrara. A pupil of Cossa, he worked for the Este Court from 1479, and in Bologna. His large altarpiece, now in the Brera Museum, is of 1480. In this he anticipates the architectural grandeur of the High Renaissance. With Tura and Cossa he represents the summit of the Ferrarese School. His nervous and intense linearism is softened by contact with the art of Bellini. (p. 164, figs. 123, 124).

Robusti, *see* Tintoretto.

Romanino, Girolamo Romani (1485-1566). Influenced by Giorgione, Titian, Savoldo, Lotto. Painter of sacred pictures and frescoes for provincial churches in northern Italy. (p. 316, fig. 238).

Rosa, Salvator (1615-1673). Grew up at Naples at a time when Ribera worked under the influence of Caravaggio. Painter of biblical subjects, mythologies, allegories, battlepieces and above all of landscapes with a strong romantic flavour and a sketchy technique which influenced Magnasco and Marco Ricci. (p. 387, fig. 287).

Rosselli, Cosimo (1439-1507). Florence. Indifferent painter of detailed Quattrocento style. Master of Piero di Cosimo and Fra Bartolommeo.

Rosso Fiorentino (1494-1541). Florentine Mannerist. Pupil of Andrea del Sarto. Chief Mannerist work: *Deposition of Christ* at Volterra. From 1530 works at Fontainebleau for Francis I decorating the Castle. With Primaticcio he is the founder of the School of Fontainebleau. (p. 270, fig. 199).

Ruoppoli, Giovanni Battista (1502-1685). Naples. Master of still life of fruit and flowers. Influenced by Caravaggio.

Sacchi, Andrea (1599-1661). Roman school. Pupil of Albani. In so far as he opposes Cortona's violently Baroque decorations he may be said to belong to a relatively more Classical group of artists together with Poussin and the sculptor Duquesnoy. His early *Miracle of S. Gregory* (c 1625) is rich in colour and Baroque in design. The *Divina Sapienza* fresco pales besides Cortona's ceiling and Sacchi develops an ever more sober and pondered idiom. *Vision of S. Romuald*, c 1639, (Vatican). (p. 382, fig. 284).

Salviati, Francesco (1510-1563). Florentine Mannerist, friend of Vasari; influenced by Sarto, Michelangelo, Pontormo. Allegorical painter and portraitist.

Sano di Pietro (1406-1481). Siena. Sassetta's pupil; also of Gentile da Fabriano. Sweetly religious painter and illustrator, unaware of Florentine space research. Follower of San Bernardino and narrator of his life.

Santi, Giovanni (c 1435-1494). Urbino. Raphael's father. Influenced by Melozzo. Unsophisticated provincial painter of devotional pictures.

Saraceni, Carlo (1585-1620). Born in Venice, in Rome since 1598, was Elsheimer's friend. His *Miracle of*

S. Benno combines Caravaggio's naturalism and chiaroscuro with Venetian colour. Frescoes in the Quirinale. Altarpieces in Roman churches. Also small paintings on copper: *Fall of Icarus* (Naples).

Sassetta, Stefano di Giovanni (c 1392-1450). Siena. Active since 1423. He combines a truly Franciscan spirit with the purity of colour and ingeniousness of design of an Angelico or Masolino. Cf. eight panels representing the legend of S. Francis completed in 1444 for the Franciscan church at Borgo San Sepolcro. The centre piece with *S. Francis in Glory* is in the Berenson Collection, Settignano; seven panels are in the National Gallery, and one in Chantilly. (p. 32, figs. 25, 26).

Sassoferrato, Giovanni Battista Salvi (1609-1685). Rome. Follower of the Carracci and of Reni. Mildly Baroque, sentimental. Cf. *Madonna del Rosario* (Rome, S. Sabina).

Savoldo, Girolamo (c 1480-1548). North-Italian school. Born in Brescia. Influenced by Giovanni Bellini, Giorgione, Lorenzo Lotto. (p. 316, figs. 236, 237).

Schedoni, Bartolomeo (c 1570-1615). Modena. Early Baroque; continues Correggio's tradition in Emilia. Also influenced by Lanfranco, the Carracci and Venetian colour. Cf. *Three Maries at the Tomb* (Parma, Galleria).

Serodine, Giovanni (1594-1631). Ascona. In Rome since 1615. Belated follower of Caravaggio. Fine painterly style. Cf. *Almsgiving of S. Lawrence* (Rome).

Signorelli, Luca (1441 ?-1523). Umbrian school. Born in Cortona. Perhaps a pupil of Piero della Fran-

cesca. In his fascination with the muscular nude also influenced by Pollaiuolo. He worked in Cortona, Arezzo, Florence, Rome and Orvieto. In 1480 Pope Sixtus IV invited him to help decorate the Sistine Chapel. Perhaps his greatest work was the Education of Pan: *Pan as the God of Music*, destroyed in the second world war. In 1499 he was appointed to complete the decorations which Angelico had started in the Chapel of S. Brizio at Orvieto Cathedral. Here Signorelli painted frescoes representing the *Deeds of Anti-Christ*. (p. 112, figs. 86-89).

Sodoma, Giovanni Antonio Bazzi (1477-1549). Vercelli. In Milan, influenced by Leonardo; in Rome by Raphael; works mainly in Siena. High Renaissance murals (Monte Oliveto; Farnesina, Rome).

Solario, Andrea (c 1460-1522). Milan. Leading Lombard painter influenced by Leonardo, but also by Venetians like Antonello.

Solimena, Francesco (1657-1747). Principal Neapolitan painter of the transition from full Baroque to Rococo. His fresco decorations, religious and profane, take the style of Lanfranco, Cortona and Giordano a step further towards the turbulent ecstasies of the eighteenth century. His pupils are Francesco de Mura and Corrado Giaquinto. (p. 393, fig. 292).

Spada, Lionello (1576-1622). Bologna. Early Baroque. Works in Parma.

Spagna, Lo (c 1450-1528). Spoleto. Umbrian master under the spell of Perugino and Raphael.

Spinello, Aretino (c 1346-1410). Arezzo. Continues Giotto's style into the Late Gothic. Frescoes in Florence,

Pisa, Siena.

Squarcione, Francesco (1394-1474). Padua. Early Renaissance master in northern Italy. Antique collector. Large workshop; trains Mantegna, Zoppo, Schiavone etc.

Stanzione, Massimo (1586-1656). Neapolitan master of Cavallino; refined colourist with Classical tendencies. Capable of religious pathos as in the *Lamentation* (National Gallery). He transmits Caravaggio's effects of light to second generation of Neapolitan Baroque painters.

Strozzi, Bernardo (1581-1644). Genoese school. Influenced by Rubens, van Dyck and the Caravagesque movement. In 1631 he settles in Venice. Also influenced by Titian and Veronese. (p. 394, fig. 293).

Suardi *see* Bramantino.

Taddeo di Bartolo (c 1362-1422). Siena. Leading master after the Lorenzetti and Simone Martini. Transition to International style.

Tassi, Agostino (1566-1644). Perugia. Roman master of decorative ceiling frescoes, quadratura painting (feigned architecture) and landscapes. He worked in the Quirinale (decorative friezes) and painted the illusionist architecture in Guercino's *Aurora* (Rome, Casino Ludovisi).

Tiarini, Alessandro (1577-1668). Bologna. Educated in the Carracci school, follows Ludovico's sombre and painterly manner; also impressed by Caravaggio. Cf. *S. Dominic resuscitating a Child* (Bologna, S. Domenico).

Tibaldi, Pellegrini (1527-1596). Mannerist. Influenced by Parmigianino and from 1550, when he goes to Rome, by the pupils of Michel-

angelo. His most original work is the decoration in Palazzo Poggi at Bologna: Scenes from the Odyssey. (p. 279, fig. 206).

Tiepolo, Giovanni Battista (1696-1770). Venice. Leading master of Late Baroque and Rococo. Pupil of Lazzarini and influenced by Piazzetta and Sebastiano Ricci. Prolific decorator of churches and palaces in Venice, Udine, Milan, Germany and Spain. Perhaps his greatest achievements are the *Banquet of Antony and Cleopatra* (Venice, Palazzo Labia, 1743), the decoration of the Villa Valmarana (near Vicenza, 1757), and that of the Prince Bishop's Residence (Würzburg, 1750-1753). Between 1762-1770 he paints the *Apotheosis of Spain* in the Royal Palace of Madrid. He was assisted by his son Domenico. (p. 408, figs. 301-303).

Tiepolo, Gian Domenico (1727-1804). Venetian painter. Son and assistant of G. B. Tiepolo. He developed a distinctive style of his own, specialising in realistic genre of village life or street scenes with masks and mummers. (p. 411, plate X).

Tintoretto, Jacopo Robusti (1518-1594). Venetian. Pupil of Bonifazio Veronese; influenced by Titian, Michelangelo, Parmigianino. Leading master of Venetian Mannerism through his dematerialization of figures, irrational space and novel effects of light, especially in his many versions of the Last Supper. His principal works are the decorations on panels of walls and ceilings in the Scuola di San Rocco at Venice; Albergo 1564-1567; Sale Grande 1576-1581; Sala Terrena 1583-1587. (p. 336, figs. 251-257, plate IX).

Tiziano Vecellio da Cadore (c 1487-1576). Venetian school. Born at Pieve of Cadore. In 1496 he enters Bellini workshop at Venice. 1508: Giorgione's assistant in the frescoes in the Fondaco dei Tedeschi. 1511: decorates the Scuola del Santo at Padua. 1516: official painter to the Venetian State. 1516-1523: Bacchanals for Duke Alfonso d'Este of Ferrara. 1533: court painter to the Emperor Charles V. 1545: visits Rome. 1548: journey to Augsburg where he paints the Emperor on horseback. 1663: mythological paintings (*Poesie*) for Philip II of Spain. A prince of painters, Titian developed from the romantic-Giorgionesque to the Prot-Baroque Frari *Assumption*, the great pagan mythologies and finally to the tragic Passion scenes of his old age. In dimension Michelangelo's peer, he surpassed him in the glowing richness of his colour. (p. 295, figs. 219-229, plate VIII).

Tommaso da Modena (c 1325-1379). Modena. Marked realism of frescoed figures in the Chapter-house of S. Niccolo in Treviso (1352).

Torbido, Francesco (il Moro) (c 1482-1562). Pupil of Liberale da Verona, works in the Venetian style of Giorgione.

Torriti, Jacopo (end of thirteenth century). Painter and mosaicist of the Cavallini circle in Rome. Prepares the way for Giotto. Transition from Byzantine to Romanesque. Mosaics in the Lateran and S.M. Maggiore, Rome.

Traini, Francesco (*active after* 1321). Born in Pisa. A pupil of Ambrogio Lorenzetti. He is the master of the *Triumph of Death* in the Campo Santo at Pisa (1360). (p. 38, figs. 30-32).

Traversari, Gaspare (*active* 1732-1769). Naples. Painter of low-life genre, tramps, beggars, with Caravaggesque naturalism.

Trevisani, Francesco (1656-1746). Rome since 1681. Trained in Venice; takes over from Maratta and continues Baroque Classicism.

Tura, Cosimo (c 1430-1495). Active in Ferrara after 1451. He worked mainly for the Este Court. He was influenced by Mantegna and Donatello, and frequently visited Padua (1452-1456). He is the founder and chief protagonist of the School of Ferrara. One of his earliest works in the *Allegory of Spring* (1460). In 1469 he paints upon the organ shutters of Ferrara Cathedral *S. George and the Princess*, and the *Annunciation*. Perhaps in 1474 he painted the altar for Bishop Roverella. The centre of this painting with the *Madonna Enthroned* is in the National Gallery. The *S. Jerome*, also in London, is of 1476. (p. 158, figs. 118, 119).

Uccello, Paolo di Dono (c 1397-1475). Principal Florentine master of perspective. Trained in the workshop of the sculptor Ghiberti from 1407 to 1414. In 1425 he worked as a master-mosaicist in S. Mark's at Venice. Chief work of his early period: the fresco representing the *Flood*, in the Chiostro Verde of Santa Maria Novella, Florence. His mature work, the three battle scenes of the Rout of San Romano, were painted for the Medici Palace around 1456. (p. 72, figs. 56-60).

Udine, Giovanni da (1487-1567). Udine. Joins Raphael in Rome and excels in fresco and stucco decoration. Had overall charge of Raphael's Loggie in the Vatican.

Ugolino da Siena (*active* between 1317 and 1327). A close follower and imitator of Duccio, whose compositions he simplified and adapted in a more Gothic spirit. (p. 11, fig. 9).

Vaccaro, Andrea (1604-1670). Naples. Studied the Bolognese, and Caravaggio (via Ribera). Early Baroque.

Vaga, Pierino del (Pietro Buonac-corsi) (1501-1547). Florence. Raphael's pupil in Rome, paints biblical scenes in the Loggie after Raphael's designs and many decorative ceilings. Later becomes Mannerist.

Vanni, Andrea (*active* 1353-1413). Siena. Partner of Bartolo di Fredi. Disciple of S. Catherine of Siena whose portrait he frescoed in San Domenico. Quest for plasticity and austere contours. Restrained colour harmonies. Looks back to Simone Martini. Cf. *Madonna del Latte*.

Vasari, Giorgio (1511-1574). Arezzo. Florentine Mannerist; friend and pupil of Michelangelo, Sarto, Salviati, Rosso etc. Worked at Arezzo, Rome, Florence especially for the Medici. One of the most cultivated men of the age. He painted vast murals and easel pictures, crowded with allegorical figures in affected poses and lurid light. As an architect he built the Uffizi. His main glory are the *Vite de' piu eccellenti architetti, pittori et scultori italiani* (1550 and 1568), the first art-historical source book and catalogue raisonné of Renaissance artists as well as evaluations. Factually not always trustworthy, but full of anecdote and local colour.

Vecchietta (1412-1480). Siena. Continues the manner of Sassetta, his master. In his important workshop he trained Neroccio, Francesco di Giorgio, Matteo di Giovanni etc. Influenced by Florentine naturalism. Fine sculptural portrait of S. Catherine of Siena, 1461 (Palazzo Pubblico).

Veronese, Paolo Caliari (1528-

1588). Venetian school. Born at Verona, pupil of Antonio Badile. Influenced by Moretto of Brescia, Parmigianino, Titian etc. Settles in Venice for life from 1553. Visits Rome in 1560. Decorates the Villa Barbaro at Maser built by Palladio. Allegorical paintings in the Palazzo Ducale. Painter of festive splendour and ceremony at the height of the Renaissance. Cf. *Marriage at Cana*, *Feast in the House of Levy*. Tiepolo is of his lineage. (p. 329, figs. 246-250).

Verrocchio, Andrea del (1435-1488). Florentine sculptor, goldsmith, painter. He kept a famous workshop where Leonardo da Vinci, Lorenzo di Credi, and probably Perugino grew up. In 1470 Andrea painted the *Baptism of Christ*, assisted by Leonardo. (p. 109, figs. 83-85).

Vivarini, Alvise (1445-1503). Venice. Son of Antonio and nephew of Bartolomeo Vivarini, the founders of the Murano school. Alvise first adopts the harsh linearism of Mantegna and later the softer, more painterly manner of Bellini and the volumetical style of Antonello. Cf. *Madonna enthroned with Six Saints*, signed and dated in 1480. (Venice, Accademia).

Vivarini, Antonio (c 1415-1470). Founder of the Vivarini workshop at Murano, near Venice; first with Giovanni d'Alamagna, later with his brother Bartolomeo. Influenced by Pisanello, Gentile da Fabriano, Squarcione. Dry, archaic manner of large polytychs in elaborately carved Gothic frames. Impact of Donatello's sculptural style, especially in the *Crowning of the Virgin* (Venice, S. Pantaleone).

Vivarini, Bartolomeo (*active* 1450-1499). Murano. Younger brother of Antonio, who is affected by the modern movement of Venice and Padua, especially Mantegna and Bellini.

Zais, Giuseppe (1709-1784). Venice. Landscape painter more vigorous and, less artificial than the more famous Zuccarelli.

Zampieri *see* Domenichino.

Zuccarelli, Francesco (1702-1788). Florentine, active in Venice as landscape painter influenced by Marco Ricci, but less original. Friend of Richard Wilson. Sweetly idyllic Rococo scenes with pastoral or Classical figures.

Zuccari, Federigo (c 1542-1609). Rome. Late Mannerist. Founder and first President of Roman Academy. Prolific painter of allegorical subjects and frescoes. Cf. Cupola of Florence Cathedral, Palazzo Ducale, Cappella Paolina.